for digital photographers

Scott Kelby and Matt Kloskowski

THE PHOTOSHOP ELEMENTS 10 BOOK FOR DIGITAL PHOTOGRAPHERS

The Photoshop Elements 10 Book for Digital Photographers Team

CREATIVE DIRECTOR Felix Nelson

TECHNICAL EDITORS Cindy Snyder Kim Doty

TRAFFIC DIRECTOR Kim Gabriel

PRODUCTION MANAGER Dave Damstra

ART DIRECTOR

Jessica Maldonado

COVER PHOTOS COURTESY OF Scott Kelby Matt Kloskowski Published by **New Riders**

Copyright ©2012 by Scott Kelby

All rights reserved. No part of this book may be reproduced or transmitted in any form, by any means, electronic or mechanical, including photocopying, recording, or by any information storage and retrieval system, without written permission from the publisher, except for inclusion of brief quotations in a review.

Composed in Frutiger, Lucida, and Apple Garamond Light by Kelby Media Group, Inc.

Trademarks

All terms mentioned in this book that are known to be trademarks or service marks have been appropriately capitalized. New Riders cannot attest to the accuracy of this information. Use of a term in the book should not be regarded as affecting the validity of any trademark or service mark.

Photoshop Elements is a registered trademark of Adobe Systems, Inc. Windows is a registered trademark of Microsoft Corporation. Macintosh is a registered trademark of Apple Inc.

Warning and Disclaimer

This book is designed to provide information about Photoshop Elements for digital photographers. Every effort has been made to make this book as complete and as accurate as possible, but no warranty of fitness is implied.

The information is provided on an as-is basis. The authors and New Riders shall have neither the liability nor responsibility to any person or entity with respect to any loss or damages arising from the information contained in this book or from the use of the discs or programs that may accompany it.

THIS PRODUCT IS NOT ENDORSED OR SPONSORED BY ADOBE SYSTEMS INCORPORATED, PUBLISHER OF ADOBE PHOTOSHOP ELEMENTS 10

ISBN 13: 978-0-321-80824-0 ISBN 10: 0-321-80824-X

987654321

www.newriders.com http://kelbytraining.com

To my amazingly wonderful 14-year-old son Jordan, who continues to amaze me with his compassion, work ethic, integrity, brains, and heart. I could not be more proud to be your dad.

—SCOTT

To my youngest son Justin, for always making me smile. I love you buddy! —MATT n every book I've ever written, I always thank my amazing wife Kalebra first, because I couldn't do any of this without her. In fact, I couldn't do anything without her. She's just an incredible woman, an inspiration to me every day, and the only thing more beautiful than how she looks on the outside is what's inside. As anyone who knows me knows, I am the luckiest guy in the world to have made her my wife 22 years ago this year. Thank you, my love, for saying "Yes."

I want to thank my wonderful son Jordan, and the most adorable little girl in the world, my daughter Kira, for putting a smile on my face and a song in my heart, each and every day. Thanks to my big brother Jeff for continuing to be the type of guy I'll always look up to.

A very special thanks to my good friend Matt Kloskowski. I'm truly honored to have shared these pages with you, and I can't thank you enough for working so hard to once again make this the best edition of the book yet. As a company, we're very lucky to have you on our team, and personally, I'm even luckier to count you among my best friends.

My heartfelt thanks go to the entire team at Kelby Media Group, who every day redefine what teamwork and dedication are all about. In particular, I want to thank my friend and Creative Director Felix Nelson, and my in-house Editor Kim Doty and way cool Tech Editor Cindy Snyder, for testing everything, and not letting me get away with anything. To Kim Gabriel for keeping the trains running on time; and to Jessica Maldonado, the duchess of book design, for making everything look really cool.

Thanks to my best buddy Dave Moser, whose tireless dedication to creating a quality product makes every project we do better than the last. Thanks to my friend and partner Jean A. Kendra for everything she does. A special thanks to my Executive Assistant Kathy Siler for all her hard work and dedication, and for handling so many things so well that I have time to write books.

Thanks to my Publisher Nancy Aldrich-Ruenzel, my Editor "D-Ted" Ted Waitt, marketing madman Scott Cowlin, Sara Jane Todd, and the incredibly dedicated team at Peachpit Press. It's an honor to work with people who just want to make great books.

I want to thank all the photographers and Photoshop experts who've taught me so much over the years, including Jim DiVitale and Kevin Ames (who helped me develop the ideas for the first edition of this book), Joe McNally, Jack Davis, Deke McClelland, Ben Willmore, Julieanne Kost, Moose Peterson, Vincent Versace, Doug Gornick, Bill Fortney, Manual Obordo, Dan Margulis, Helene Glassman, Eddie Tapp, David Ziser, Peter Bauer, Joe Glyda, Russell Preston Brown, Bert Monroy, and Calvin Hollywood.

Thanks to my friends at Adobe Systems: Terry White, Cari Gushiken, John Nack, Mala Sharma, Sharon Doherty, and Mark Dahm.

Thanks to my mentors whose wisdom and whip-cracking have helped me immeasurably, including John Graden, Jack Lee, Dave Gales, Judy Farmer, and Douglas Poole.

Most importantly, I want to thank God, and His son Jesus Christ, for leading me to the woman of my dreams, for blessing us with such a wonderful son and an amazing daughter, for allowing me to make a living doing something I truly love, for always being there when I need Him, for blessing me with a wonderful, fulfilling, and happy life, and such a warm, loving family to share it with.

f course, there are many people behind the scenes that helped make this book happen. One of my favorite parts of writing a book is that I get to thank them publicly in front of all the people who read it. So here goes:

To my wife, Diana: You've been my best friend for 12 years, and I've had the time of my life with you as we enjoy watching our family grow. No matter what the day brings, you always have a smile on your face when I come home. I could never thank you enough for juggling our lives, being such a great mom to our kids, and for being the best wife a guy could ever want.

To my oldest son, Ryan: Your inquisitive personality amazes me and I love sitting down with you for "cuddle" time at night. And even though you always grenade launcher yourself to a win, I enjoy our quality Xbox 360 time. By the way, you're grounded from playing until I get better!

To my youngest son, Justin: I have no doubt that you'll be the class clown one day. No matter what I have on my mind, you always find a way to make me smile. Plus, there's nothing like hearing your eight-year-old shout, "Say hello to my little friend!" as an RPG missile comes flying at you in a video game.

To my family (Mom and Dad, Ed, Kerry, Kristine, and Scott): Thanks for giving me such a great start in life and always encouraging me to go for what I want.

To Scott Kelby: Having my name on a cover with yours is an honor, but becoming such good friends has truly been a privilege and the ride of my life. I've never met anyone as eager to share their ideas and encourage success in their friends as you are. You've become the greatest mentor and source of inspiration that I've met. More importantly, though, you've become one heck of a good friend. Thanks man!

To the designer that made this book look so awesome: Jessica Maldonado. Thank you, Jess!

To my two favorite editors in the world: Cindy Snyder and Kim Doty. You guys do so much work on your end, so I can continue writing and working on all the techniques (which is really the fun stuff) on my end. I can't tell you how much I appreciate the help you guys give me and the effort you put into making me look good.

To Dave Moser, my boss and my buddy: Your militaristic, yet insightful, comments throughout the day help motivate me and sometimes just make me laugh (a little of both helps a lot). Thanks for continuing to push me to be better each day.

To Corey Barker, Rafael (RC) Concepcion, and Pete Collins: Thanks for the ideas you guys generate and the friends you've become. You guys rock!

To Bob Gager (Elements Product Manager) and Sharon Doherty at Adobe: Thanks for taking the time to go over this new version of Elements (with a fine-toothed comb) with me. It helped more than you know to see your perspective and how you and your team are constantly pushing Elements to be better each year.

To all my friends at Peachpit Press: Ted Waitt, Scott Cowlin, Gary Prince, and Sara Jane Todd. It's because you guys are so good at what you do that I'm able to continue doing what I love to do.

To you, the readers: Without you, well...there would be no book. Thanks for your constant support in emails, phone calls, and introductions when I'm out on the road teaching. You guys make it all worth it.

OTHER BOOKS BY SCOTT KELBY

The Adobe Photoshop Lightroom 3 Book for Digital Photographers

Scott Kelby's 7-Point System For Adobe Photoshop CS3

The Digital Photography Book, volumes 1, 2 & 3

Photo Recipes Live: Behind the Scenes

Professional Portrait Retouching Techniques for Photographers Using Photoshop

The Adobe Photoshop CS5 Book for Digital Photographers

The Photoshop Channels Book

Photoshop CS4 Down & Dirty Tricks

The iPhone Book

Mac OS X Leopard Killer Tips

Getting Started with Your Mac and Mac OS X Tiger

OTHER BOOKS BY MATT KLOSKOWSKI

Photoshop Compositing Secrets: Unlocking the Key to Perfect Selections & Amazing Photoshop Effects for Totally Realistic Composites

Layers: The Complete Guide to Photoshop's Most Powerful Feature

The Photoshop Elements 5 Restoration & Retouching Book

Photoshop CS2 Speed Clinic

The Windows Vista Book

Illustrator CS2 Killer Tips

ABOUT THE AUTHORS

Scott Kelby

Scott is Editor, Publisher, and co-founder of *Photoshop User* magazine, co-host of the top-rated weekly videocast *Photoshop User TV*, and co-host of *The Grid*, the weekly videocast for photographers and Photoshop users.

Scott is President and co-founder of the National Association of Photoshop Professionals (NAPP), the trade association for Adobe® Photoshop® users, and he's President of the software training, education, and publishing firm Kelby Media Group.

Scott is a photographer, designer, and an award-winning author of more than 50 books, including *The Digital Photography Book*, volumes 1, 2 & 3, *The Adobe Photoshop Lightroom Book for Digital Photographers*, *The Photoshop Channels Book*, *Scott Kelby's 7-Point System for Adobe Photoshop CS3*, and *The Adobe Photoshop CS5 Book for Digital Photographers*.

Scott's book, *The Digital Photography Book*, vol. 1, is the best-selling book ever on digital photography. In 2010, Scott became the #1 best-selling author across all photography book categories. From 2004–2009, he held the honor of being the world's #1 best-selling author of all computer and technology books, across all categories.

His books have been translated into dozens of different languages, including Chinese, Russian, Spanish, Korean, Polish, Taiwanese, French, German, Italian, Japanese, Dutch, Swedish, Turkish, and Portuguese, among others, and he is a recipient of the prestigious Benjamin Franklin Award.

Scott is Training Director for the Adobe Photoshop Seminar Tour and Conference Technical Chair for the Photoshop World Conference & Expo. He's featured in a series of Adobe Photoshop online training courses and DVDs and has been training Adobe Photoshop users since 1993.

For more information on Scott, visit www.scottkelby.com.

Matt Kloskowski

Matt is a best-selling author and full-time Photoshop guy for the National Association of Photoshop Professionals (NAPP). His books, videos, and classes have simplified the way thousands of people work on digital photos and images. Matt teaches Photoshop and digital photography techniques to thousands of people around the world each year. He co-hosts the top-rated videocast *Photoshop User TV*, as well as *The Grid*, a live talk show videocast about photography, Photoshop, and other industry-related topics. He also hosts the *Adobe Photoshop Lightroom Killer Tips* podcast and blog, which provides tips and techniques for using Lightroom. You can find Matt's DVDs and online training courses at http://kelbytraining.com, and a large library of his weekly videos and written articles in *Photoshop User* magazine and on its website at www.photoshopuser.com.

TABLE OF CONTENTS http://kelbytraining.com

CHAPTER 1
Importing Your Photos
Backing Up Your Photos to a Disc or Hard Drive 6
Importing Photos from Your Scanner 8
Automating the Importing of Photos by Using Watched Folders
Changing the Size of Your Photo Thumbnails
Seeing Full-Screen Previews
Sorting Photos by Date and Viewing Filenames
Adding Scanned Photos? Enter the Right Time & Date
Finding Photos Fast by Their Month & Year
Tagging Your Photos (with Keyword Tags)
Auto Tagging with Smart Tags
Tagging Multiple Photos
Assigning Multiple Tags to One Photo
Tagging Images of People
Sharing Your Keyword Tags with Others
Albums: It's How You Put Photos in Order One by One
Using Smart Albums for Automatic Organization
Choosing Your Own Icons for Keyword Tags
Deleting Keyword Tags or Albums
Seeing Your Photo's Metadata (EXIF Info)
Adding Your Own Info to Photos
Finding Photos
Finding Duplicate Photos
Finding Photos Using the Date View
Seeing an Instant Slide Show
Comparing Photos
Reducing Clutter by Stacking Your Photos
Sharing Your Photos

CHAPTER 2 53
Raw Justice Processing Your Images Using Camera Raw
Opening RAW, JPEG, and TIFF Photos into Camera Raw
Miss the JPEG Look? Try Applying a Camera Profile
The Essential Adjustments: White Balance
The Essential Adjustments #2: Exposure
zerting cannot a riant riant control and a riant
The Fix for Shadow Problems: Fill Light
Adding "Snap" (or Softening) to Your Images Using the Clarity Slider
Making Your Colors More Vibrant 73
Cropping and Straightening 74
Editing Multiple Photos at Once 78
Saving RAW Files in Adobe's Digital Negative (DNG) Format
Sharpening in Camera Raw 8
Camera Raw's Noise Reduction 86
Removing Red Eye in Camera Raw
The Trick for Expanding the Range of Your Photos
Black & White Conversions in Camera Raw 95
CHAPTER 3 9
Scream of the Crop
How to Resize and Crop Photos
Cropping Photos 98
Auto-Cropping to Standard Sizes
Cropping to an Exact Custom Size
Cropping into a Shape
Using the Crop Tool to Add More Canvas Area 110
Auto-Cropping Gang-Scanned Photos
Straightening Photos with the Straighten Tool 11.
Resizing Digital Camera Photos
Resizing and How to Reach Those Hidden Free Transform Handles
Making Your Photos Smaller (Downsizing)
Automated Saving and Resizing
Resizing Just Parts of Your Image
Using the Recompose Tool

TABLE OF CONTENTS http://kelbytraining.com

Jonas Sees in Color Color Correction Secrets	131
Before You Color Correct Anything, Do This First!	132
The Advantages of Adjustment Layers	134
Photo Quick Fix	138
Getting a Visual Readout (Histogram) of Your Corrections	143
Color Correcting Digital Camera Images	144
Dave's Amazing Trick for Finding a Neutral Gray	152
Studio Photo Correction Made Simple	154
Adjusting Flesh Tones	156
Warming Up (or Cooling Down) a Photo	159
Color Correcting One Problem Area Fast!	161
Getting a Better Conversion from Color to Black and White	164
Correcting Color and Contrast Using Color Curves	169
CHAPTER 5 Little Problems Fixing Common Problems	175
Using the Smart Brush Tool to Select and Fix at the Same Time	176
Removing Digital Noise	181
Focusing Light with Digital Dodging and Burning	183
Opening Up Shadow Areas That Are Too Dark	188
Fixing Areas That Are Too Bright	190
When Your Subject Is Too Dark	192
Automatic Red-Eye Removal	195
Instant Red-Eye Removal	197
Fixing Problems Caused by Your Camera's Lens	199
The Elements Secret to Fixing Group Shots	203
Blending Multiple Exposures (a.k.a. Pseudo-HDR Technique)	207

CHAPTER 6 Select Start Selection Techniques	215
Selecting Square, Rectangular, or Round Areas	216
Saving Your Selections	221
Softening Those Harsh Edges	222
Selecting Areas by Their Color	224
Making Selections Using a Brush	226
Getting Elements to Help You Make Tricky Selections	227
Easier Selections with the Quick Selection Tool	228
Removing People (or Objects) from Backgrounds	230
CHAPTER 7 Retouch Me Retouching Portraits	235
Quick Skin Tone Fix	236
The Power of Layer Masks	238
Removing Blemishes and Hot Spots	243
Lessening Freckles or Facial Acne	245
Removing Dark Circles Under Eyes	248
Removing or Lessening Wrinkles	250
Brightening the Whites of the Eyes	252
Making Eyes That Sparkle	256
Whitening and Brightening Teeth	259
Repairing Teeth	262
Digital Nose Jobs Made Easy	271
Transforming a Frown into a Smile	273
Slimming and Trimming	275
Advanced Skin Softening	278
Fixing Reflections in Glasses	287

TABLE OF CONTENTS http://kelbytraining.com

CHAPER 8	295
Cloning Away Distractions	296
Removing Spots and Other Artifacts	300
Removing Distracting Objects (Healing Brush)	302
The Magic of Content-Aware Fill	306
Automatically Cleaning Up Your Scenes (a.k.a. The Tourist Remover)	310
CHAPTER 9	315
Automatic Special Effects	316
Creating a Picture Stack Effect	317
The Orton Effect	320
Enhancing Depth of Field	324
Trendy Desaturated Portrait Look	328
Getting the Grungy, High-Contrast Look Right Within Camera Raw	338
Converting to Black and White	341
Panoramas Made Crazy Easy	343
Creating Drama with a Soft Spotlight	346
Burned-In Edge Effect (Vignetting)	349
Using Color for Emphasis	352
The Faded Antique Look	354
Matching Photo Styles	360
Replacing the Sky	364
Neutral Density Gradient Filter	367
Skylight Filter Effect	371
Taming Your Light	373
Creating Photo Collages	375
Scott's Three-Step Portrait Finishing Technique	379
Fake Duotone	384
Simulating Film Grain	386

CHAPTER 10 Sharpen Your Teeth Sharpening Techniques	389
Basic Sharpening	390
Creating Extraordinary Sharpening	397
Luminosity Sharpening	400
Edge Sharpening Technique	403
Advanced Sharpening Using Adjust Sharpness	406
CHAPTER 11 Fine Print Step-by-Step Printing and Color Management	411
Setting Up Your	
Color Management	
Calibrating Your Monitor	413
Getting Pro-Quality Prints That Match Your Screen	416
Making the Print	
	420
My Elements 10 Workflow from Start to Finish	

THE QUICK Q&A YOU'RE GOING TO WISH YOU READ FIRST

Q. So why am I going to wish I read this first?

A. Because there's a bunch of important stuff found only in here (like where to download the practice files so you can follow along), and if you skip this short Q&A, you'll keep saying things to yourself like, "I wish they had made these photos available for download" or "I wonder if there's a website where I can download these photos?" and stuff like that. But there's more here than that—in fact, this whole section is just to help you get the most out of the book. So, take two minutes and give it a quick read.

O. Is Matt new to this book?

A. Actually, this is the fifth edition of the book with Matt as my co-author, and I'm thrilled to have him on board (mostly because I gave him all the hard stuff. Okay, that's not the real reason. Just a perk). Matt's one of the leading experts on Elements, was a featured columnist for the *Adobe Photoshop Elements Techniques* newsletter, and along with his online Elements classes, articles, and well...he's "the man" when it comes to Elements 10 (by the way, throughout the book, we just call it "Elements" most of the time—it's just shorter). So, I asked (read as: begged) him to be my co-author, and the book is far better because of his involvement.

Q. How did you split things up?

A. I (Scott) wrote the chapters on Camera Raw, printing, photographic special effects, sharpening, resizing and cropping, and the special workflow tutorial at the end of the printing chapter. Matt provided the chapters on organizing, color correction, image problems, selections, retouching, and removing unwanted objects, as well as a video on showing your work (including using the Create and Share functions).

Q. Is this book for Windows users, Mac users, or both?

A. Elements 10 is available for both Windows and Macintosh, and the two versions are nearly identical. However, there are three keys on the Mac keyboard that have different names from the same keys on a PC keyboard, but don't worry, we give you both the Windows and Mac shortcuts every time we mention a shortcut (which we do a lot).

Q. I noticed you said "nearly identical." What exactly do you mean by "nearly"?

A. Well, here's the thing: the Editor in Photoshop Elements 10 is the same on both platforms, but the Organizer (where we sort and organize our images) was only made available on the Mac starting with Elements 9. As a result, there are some Organizer functions that still aren't available on the Mac yet, and we've noted it in the book wherever this is the case.

Q. What's the deal with the chapter intros?

A. They're actually designed to give you a quick mental break, and honestly, they have little to do with the chapters. In fact, they have little to do with anything, but writing these off-the-wall chapter intros is kind of a tradition of mine (so don't blame Matt—it's not his fault), but if you're one of those really "serious" types, you can skip them because they'll just get on your nerves.

Q. How did you develop the original content for this book?

A. Each year, I'm fortunate enough to train literally thousands of professional digital photographers around the world at my live seminars, and although I'm doing the teaching, at every seminar I always learn something new. Photographers love to share their favorite techniques, and during the breaks between sessions or at lunch, somebody's always showing me how they "get the job done." It's really an amazing way to learn. Plus, and perhaps most importantly, I hear right from their own lips the problems and challenges these photographers are facing in their own work in Elements, so I have a great insight into what photographers really want to learn next. Plus, I'm out there shooting myself, so I'm constantly dealing with my own problems in Elements and developing new ways to make my digital workflow faster, easier, and more fun. That's because (like you) I want to spend less time sitting behind a computer screen and more time doing what I love best—shooting! So as soon as I come up with a new trick, or if I learn a slick new way of doing something, I just can't wait to share it with other photographers. It's a sickness, I know.

Q. So what's not in this book?

A. We tried not to put things in this book that are already in every other Elements book out there. For example, we don't have a chapter on the Layers palette or a chapter on the painting tools or a chapter showing how each of Elements' 110 filters look when applied to the same photograph. We just focused on the most important, most asked-about, and most useful things for digital photographers. In short—it's the funk and not the junk.

Q. So where are the photos we can download and the video?

A. You can download the photos and watch the video on showing your work at http://kelbytraining.com/books/elements10. Of course, the whole idea is that you'd use these techniques on your own photos, but if you want to practice on ours, we won't tell anybody. Although Matt and I shot most of the images you'll be downloading, I asked our friends over at iStockphoto.com and Fotolia.com to lend us some of their work, especially for the portrait retouching chapter (it's really hard to retouch photos of people you know, and still be on speaking terms with them after the book is published). So, I'm very grateful to iStockphoto.com and Fotolia.com for lending us (you, we, etc.) their images, and I'm particularly thankful they let us (you) download low-res versions of their photos used here in the book, so you can practice on them, as well. Please visit their sites—they've got really great communities going on there, and it wouldn't hurt if you gave them a great big sack of money while you're there. At the very least, make a stock shot of a big stack of money and upload that. It might turn into an actual big stack of money.

Q. Okay, so where should I start?

A. You can treat this as a "jump-in-anywhere" book because we didn't write it as a "build-on-what-you-learned-in-Chapter-1" type of book. For example, if you just bought this book, and you want to learn how to whiten someone's teeth for a portrait you're retouching, you can just turn to Chapter 7, find that technique, and you'll be able to follow along and do it immediately. That's because we spell everything out. So if you're a more advanced Elements user, don't let it throw you that we say stuff like "Go under the Image menu, under Adjust Color, and choose Levels" rather than just writing "Open Levels." We did that so everybody could follow along no matter where they are in the Elements experience. Okay, that's the scoop. Thanks for taking a few minutes to read this, and now it's time to turn the page and get to work.

Organized Chaos managing photos using the organizer

If you're reading this chapter opener (and you are, by the way), it's safe to assume that you already read the warning about these openers in the introduction to the book (by the way, nobody reads that, so if you did, you get 500 bonus points, and a chance to play later in our lightning round). Anyway, if you read that and you're here now, you must be okay with reading these, knowing full well in advance that these have little instructional (or literary) value of any kind. Now, once you turn the page, I turn all serious on you, and the fun and games are over, and it's just you and me, and most of the time I'll be screaming at you (stuff like, "No, no—that's too much sharpening you goober!" and "Are you kidding me? You call that a Levels adjustment?" and "Who spilled my mocha Frappuccino?"), so although we're all friendly now, that all ends when you turn the page, because then we're down

to business. That's why, if you're a meany Mr. Frumpypants type who feels that joking has no place in a serious book of learning like this, then you can: (a) turn the page and get to the discipline and order you crave, or (b) if you're not sure, you can take this quick quiz that will help you determine the early warning signs of someone who should skip all the rest of the chapter openers and focus on the "real" learning (and yelling). Question #1: When was the last time you used the word "poopy" in a sentence when not directly addressing or referring to a toddler? Was it: (a) During a morning HR meeting? (b) During a legal deposition? (c) During your wedding vows? Or, (d) you haven't said that word in a meaningful way since you were three. If you even attempted to answer this question, you're clear to read the rest of the chapter openers. Oh, by the way: pee pee. (Hee hee!)

Importing Your Photos

One of the major goals of Adobe Photoshop Elements is simply to make your life easier and the Photo Downloader is there to help do just that. Adobe has not only made the process of getting your photos from your digital camera into the Elements Organizer much easier, they also included some automation to make the task faster. Why? So you can get back to shooting faster. Here's how to import your photos and take advantage of this automation:

Step One:

When you attach a memory card reader to your computer (or attach your camera directly using a USB cable), the Elements Organizer – Photo Downloader standard dialog appears onscreen (if you have it set that way; by the way, it will also download photos from your mobile phone). The first thing it does is it searches the card for photos, and then it tells you how many photos it has found, and how much memory (hard disk space) those photos represent.

Step Two:

The Import Settings section is where you decide how the photos are imported. You get to choose where (on your hard disk) they'll be saved to, and you can choose to create subfolders with photos sorted by a custom name, today's date, when they were shot, and a host of attributes you can choose from the Create Subfolder(s) pop-up menu (as shown here).

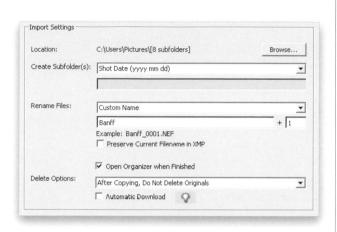

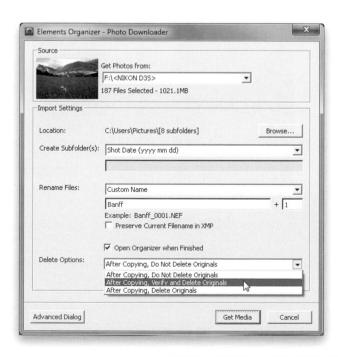

Step Three:

If you want to rename files as they're imported, you can do that in the next field down. You can use the built-in naming conventions, but I recommend choosing Custom Name from the Rename Files pop-up menu, so you can enter a name that makes sense to you. You can also choose to have the date the photo was shot appear before your custom name. Choosing Custom Name reveals a text field under the Rename Files pop-up menu where you can type your new name (you get a preview of how it will look). By the way, it automatically appends a four-digit number starting with 0001 at the end of your filename to keep each photo from having the same name.

TIP: Storing the Original Name If you're fanatical (or required by your job) and want to store the original filename, turn on the Preserve Current Filename in XMP checkbox and your original filename will be stored in the photo's metadata.

Step Four:

The last setting here is Delete Options. Basically, it's this: do you want the photos deleted off your memory card after import, or do you want to leave the originals on the card? What's the right choice? There is no right choice it's up to you. If you have only one memory card, and it's full, and you want to keep shooting, well...the decision is pretty much made for you. You'll need to delete the photos to keep shooting. If you've got other cards, you might want to leave the originals on the card until you can make a secure backup of your photos, then erase the card later.

Continued

Step Five:

Beneath the Delete Options pop-up menu, is the Automatic Download checkbox (this feature is currently only available in the PC version of Elements 10) and this feature is designed to let you skip the Photo Downloader. When you plug in a memory card reader, or camera, it just downloads your photos using your default preferences, with no input from you (well, except it asks whether you want to erase the original photos on the card or not). Now, where are these default preferences set? They're set in the Organizer's Preferences. Just go under the Organizer's Edit menu, under Preferences, and choose Camera or Card Reader. This brings up the Preferences dialog you see here.

Step Six:

Here is where you decide what happens when you turn on the Automatic Download checkbox in the Photo Downloader. You get to choose a default location to save your photos (like your Pictures folder), and whether you want it to automatically fix any photos that it detects have red eye. You can also choose to have it automatically suggest photo stacks (it groups photos it thinks belong together), or make a keyword tag. You can have settings for specific cameras or card readers (if you want separate settings for your mobile phone, or a particular camera). At the bottom, you've got some other options (when to begin the downloading, if you're going to have subfolders, and your delete options). Click OK when the preferences are set the way you want them.

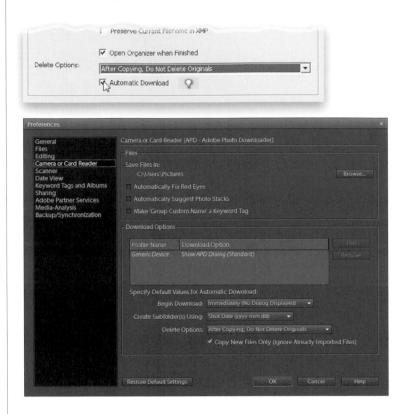

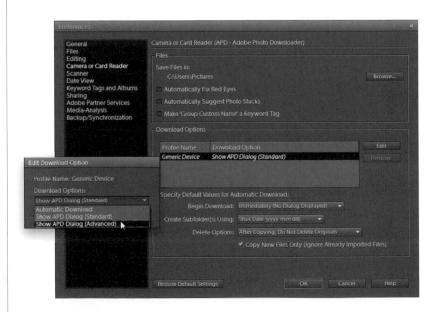

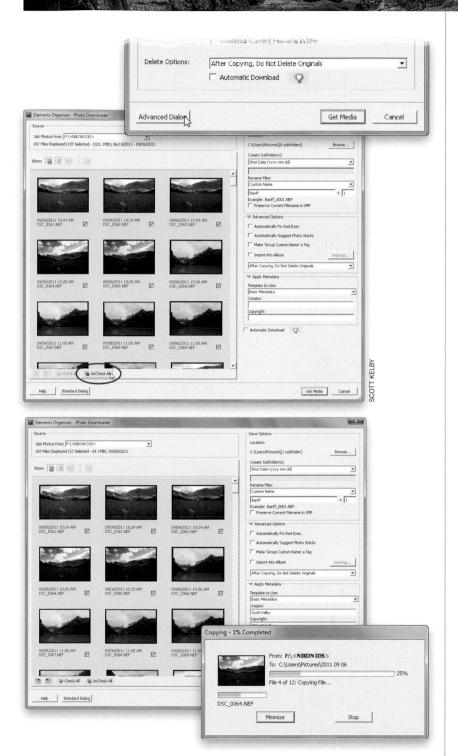

Step Seven:

Okay, back to the Photo Downloader. Now, at this point, all the photos on the card will be imported, but if you want to import just a few selected photos, then you'll need to click on the Advanced Dialog button at the bottom-left corner of the dialog (shown at the top). That expands the dialog and displays thumbnails of all the photos on the card. By default, every photo has a checkbox turned on below it, indicating that every photo will be imported. If you just want some of these photos imported, then you'll need to click the UnCheck All button at the bottom left of your thumbnails. This turns off all the photos' checkboxes. which enables you to then go and turn on the checkboxes below only the photos you actually want imported.

Step Eight:

When you look at the right side of the dialog, you'll see some familiar Save Options (the subfolder choice, renaming files), and in the Advanced Options section, you'll see choices to automatically fix red eyes, suggest photo stacks, make a tag, import into an album, and delete options. Another nice feature is the ability to embed metadata (like your name and your copyright info) directly into the digital file, just like your camera embeds information into your digital camera images. So, just type in your name and your copyright info, and these are embedded into each photo automatically as they're imported. This is a good thing. When you click Get Media, your photos are imported (well, at least the photos with a checkmark under them). If you want to ignore these advanced features and just use the standard dialog, click on the Standard Dialog button.

Backing Up Your Photos to a Disc or Hard Drive

When you think about backing up, I'd like you to consider this: it's not a matter of if your hard drive will crash, it's a matter of when. I've personally had new and old computers crash. So many times that now I'm totally paranoid about it. Sorry, but it's a harsh fact of computer life. You can protect yourself, though, by backing up your entire catalog to a disc or hard drive, and/or using an online backup, so your photos are protected in an off-site location. So even if your hard drive dies or your computer is lost, stolen, damaged in a fire, flood, or hurricane, you can retrieve your images.

Step One:

To back up your catalog to a hard drive or disc, you simply go under the Organizer's File menu and choose **Backup Catalog to CD, DVD or Hard Drive** (as shown here; currently in the Mac version of Elements 10, you can only back up to a hard drive).

TIP: Back Up to an External Hard Drive

We recommend backing up to an external hard drive. They're much larger than a CD, or even a DVD, and easier to manage. Plus, you can always take them with you or to a nice off-site location to really keep your backups safe.

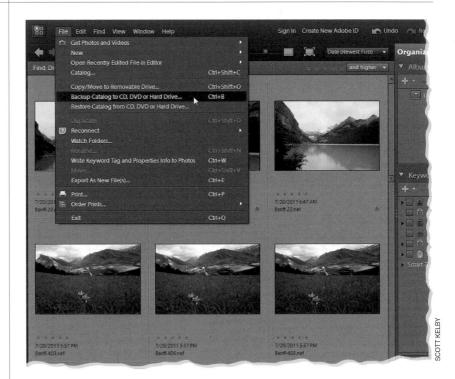

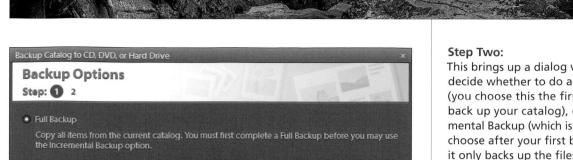

This brings up a dialog where you decide whether to do a Full Backup (you choose this the first time you back up your catalog), or an Incremental Backup (which is what you'll choose after your first backup, as it only backs up the files that have changed since your last backup, which is a big time saver). In this case, since this is your first time, choose Full Backup (as shown here), then click the Next button.

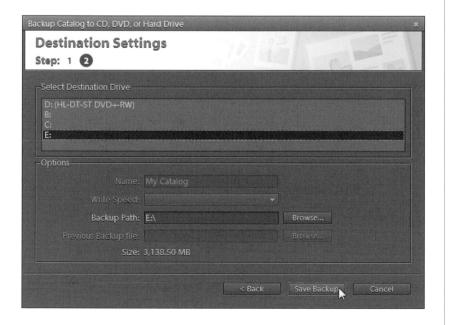

Copy the current catalog and all new or modified files since the last backup.

Step Three:

When you click Next, the Destination Settings screen appears, which is basically where you tell Elements to back up your stuff to. If it's a DVD or CD, just insert a blank DVD or CD into your DVD/CD drive and choose that drive from the list. Give your disc a name and click the Save Backup button, and it does its thing. Same thing for a hard drive—just choose it from the list and click the Save Backup button.

Importing Photos from Your Scanner

If you're reading this and thinking: "But this is supposed to be a book for digital photographers. Why is he talking about scanning?" Then ask yourself this: "Do I have any older photos lying around that I wish were on my computer?" If the answer is "Yes," then this tutorial is for you. We'll take a quick look at importing scanned images into the Organizer.

Step One:

In the Elements Organizer, go under the File menu, under Get Photos and Videos, and choose **From Scanner**. By the way, in the Organizer, you can also use the shortcut **Ctrl-U** to import photos from your scanner. (*Note:* This feature is currently only available in the PC version of Elements 10.)

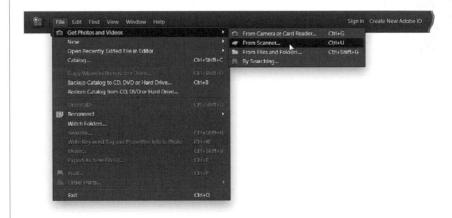

Step Two:

Once the Get Photos from Scanner dialog is open, choose your scanner from the Scanner pop-up menu. Choose a high Quality setting (I generally choose the highest quality, unless the photo is for an email to my insurance company for a claim—then I'm not as concerned). Then click OK to bring in the scanned photo. See? Pretty straightforward stuff.

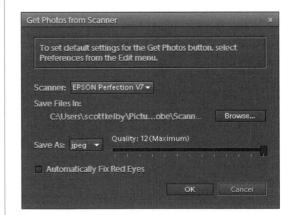

If you're the type that likes to squeeze every ounce of productivity out of your computer, then try this tutorial out. Elements lets you choose a folder that is "watched" by the Organizer. So whenever you put photos into that watched folder, they'll automatically be added into the Organizer.

Yep, no interaction from you is needed at all. Here's how it works:

Automating the Importing of Photos by Using Watched Folders

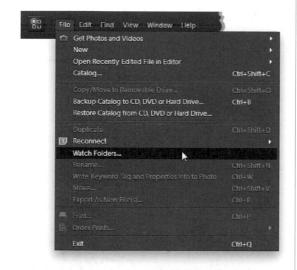

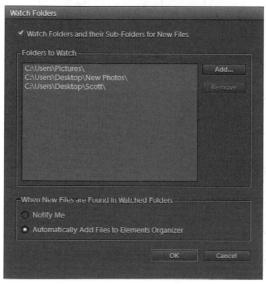

Step One:

Go under the Organizer's File menu and choose **Watch Folders**. (*Note:* This feature is currently only available in the PC version of Elements 10.)

Step Two:

When the Watch Folders dialog appears, make sure the Watch Folders and Their Sub-Folders for New Files checkbox is turned on. In the Folders to Watch section, click the Add button, and then in the resulting dialog, navigate to any folders you want the Organizer to "watch" for the addition of new photos. Select the folder you want to watch, and then click OK. Continue to click the Add button and select more folders to watch. When you've selected all your folders, they will appear in the Folders to Watch section of the Watch Folders dialog. In the When New Files are Found in Watched Folders section, you have the choice of having the Organizer alert you when new photos are found in the watched folders (meaning you can choose to add them) or you can have them added automatically, which is what this feature is really all about. But if you're fussy about what gets added when (i.e., you're a control freak), at least you get an option.

Changing the Size of Your Photo Thumbnails

We all have our personal preferences. Some people like to cram as many photos onscreen at once as they can, while others like to see the photos in the Organizer's Media Browser at the largest view possible. Luckily, you have total control over the size they're displayed at.

Step One:

The size of your thumbnails is controlled by a slider at the top of the Media Browser. Click-and-drag the slider to the right to make them bigger and to the left to make them smaller. To jump to the largest possible view, just click on the Single Photo View icon to the right of the slider. To jump to the smallest size, click on the Small Thumbnail Size icon to the left of the slider.

TIP: Jumping Up a Size

To jump up one size at a time, click on a thumbnail, then press-and-hold the **Ctrl (Mac: Command) key** and press the + (plus sign) **key**. To go down in size, press **Ctrl--** (minus sign; **Mac: Command--**).

Step Two:

Another shortcut to jump to the largest view is to just double-click on your thumbnail. At this large view, you can enter a caption directly below the photo by clicking on the placeholder text (which reads "Click here to add caption") and typing in your caption.

If you like seeing a super-big view of your photos, then use Elements' Full Screen View. It shows you a huge preview of a selected thumbnail without having to leave the Organizer. Here's how:

Seeing Full-Screen Previews

Step One:

To see a full-screen preview of your currently selected photo(s), click on the Display button (it looks like a tiny monitor) at the right side of the menu bar up top and choose View, Edit, Organize in Full Screen (or press F11 [Mac: Command-F11], or just click on the View, Edit, Organize in Full Screen icon in the Options Bar [it's to the right of the Single Photo View icon]).

Step Two:

This brings you into Full Screen view, and your photo should appear large onscreen with everything else black around it. This is really a way to launch into a slide show, but if you don't do anything here, you're simply just viewing your photos in a larger view. If you want to return to the Media Browser, press the **Esc key** on your keyboard. But wait, there's more.

Continued

Step Three:

Once your photo(s) appears full screen, there's a control palette at the bottom of the screen where you can control your viewing options—click the Play button to start moving through your photos and click the Pause button to stop. You can also click the Right Arrow and Left Arrow buttons to view the next or previous photo.

Step Four:

One more thing: Try clicking the Toggle Film Strip button at the left side of the control palette (or just press **Ctrl-F [Mac: Command-F]**). This opens a filmstrip view of your photos on the right side of the screen. So you don't necessarily have to hit the Right Arrow button a bunch of times to get to a photo that's 25 photos into your list. You can just scroll the filmstrip until you see it and click on it. Nifty, huh?

When photos are imported into the Organizer, the Organizer automatically sorts them by date. How does it know on which dates the photos were taken? The time and date are embedded into the photo by your digital camera at the moment the photo is taken (this info is called EXIF data). The Organizer reads this info and then sorts your photos automatically by date, putting the newest ones on top. You can change that, though, and you can choose whether or not to view your filenames.

Sorting Photos by Date and Viewing Filenames

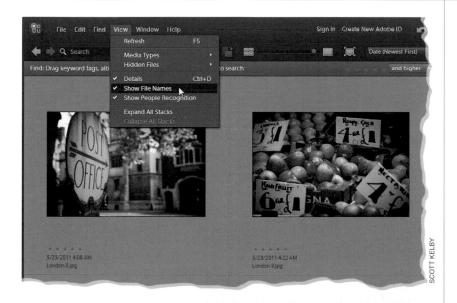

Step One:

By default, the newest photos are displayed first, so basically, your last photo shoot will be the first photos in the Organizer. Also, by default, the exact date and time each photograph was taken is shown directly below each photo's thumbnail, but it doesn't show you the filename. To turn them on, choose **Show File Names** from the View menu.

Step Two:

If you'd prefer to see your photos in reverse order (the oldest photos up top), then choose **Date (Oldest First)** from the pop-up menu above the top right of the Media Browser. There you have it!

Adding Scanned Photos? Enter the Right Time & Date

Let's say that you have a scanner and you scan in a bunch of photos and import them into the Organizer. They're all going to show up on the date you scanned them, not the date they were taken. That's when you'll need to manually go in and enter the date. I know, you're wondering how you'll know what date the photos were taken. It could have been decades ago. Well, just getting close is a start. For example, if you see a guy wearing a tie-dyed shirt and socks pulled up to his knees, you can pretty much bet it was taken in the late '70s (at least you hope).

Step One:

First, get the photos from your scanner (see the "Importing Photos from Your Scanner" tutorial earlier in this chapter). Select all the photos you want to set the date for by Ctrl-clicking (Mac: Command-clicking) on each image (or Shift-clicking on the first and last images if they are contiguous) in the Media Browser. Then, go under the Organizer's Edit menu and choose Adjust Date and Time of Selected Items (or press Ctrl-J [Mac: Command-J]).

Step Two:

This brings up a dialog asking how you want to handle the date and time for these photos. For this example, select Change to a Specified Date and Time and click OK.

Step Three:

This brings up the Set Date and Time dialog, where you can use the pop-up menus to set your selected photos' date and time. Now these photos will appear sorted by the date you entered, rather than the date you imported them.

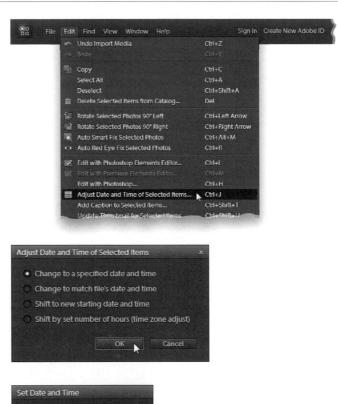

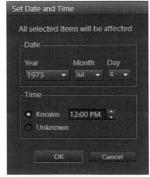

By default, the Organizer sorts your photos by date and time, with the most recent photos appearing at the top. You know and I know that it's hard to always remember when you took some of your favorite photos, though. With the Timeline, you can at least get pretty close. Let's say you're trying to find photos from a photo shoot you did around Thanksgiving last year. You may not remember exactly whether it was November or December, but by moving a slider you can hone in and find them really fast.

Finding Photos Fast by Their Month & Year

Step One:

First things first. You need to display the Timeline to use it. Go under the Window menu and choose Timeline (or just press Ctrl-L [Mac: Command-L]). It'll appear right above the Media Browser. We're going to assume you're trying to find photos from a shoot you did around Thanksgiving last year (as mentioned above). You see those bars along the Timeline that look like the little bar charts from Microsoft Excel? Well, the higher the bar, the more photos that appear in that month. So click on any month in 2011 and the photos taken in that month will appear in the Media Browser. As you slide your cursor to the left (or right), you'll see each month's name appear. When you move to 2010 and click on November, photos taken in November 2010 will appear. Take a quick look and see if any of those photos are the ones from your shoot. If they're not in November, scroll on the Timeline to December, and those photos will be visible.

Tagging Your Photos (with Keyword Tags)

Although finding your photos by month and year is fairly handy, the real power of the Organizer appears when you assign tags (keywords) to your photos. This simple step makes finding the exact photos you want very fast and very easy. The first step is to decide whether you can use the pre-made tags that Adobe puts there for you or whether you need to create your own. In this situation, you're going to create your own custom tags.

Step One:

Start by finding the Keyword Tags palette in the Organizer (it's on the right side of the window on the Organize tab in the Task pane). Adobe's default set of keyword tag categories will appear in a vertical list. Now, there are a few different ways to tag photos, so let's take a look at them all. In the end, they all do the same thing, just in a different way.

Step Two: The Really Easy Way

Let's start by tagging the really easy way. Type a tag name in the Tag Selected Media text field at the bottom of the Keyword Tags palette. Then in the Media Browser, click on the photo (Ctrlclick [Mac: Command-click] to select multiple photos) you want to assign this tag to and click the Apply button to the right of the text field. The tag will automatically be created and applied to the selected photo(s).

TIP: Use an Existing Keyword Tag Since the Keyword Tags text field dynamically displays existing keyword tags based on the letters you type, you can use it to assign an existing keyword tag to your photos instead of creating a brand new one.

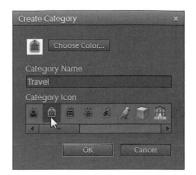

The More Customized and Visual Way The thing about Step Two is that it automatically creates your tag in the Other category. As you start tagging, you may want to categorize your tags and even create your own categories. So, let's start by creating a custom category (in this case, we're going to create a category for travel shots). Click on the Create New Keyword Tag button (the little green plus sign) at the top left of the Keyword Tags palette and choose **New Category** from the pop-up menu. This brings up the Create Category dialog. Type in "Travel." Now choose an icon from the Category Icon list and then click OK. (The icon choices are all pretty lame, so we'll just choose the green Places category icon here.)

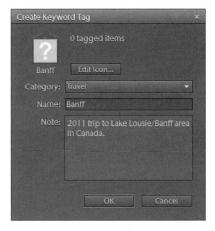

Step Four:

To create your own custom tag, click on the Create New Keyword Tag button again and choose **New Keyword Tag**. This brings up the Create Keyword Tag dialog. Choose Travel from the Category pop-up menu (if it's not already chosen), then in the Name field, type in a name for your new tag (here I entered "Banff"). If you want to add additional notes about the photos, you can add them in the Note field, and you can choose a photo as an icon by clicking the Edit Icon button (there's more on choosing icons later in this chapter). Now click OK to create your tag.

Step Five:

Next, you'll assign this tag to all the photos from this shoot. In the Media Browser, scroll to the photos from that shoot. We'll start by tagging just one photo, so click on your new tag that appears in your Keyword Tags list and drag-and-drop that tag onto any one of the photos. That photo is now "tagged" and you'll see a small tag icon appear below the photo's thumbnail.

Step Six:

So at this point, we've only tagged one photo from this shoot. Drag-and-drop that same tag onto three more photos from the shoot, so a total of four photos are tagged. Now, in the Keyword Tags palette, click in the small box to the left of your new tag (a tiny binoculars icon will appear in that box), and instantly, only the photos with that tag will appear in the Media Browser. To see all your photos again, click on the Show All button that appears at the top left of the Media Browser.

You saw how to tag your photos in the previous tutorial and I won't lie to you—it takes a little bit of time. However, there is a feature called Smart Tagging that does some auto-tagging for you. Now, it can't figure out that you were at Disney World and tag your photos with Disney tags, but there are a few useful Smart Tags to help you get started.

Auto Tagging with Smart Tags

Step One:

Take a look at the Keyword Tags palette and, at the bottom of the tag category list, you'll see Smart Tags. When you click on the right-facing arrow and expand it, you'll see there are tags named High Quality, Faces, Too Bright, Too Dark, etc. There are also tags named Audio and Shaky, which are actually meant for video, if you're using Premier Elements.

Step Two:

To use Smart Tags, you've got to first let Elements analyze your photos. It's a snap, though. Just Ctrl-click (Mac: Command-click) on the photos in the Media Browser that you want to select, Right-click on any of the ones you just selected, and choose **Run Auto-Analyzer** from the pop-up menu. A progress bar will appear, so you'll know the Auto-Analyzer is doing something. This may take a few minutes depending on how many photos you select.

Continued

Step Three:

When the Auto-Analyzer is done running, go back to the Smart Tags in the Keyword Tags palette. Click in the small box next to one of the Smart Tags (I'll choose the High Quality tag here) and you'll see the photos that Elements has deemed are high quality. Like I said in the intro, the Smart Tags aren't the solution to everything, but they do give you a good starting point.

Okay, if you had to tag any more than a few photos, you've probably realized that dragging-and-dropping the tag onto each photo is a pain in the neck. If you had a whole photo shoot, that process would take forever and you'd probably be getting ready to send Adobe (or us for even showing you this feature) a nasty email. You'll be happy to know there are faster ways than this one-tag-at-a-time method. For example...

Tagging Multiple Photos

Step One:

To tag all the photos from your shoot at the same time, try this: First, click on any photo from the shoot. Then press-and-hold the Ctrl (Mac: Command) key and click on other photos from that particular shoot. As you click on them, they'll become selected (the area around each selected photo will appear in light gray). Or, if all the photos are contiguous, click on the first image in the series, press-and-hold the Shift key, and then click on the last image in the series to select them all.

Step Two:

Now drag-and-drop your chosen tag onto any one of those selected photos, and all of the selected photos will have that tag. If you want to see just the photos from that shoot, you can click in the box to the left of that tag in the Keyword Tags palette and only photos with that tag will appear. By the way, if you decide you want to remove a tag from a photo, just Right-click on the tag icon below the photo and from the popup menu that appears, choose **Remove** Keyword Tag. If you have more than one tag applied (like the Notre Dame vs. Michigan State [where I took these photos] keyword tag and the College Football keyword tag), you can choose which tag you want removed.

Assigning Multiple Tags to One Photo

Okay, what if you want to assign a keyword tag to a photo, but you also want to assign other keyword tags (perhaps an "Upload to Website" tag and a "Make Prints" tag) to that photo, as well? Here's how:

Step One:

To assign multiple tags at once, first, of course, you have to create the tags you need, so go ahead and create your new tags by clicking on the Create New Keyword Tag button and choosing **New Keyword Tag** from the pop-up menu. Name them "Upload to Website," "Make Prints," and two others specific to this shoot. Now you have four tags you can assign. To assign all four tags at once, just press-and-hold the Ctrl (Mac: Command) key, then in the Keyword Tags palette, click on each tag you want to assign (Moab, Mountain Bike, Make Prints, and Upload to Website).

Step Two:

Now click-and-drag those selected tags, and as you drag, you'll see you're dragging four tag icons as one group. Drop them onto a photo, and all four tags will be applied at once. If you want to apply the tags to more than one photo at a time, first press-and-hold the Ctrl (Mac: Command) key and click on all the photos you want to have all four tags. Then, go to the Keyword Tags palette, press-and-hold the Ctrl key again, and click on all the tags you want to apply. Drag those tags onto any one of the selected photos, and all the tags will be applied at once. Cool.

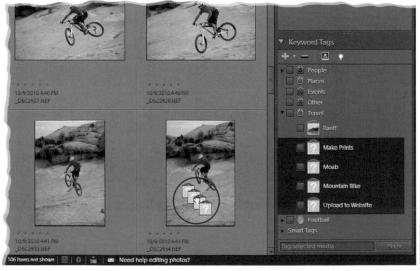

You're either going to think this is the coolest, most advanced technology in all of Elements, or you're going to think it's creepy and very Big Brother-ish (from the book by George Orwell, not the TV show). Either way, it's here to help you tag people easier because the Organizer can automatically find photos of people for you—as it has some sort of weird science, facial-recognition software built in (that at one point was developed for the CIA, which is all the more reason it belongs in Elements).

Tagging Images of People

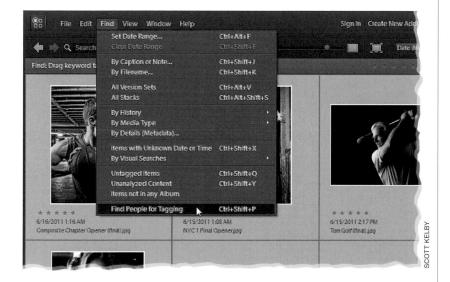

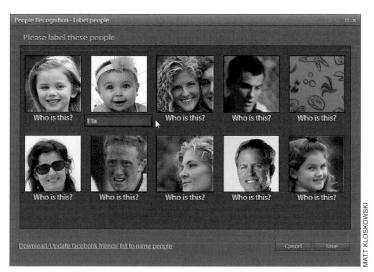

Step One:

Let's say you want to quickly find all the photos of your daughter. In the Organizer, select the group of photos you want to search through (you can press Ctrl-A [Mac: Command-A] to Select All, click on an album, or just Ctrl-click [Mac: Command-click] on as many images as you want to sort through). Then go under the Find menu and choose Find People for Tagging, or just click on the Start People Recognition button at the top of the Keyword Tags palette.

Step Two:

This brings up the People Recognition -Label People dialog with the images that contain a human face. Just click on the "Who is this?" link beneath one of the image thumbnails, type in a name to tag the photo with, and press Enter (Mac: Return). If this keyword doesn't already exist, this will create a new one. If Elements found something that isn't a face in a photo, just hover your cursor over the image, and click the X in the black circle at the top right. If multiple images contain the same people, there's no need to tag each image. Just click the Save button and in the next dialog, you'll be given the option to tag the other images with the keyword(s) you just created. Click beneath the other image thumbnails and choose the keyword(s) you just created.

Continued

TIP: Use Your Facebook Friend List At the end of this chapter, you'll see a tutorial that shows you how to share your photos on Facebook. Well, when you set up Elements to be authorized to work with your Facebook account, you'll also get an option to download your Facebook friend list (circled here). If you turn that option on, then your Facebook friends will appear in the list when you tag people. Each time you find people for tagging, you'll also get the chance to download or update your Facebook friend list by clicking on the link in the bottom left of the People Recognition - Label People dialog.

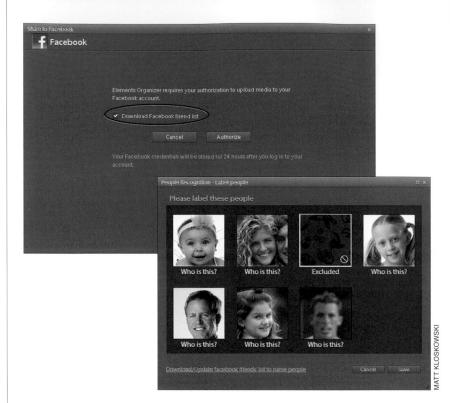

Step Three:

If you've selected images that all contain the same person, Elements will give you the option of tagging all the images at once. When you click the Save button in the Label People dialog, the People Recognition – Confirm Groups of People dialog will appear. Here, you'll click on any images that you want to exclude from tagging. Once you're done, click Save and you'll get a dialog letting you know that you successfully tagged all of the faces in the images that you selected.

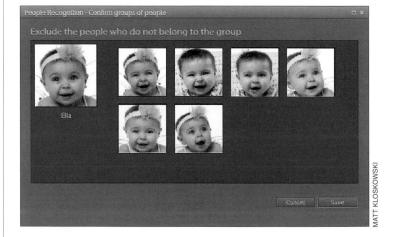

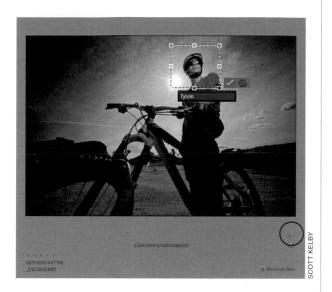

Step Four:

If Elements didn't recognize a face, you can always add your own. In the Media Browser, double-click on the image with the person you want to tag, then click the Add Missing Person icon beneath the bottom right of the image thumbnail. Click-and-drag the rectangle over the person's face, resize it by dragging any of the corner handles, and give 'em a name.

TIP: Train Elements to Find Faces
The more you tag and the more you use this face tagging technology, the better you train Elements to find faces. Each time you tag faces, it gets more and more accurate.

Sharing Your Keyword Tags with Others

Let's say you went to the Super Bowl with a group of photographers, and they're using Elements, too. If you've created a nice set of keyword tags for identifying images, you can export these tags and share them with the other photographers from that trip. That way, they can import them and start assigning tags to their Super Bowl photos without having to create tags of their own.

Step One:

To export your keyword tags to share with others, start by going to the Keyword Tags palette (on the right side of the Organizer), then click on the Create New Keyword Tag button and, from the pop-up menu, choose **Save Keyword Tags to File**.

Step Two:

When the Save Keyword Tags to File dialog appears, you can choose to Export All Keyword Tags or, better yet, click on the Export Specified Keyword Tags radio button, then you can choose which tag category or sub-category you want to export from the pop-up menu, and just click OK. A standard Save dialog will appear, so you can choose where you want your file saved. Name your file, click Save, and now you can email your exported tags to your friends.

Step Three:

Once your friends receive your tags, tell them they can import them by going to the Keyword Tags palette, clicking on the Create New Keyword Tag button, and from the pop-up menu, choosing From File. Now they just locate the file on their hard drive and click Open. The new tags will appear in their Keyword Tags palette. (Note: You can export your albums in a similar way from the Albums palette. See the next page for more on albums.)

Once you've tagged all your photos, you may want to create a collection of just the best photos (the ones you'll show to your friends, family, or clients). You do that by creating an "album" (which used to be called a collection in earlier versions of Elements). An advantage of albums is that once photos are in an album, you can put the photos in the order you want them to appear (you can't do that with tags). This is especially important when you start creating your own slide shows and Web galleries.

Albums: It's How You Put Photos in Order One by One

Step One:

To create an album, go to the Albums palette on the top-right side of the Organizer (it's above the Keyword Tags palette we just looked at). You create a new album by clicking on the Create New Album button (the green plus sign), and from the pop-up menu, choosing **New Album**. When the Album Details pane appears, enter a name for your album, and then click Done.

Step Two:

Now that your album has been created, you can either (a) drag the album icon onto the photos you want in your album, or (b) Ctrl-click (Mac: Command-click) on photos to select them and then drag-and-drop them onto your album icon in the Albums palette. Either way, the photos will be added to your album. To see just those photos, click on your album name. Now, to put the photos in the order you want, just click on any photo and drag it into position. The Organizer automatically numbers the photos for you in each thumbnail's top-left corner. so it's easy to see what's going on as you click-and-drag. To return to all of your images, click the Show All button in the top-left corner of the Media Browser.

Using Smart Albums for Automatic Organization

As we saw in the previous tutorial, albums are the way to go, right? They're such an easy way to get to your best photos. But let's say you find yourself always searching for photos of three people together in one shot (maybe your nieces). You could tag each photo separately and then create an album of those photos, so you could get to them quickly. However, what happens when you add more photos to your photo library with your nieces together? You'd have to manually tag them and then add them to the album to keep it up to date. Or, you could use this handy little feature in Elements called Smart Albums to do it automatically.

Step One:

Here's a good scenario: I've got some photos of three girls separately and others with them together, as well. They've all been tagged with either their own or all three tags. What I want is an easy way to find photos of the three of them. I could: (1) Turn on all three tags in the Keyword Tags palette to see just those photos, but that's a pain to do every time I want to see them. (2) Create an album named "My Nieces" and put the photos of the three of them in it, but what happens when I import more photos of them? I'd have to manually add them to the album each time. (3) Use a Smart Album that watches my photo library for a specified set of criteria (in this case, all three tags). In case you haven't realized it yet, this is the better option.

Step Two:

At the top of the Albums palette, click on the Create New Album button and choose **New Smart Album**. In the New Smart Album dialog, give it a descriptive name (like "My Nieces," since they'll be in the photos we'll be including here). Next, choose what criteria the photos match. Since we want our photos to match three criteria, not just one or the other, I'm going to set Search for Files Which Match to All of the Following Search Criteria [AND].

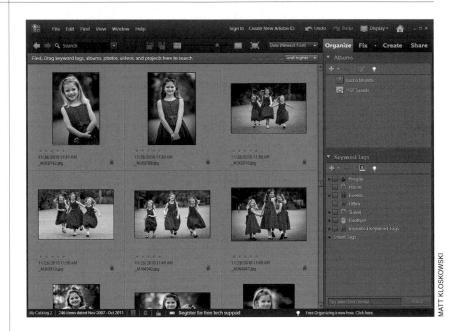

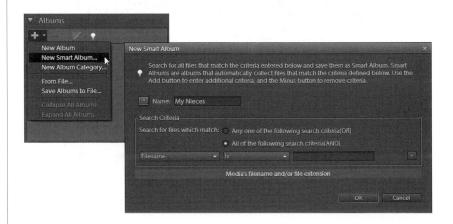

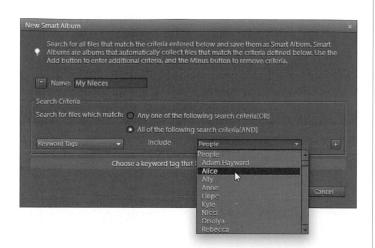

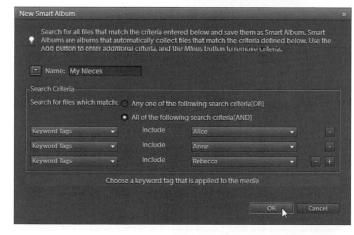

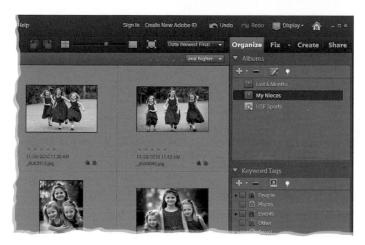

Now, click on Filename and, from the pop-up menu, choose **Keyword Tags**, then from the pop-up menu that appears on the right, choose the keyword tag you want to search by.

TIP: Search By Other Criteria

If you scroll through the first pop-up menu, you'll see there are a ton of things you can search by instead of just Keyword Tags. For example, you can search by a certain focal length. So, if you wanted an album of all photos shot at 85mm, no problem.

Step Four:

Let's add to this. Click the little + (plus sign) icon to the right of the second pop-up menu to create another line of criteria. Choose Keyword Tags from the first pop-up menu, and set it to include the second girl. Create a third line of criteria for the third girl. You can keep adding more criteria by clicking the little + icon, but let's stop with three names and click OK.

Step Five:

Notice that without you doing anything else, Elements has already populated the Smart Album with some photos. You'll see that all of the photos in it are tagged with the tags you just chose (for me, it was all three tags). But that's not the really super cool part. The really super cool part is that Elements monitors your photo library, and the next time you add all three tags to a photo, it will automatically add that photo to the Smart Album. You don't have to lift a finger to make it happen because you've already created that Smart Album. It does all the work of staying updated for you as long as you do your job of tagging as you go along.

Choosing Your Own Icons for Keyword Tags

By default, a keyword tag uses the first photo you add to that tag as its icon. Most of the time, these icons are so small that you probably can't tell what the icon represents. That's why you'll probably want to choose your own photo icons instead.

Step One:

It's easier to choose an icon once you've created a keyword tag and tagged a few photos. Once you've done that, Right-click on your tag, and choose **Edit Keyword Tag** from the pop-up menu. This brings up the Edit Keyword Tag dialog. In this dialog, click on the Edit Icon button to launch the dialog you see here.

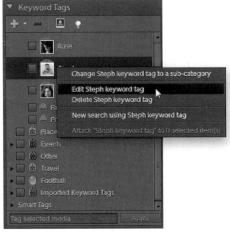

Step Two:

You'll see the first photo you tagged with this keyword in the preview window (this is why it's best to edit the icon after you've added tags to the photos). If you don't want to use this first photo, click the arrow buttons under the bottom-right corner of the preview window to scroll through your photos. Once you find the photo you want to use, click on the little cropping border (in the preview window) to isolate part of the photo. This gives you a better close-up photo that's easier to see as an icon. Then click OK in the open dialogs and that cropped image becomes your icon.

There will be plenty of times when you create a keyword tag or an album and later decide you don't want it anymore. Here's how to get rid of them:

Deleting Keyword Tags or Albums

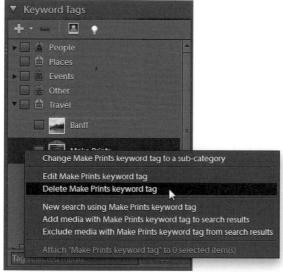

Step One:

To delete a keyword tag or album, start by Right-clicking on the keyword tag or album you want to delete in the Keyword Tags or Albums palette on the right side of the Organizer, and choosing **Delete Keyword Tag** or **Delete Album** from the pop-up menu.

Step Two:

If you're deleting a tag, it brings up a warning dialog letting you know that deleting the tag will remove it from all your photos and Smart Albums, and if you used this keyword to tag a person, it will be removed from the People Recognition System. If you want to remove that tag, click OK. If you've got an album selected, it asks if you're sure you want to delete the album, and lets you know that if you used that album in a Smart Album, it'll be removed from there, as well. Click OK and it's gone. However, it does not delete these photos from your main catalog—it just deletes that album.

Seeing Your Photo's Metadata (EXIF Info)

When you take a photo with a digital camera, a host of information about that photo is embedded into the photo by the camera itself. It contains just about everything, including the make and model of the camera that took the photo, the exact time the photo was taken, what the f-stop setting was, what the focal length of the lens was, and whether or not the flash fired when you took the shot. You can view all this info (called Exchangeable Image File [EXIF] data—also known as metadata) from right within the Organizer. Here's how:

Step One:

To view a photo's EXIF data, click on the image in the Media Browser and then from the Window menu, choose **Properties**. The Properties palette will appear as a floating palette. To nest it below the Keyword Tags palette (as shown here), click the Dock to Organizer Pane icon at the top right.

TIP: Properties Palette Shortcut You can also just press Alt-Enter (Mac: Option-Return) to open and close the palette.

Step Two:

When the Properties palette appears, click the Metadata button at the top of the palette (it's the second button from the left). This shows an abbreviated version of the photo's EXIF data (basically, the make, model, ISO, exposure, f-stop, focal length of the lens, and the status of the flash). Of course, the camera embeds much more info than this. To see the full EXIF data, in the View section at the bottom of the palette, just select Complete and you'll get more information on this file than you'd probably ever want to know.

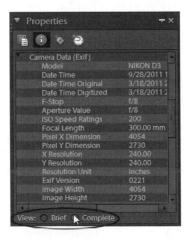

As soon as you press the shutter button, your digital camera automatically embeds information into your photos. But you can also add your own info if you want. This includes simple things like a photo caption (that can appear onscreen when you display your photos in a slide show), or you can add notes to your photos for your personal use, either of which can be used to help you search for photos later.

Adding Your Own Info to Photos

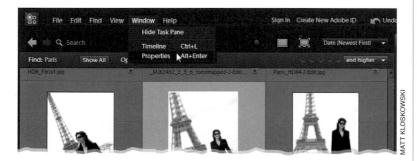

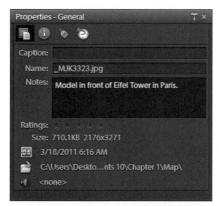

Step One:

First, click on the photo in the Media Browser that you want to add your own info to, and then from the Window menu, choose **Properties** to open the Properties palette (or you can use the keyboard shortcut **Alt-Enter [Mac: Option-Return]**).

Step Two:

This brings up the Properties palette. At the top of the palette are four buttons for the four different sections of your photo's properties. By default, the General section is selected. In the General section, the first field is for adding captions (I know, that's pretty self-explanatory), and then the photo's filename appears below that. It's the third field down—Notes—where you add your own personal notes about the photo.

Step Three:

If you want to see other info about your photo (for example, which keyword tags have been added to your photo; the date when you imported the photo or when you last printed, emailed, or posted the photo on the Web; or the info embedded into the photo by your digital camera), just click on the various buttons at the top of the palette.

Finding Photos

Aside from actually doing things to fix your photos, finding them will be the most common task you do in Elements. If you've tagged them, then it's easy to find groups of photos. But finding just one photo can be a little harder (not really too hard, though). You first have to narrow the number of photos to a small group. Then you'll look through that group until you find the one you want. I know, it sounds complicated but it's really not. Here are the most popular searching methods:

From the Timeline:

We saw this one earlier. The Timeline (from the Window menu, choose Timeline to see it), which is a horizontal bar across the top of the Media Browser, shows you all the photos in your catalog. Months and years are represented along the Timeline. The years are visible below the Timeline; the small light blue bars above the Timeline are individual months. If there is no bar visible, there are no photos stored in that month. A short blue bar means just a few photos were taken that month; a tall bar means lots of photos. If you hover your cursor over a blue bar, the month it represents will appear. To see the photos taken in that month, click on the bar and only those photos will be displayed in the Media Browser. Once you've clicked on a month, you can click-and-drag the locator bar to the right or left to display different months.

Using Keyword Tags:

If there's a particular shot you're looking for, and you've tagged all your shots with a particular tag, then just go to the Keyword Tags palette and click on the empty box to the left of that tag. Now only shots with that tag will appear in the Media Browser.

By Date Range:

Let's say you're looking to find a particular photo you shot on vacation. If you can remember approximately when you went on vacation, you can display photos taken within a certain date range (for example, all the photos taken between July 1 and July 15, 2011). Here's how: Go under the Organizer's Find menu and choose **Set Date Range**. This brings up a dialog where you can enter start and end dates. Click OK and only photos taken within that time frame will be visible. Scroll through those images to see if you can find your photo.

By Caption or Note:

If you've added personal notes within tags or you've added captions to individual photos, you can search those fields to help you narrow your search. Just go under the Organizer's Find menu and choose **By Caption or Note**. Then, in the resulting dialog, enter the word that you think may appear in the photo's caption or note, and click OK. Only photos that have that word in a caption or note will appear in the Media Browser.

By History:

The Organizer keeps track of when you imported each photo and when you last shared it (via email, print, webpage, etc.); so if you can remember any of those dates, you're in luck. Just go under the Organizer's Find menu, under **By History**, and choose which attribute you want to search under in the submenu. (Note: Some of the options shown here are currently not available in the Elements 10 version for the Mac.) A dialog with a list of names or locations and dates will appear. Click on a date and name, click OK, and only photos that fit that criterion will appear in the Media Browser.

By Textual Information:

Elements has a search field that basically lets you search all text information in a photo—not just keyword tags, but all of the metadata and stuff that gets stored with your photos. In fact, it's probably one of the most powerful and easiest ways to search, since you don't have to worry as much about what you're looking for and where to look for it. Just go to the search field in the top left of the Organizer window (right under the File menu) and type in your search terms. Here, I entered D3 and it found all of the photos taken with my Nikon D3. I could have just as easily typed a keyword tag or even part of a filename.

If you're like most photographers out there, when you take a photo of someone (or something), you don't just take one. You take 18 or more. It's totally normal. We figure the more photos we take, the better chance we have that at least one photo will be exactly what we want. The problem comes when we're trying to organize our photos. We tend to build up huge libraries of photos that include a bunch of duplicates. I'm not talking exact filename duplicates (as if we imported the same photo twice), but duplicates in that one photo looks just like another. Well, in Elements 10, a new feature was added to help find them.

Finding Duplicate Photos

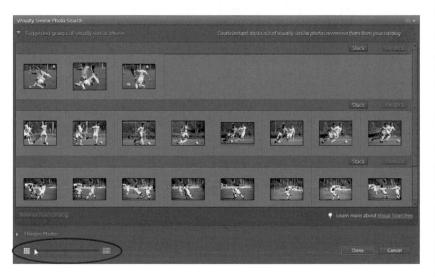

Step One:

Let's say you took some photos of a soccer game, and you wanted to quickly sort through them to find the best ones. Since it's sports, chances are you were shooting in burst mode, so you'll have 10-15 photos of basically the same play. You only really need one keeper, right? In the Organizer, select the group of photos you want to search through (you can press Ctrl-A [Mac: Command-A] to Select All, click on an album, or just Ctrl-click [Mac: Command-click] on as many images as you want to sort through). Then go under the Find menu, under By Visual Searches, and choose Search for Duplicate Photos. Depending on how many photos you're looking through, it can take anywhere from a few seconds for 50 photos to a few minutes for a few thousand.

Step Two:

When Elements is done, you'll see the Visually Similar Photo Search dialog open. Elements will put each series of photos that it finds similar into suggested groups. For me, it was kinda hard to really see what was in each group, because the thumbnails are so small. Since we're going to actually do things with the photos in these series, you may want to increase the size of the thumbnails of the photos using the slider at the bottom left (circled here).

Continued

At this point, you've got two choices for what you can do with these suggested duplicate photos. First, you can look through the photos to find the best one from the series (which is why increasing the thumbnail size is important here), and then delete the rest, since you'll probably never use them. To do that, simply click on one of the photos (or Ctrl-click to select multiple ones) and click the Remove From Catalog button at the bottom left of the dialog (circled here). If you do that, Elements will ask you if you simply want to remove the photos from the catalog or remove them from the hard disk, as well. I also remove them from the hard disk altogether, since I don't need them anymore.

Step Four:

Your other option is to group the series of photos together in a stack. That way, when you're looking at them in the Organizer, you'll have fewer photos to look through since the entire series will be stacked. To stack the photos together, just click the Stack button above the right side of each group. Or, if you only want to stack certain photos from the group together, then select them first, and click the Stack button. When you're done stacking (or removing the photos from the catalog), just click the Done button in the lower-right corner to return to the Organizer view.

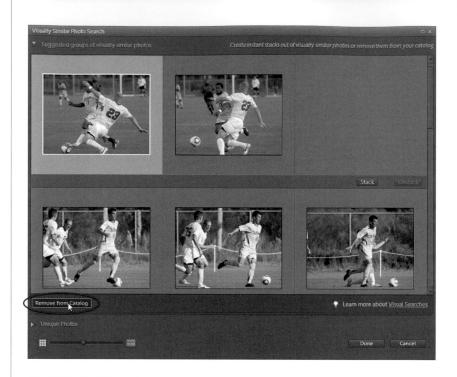

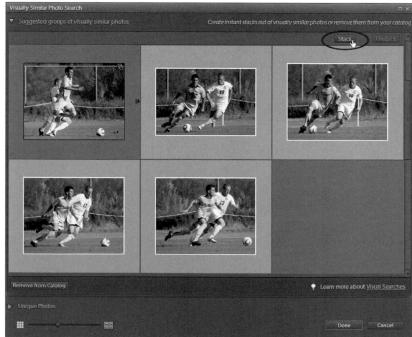

Okay, I have to admit, this particular feature is probably going to be your least-used Organizer feature because it seems so...I dunno...cheesy (for lack of a better word). When you use it, you see a huge calendar, and if photos were created on a particular day in the currently visible month, you'll see a small thumbnail of one of those images on that date. Personally, when I see this view, I feel like I've just left a professional-looking application and entered a "consumer" application, so I avoid it like the plague, but just in case you dig it (hey, it's possible), here's how it works:

Finding Photos Using the Date View

Step One:

To enter the Date View in the Organizer, click the Display button on the right side of the Organizer's menu bar. Then choose **Date View** from the pop-up menu.

Step Two:

This brings up the Date View calendar with the Month view showing by default (if you're not in Month view, click the Month button along the bottom center of the window). If you see a photo on a date, it means there are photos that were taken (or you scanned or imported) on that day. To see a photo, click on it within the calendar and a larger version will appear at the top right of the window. To see the rest of the photos on this day, click the Next Item on Selected Day button found directly under this preview window. Each time you click this button, the window displays a preview of the next photo taken on that day.

TIP: Returning to Media Browser
You can always get back to the
Media Browser by clicking the Media
Browser button at the bottom center
of the window.

Continued

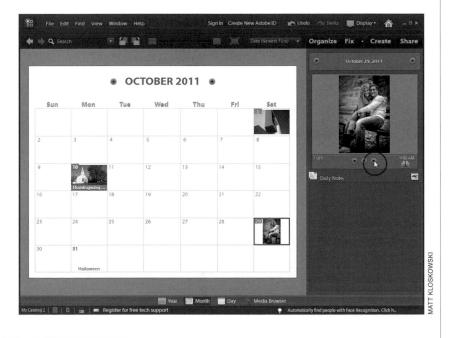

If you find the photo you're looking for (I'm assuming that if you're searching around in the Date View, you're looking for a particular photo) and you want to edit that photo, Right-click on the photo's preview and choose **Edit with Photoshop Elements Editor** from the pop-up menu (or just press **Ctrl-I [Mac: Command-I]**). The Elements Editor will launch with your photo open and ready to edit.

Step Four:

Return to the Organizer in Date View. While we're here, I want to show you a couple of the other features. Although the Month view is shown by default, there are buttons at the bottom center of the window for viewing the entire year (where days that have photos appear as solid-color blocks) or an individual day (where all the photos from that day appear in a slide-show-like view, as shown here).

While in the Date View, you can add a Daily Note, which is a note that doesn't apply to only the current photo—it applies to every photo taken on that calendar day. In all three views (Year, Month, and Day), a field for adding a Daily Note to the currently displayed photo will appear along the right side of the window. Now, when you're in Day view, you can not only see your Daily Note for your photo, but you can also see the caption for your photo below the Daily Note.

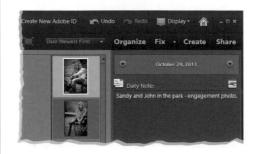

Here's a scenario: You get back from a photo shoot and download your photos into the Organizer. You know you got some great shots and you just want to see them in a quick full-screen slide show. Nothing fancy. Just your photos, big onscreen. That's where the Full Screen option comes in. FYI...we've provided a video (on the book's companion website mentioned in the introduction) on how to show your work, where we look at how to create a rich, fully-featured slide show using another feature in Elements, but this one is a good trick to know.

Seeing an Instant Slide Show

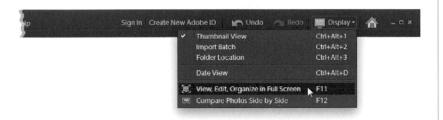

Step One:

First, open the Organizer. Now pressand-hold the Ctrl (Mac: Command) key and click on each photo you want to appear in your slide show (if the photos are contiguous, you can click on the first photo, press-and-hold the Shift key, click on the last photo, and all the photos in between will be selected). Once the photos you want are selected, click on the Display button (on the right side of the Organizer's menu bar) and choose View, Edit, Organize in Full Screen from the pop-up menu (or just press F11 [Mac: Command-F11]).

Step Two:

This brings you into Full Screen view, where you'll see your photo large onscreen with a few pop-up palettes on the left and bottom of the screen and a filmstrip bar on the right. The Quick Edit and Quick Organize palettes on the left side will slide in and out of the screen as you move your cursor over them. They're basically there in case you want to make some quick edits or organizational changes as you see your photos large onscreen during the slide show.

Continued

Your slide show won't start until you click the Play button in the control palette at the bottom of the screen (or press the **Spacebar**, or **F5**). To stop your slide show (to pause), click the Pause button (the Play button toggles to the Pause button), and then to resume it, click Play/Pause again.

Step Four:

If you want to change the presentation options for your slide show, click the Open Settings Dialog button (the little wrench) in the control palette. This brings up the Full Screen View Options dialog, where you choose the music for your slide show from the Background Music pop-up menu and how long each photo will appear onscreen from the Page Duration pop-up menu. It assumes you want any captions included, but you can turn that off by clicking on the Include Captions checkbox, and you can also have your slide show loop when it reaches the end by turning on the Repeat Slide Show checkbox. Click OK to close the dialog when you're done.

Step Five:

Okay, if you get anything out of this tutorial, this needs to be it: Next to the Open Settings Dialog button is the Transitions button. When you click the button, it opens the Select Transition dialog. The first three are pretty selfexplanatory (to me at least) but if you want to see a quick preview of them, just hover your cursor over the thumbnail and you'll see a quick animation of what the transition from slide to slide will look like. It's the last one, 3D Pixelate, that's crazy. You'll have to see it full screen to really appreciate it, so go ahead and click on the 3D Pixelate radio button, and then click OK.

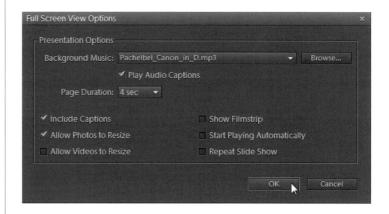

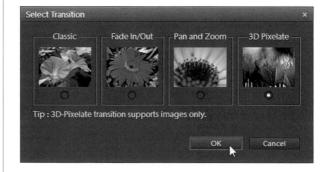

Step Six:

Now click the Play button or hit the Spacebar or F5 key to start the slide show. Then watch in amazement as one photo transitions to another. I gotta warn you, though, if you've been drinking (alcohol, that is) it's really going to freak you out, and if you haven't been drinking, well, it's probably going to make you feel like you have been. After you kill an hour watching this (I'm serious, it's mesmerizing), go ahead and press the Esc key to get out of slide show mode (if you chose the Pan and Zoom or 3D Pixelate transition) or click on the Exit (X) button at the right end of the control palette (if you chose the Classic or Fade In/Out transition) to go back to Full Screen view.

Step Seven:

There are extra controls at the right side of the control palette (click on the tiny left-facing arrow on the far right of the palette to reveal them) for comparing still images, but they are not used during your slide show. I usually keep them hidden and just display the slide show controls.

Step Eight:

To get out of Full Screen view and return to the Organizer, press the **Esc key** again on your keyboard, or click the Exit button in the control palette.

Comparing Photos

When you see a great photo opportunity do you take just one shot? Probably not, right? Most times you snap off a few (or 10, if you're like me), just to make sure you have several to choose from. But when you get back to your computer, you've got to make sure you do just that—choose the best ones and delete the rest. Because if you don't, you'll then have a bunch of similar-looking photos cluttering your screen, and you'll never really know which one to go to. Here's a way to help:

Step One:

First, open the Organizer. To compare (or review) photos side by side, press-and-hold the Ctrl (Mac: Command) key and click on all the photos you want to compare. Then click the Display button on the right side of the menu bar and choose **Compare Photos Side by Side** from the pop-up menu (or just press **F12** [Mac: Command-F12]). This brings up the same Full Screen view we saw in the last tutorial.

Step Two:

Full Screen View mode will open, placing the first and second photos you selected side by side onscreen. You'll also see the control palette at the bottom of your screen, the Quick Edit and Quick Organize palettes tucked away on the left, and a filmstrip bar on the right. The first photo (on the left) has the number 1 in its upper left-hand corner, and the second photo (the one being compared) is noted as number 2 when clicked on.

Visually compare these two photos. You want the one that looks best to remain onscreen so you can compare other selected photos to it, right? To do that, click on the "bad" photo, and a blue highlight will appear around that photo, indicating that this is the one that will change. In this example, I thought the second photo looked better, so I left the blue highlight around photo number 1 (on the left).

Step Four:

Now go to the control palette, click on the Next Photo button, and the photo on the left will be replaced with your next photo in that series. Again, review which of these two looks the best, then click on the photo that looks worst (that way, you can replace it with another photo you want to compare). Click the Next Photo button to compare the next photo (and so on). To back up and review a previous photo, click the Previous Photo button in the control palette.

Step Five:

Besides this side-by-side mode, there's also an option that lets you see your photos stacked one on top of the other (which you might like for comparing photos in landscape orientation). To change to that mode, click on the rightfacing arrow at the right end of the control palette to get the other view options (if they're not already visible), then click on the down-facing arrow to the immediate right of the Side by Side View button in the control palette, and from the pop-up menu that appears, choose Above and Below. Cycle through the images as you did beforejust repeat Steps Three and Four until you find the photo you like best. When you're finished, press the Esc key on your keyboard or click the Exit (X) button in the control palette.

Reducing Clutter by Stacking Your Photos

I love stacks, because as much as I try to compare my photos and get rid of the ones that I have duplicates of, I inevitably wind up with several photos that look the same. Well, there's a feature called stacking and it works just like its real-world counterpart does—it stacks several photos on top of each other and you'll just see the top one. So if you have 20 shots of the same scene, you don't have to have all 20 cluttering up your Media Browser. Instead, you can have just one that represents all of them with the other 19 underneath it.

Step One:

With the Organizer open, press-and-hold the Ctrl (Mac: Command) key on your keyboard and click on all the photos you want to add to your stack (or if the images are contiguous, simply click on the first image in the series, press-and-hold the Shift key, and click on the last image in the series). Once they're all selected, go under the Organizer's Edit menu, under Stack, and choose **Stack Selected Photos** in the submenu.

Step Two:

No dialog appears, it just happens—your other photos now are stacked behind the first photo you selected (think of it as multiple layers, and on each layer is a photo, stacked one on top of another). You'll know a photo thumbnail contains a stack because a Stack icon (which looks like a little stack of paper) will appear in the upper-right corner of your photo. You'll also see a right-facing arrow to the right of the image thumbnail, and the words "Photo Stack" below the bottom right of the image thumbnail.

Once your photos are stacked, you can view these photos at any time by clicking on the photo with the Stack icon, and then going under the Edit menu, under Stack, and choosing Expand Photos in Stack, or just clicking on the right-facing arrow to the right of the image thumbnail. This is like doing a Find, where all the photos in your stack will appear in the Media Browser within a gray shaded area so you can see them without unstacking them. Then, to collapse the stack, just click on the left-facing arrow that appears to the right of the last image thumbnail in the stack.

Step Four:

If you do want to unstack the photos, select the photo with the Stack icon in the Media Browser, then go under the Edit menu, under Stack, and choose **Unstack Photos**. If you decide you don't want to keep any of the photos in your stack, select the photo with the Stack icon in the Media Browser, go back under the Edit menu, under Stack, and choose **Flatten Stack**. It's like flattening your layers—all that's left is that first photo. However, when you choose to flatten, you will have the choice of deleting the photos from your hard disk or not.

Sharing Your Photos

You'll find a bunch of different ways to share your photos in Photoshop Elements. One of the ways is to share directly to Facebook, but you'll also see there are options to share via email, DVD, online video, Flickr, and SmugMug to name a few. Since Facebook sharing is probably the most popular, we'll walk through it here, but we've also provided a video for you that covers the other sharing options and how they work. You can find the video on the book's companion website mentioned in the introduction.

Step One:

In the Organizer, Ctrl-click (Mac: Command-click) on the images that you'd like to share to select them, then click the Share tab at the top right of the window, and click Share to Facebook. Remember, we're using Facebook sharing as an example in this tutorial since it's incredibly popular, but we've provided a video to show you the other options, as well (again, you can find the video on the book's companion website).

TIP: Use Your Facebook Friend List
One of the new features in Elements 10
is the ability to download your Facebook
friend list to Elements. This comes in
really handy when you're tagging
faces, because your friends' names
will automatically pop up when you
start typing them.

Step Two:

If this is your first time sharing photos to Facebook through Elements 10, then you'll have to authorize your Facebook account to accept photos from Elements. So, click the Authorize button and your Web browser will automatically launch to Facebook.

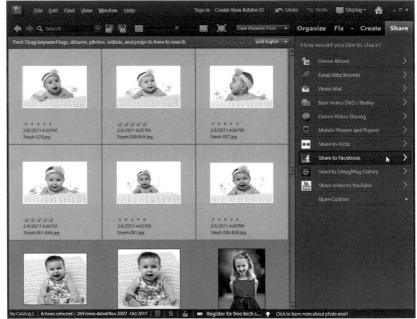

AATT KLOSKOWSKI

When your browser opens, log in to your Facebook account with your email address and password. Also, since I'm the only one using my computer, I usually turn on the Keep Me Logged In to Photoshop & Adobe Premiere Elements Uploader checkbox.

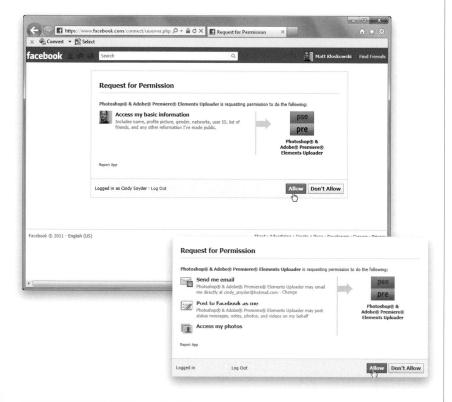

Step Four:

The next screen asks for permission for Elements to work with your Facebook account. Click the Allow button to move on, and the next screen will ask for permission to do some other things. Click Allow again, and the last screen will let you know it's okay to close the Web browser window and return to the Organizer. Once you're back, you'll see a dialog telling you everything is all set up and you're ready to go, so just click the Complete Authorization button.

Continued

Step Five:

Now that everything is authorized, you're ready to start uploading photos. The next dialog you see will have the photos you selected back in Step One on the left side, as well as some album choices on the right side. If you want to upload to an existing album (one that you've already created on your Facebook page), then choose Upload Photos to an Existing Album. If you want to create a new album (which we'll do here), then choose Upload Photos to a New Album and fill in the album details below. From the Who Can See These Photos? pop-up menu, choose whether you'd like your album to be public or private, then choose your upload quality, and click Upload.

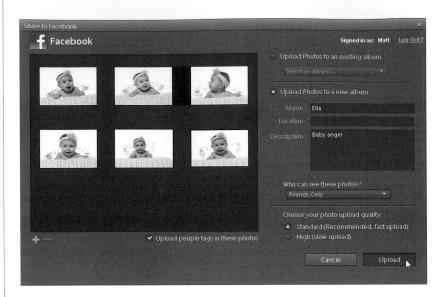

Step Six:

A progress bar will appear while the photos are uploading, and when it's done, you'll see an Upload Complete screen. Click Done to return to the Organizer or Visit Facebook to go check out your new album in all of its glory. And don't forget to tell all of your friends to come by and "Like" it :-).

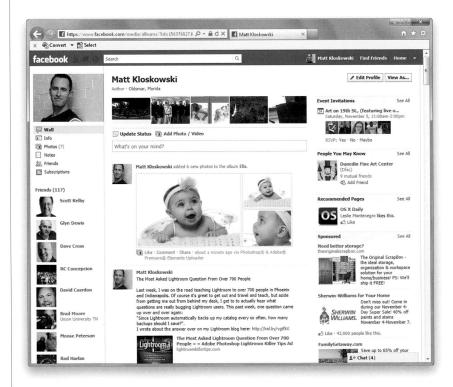

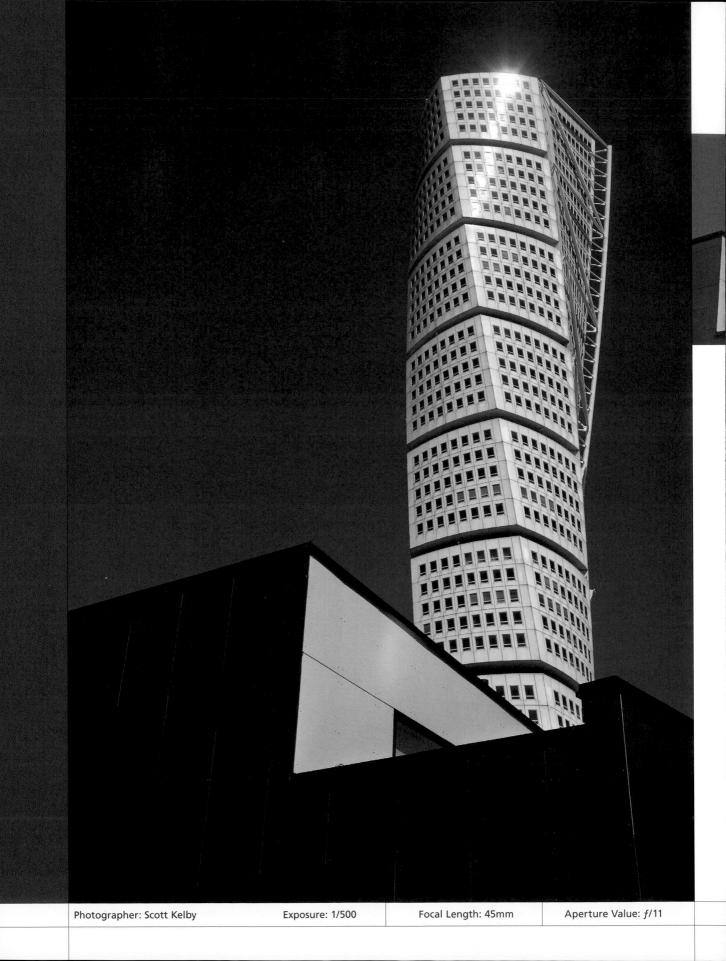

Raw Justice

processing your images using camera raw

When I searched The Internet Movie Database (IMDb) for movies or TV shows containing the word "Raw," I was pleasantly surprised to find out just how many choices I actually had. However, I went with the 1994 movie Raw Justice, but I don't want you to think for one minute that I was influenced in any way by the fact that the star of the movie was Pamela Anderson. That would be incredibly shallow of me. Like any serious movie buff, I was drawn to this movie by what drew most of the audience to this movie: actor Robert Hays (who could forget his role in 2007's Nicky's Birthday Camera or the Michael Tuchner-directed film Trenchcoat?). Of course, the fact that Stacey Keach was in the movie was just the icing on the cake, but everybody knows the real draw of this flick clearly was Hays. However, what I found most puzzling was this: in the movie poster, Pamela Anderson totally dominates

the poster with a large, full-color, 3/4-length pose of her wearing a skimpy black dress, thigh-high boots, and holding a pistol at her side, but yet the other actors appear only as tiny black-and-white, backscreened headshots. I have to admit, this really puzzles me, because while Pamela Anderson is a fine actress—one of the best, in fact—I feel, on some level, they were trying to fool you into watching a movie thinking it was about Pamela Anderson's acting, when in fact it was really about the acting eye candy that is Hays. This is called "bait and switch" (though you probably are more familiar with the terms "tuck and roll" or perhaps "Bartles & Jaymes"). Anyway, I think, while "Raw Justice" makes a great title for a chapter on processing your images in Camera Raw, there is no real justice in that this finely crafted classic of modern cinematography wound up going straight to DVD.

Opening RAW, JPEG, and TIFF Photos into Camera Raw

Although Adobe Camera Raw was created to process photos taken in your camera's RAW format, it's not just for RAW photos, because you can process your JPEG and TIFF photos in Camera Raw, as well. So even though your JPEG and TIFF photos won't have all of the advantages of RAW photos, at least you'll have all of the intuitive controls Camera Raw brings to the table.

Step One:

We'll start with the simplest thing first: opening a RAW photo from the Organizer. If you click on a RAW photo to select it in the Organizer, then click on the down-facing arrow on the right of the Fix tab (at the top of the Palette Bin on the right side of the window) and choose any of the options from the pop-up menu, it automatically takes the photo over to the Editor and opens it in Camera Raw.

Step Two:

To open more than one RAW photo at a time, go to the Organizer, Ctrlclick (Mac: Command-click) on all the photos you want to open, then choose an option from the Fix tab's pop-up menu (as shown here, or just press Ctrl-I [Mac: Command-I]). It follows the same scheme—it takes them over to the Elements Editor and opens them in Camera Raw. On the left side of the Camera Raw dialog, you can see a filmstrip with all of the photos you selected.

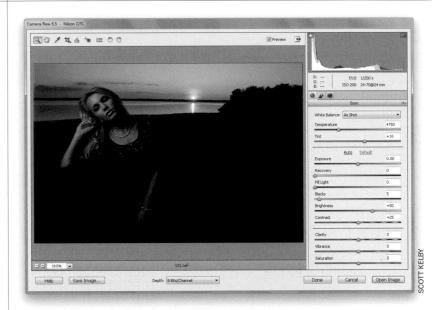

Okay, so opening RAW photos is pretty much a no-brainer, but what if you want to open a JPEG or TIFF photo in Camera Raw? Go under the Editor's File menu and choose Open As (Mac: Open). In the Open As (Mac: Open) dialog, navigate to the JPEG or TIFF photo you want to open and click on it once. When you click on a JPEG or TIFF photo, if you choose JPEG or TIFF in the Open As (Mac: Format) popup menu at the bottom, it will open in the Elements Editor like any other JPEG or TIFF. So to open this JPEG or TIFF photo in Camera Raw instead, you have to choose Camera Raw from the Open As pop-up menu (as shown here).

Step Four:

When you click the Open button, that JPEG or TIFF photo is opened in the Camera Raw interface, as shown here (notice how JPEG appears up in the title bar, just to the right of Camera Raw 6.5?). Note: When you make adjustments to a JPEG or TIFF photo in Camera Raw and you click either the Open Image button (to open the adjusted photo in Elements) or the Done button (to save the edits you made in Camera Raw), unlike when editing RAW photos, you are now actually affecting the pixels of the original photo. Of course, there is a Cancel button in Camera Raw and even if you open the JPEG or TIFF photo in Elements, if you don't save your changes, the original photo remains untouched.

Miss the JPEG Look? Try Applying a Camera Profile

If you've ever looked at a JPEG photo on the LCD screen on the back of your digital camera, and then wondered why your RAW image doesn't look as good, it's because your camera adds color correction, sharpening, contrast, etc., to your JPEG images while they're still in the camera. But when you choose to shoot in RAW, you're telling the camera, "Don't do all that processing—just leave it raw and untouched, and I'll process it myself." But, if you'd like that JPEG-processed look as a starting place for your RAW photo editing, you can use Camera Raw's Camera Profile feature to get you close.

Step One:

As I mentioned above, when you shoot in RAW, you're telling the camera to pretty much leave the photo alone, and you'll do all the processing yourself using Camera Raw. Each camera has its own brand of RAW, so Adobe Camera Raw applies a Camera Profile based on the camera that took the shot (it reads the embedded EXIF data, so it knows which camera you used). Anyway, if you click on the Camera Calibration icon (the icon on the right above the right-side Panel area), you'll see the built-in default Camera Profile (Adobe Standard) used to interpret your RAW photo.

Step Two:

If you click-and-hold on the Name pop-up menu at the top of the panel, a menu pops up with a list of profiles for the camera you took the shot with (as seen here, for images taken with a Nikon digital camera). Adobe recommends that you start by choosing **Camera Standard** (as shown here) to see how that looks to you.

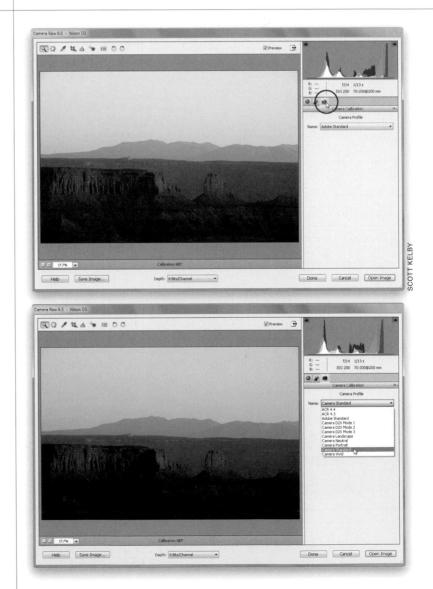

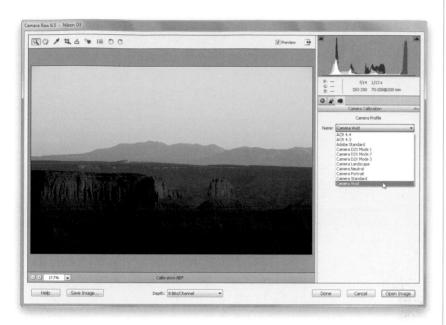

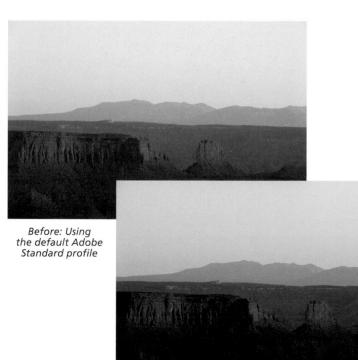

After: Using the Camera Vivid profile

Depending on the individual photo you're editing, Camera Standard might not be the right choice, but as the photographer, this is a call you have to make (in other words, it's up to you to choose which one looks best to you). I usually wind up using either Camera Standard, Camera Landscape, or Camera Vivid for images taken with a Nikon camera, because I think Landscape and Vivid look the most like the JPEGs I see on the back of my camera. But again, if you're not shooting Nikon, Landscape or Vivid won't be one of the available choices (Nikons have eight picture styles and Canons have five). If you don't shoot Canon or Nikon, then you'll only have Adobe Standard, and possibly Camera Standard or one other, to choose from, but you can create your own custom profiles using Adobe's free DNG Profile Editor utility, available from Adobe at http://labs.adobe.com.

Step Four:

Here's a before/after with only one thing done to this photo: I chose Camera Vivid (as shown in the popup menu in Step Three). Again, this is designed to replicate color looks you could have chosen in the camera, so if you want to have Camera Raw give you a similar look as a starting point, this is how it's done. Also, since Camera Raw allows you to open more than one image at a time (in fact, you can open hundreds at a time), you could open a few hundred images, then click the Select All button that will appear at the top-left corner of the window. change the camera profile for the firstselected image, and then all the other images will have that same profile automatically applied. Now, you can just click the Done button.

The Essential Adjustments: White Balance

If you've ever taken a photo indoors, chances are the photo came out with kind of a yellowish tint. Unless, of course, you took the shot in an office, and then it probably had a green tint. Even if you just took a shot of somebody in a shadow, the whole photo probably looked like it had a blue tint. Those are white balance problems. If you've properly set your white balance in the camera, you won't see these distracting tints (the photos will just look normal), but most people shoot with their cameras set to Auto White Balance, and well...don't worry, we can fix it really easily in Camera Raw.

Step One:

On the right side of the Camera Raw window, there's a section for adjusting the white balance. Think of this as "the place we go to get rid of yellow, blue, or green tints that appear on photos." There are three ways to correct this, and we'll start with choosing a new white balance from the White Balance pop-up menu. By default, Camera Raw displays your photo using your camera's white balance setting, called As Shot. Here, I had my white balance set to Auto, but it is way off.

Step Two:

To change the white balance, click on the White Balance pop-up menu and choose a preset. As I mentioned, the white balance in my camera was set to Auto, and since I shot this indoors, you could choose Fluorescent (as shown here), which removes some of the blue tint, although to me it still looks a little too cool. *Note:* You will only get this complete list of white balance presets (Cloudy, Shade, etc.) when working with RAW images. If you open a JPEG or TIFF image in Camera Raw, your only preset choice (besides As Shot and creating a custom white balance) is Auto.

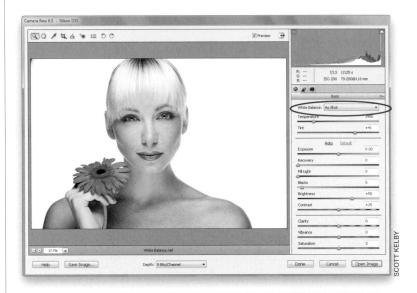

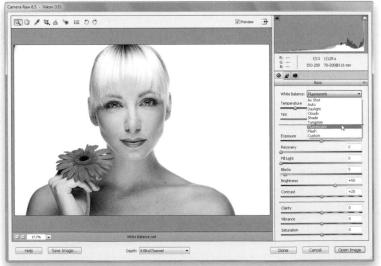

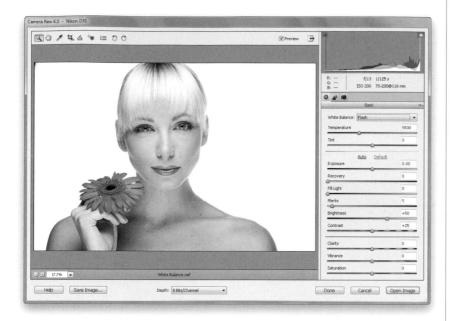

This is going to sound pretty simplistic, but it works—just take a quick look at the seven different white balance presets and see if any of them look more natural to you (less blue). This process takes around 14 seconds (I just timed it). Some will be way off base immediately (like Tungsten, which looks way too blue). The preset that looked best (to me anyway) was Flash (as shown here). Anyway, this is why it pays to take a quick look at all seven presets. Notice how she looks less blue, and the cool tint is gone?

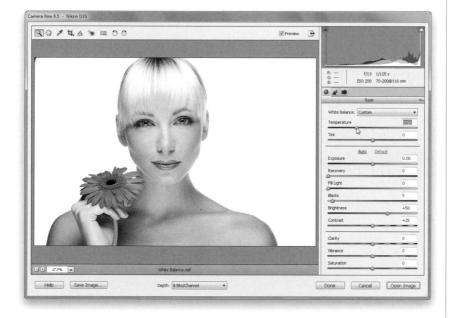

Step Four:

Although the Flash setting is the best of the built-in presets here, if you don't think it's right on the money, then you can simply use it as a starting point (hey, at least it gets you in the ballpark, right?). So, I would choose Flash first, and if I thought this made her a bit too yellow, I would then drag the Temperature slider to the left (toward the blue side of the slider) to cool the photo back down just a little bit. In this example, the Flash preset was close, but made it a little too yellow, so I dragged the Temperature slider a little bit toward blue, to 5150 (as shown here).

Step Five:

The second method of setting your white balance is to simply use just the Temperature and Tint sliders (although most of the time you'll only use the Temperature slider, as most of your problems will be too much [or too little] yellow or blue). The sliders themselves give you a clue on which way to drag (on the Temperature slider, blue is on the left and it slowly transitions over to yellow). This makes getting the color you want so much easier—just drag in the direction of the color you want. By the way, when you adjust either of these sliders, your White Balance popup menu changes to Custom (as shown).

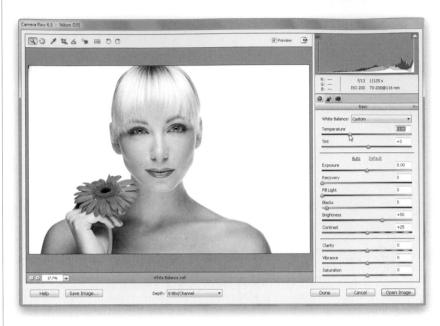

Step Six:

The third method, using the White Balance tool, is perhaps the most accurate because it takes a white balance reading from the photo itself. You just click on the White Balance tool (I) in the toolbar at the top left (it's circled in red here), and then click it on something in your photo that's supposed to be a light gray (that's right—you properly set the white balance by clicking on something that's light gray). So, take the tool and click it once on the side of her head (as shown here) and it sets the white balance for you. If you don't like how it looks (maybe it's still too blue), then just click on a different light gray area until it looks good to you.

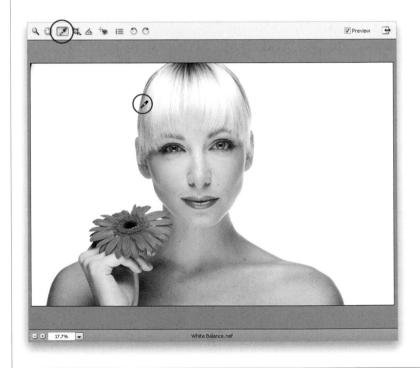

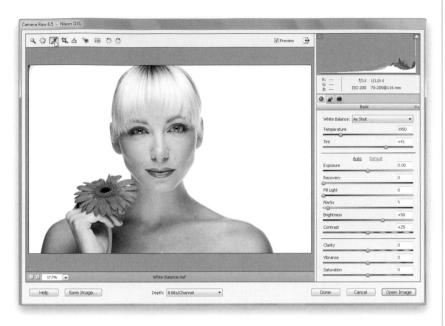

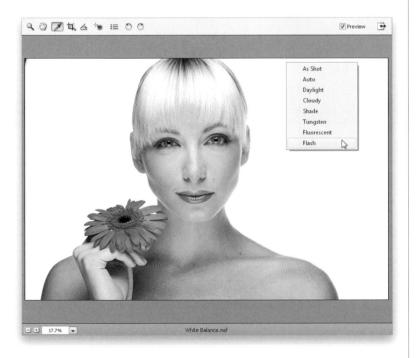

Step Seven:

Now, here's the thing: although this can give you a perfectly accurate white balance, it doesn't mean that it will look good (for example, people usually look better with a slightly warm white balance). White balance is a creative decision, and the most important thing is that your photo looks good to you. So don't get caught up in that "I don't like the way the white balance looks, but I know it's accurate" thing that sucks some people in—set your white balance so it looks right to you. You are the bottom line. You're the photographer. It's your photo, so make it look its best. Accurate is not another word for good. Okay, I'm off the soapbox, and it's time for a tip: Want to quickly reset your white balance to the As Shot setting? Just double-click on the White Balance tool up in the toolbar (as shown here).

Step Eight:

One last thing: once you have the White Balance tool, if you Right-click within your photo, a White Balance preset pop-up menu appears under your cursor (as shown here), so you can quickly choose a preset.

TIP: Using a Swatch Card

To help you find the neutral light gray color in your images, we've included a swatch card for you in the back of this book (it's perforated so you can tear it out), and it has a special Camera Raw white balance light gray swatch area. Just put this card into your scene (or have your subject hold it), take the shot, and when you open the image in Camera Raw, click the White Balance tool on the neutral gray area on the swatch card to instantly set your white balance.

The Essential Adjustments #2: Exposure

The next thing I fix (after adjusting the white balance) is the photo's exposure. Now, some might argue that this is the most essential adjustment of them all, but if your photo looks way too blue, nobody will notice if the photo's underexposed by a third of a stop, so I fix the white balance first, then I worry about exposure. In general, I think of exposure as three things: highlights, shadows, and midtones. So in this tutorial, I'll address those three, which in Camera Raw are the exposure (highlights), blacks (shadows), and brightness (midtones).

Step One:

The Exposure slider (circled here in red) affects the overall exposure (highlights) of the photo (dragging to the right makes your overall exposure lighter; dragging to the left makes it darker). Now, before you start dragging the Exposure slider around, there is one thing you're going to want to avoid: losing detail in the brightest parts of your image. This is called "clipping the highlights." When you clip your photo's highlights, the very brightest parts of your photo turn solid white, so you lose all detail in these clipped areas (which is bad, since your goal is to retain as much important detail as possible).

Step Two:

Luckily, Camera Raw can give you a clipping warning so you don't accidentally lose highlight detail. In the top-right corner of the Camera Raw window, you'll see a histogram (like the one on your digital camera), and do you see the triangle in the top-right corner of that histogram? It should stay black. If it becomes white (like you see here), that's warning you that some parts of your highlights are now clipping (if the triangle becomes red, blue, yellow, or green, it means you're only clipping highlights in that color).

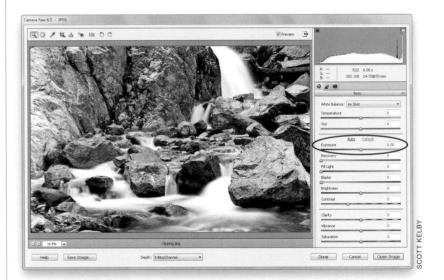

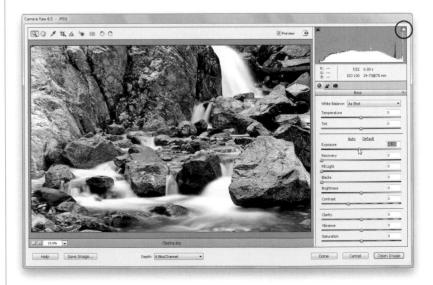

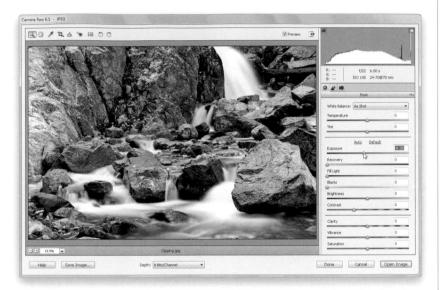

Okay, now that you know what you want to avoid (clipping the highlights and losing highlight detail), the original image looks just a little overexposed (meaning it's too bright). To make the image darker, go ahead and drag the Exposure slider to the left until the exposure looks right to you. To me, on my monitor, it looked right once I dragged it over to a reading of -0.35, but that still clipped the highlights a bit (I could tell by looking at the clipping warning triangle at the top right of the histogram, as seen here).

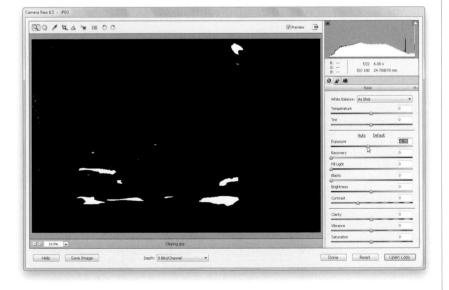

Step Four:

Before we go any further, there are two other methods you need to know for keeping an eye on highlight clipping (so you can choose which one works best for you). When you move the Exposure slider, you can turn on a warning that lets you know not only if, but exactly where, your highlights are clipping. Just press-and-hold the Alt (Mac: Option) key, then drag the Exposure slider. This turns your entire preview area black, and any clipped areas will appear in their color (so if the Blue channel is clipping, you'll see blue) or, worse, in solid white (which means all the colors are clipping, as seen here). By the way, this warning will stay on as you drag as long as you have the Alt key held down. So if you see areas appear in color (or white), you know you need to drag the Exposure slider to the left until they go away.

Step Five:

Now, if you don't like the whole-screenturns-black clipping warning, there is another warning method. You turn it on by clicking once on that little clipping warning triangle at the top right of the histogram (it's shown circled here in red, again), and now any clipped highlights will appear as solid red (as shown here). The nice thing about this method is you don't have to hold down any keys—the warning stays on until you click on that triangle again to turn it off. It also updates live as you make adjustments. So if you drag the Exposure slider back to the left, darkening the exposure, you'll see the red clipping warning areas go away, unless that area is completely blown out. These warnings (the highlight triangle, and the black preview window) do exactly the same thingwarn you about clipping. It's up to you which of them you like using best.

Step Six:

So, now you know how to spot a clipping problem, but what do you do to fix it? Well, in earlier versions of Camera Raw, there was really only one thing you could do—drag the Exposure slider back to the left until the clipping warnings went away (which stinks, because that usually made the whole photo underexposed). But thankfully, in Elements 6, Adobe added the Recovery slider (for recovering clipped highlights). Start by setting the Exposure slider first until the exposure looks right to you—if you see some small areas are clipping, don't worry about it. Now, drag the Recovery slider to the right and as you do, just the very brightest highlights are pulled back (recovered) from clipping. Here I still have that clipping warning turned on, and from just dragging the Recovery slider to the right, you can see that most of the red clipped areas are now gone.

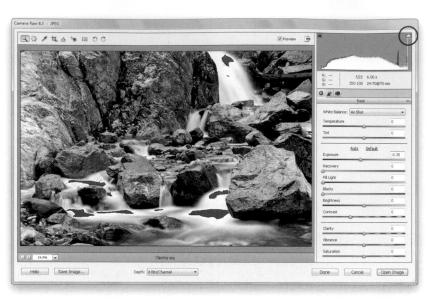

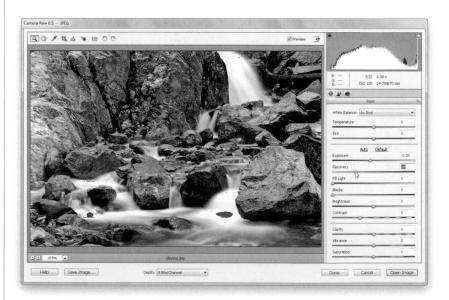

Step Seven:

Like the Exposure slider, you can use that same press-and-hold-the-Alt-key trick while you're dragging the Recovery slider, and the screen will turn black, revealing just the clipped areas (as shown here). As you drag to the right, you'll actually see the clipped areas go away.

TIP: Toggle the Warning On/Off You can toggle the red highlight clipping warning preview on and off by pressing the letter **O** on your keyboard.

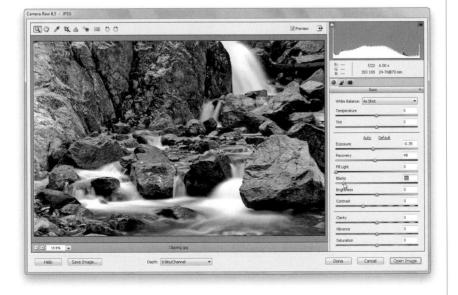

Step Eight:

Next, I adjust the shadow areas using the Blacks slider. Dragging to the right (as shown here) increases the amount of black in the darkest shadow areas of your photo. Dragging to the left opens up (lightens) the shadow areas. See how the slider bar goes from white on the left to black on the right? That lets you know that if you drag to the right, the blacks will be darker. Increasing the blacks will usually saturate the colors in your photo, as well, so if you have a really washed out photo, you may want to start with this slider first instead of the Exposure slider.

Step Nine:

Although, in digital photography, our main concern is clipping off highlights, you can also see if you're clipping any shadow areas by using the same tricksthe triangle, turning on the clipping warning (but the clipped shadows appear in blue), or the ol' press-andhold-the-Alt-key trick with the Blacks slider (but the preview area turns solid white, and any areas that are solid black have lost detail. If you see other colors, like red, green, or blue, they're getting clipped, too). Personally, I'm not nearly as concerned about a little bit of clipping in the shadows. especially since the only fix is to drag the Blacks slider to the left to reduce the amount of blacks in the shadows.

Step 10:

Again, my main concern is highlight clipping, but in some cases some highlight clipping is perfectly acceptable. For example, clipping specular highlights, like a bright reflection on a car's bumper or the center of the sun, isn't a problem—there wouldn't be important detail (or any detail for that matter) there anyway. So, as long as we make sure important areas aren't clipped off, we can adjust the photo until it looks right to us. Here the exposure is set by using the Exposure and Recovery sliders, my shadows are set by using the Blacks slider, and while there is still a bit of shadow clipping, I don't care because these aren't areas of really important detail (to me, anyway).

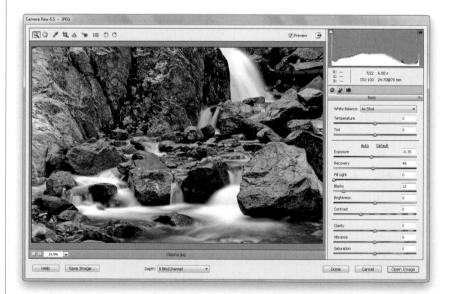

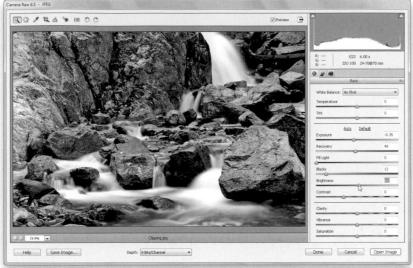

The next slider down is Brightness. Since you've already adjusted the highlights (Exposure slider) and the shadows (Blacks slider), the Brightness slider adjusts everything else (I relate this slider to the midtones slider in Elements' Levels dialog, so that might help in understanding how this slider differs from the Exposure or Blacks sliders). Of the three main adjustments (Exposure, Blacks, and Brightness), this one I personally use the least—if I do use it, I usually just drag it a very short amount to the right to open up some of the midtone detail. In this case, I dragged it to +6. There are no clipping warnings for midtones, but if you push it far enough to the right, it can sometimes create some highlight clipping (as it did in the image here), so be careful.

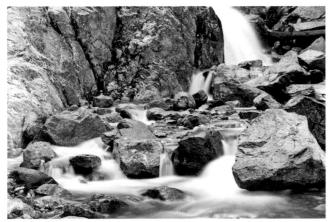

Before

After

Letting Camera Raw Auto Correct Your Photos

If you're not quite comfortable with manually adjusting each image, Camera Raw does come with a one-click Auto function, which takes a stab at correcting the overall exposure of your image (including shadows, fill light, contrast, and recovery). If you like the results, you can set up Camera Raw's preferences so every photo, upon opening in Camera Raw, will be auto adjusted using that same feature. Ahhh, if only that Auto function worked really well.

Step One:

To have Camera Raw auto adjust your image, click on the Auto button (it's the underlined word Auto that appears just below the Tint slider). Sometimes this works, sometimes it does very little (other than adjusting the Exposure and Recovery sliders to eliminate highlight clipping), but most times, to me it seems to way overexpose the photo. It usually pushes the Exposure slider as far to the right as it can without clipping the highlights, which I guess in theory gives you a full range of exposure, but in reality gives you what looks like (to me anyway) an overexposed photo. If you don't like the Auto results, you can click on the Default button (to the immediate right of the Auto button) to reset the photo to what it looked like when you first opened it in Camera Raw.

Step Two:

To have Camera Raw apply this Auto adjustment to every photo you open, just click on the Preferences icon up in Camera Raw's toolbar (the third from the right), and turn on the checkbox for Apply Auto Tone Adjustments (shown circled in red here), then click OK. Again, if you don't like the Auto correction, just click on the Default button (the Auto button will be grayed out because it has already been applied).

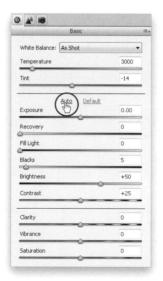

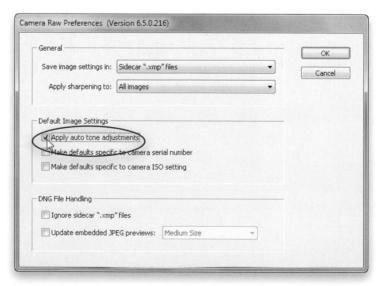

This is a control you're not going to need to use every time (well, at least hopefully not. If you do, we have bigger problems to discuss). You'll generally only use the Fill Light slider in situations where your subject is in the shadows, like when your subject is backlit (and you should have used a fill flash when you took the shot).

The Fix for Shadow Problems: Fill Light

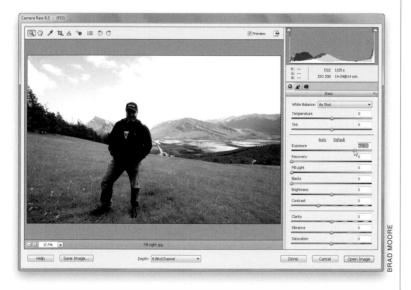

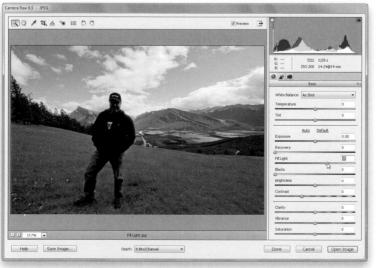

Step One:

When you open a photo where your subject is in the shadows, the Fill Light slider can do a remarkable job of fixing your problem. My photo assistant, Brad, took this shot of me at Mt. Norquay in Banff, Canada. It was shot late in the day and if you look at the before image on the next page, you can see that I'm backlit. While you can see some detail, the detail areas of the subject (me) are mostly in the shadows. If you drag the Exposure slider to the right (as shown here), it overexposes the sky.

Step Two:

To open up the detail in those dark lower-midtone areas, just drag the Fill Light slider to the right (as seen here, where I dragged it over to 65, which opens up the foreground big time).

If you don't wind up dragging it too far to the right, you're done. However, if you wind up dragging it quite a bit to the right (like I did here), it can sometimes cause the photo to look a little washed out. In those situations, I go to the Blacks slider and drag it just a little to the right to bring back some of the richness and color saturation in the deep shadow areas. Now, there is a difference if you're working with RAW or JPEG/TIFF images. With RAW images, the default setting for the Blacks will be 5, and generally all you'll need to do is move them over to 7 or 8. However, on JPEG or TIFF images, your default is 0, and I tend to drag them a little farther. Of course, every image is different (here, I only dragged them to 4), but either way, you shouldn't have to move the Blacks slider too far (just remember—the farther you move your Fill Light slider to the right, the more you'll have to compensate by adding more Blacks).

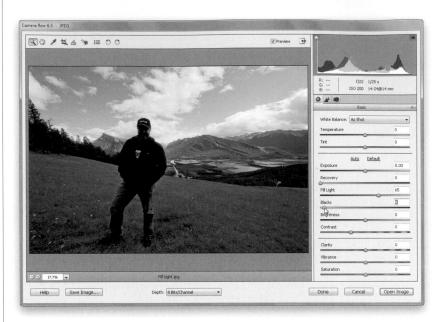

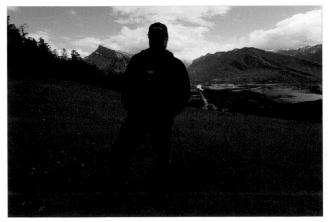

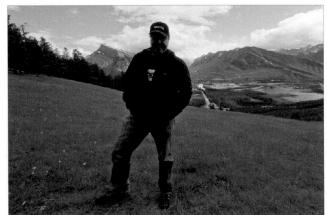

Before

After

This is one of my favorite features in Camera Raw, and whenever I show it in a live class, it never fails to get "Ooohhs" and "Ahhhhs." I think it's because it's just one simple slider, yet it does so much to add "snap" to your image. The Clarity slider (which is well-named) basically increases the midtone contrast in a way that gives your photo more punch and impact, without actually sharpening the image.

Adding "Snap" (or Softening) to Your Images Using the Clarity Slider

Step One:

The Clarity slider (circled in red here) is found in the bottom section of the Basic panel in Camera Raw, right above the Vibrance and Saturation sliders. (Although its official name is Clarity, I heard that at one point Adobe engineers considered naming it "Punch" instead, as they felt using it added punch to the image.) To clearly see the effects of Clarity, first zoom in to a 100% view by double-clicking on the Zoom tool up in the toolbar (it looks like a magnifying glass).

Step Two:

Using the Clarity control couldn't be easier—drag the slider to the right to increase the amount of snap (midtone contrast) in your image (compare the top and bottom images shown here). Almost every image I process gets between +25 and +50 Clarity. If the image has lots of detail, like a cityscape, or a sweeping landscape shot, or something with lots of little details like a motorcycle, or the feathers of a bird, or really weathered wood, or leaves, then I'll go as high as +75 to +80, as seen here. If the subject is of a softer nature, like a portrait of a child, then in that case, I don't generally apply any Clarity at all.

You can also use the Clarity control in reverse—to soften skin. This is called adding negative Clarity, meaning you can apply less than 0 (zero) to reduce the midtone contrast, which gives you a softening effect. For example, here's an original image without any negative Clarity applied.

Step Four:

Now drag the Clarity slider to the left (which gives you a negative amount of Clarity), and take a look at how much softer our subject's skin looks. Everything else in the image looks softer too, so it's an overall softening, but in the chapter on retouching (Chapter 7), you'll learn how to apply softening just to your subject's skin, while leaving the rest of the image sharp.

Besides the White Balance control, there's only one other adjustment for color that you want to use to make your colors more vibrant, and that's the Vibrance slider. Rather than making all your colors more saturated (which is what the Saturation slider does), the Vibrance slider is smarter—it affects the least saturated colors the most, it affects the already saturated colors the least, and it does its darndest to avoid flesh tones as much as possible. It's one very savvy slider, and since it came around, I avoid the Saturation slider at all costs.

Making Your Colors More Vibrant

Step One:

Here's an image where the colors are kind of flat and dull. If I used the Saturation slider, every color in the image would get the same amount of saturation, so I do my best to stay away from it (in fact, the only time I use the Saturation slider anymore is when I'm removing color to create a color tint effect or a black-and-white conversion).

Step Two:

Drag the Vibrance slider to the right, and you'll notice the colors become more vibrant (it's a well-named slider), but without the color becoming cartoonish, which is typical of what the Saturation slider would do. You'll notice in the image here that the color isn't "over the top" but rather subtle, and maybe that's what I like best about it.

Cropping and Straightening

There are some distinct advantages to cropping your photo in Camera Raw, rather than in Elements itself, and perhaps the #1 benefit is that you can return to Camera Raw later and return to the uncropped image. (Here's one difference in how Camera Raw handles RAW photos vs. JPEG and TIFF photos: this "return to Camera Raw later and return to the uncropped image" holds true even for JPEG and TIFF photos, as long as you haven't overwritten the original JPEG or TIFF file. To avoid overwriting, when you save the JPEG or TIFF in Elements, change the filename.)

Step One:

The fourth tool in Camera Raw's toolbar is the Crop tool. By default, it pretty much works like the Crop tool in Elements (you click-and-drag it out around the area you want to keep), but it does offer some features that Elements doesn't—like access to a list of preset cropping ratios. To get them, click-and-hold on the Crop tool and a pop-up menu will appear (as shown here). The Normal setting gives you the standard drag-it-where-you-wantit cropping. However, if you choose one of the cropping presets, then your cropping is constrained to a specific ratio. For example, choose the 2-to-3 ratio, click-and-drag it out, and you'll see that it keeps the same aspect ratio as your original uncropped photo.

Step Two:

Here's the 2-to-3-ratio cropping border dragged out over my image. The area that will be cropped away appears dimmed, and the clear area inside the cropping border is how your final cropped photo will appear. If you reopen this RAW photo later and click on the Crop tool, the cropping border will still be visible onscreen, so you can move it, resize it, or remove it altogether by simply pressing the **Esc key** or the **Backspace (Mac: Delete) key** on your keyboard (or by choosing **Clear Crop** from the Crop tool's pop-up menu).

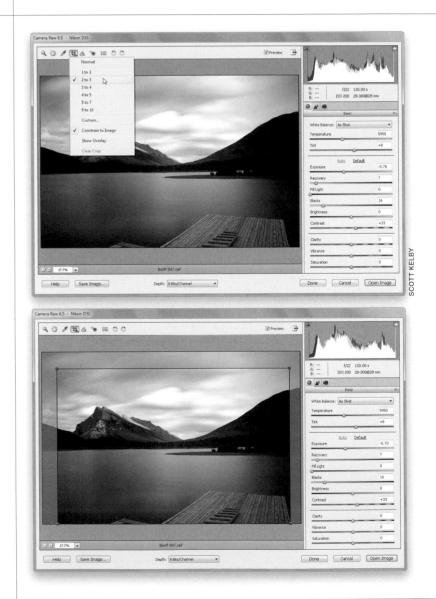

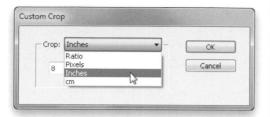

If you want your photo cropped to an exact size (like 8x10", 13x19", etc.), choose **Custom** from the Crop tool's pop-up menu. You can choose to crop by pixels, inches, centimeters, or a custom ratio. In our example, we're going to create a custom crop so our cropped photo winds up being exactly 8x10", so choose Inches from the pop-up menu (as shown here), then type in your custom size. Click OK, click-and-drag out the Crop tool, and the area inside your cropping border will be exactly 8x10".

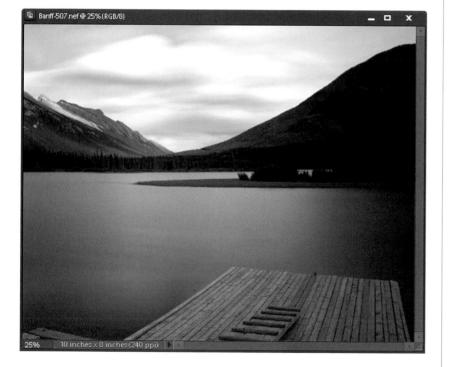

Step Four:

Once you click on the Open Image button in Camera Raw, the image is cropped to your specs and opened in Elements (as shown here). If instead, you click on the Done button, Camera Raw closes and your photo is untouched, but it keeps your cropping border in position for the future.

Step Five:

If you save a cropped JPEG or TIFF photo out of Camera Raw (by clicking on the Save Image button on the bottom left of the Camera Raw window), the only option is to save it as a DNG (Digital Negative) file. DNG files open in Camera Raw, so by doing this, you can bring back those cropped areas if you decide to change the crop.

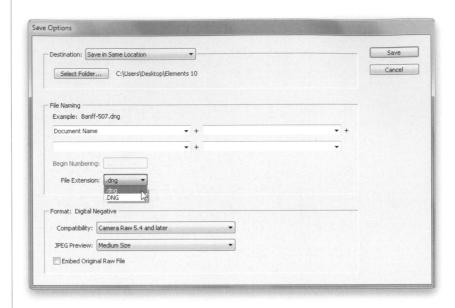

Step Six:

If you have a number of similar photos you need to crop the same way, you're going to love this: First, select all the photos you want to crop (either in the Organizer or on your computer), then open them all in Camera Raw. When you open multiple photos, they appear in a vertical filmstrip along the left side of Camera Raw (as shown here). Click on the Select All button (it's above the filmstrip) and then crop the currently selected photo as you'd like. As you apply your cropping, look at the filmstrip and you'll see all the thumbnails update with their new cropping instructions. A tiny Crop icon will also appear in the bottom-left corner of each thumbnail, letting you know that these photos have been cropped in Camera Raw.

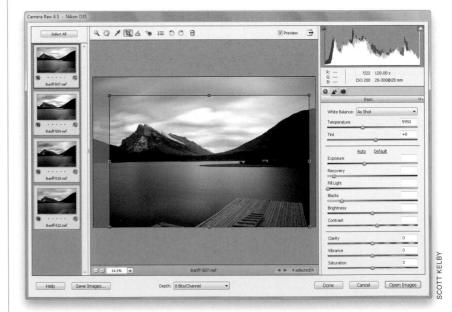

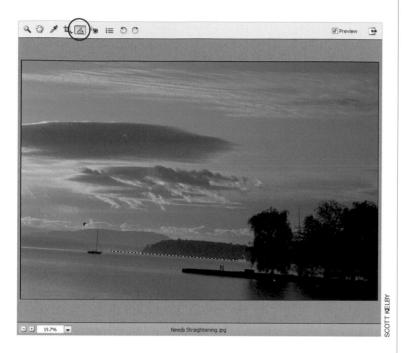

Step Seven:

Another form of cropping is actually straightening your photos using the Straighten tool. It's a close cousin of the Crop tool because what it does is essentially rotates your cropping border, so when you open the photo, it's straight. In the Camera Raw toolbar, choose the Straighten tool (it's immediately to the right of the Crop tool, and shown circled here in red). Now, click-and-drag it along the horizon line in your photo (as shown here). When you release the mouse button, a cropping border appears and that border is automatically rotated to the exact amount needed to straighten the photo.

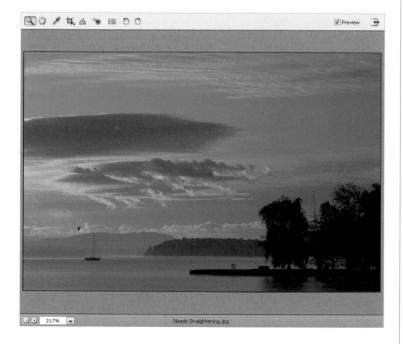

Step Eight:

You won't actually see the rotated photo until you click on another tool (which I've done here) or open it in Elements (which means, if you click Save Image or Done, Camera Raw closes, and the straightening information is saved along with the file. So if you open this file again in Camera Raw, that straightening crop border will still be in place). If you click Open Image, the photo opens in Elements, but only the area inside the cropping border is visible, and the rest is cropped off. Again, if this is a RAW photo (or you haven't overwritten your JPEG or TIFF file), you can always return to Camera Raw and remove this cropping border to get the original uncropped photo back.

TIP: Canceling Your Straightening If you want to cancel your straightening, just press the **Esc key** on your keyboard, and the straightening border will go away.

Editing Multiple Photos at Once

One of the coolest things about Camera Raw is the ability to apply changes to one photo, and then have those same changes applied to as many other similar images as you'd like. It's a form of built-in automation, and it can save an incredible amount of time in editing your shoots.

Step One:

Start off in the Organizer by selecting a group of photos that were shot in the same, or very similar, lighting conditions (click on one photo, pressand-hold the Ctrl [Mac: Command] key, and click on the other photos), then open these images in Camera Raw (see the first tutorial in this chapter on how to open RAW, JPEG, and TIFF photos in Camera Raw).

Step Two:

The selected photos will appear along the left side of the Camera Raw window. First, click on the photo you want to edit (this will be your target photo—the one all the adjustments will be based upon), then click the Select All button at the top left of the window to select all the other images (as shown here).

Go ahead and adjust the photo the way you'd like. You can see the settings I used here, for this photo. You'll notice that the changes you make to the photo you selected first are being applied to all the photos in the Camera Raw filmstrip on the left (you can see their thumbnails update as you're making adjustments).

Step Four:

When you're done making adjustments, you have a choice to make: (a) if you click the Open Images button, all of your selected images will open in the Elements Editor (so if you're adjusting 120 images, you might want to give that some thought before clicking the Open Images button), or (b) you can just click the Done button, which applies all your changes to the images without opening them in Elements. So, your changes are applied to all the images, but you won't see those changes until you open the images later (I usually choose [b] when editing lots of images at once). That's it—how to make changes to one image and have them applied to a bunch of images at the same time.

Saving RAW Files in Adobe's Digital Negative (DNG) Format

At this point in time, there's a concern with the RAW file format because there's not a single, universal format for RAW images—every digital camera manufacturer has its own. That may not seem like a problem, but what happens if one of these camera companies stops supporting a format or switches to something else? Seriously, what if a few years from now there was no easy way to open your saved RAW photos? Adobe recognized this problem and created the Digital Negative (DNG) format for long-term archival storage of RAW images.

Step One:

As of the writing of this book, only a few major camera manufacturers have built in the ability to save RAW files in Adobe's DNG format (although we believe it's only a matter of time before they all do); so if your camera doesn't support DNG files yet—no sweat—you can save your RAW files to Adobe DNG format from right within the Camera Raw window. Just open your image in Camera Raw and hit the Save Image button at the bottom left of the window. This brings up the Save Options dialog, which saves your RAW file to DNG by default.

Step Two:

At the bottom of this dialog, you have some additional DNG options: You can choose to embed the original RAW file into your DNG (making the file larger, but your original is embedded for safekeeping in case you ever need to extract it. If you have the hard disk [or CD] space, go for it!). There's a Compatibility option (you can save it for earlier versions of Camera Raw or choose Custom for compression options). You can also choose to include a JPEG preview. That's it—click Save and you've got a DNG archival-quality file that can be opened by Photoshop Elements (or the free DNG utility from Adobe).

In Elements, we have pro-level sharpening within Camera Raw. So when do you sharpen here, and when in Elements? I generally sharpen my photos twice—once here in Camera Raw (called "capture sharpening"), and then once in Elements at the very end of my editing process, right before I save the final image for print or for the Web (called "output sharpening").

Here's how to do the capture sharpening part in Camera Raw:

Sharpening in Camera Raw

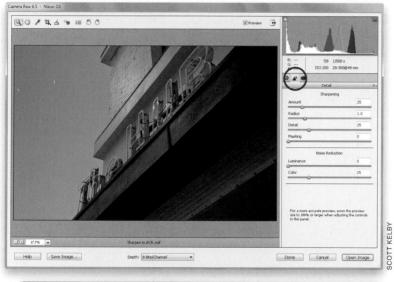

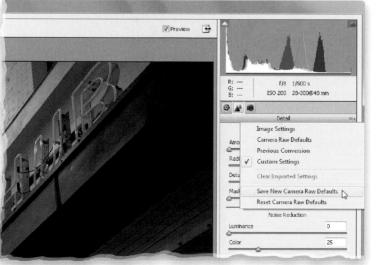

Step One:

When you open a RAW image in Camera Raw, by default it applies a small amount of sharpening to your photo (not the JPEGs or TIFFs—only RAW images). You can adjust this amount (or turn if off altogether, if you like) by clicking on the Detail icon (circled here in red), or using the keyboard shortcut Ctrl-Alt-2 (Mac: Command-Option-2). At the top of this panel is the Sharpening section, where by a quick glance you can see that sharpening has already been applied to your RAW photo. If you don't want any sharpening applied at this stage (it's a personal preference), then simply click-and-drag the Amount slider all the way to the left, to lower the amount of sharpening to 0 (zero), and the sharpening is removed.

Step Two:

If you want to turn off this "automatic-by-default" sharpening (so image sharpening is only applied if you go and manually add it yourself), first set the Sharpening Amount slider to 0 (zero), then go to the Camera Raw flyout menu and choose **Save New Camera Raw Defaults** (as shown here). Now, RAW images taken with that camera will not be automatically sharpened.

This may seem kind of obvious (since it tells you this right at the bottom of the Detail panel, as seen in Step One), but so many people miss this that I feel it's worth repeating: before you do any sharpening, you should view your image at a 100% size view, so you can see the sharpening being applied. A quick way to get to a 100% size view is simply to double-click directly on the Zoom tool (the one that looks like a magnifying glass) up in Camera Raw's toolbar. This zooms you right to 100% (you can double-click on the Hand tool later to return to the normal Fit in Window view).

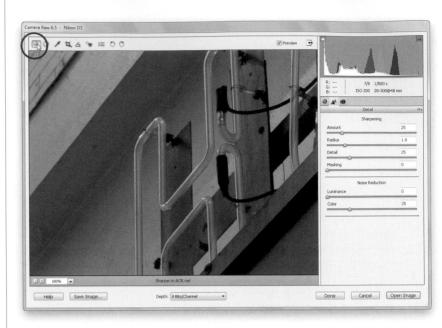

Step Four:

Now that you're at a 100% view, just for kicks, drag the Amount slider all the way to the right so you can see the sharpening at work (then drag it back to its default of 25). Again, dipping into the realm of the painfully obvious, dragging the Amount slider to the right increases the amount of sharpening. Compare the image shown here, with the one in Step Three (where the Sharpening Amount was set to the default of 25), and you can see how much sharper the image now appears, since I dragged it to 80.

TIP: Switch to Full Screen

To have Camera Raw expand to fill your entire screen, click the Full Screen icon to the right of the Preview checkbox, at the top of the window.

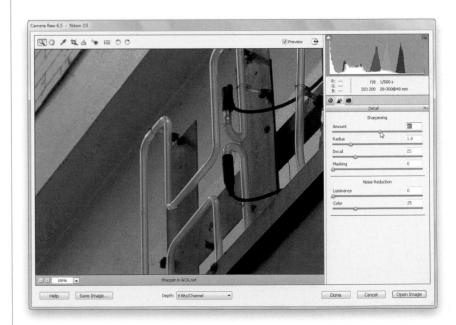

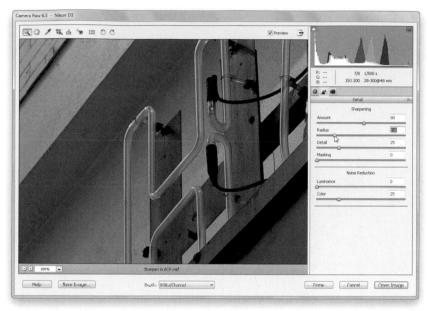

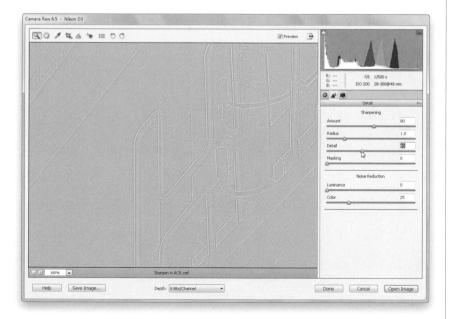

Step Five:

The next slider down is the Radius slider, which determines how far out the sharpening is applied from the edges being sharpened in your photo. I leave my Radius set at 1 most of the time. I use less than a Radius of 1 if the photo I'm processing is only going to be used on a website, in video editing, or something where it's going to be at a very small size or resolution. I only use a Radius of more than 1 when the image is visibly blurry and needs some "emergency" sharpening. If you decide to increase the Radius amount above 1 (unlike the Unsharp Mask filter, you can only go as high as 3 here), just be careful, because your photo can start to look oversharpened. You want your photo to look sharp, not sharpened, so be careful out there.

Step Six:

The next slider down is the Detail slider. which is kind of the "halo avoidance" slider (halos occur when you oversharpen an image and it looks like there's a little halo, or line, traced around your subject or objects in your image, and they look pretty bad). The default setting of 25 is good, but you'd raise the Detail amount (dragging it to the right) when you have shots with lots of tiny important detail, like in landscapes or the architectural photo here. Otherwise, I leave it as is. By the way, if you want to see the effect of the Detail slider, make sure you're at a 100% view, then press-and-hold the Alt (Mac: Option) key, and you'll see your preview window turn gray (as shown here). As you drag the Detail slider to the right. you'll see the edges start to become more pronounced, because the farther you drag to the right, the less protection from halos you get (those edges are those halos starting to appear).

Step Seven:

The last Sharpening slider—Masking is easier to understand, and for many people I think it will become invaluable. Here's why: generally speaking, sharpening gets applied to everything fairly evenly. But what if you have an image where there are areas you'd like sharpened, but other areas of softer detail you'd like left alone? For example, when sharpening portraits of women or children, you'd like their hair, eyes, teeth, etc., sharp, but their skin to remain soft, right? Well, that's kind of what the Masking slider here in Camera Raw does—as you drag it to the right, it reduces the amount of sharpening on non-edge areas (like the skin). So for portraits of women and children, I always raise the Masking amount quite a bit. I'm switching photos here to a portrait, so you can better see what I mean.

Step Eight:

For you to see the sharpening (and especially to be able to use another preview effect to see how the sharpening is being applied), you need to first zoom to a 100% view (remember that double-click-on-the-Zoom-tool trick?). Now that you're at 100%, here's the deal: the default Masking setting is 0 (zero), so sharpening is applied evenly to everything with an edge to be sharpened. As you drag to the right, the non-edge areas are masked (protected) from being sharpened. Seeing this visually will help, so press-and-hold the Alt (Mac: Option) key, and then drag the Masking slider to the right until it reads 25 (as shown here). You'll see that the preview window turns solid white at first (that means the sharpening is applied to everything), then some little areas start to turn black. Those black areas aren't being sharpened.

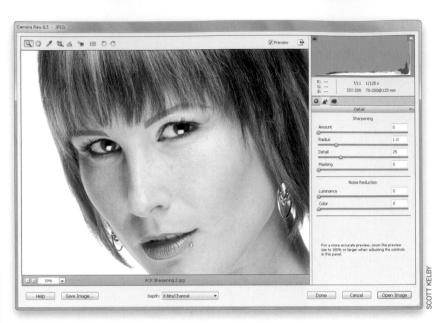

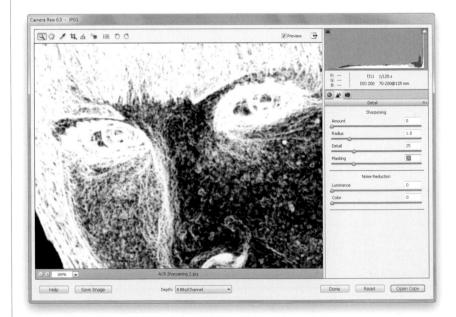

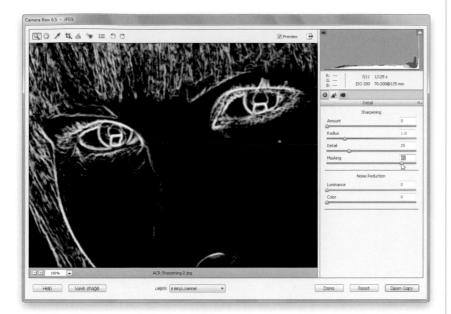

Step Nine:

Keep holding that Alt key down, then drag way over—to around 85—and you'll see most of the skin is turning black, and only the detail edge areas (like her eyes, eyelashes, etc.) are still solid white. So, in short, you'd drag far to the right for softer looking portraits. Here are the two settings I use most often for my Camera Raw sharpening:

For Landscapes: Amount: 40

Radius: 1 Detail: 50 Masking: 0

For Portraits: Amount: 35

Radius: 1.2 Detail: 20 Masking: 70

Below is a before and after of our original shot (the building), with no sharpening applied (Before), and then with a nice crisp amount applied (After) using these settings—Amount: 80, Radius: 1, Detail: 40, Masking: 0.

Before

After

Camera Raw's Noise Reduction

If you wind up shooting in low light (at night, indoors, at a concert, etc.), then you're probably used to cranking up your ISO to 800 or more, so you can hand-hold the shots, right? The downside of a high ISO is the same with digital as it was with film—the higher the ISO, the more visible the noise (those annoying red and green spots or splotchy patches of color), especially in shadows, and it gets even worse when you try to lighten them. Here's what you can do in Camera Raw to lessen the noise.

Step One:

Open an image in Camera Raw that has a digital noise issue, and double-click on the Zoom tool in the toolbar to zoom in to 100%, so the noise is easily visible. There are two types of noise you can deal with in Camera Raw: (1) high ISO noise, which often happens when you're shooting in low-light situations using a high ISO setting; and (2) color noise, which can happen even in normal situations (this noise is more prevalent in some cameras than others). When you see this junk, click on the Detail icon (the middle one) and get to work.

Step Two:

First, decrease the color noise by dragging the Noise Reduction Color slider to the right. It does a fair job of removing at least some of the color noise (the default setting of 25 for RAW files does a pretty decent job), though it does tend to desaturate your overall color just a bit. Next, take care of the Luminance noise by dragging the Luminance slider to the right. Be careful, as it can tend to make your photo look a bit soft.

Camera Raw has its own built-in Red Eye Removal tool, and there's a 50/50 chance it might actually work. Of course, my own experience has been a little less than that (more like 40/60), but hey—that's just me. Anyway, if it were me, I'd probably be more inclined to use the regular Red Eye tool in Elements itself, which actually works fairly well, but if you're charging by the hour, this might be a fun place to start. Here's how to use this tool, which periodically works for some people, somewhere. On occasion. Perhaps.

Removing Red Eye in Camera Raw

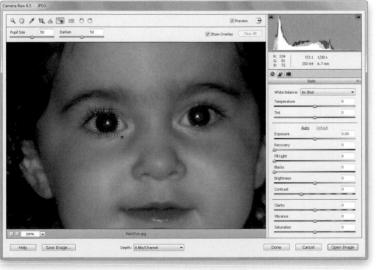

Step One:

Open a photo in Camera Raw that has the dreaded red eye (like the one shown here). To get the Red Eye Removal tool, you can press the letter **E** or just click on its icon up in Camera Raw's toolbar (as shown here).

Step Two:

You'll want to zoom in close enough so you can see the red-eye area pretty easily (as I have here, where I just simply zoomed to 200%, using the zoom level pop-up menu in the bottom-left corner of the Camera Raw window). The way this tool works is pretty simple—you click-and-drag the tool around one eye (as shown here) and as you drag, it makes a box around the eye (seen here). That tells Camera Raw where the red eye is located.

When you release the mouse button, theoretically it should snap down right around the pupil, making a perfect selection around the area affected by red eye (as seen here). You'll notice the key word here is "theoretically." If it doesn't work for you, then press **Ctrl-Z** (**Mac: Command-Z**) to undo that attempt, and try again. Before you do, try to help the tool along by increasing the Pupil Size setting (in the options section) to around 100 (as I did here).

Step Four:

Once that eye looks good, go over to the other eye, drag out that selection again (as shown here), and it does the same thing (the before and after are shown below). One last thing: if the pupil looks too gray after being fixed, then drag the Darken amount to the right (as I have here). Give it a try on a photo of your own. It's possible it might work.

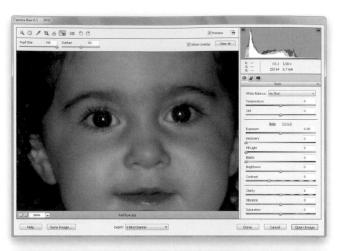

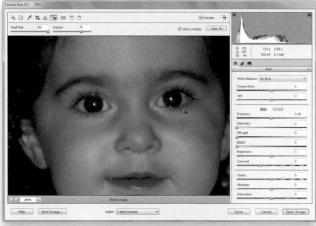

After

As good as today's digital cameras are, there are still some scenes they can't accurately expose for (like backlit situations, for example). Even though the human eye automatically adjusts for these situations, your camera is either going to give you a perfectly exposed sky with a foreground that's too dark, or vice versa. Well, there's a very cool trick (called double processing) that lets you create two versions of the same photo (one exposed for the foreground, one exposed for the sky), and then you combine the two to create an image beyond what your camera can capture!

The Trick for Expanding the Range of Your Photos

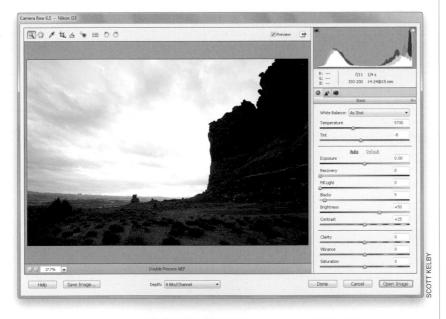

Step One:

Open an image with an exposure problem in Camera Raw. In our example, the camera properly exposed for the foreground, so the sky is totally blown out. Of course, or goal is to create something our camera can't—a photo where both the foreground and sky are exposed properly. You can tweak the white balance, recovery, fill light, etc., a little, then just click Open Image to create the first version of your photo.

Step Two:

In the Editor, go under the File menu, choose **Save As**, and rename and save this adjusted image. Then go back under the File menu, and under **Open Recently Edited File**, choose the same photo you just opened. It will reopen in Camera Raw. The next step is to create a second version of this image that exposes for the sky, even though it will make the foreground very dark.

Drag the Exposure slider way over to the left, until the sky looks properly exposed. Here, I dragged to –2.00, and also increased the Recovery, Blacks, and Vibrance settings. When it looks good to you, click the Open Image button to open this version of the photo in the Elements Editor.

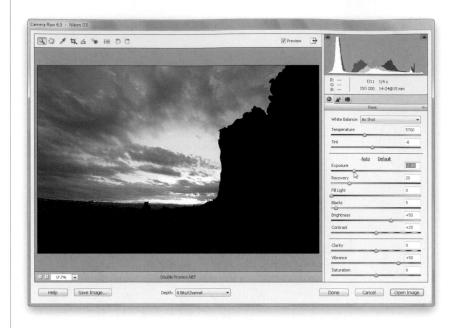

Step Four:

Now you should have both versions of the image open in the Elements Editor: one exposed for the foreground and one exposed for the sky. Arrange the image windows so you can see both onscreen at the same time (with the darker photo in front). Press V to get the Move tool, press-and-hold the Shift key, and drag-and-drop the darker version on top of the good foreground exposure version. The key to this part is holding down the Shift key while you drag between documents, which perfectly aligns the darker image (that now appears on its own layer in the Layers palette) with the brighter version on the Background layer. (This exact alignment of one identical photo over another is referred to as being "pin-registered.") You can now close the darker document without saving, as both versions of the image are contained within one document.

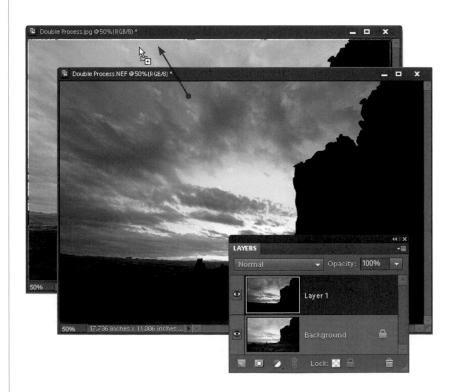

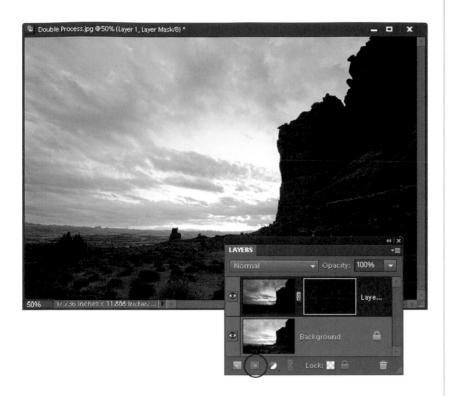

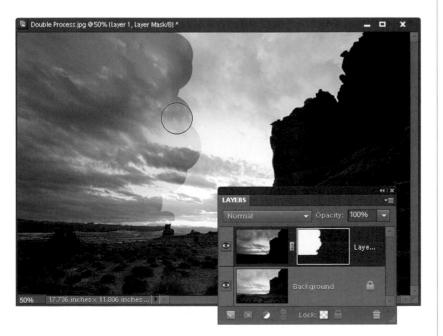

Step Five:

Next, we'll blend these two images using a layer mask (to learn more about layer masks, see Chapter 7). With the top layer active, go to the Layers palette, press-and-hold the Alt (Mac: Option) key, and click on the Add Layer Mask icon at the bottom of the palette. This adds a black mask to the layer with the good sky, hiding it so you only see the lighter image on the Background layer (as shown here).

Step Six:

It's time to "reveal" the sky on the darker version of the photo. So, press the letter B to get the Brush tool, then click on the brush thumbnail in the Options Bar and choose a medium-sized, hardedged brush from the Brush Picker (this helps to keep you from painting outside the lines). Press the letter **D** to set your Foreground color to white, and start painting over the areas of the photo that you want to be darker (in this case, the sky). As you paint with white directly on that black mask (you can tell it's active, because you'll see a white frame around the mask thumbnail), the white reveals the darker version beneath the mask. I also painted over the mountains in the background to make them a bit darker, so that they'd blend better with the darker sky. (Note: If you make a mistake, press X to switch your Foreground color to black, and paint over your mistake to hide it again.)

Step Seven:

Continue painting in black over the areas that you want to be darker. You may need to make your brush smaller (or larger) as you paint—just press the Left Bracket key ([) to make your brush smaller and the **Right Bracket** key (]) to make it larger. If the area you just painted in looks too dark, simply lower the Opacity of the top layer (with the layer mask) until it looks right. Below are a before and after showing the double-processing effect.

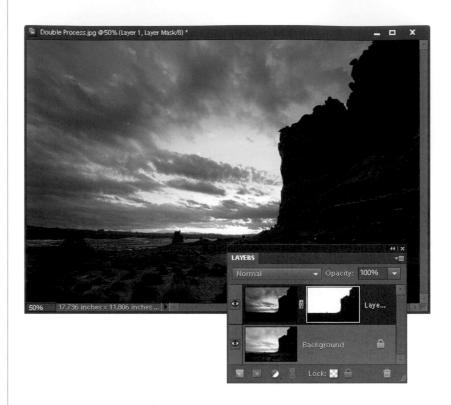

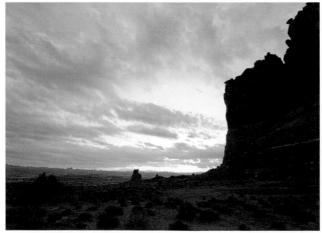

After

One of the easiest ways to make great black-and-white photos (from your color images) is to do your conversion completely within Camera Raw. You're basically just a few sliders away from a stunning black-and-white photo, and then all you have left to do is finish off the image by opening it in Photoshop Elements and adding some sharpening. Here's how it's done:

Black & White Conversions in Camera Raw

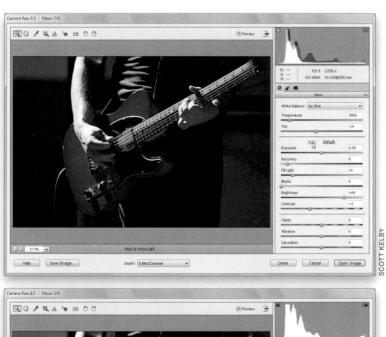

Step One:

Start by opening a photo you want to convert to black and white. This is one of the rare times I start by clicking the Auto button (you know, the button beneath the Tint slider that looks like a Web link), because it usually pumps up the exposure about as high as it can go without too much clipping (if any). So, start there—click the Auto button. Here, it adjusted the Contrast setting, along with Fill Light, Brightness, and Recovery.

Step Two:

Now we're going to work from the bottom of the Basic panel up. The next step in converting to black and white is to remove the color from the photo. Go to the Saturation slider and drag it all the way to the left. Although this removes all the color, it usually makes for a pretty flat-looking (read as: lame) black-and-white photo. Now go up two sliders to the Clarity slider and drag it over quite a bit to the right to really make the midtones snap (I dragged over to +88).

Now you're going to add extra contrast by (you guessed it) dragging the Contrast slider to the right until the photo gets real contrasty (as shown here). It's important that you set this slider first—before you set the Blacks slider—or you'll wind up setting the blacks, then adjusting the contrast, and then lowering the Blacks slider back down. That's because what the Contrast slider essentially does is makes the darkest parts of the photo darker, and the brightest parts brighter. If the blacks are already very dark, then you add contrast, it makes them too dark, and you wind up backing them off again. So, save yourself the extra step and set the contrast first.

Step Four:

Lastly, drag the Brightness slider to the left a bit, then go to the Blacks slider and drag it to the right until you get very rich-looking shadows. One of the characteristics of great black-and-white prints is that they have deep, rich blacks and bright, crisp whites, so don't be shy when you're dragging this slider to the right. Now head up to the Exposure slider and drag it a ways over to the right until the highlights lighten up a bit. That's it—the quickest way to convert to black and white (and get a nice high-contrast look) right within Camera Raw.

TIP: Change the White Balance

Another thing you might try for RAW images is going through each of the White Balance presets (in the White Balance pop-up menu) to see how they affect your black-and-white photo. You'll be amazed at how this little change can pay off (make sure you try Fluorescent and Tungsten—they often look great in black and white).

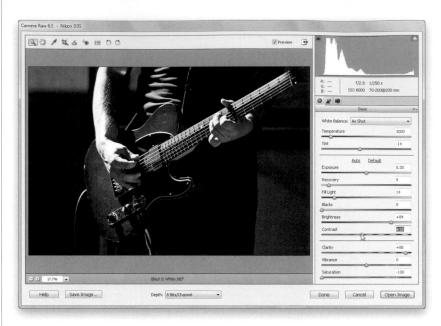

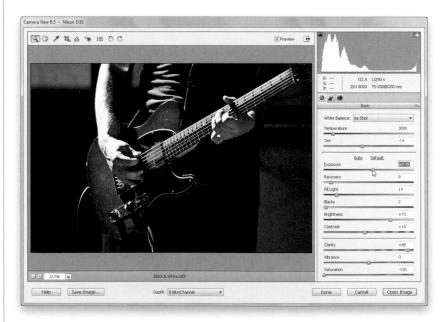

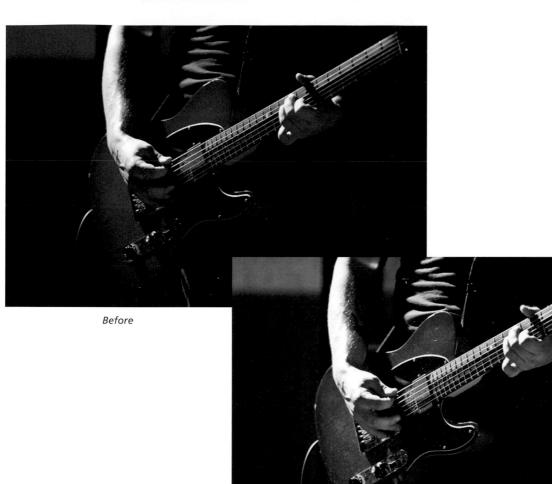

After

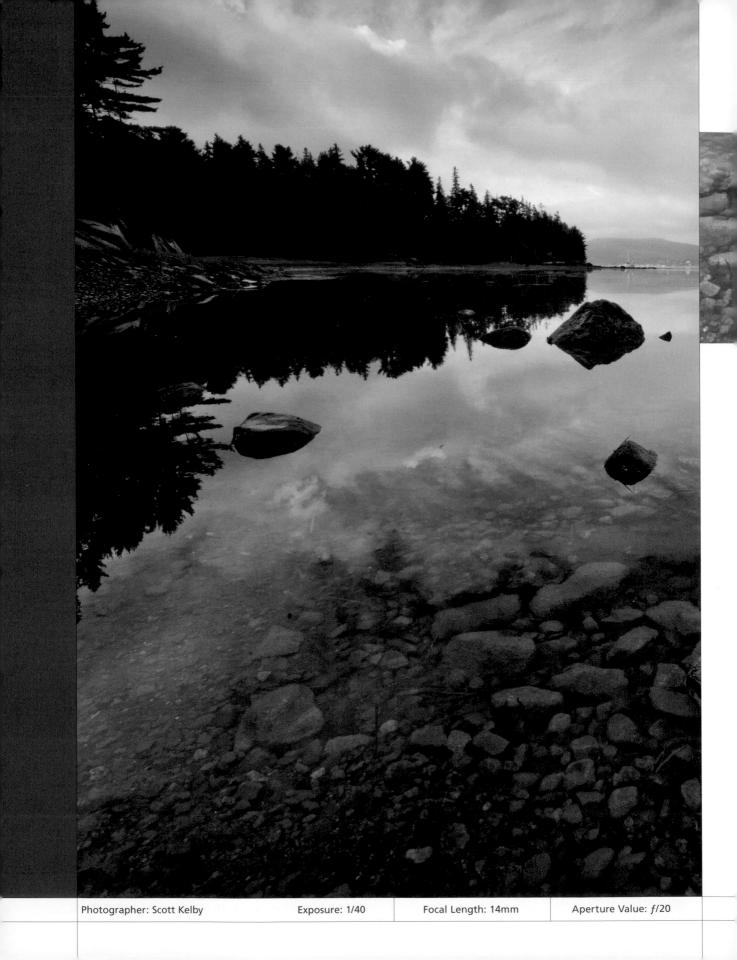

Scream of the Crop

how to resize and crop photos

I love the title of this chapter—it's the name of an album from the band Soulfarm (tell me that Soulfarm wouldn't make a great name for a horror movie!). Anyway, I also found a band named Cash Crop, which would make a great title, too, but when I looked at their album, every song was marked with the Explicit warning. I listened to a 30-second preview of the first track (which was featured in the original motion picture soundtrack for the movie Sorority Row), and I immediately knew what kind of the music they did. Naughty, naughty music. Anyway, while I was listening, and wincing from time to time as F-bombs exploded all around me, I realized that someone at the iTunes Store must have the full-time job of listening to each song and choosing the 30-second preview. I imagine, at this point, that person has to be 100% completely numb to hearing things like the F-bomb, the S-missile, and the

B-grenade (which means they could totally do a stint as Joe Pesci's nanny). But, I digress. The "Scream of the Crop" title (which would make a great title for a movie about evil corn) is almost ideal for this chapter, except for the fact that this chapter also includes resizing. So, I thought, what the heck, and searched for "resize" and found a song called "Undo Resize" by electronic ambient artist DJ Yanatz Ft. The Designers, and it literally is an 8:31 long background music track with two European-sounding women whispering the names of menu commands from Adobe products. Stuff like "Select All," "Fill," "Distort," "Snap to Grid," and so on. I am not making this up (go listen to the free 30-second preview). It was only 99¢, which is a bargain for 8+ minutes of menu commands set to music. Normally, this many minutes of menu commands set to music would be more like, I dunno, \$1.29 or so.

Cropping Photos

After you've sorted your images in the Organizer, one of the first editing tasks you'll probably undertake is cropping a photo. There are a number of different ways to crop a photo in Elements. We'll start with the basic garden-variety options, and then we'll look at some ways to make the task faster and easier.

Step One:

Open the image you want to crop in the Elements Editor, and then press the letter **C** to get the Crop tool (you could always select the tool directly from the Toolbox, but I only recommend doing so if you're charging by the hour).

SCOTT KELBY

Step Two:

Click within your photo and drag out a cropping border. By default, you'll see a grid appear within your cropping border. This is a new feature in Elements 10, which lets you crop photos based on some of the popular composition rules that photographers and designers use. We'll go over this feature more in a moment, so for now choose **None** from the Overlay pop-up menu in the Options Bar. The area to be cropped away will appear dimmed (shaded). You don't have to worry about getting your cropping border right when you first drag it out, because you can edit it by dragging the control handles that appear in each corner and at the center of each side.

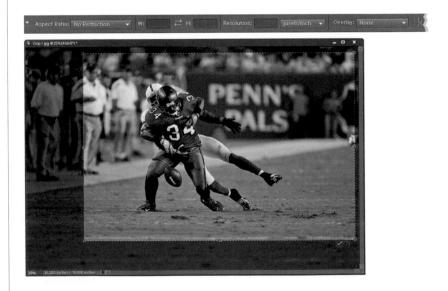

TIP: Turn Off the Shading

If you don't like seeing your photo with the cropped-away areas appearing shaded (as in the previous step), you can toggle this shading feature off/on by pressing the **Forward Slash key (/)** on your keyboard. When you press the Forward Slash key, the border remains in place but the shading is turned off.

Step Three:

While you have the cropping border in place, you can rotate the entire border. Just move your cursor outside the border, and your cursor will change into a double-headed arrow. Then, click-anddrag, and the cropping border will rotate in the direction that you drag. (This is a great way to save time if you have a crooked image, because it lets you crop and rotate at the same time.)

Step Four:

Once you have the cropping border where you want it, click on the green checkmark icon at the bottom corner of your cropping border, or just press the **Enter (Mac: Return) key** on your keyboard. To cancel your crop, click the red international symbol for "No Way!" at the bottom corner of the cropping border, or press the **Esc key** on your keyboard.

Step Five:

Like I mentioned, Elements 10 includes new Overlay features to help you crop your photos. The one you'll use the most is called the Rule of Thirds (and is the default overlay). It's essentially a trick that photographers sometimes use to create more interesting compositions. Basically, you visually divide the image you see in your camera's viewfinder into thirds, and then you position your horizon so it goes along either the top imaginary horizontal line or the bottom one. Then, you position the subject (or focal point) at the center intersections of those lines (as you'll see in the next step). But if you didn't use the rule in the viewfinder, no sweat! You can use this Overlay feature to achieve it. There are also two other options in the Overlay popup menu: (1) Grid, which is useful for straightening horizons and (2) Golden Ratio, which is used for more of a "spiral" composition.

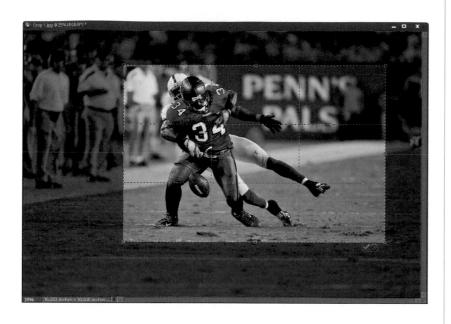

Step Six:

So, choose **Rule of Thirds** from the Overlay pop-up menu in the Options Bar and then click within your photo and drag out a cropping border. When you drag the cropping border onto your image, you'll see the Rule of Thirds overlay appear over your photo. Just position your image's horizon along one of the horizontal grid lines, and be sure your focal point (the football player, in this case) falls on one of the intersecting points (the top-left intersection, in this example).

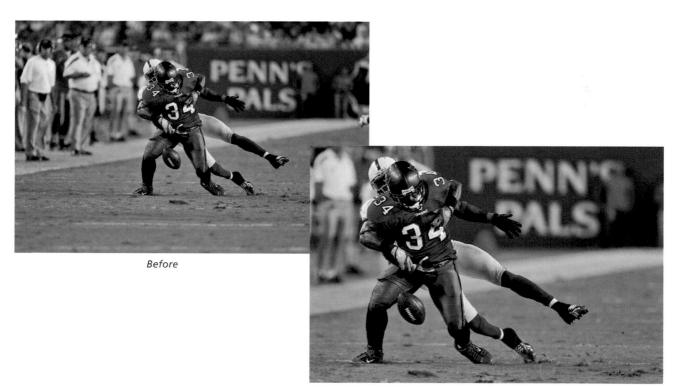

After

Auto-Cropping to Standard Sizes

If you're outputting photos for clients, chances are they're going to want them in standard sizes so they can easily find frames to fit. If that's the case, here's how to crop your photos to a predetermined size (like a 5x7", 8x10", etc.):

Step One:

Open an image in the Elements Editor that you want to crop to be a perfect 5x7" for a vertical image, or 7x5" if your image is horizontal. Press **C** to get the Crop tool, then go to the Options Bar, and from the Aspect Ratio pop-up menu, click on the words "No Restriction." When the list of preset crop sizes appears, click on **5x7 in**. (*Note:* To hide the Rule of Thirds overlay grid, choose **None** from the Overlay pop-up menu on the right side of the Options Bar.)

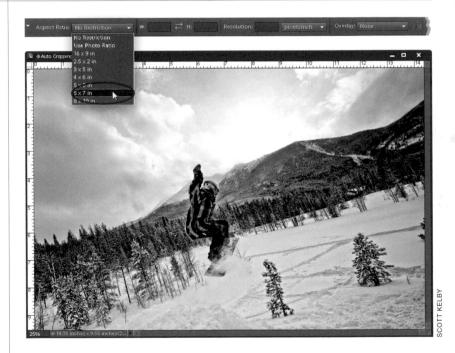

TIP: Swapping Fields

The Width and Height fields are populated based on the type of image you open—7x5" for horizontal images and 5x7" for vertical images. If you opened a horizontal image, but your crop is going to be vertical (tall), you'll need to swap the figures in the Width and Height fields by clicking on the Swaps icon between the fields in the Options Bar (as shown here).

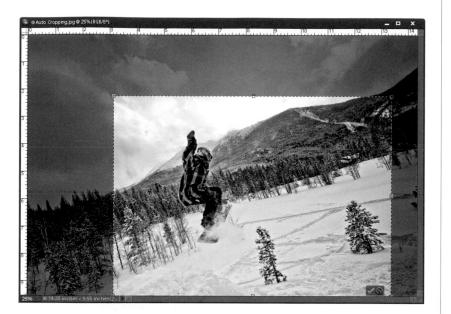

Step Two:

Now click-and-drag the Crop tool over the portion of the photo that you want to be 7x5" (if your image is vertical, Elements will automatically adjust your border to 5x7"). While dragging, you can press-and-hold the Spacebar to adjust the position of your border, if needed.

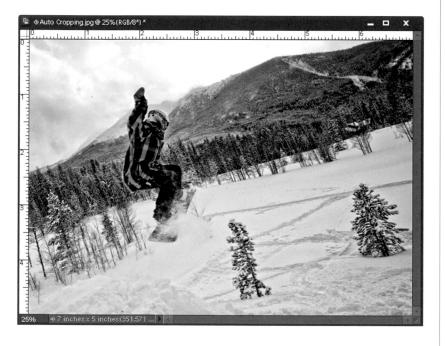

Step Three:

Once it's set, press the **Enter (Mac: Return) key** and the area inside your cropping border will become 7x5" (as shown here).

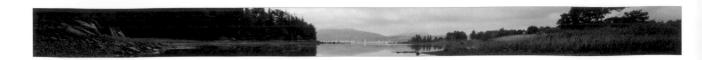

Cropping to an Exact Custom Size

Okay, now you know how to crop to Elements' built-in preset sizes, but how do you crop to a nonstandard size—a custom size that you determine? Here's how:

Step One:

Open the photo that you want to crop in the Elements Editor. (I want to crop this image to 8x6".) First, press **C** to get the Crop tool. In the Options Bar, you'll see fields for Width and Height. Enter the size you want for Width, followed by the unit of measure you want to use (e.g., enter "in" for inches, "px" for pixels, "cm" for centimeters, "mm" for millimeters, etc.). Next, press the **Tab key** to jump over to the Height field and enter your desired height, again followed by the unit of measure.

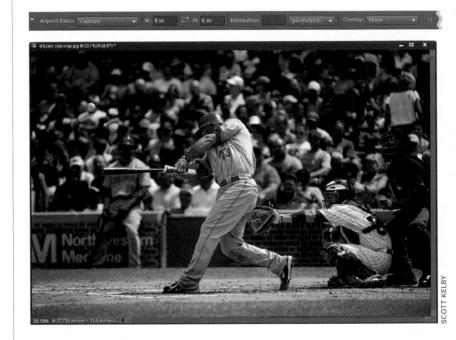

Step Two:

Once you've entered these figures in the Options Bar, click within your photo with the Crop tool and drag out a cropping border. (Note: To hide the Rule of Thirds overlay grid, choose None from the Overlay pop-up menu on the right side of the Options Bar.) You'll notice that as you drag, the border is constrained to an 8x6" aspect ratio; no matter how large of an area you select within your image, the area within that border will become your specified size. When you release your mouse button, you'll still have both side handles and corner handles visible, but the side handles will act like corner handles to keep your size constrained.

Step Three:

Once your cropping border is onscreen, you can resize it using the corner handles or you can reposition it by moving your cursor inside the border. Your cursor will change to a Move arrow, and you can now click-and-drag the border into place. You can also use the Arrow keys on your keyboard for more precise control. When it looks right to you, press Enter (Mac: Return) to finalize your crop or click on the checkmark icon beneath the bottom-right corner of your cropping border. Here, I made the rulers visible (Ctrl-Shift-R [Mac: Command-Shift-R]) so you could see that the image measures exactly 8x6".

TIP: Clearing the Fields

Once you've entered a Width and Height in the Options Bar, those dimensions will remain there. To clear the fields, just choose **No Restriction** from the Aspect Ratio pop-up menu. This will clear the Width and Height fields, and now you can use the Crop tool for freeform cropping (you can drag it in any direction—it's no longer constrained to your specified size).

COOLER TIP: Changing Dimensions

If you already have a cropping border in place, you can change your dimensions without re-creating the border. All you have to do is enter the new sizes you want in the Width and Height fields in the Options Bar, and Elements will resize your cropping border.

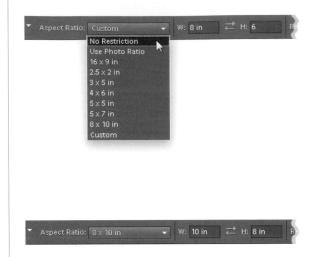

After

Elements has a cool feature that lets you crop your photo into a pre-designed shape (like putting a wedding photo into a heart shape), but even cooler are the edge effects you can create by cropping into one of the pre-designed edge effects that look like old Polaroid transfers. Here's how to put this feature to use to add visual interest to your own photos.

Cropping into a Shape

Step One:

In the Elements Editor, open the photo you want to crop into a pre-designed shape, and press the letter **Q** to get the Cookie Cutter tool.

Step Two:

Now, go up to the Options Bar and click on the Shape thumbnail. This brings up the Custom Shape Picker, which contains the default set of 30 shapes. To load more shapes, click on the right-facing arrows at the top right of the Picker and a list of built-in shape sets will appear. From this list, choose **Crop Shapes** to load the edge-effect shapes, which automatically crop away areas outside your custom edges.

Once you select the custom edge shape you want to use in the Custom Shape Picker, just click-and-drag it over your image to the size you want it. When you release the mouse button, your photo is cropped to fit within the shape. Note: I like Crop Shape 10 (which is shown here) for something simple, and Crop Shape 20 for something a little wilder. The key thing here is to experiment and try different crop shapes to find your favorite.

Step Four:

You'll see a bounding box around the shape, which you can use to resize, rotate, or otherwise mess with your shape. To resize your shape, pressand-hold the Shift key (or turn on the Constrain Proportions checkbox in the Options Bar) to keep it proportional while you drag a corner handle. To rotate the shape, move your cursor outside the bounding box until your cursor becomes a double-sided arrow, and then click-and-drag. As long as you see that bounding box, you can still edit the shape. When it looks good to you, press Enter (Mac: Return) and the parts of your photo outside that shape will be permanently cropped away.

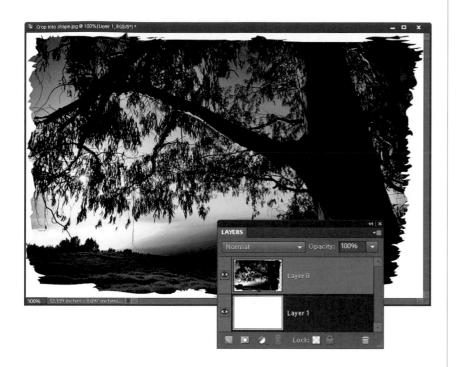

TIP: Tightly Crop Your Image

If you want your image area tightly cropped, so it's the exact size of the shape you drag out, just turn on the Cookie Cutter's Crop checkbox (up in the Options Bar) before you drag out your shape. Then when you press Enter to lock in your final shape, Elements will tightly crop the entire image area to the size of your shape. Note: The checkerboard pattern you see around the photo is letting you know that the background around the shape is transparent. If you want a white background behind the shape, click on the Create a New Layer icon at the bottom of the Layers palette, and then drag your new layer below the Shape layer. Press D, then X to set your Foreground to white, then press Alt-Backspace (Mac: Option-Delete) to fill this layer with white.

Before

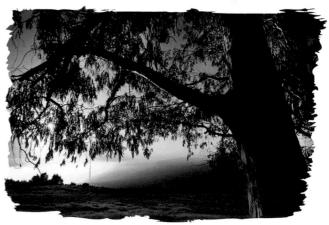

After

Using the Crop Tool to Add More Canvas Area

I know the heading for this technique doesn't make much sense—"Using the Crop Tool to Add More Canvas Area." How can the Crop tool (which is designed to crop photos to smaller sizes) actually make the canvas area (white space) around your photo larger? That's what I'm going to show you.

Step One:

In the Elements Editor, open the image to which you want to add additional blank canvas area. Press the letter **D** to set your Background color to its default white.

Step Two:

If you're in Maximize Mode or tabbed viewing, press **Ctrl**— (minus sign; **Mac: Command**—) to zoom out a bit (so your image doesn't take up your whole screen). If your image window is floating, click-and-drag out the bottom corner of the document window to see the gray desktop area around your image. (To enter Maximize Mode, click the Maximize Mode icon in the topright corner of the image window. To enter tabbed viewing, go under the Window menu, under Images, and choose **Consolidate All to Tabs.**)

Press the letter **C** to switch to the Crop tool and drag out a cropping border to any random size (it doesn't matter how big or little it is at this point).

Step Four:

Now, grab any one of the side or corner handles and drag outside the image area, out into the gray area that surrounds your image. The cropping border extending outside the image is the area that will be added as white canvas space, so position it where you want to add the blank canvas space.

Step Five:

Now, just press the **Enter (Mac: Return) key** to finalize your crop, and when you do, the area outside your image will become white canvas area.

Auto-Cropping Gang-Scanned Photos

A lot of photographers scan photos using a technique called "gang scanning." That's a fancy name for scanning more than one picture at a time. Scanning three or four photos at once with your scanner saves time, but then you eventually have to separate these photos into individual documents. Here's how to have Elements do that for you automatically:

Step One:

Place the photos you want to "gang scan" on the bed of your flat-bed scanner. In the Organizer, you can scan the images by going under the File menu, under Get Photos and Videos, and choosing **From Scanner** (they should appear in one Elements document). In the dialog that appears, select where and at what quality you want to save your scanned document. (*Note:* This feature is currently not available in the Elements 10 version for the Mac, so you'll need to use your scanner's software.)

Step Two:

Once your images appear in one document in the Editor, go under the Image menu and choose **Divide Scanned Photos**. It will immediately find the edges of the scanned photos, straighten them if necessary, and then put each photo into its own separate document. Once it has "done its thing," you can close the original gang-scanned document, and you'll be left with just the individual documents.

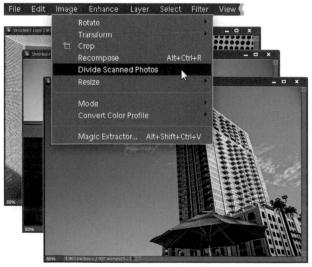

In Elements, there's a simple way to straighten photos, but it's knowing how to set the options for the tool that makes your job dramatically easier. Here's how it's done:

Straightening Photos with the Straighten Tool

Step One:

Open the photo that needs straightening (the photo shown here looks like the horizon is sloping down to the left). Then, choose the Straighten tool from the Toolbox (or just press the **P key**).

Step Two:

Take the Straighten tool and drag it along an edge in the photo that you think should be perfectly horizontal, like a horizon line (as shown here).

When you release the mouse button, the image is straightened, but as you see here, the straightening created a problem of its own—the photo now has to be re-cropped because the edges are showing a white background (as the image was rotated until it was straight). That's where the options (which I mentioned in the intro to this technique) come in. You see, the default setting does just what you see here—it rotates the image and leaves it up to you to crop away the mess. However, Elements can do the work for you (as you'll see in the next step).

Step Four:

Once you click on the Straighten tool, go up to the Options Bar, and in the Canvas Options pop-up menu, choose **Crop to Remove Background**.

Step Five:

Now when you drag out the tool and release the mouse button, not only is the photo straightened, but the annoying white background is automatically cropped away, giving you the clean result you see here.

TIP: Straightening Vertically

In this example, we used the Straighten tool along a horizontal plane, but if you wanted to straighten the photo using a vertical object instead (like a column or light pole), just click with the Straighten tool, then press-and-hold the Ctrl (Mac: Command) key before you drag it, and that will do the trick.

If you're more familiar with resizing scanned images, you'll find that resizing images from digital cameras is a bit different, primarily because scanners create high-resolution images (usually 300 ppi or more), but the default setting for most digital cameras usually produces an image that is large in physical dimension, but lower in ppi (usually 72 ppi). The trick is to decrease the physical size of your digital camera image (and increase its resolution) without losing any quality in your photo. Here's the trick:

Resizing Digital Camera Photos

Step One:

Open the digital camera image that you want to resize. Press **Ctrl-Shift-R (Mac: Command-Shift-R)** to make Elements' rulers visible. Check out the rulers to see the approximate dimensions of your image. As you can see from the rulers in the example here, this photo is around 20x30".

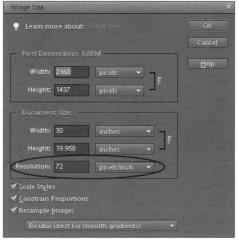

Step Two:

Go under the Image menu, under Resize, and choose **Image Size** to bring up the Image Size dialog. In the Document Size section, the Resolution setting is 72 pixels/inch (ppi). A resolution of 72 ppi is considered "low resolution" and is ideal for photos that will only be viewed onscreen (such as Web graphics, slide shows, etc.). This res is too low, though, to get high-quality results from a color inkjet printer, color laser printer, or for use on a printing press.

If we plan to output this photo to any printing device, it's pretty clear that we'll need to increase the resolution to get good results. I wish we could just type in the resolution we'd like it to be in the Resolution field (such as 200 or 240 ppi), but unfortunately, this "resampling" makes our low-res photo appear soft (blurry) and pixelated. That's why we need to make sure the Resample Image checkbox is turned off (as shown here). That way, when we type in the setting that we need in the Resolution field, Elements automatically adjusts the Width and Height fields for the image in the exact same proportion. As your Width and Height decrease (with Resample Image turned off), your Resolution increases. Best of all, there's absolutely no loss of quality. Pretty cool!

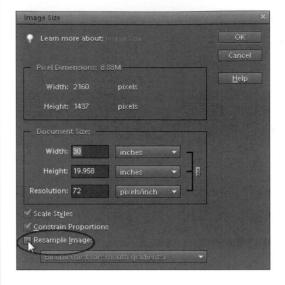

Step Four:

Here I've turned off Resample Image, then I typed 240 in the Resolution field (for output to a color inkjet printer—I know, you probably think you need a lot more resolution, but you don't. In fact, I never print with a resolution higher than 240 ppi). At a resolution of 240 ppi here, I can actually print a photo that is 9 inches wide by almost 6 inches high.

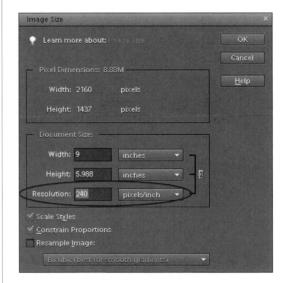

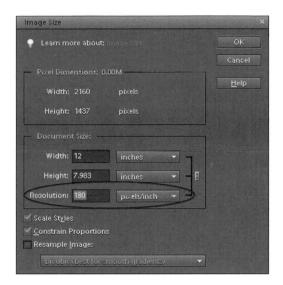

Step Five:

Here's the Image Size dialog for my source photo, and this time I've lowered the Resolution setting to 180 ppi. (Again, you don't need nearly as much resolution as you'd think, but 180 ppi is pretty much as low as you should go when printing to a color inkjet printer.) As you can see, the Width of my image is no longer 30"— it's now 12". The height is no longer nearly 20"—now it's almost 8". Best of all, we did it without damaging a single pixel, because we were able to turn off Resample Image.

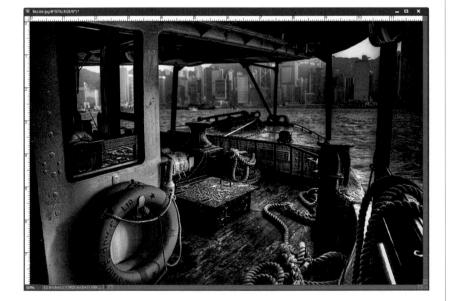

Step Six:

When you click OK, you won't see the image window change at all it will appear at the exact same size onscreen. But now look at the rulers you can see that your image's dimensions have changed. Resizing using this technique does three big things: (1) It gets your physical dimensions down to size (the photo now fits on an 11x14" sheet); (2) it increases the resolution enough so you can output this image on a color inkjet printer; and (3) you haven't softened or pixelated the image in any way—the quality remains the same—all because you turned off Resample Image. Note: Do not turn off Resample Image for images that you scan on a scanner they start as high-res images in the first place. Turning off Resample Image is only for photos taken with a digital camera at a low resolution.

Resizing and How to Reach **Those Hidden Free Transform Handles**

What happens if you drag a large photo onto a smaller photo in Elements? (This happens all the time, especially if you're collaging or combining two or more photos.) You have to resize the photo using Free Transform, right? Right. But here's the catch—when you bring up Free Transform, at least two (or, more likely, all four) of the handles that you need to resize the image are out of reach. You see the center point, but not the handles you need to reach to resize. Here's how to get around that hurdle quickly and easily:

Step One:

Open two different-sized photos in the Elements Editor. Use the Move tool (V) to drag-and-drop the larger photo on top of the smaller one (if you're in tabbed viewing, drag one image onto the other image's thumbnail in the Project Bin). To resize a photo on a layer, press Ctrl-T (Mac: Command-T) to bring up the Free Transform command. Next, press-andhold the Shift key to constrain your proportions (or turn on the Constrain Proportions checkbox in the Options Bar), grab one of the Free Transform corner handles, and (a) drag inward to shrink the photo, or (b) drag outward to increase its size (not more than 20%, to keep from making the photo look soft and pixelated). But wait, there's a problem. The problem is—you can't even see the Free Transform handles in this image.

Step Two:

To instantly have full access to all of Free Transform's handles, just press Ctrl-0 (zero; Mac: Command-0), and Elements will instantly zoom out of your document window and surround your photo with gray desktop, making every handle well within reach. Try it once, and you'll use this trick again and again. Note: You must choose Free Transform first for this trick to work.

There is a different set of rules we use for maintaining as much quality as possible when making an image smaller, and there are a couple of different ways to do just that (we'll cover the two main ones here). Luckily, maintaining image quality is much easier when sizing down than when scaling up (in fact, photos often look dramatically better—and sharper—when scaled down, especially if you follow these quidelines).

Making Your Photos Smaller (Downsizing)

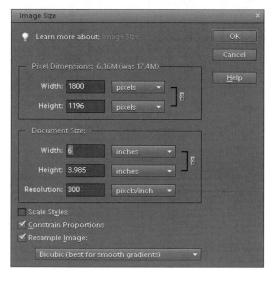

Downsizing photos where the resolution is already 300 ppi:

Although earlier we discussed how to change image size if your digital camera gives you 72-ppi images with large physical dimensions (like 24x42" deep), what do you do if your camera gives you 300-ppi images at smaller physical dimensions (like a 10x6" at 300 ppi)? Basically, you turn on Resample Image (in the Image Size dialog, under the Image menu, under Resize), then simply type the desired size (in this example, we want a 4x6" final image size), and click OK (don't change the Resolution setting, just click OK). The image will be scaled down to size, and the resolution will remain at 300 ppi. IMPORTANT: When you scale down using this method, it's likely that the image will soften a little bit, so after scaling you'll want to apply the Unsharp Mask filter to bring back any sharpness lost in the resizing (look at the sharpening chapter [Chapter 10] to see what settings to use).

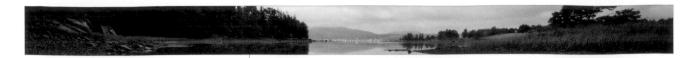

Making one photo smaller without shrinking the whole document:

If you're working with more than one image in the same document, you'll resize a bit differently. To scale down a photo on a layer, first click on that photo's layer in the Layers palette, then press Ctrl-T (Mac: Command-T) to bring up Free Transform. Press-andhold the Shift key to keep the photo proportional (or turn on the Constrain Proportions checkbox in the Options Bar), grab a corner handle, and drag inward. When it looks good to you, press the Enter (Mac: Return) key. If the image looks softer after resizing it, apply the Unsharp Mask filter (again, see the sharpening chapter).

Resizing problems when dragging between documents:

This one gets a lot of people, because at first glance it just doesn't make sense. You have two documents, approximately the same size, side-by-side onscreen. But when you drag a 72-ppi photo (of a lighthouse in Oregon, in this case) onto a 300-ppi document (Untitled-1), the photo appears really small. Why is that? Simply put: resolution. Although the documents appear to be the same size, they're not. The tip-off that you're not really seeing them at the same size is found in the title bar of each photo. For instance, the photo of the lighthouse is displayed at 100%, but the Untitled-1 document is displayed at only 25%. So, to get more predictable results, make sure both documents are at the same viewing size and resolution (check in the Image Size dialog under the Image menu, under Resize).

Elements has a pretty slick little utility that lets you take a folder full of images and do any (or all) of the following automatically at one time: (1) rename them; (2) resize them; (3) change their resolution; (4) color correct and sharpen them; and (5) save them in the file format of your choice (JPEG, TIFF, etc.). If you find yourself processing a lot of images, this can save a ton of time. Better yet, since the whole process is automated, you can teach someone else to do the processing for you, like your spouse, your child, a neighbor's child, passersby, local officials, etc.

Automated Saving and Resizing

Step One:

In the Elements Editor, go under the File menu and choose **Process Multiple Files**.

Step Two:

When the Process Multiple Files dialog opens, the first thing you have to do is choose the folder of photos you want to process by clicking on the Source Browse button in the first section of the dialog. Then navigate to the folder you want and click OK (Mac: Choose). If you already have some photos open in Elements, you can choose Opened Files from the Process Files From popup menu (or you can choose Import to import files). Then, in the Destination field, you decide whether you want the new copies to be saved in the same folder (by turning on the Same as Source checkbox), or copied into a different folder (in which case, click on the Destination Browse button and choose that folder).

Löntinued

The second section is File Naming. If you want your files automatically renamed when they're processed, turn on the Rename Files checkbox, then in the fields directly below that checkbox, type the name you want these new files to have and choose how you want the numbering to appear after the name (a two-digit number, three-digit, etc.). Then, choose the number with which you want to start numbering images. You'll see a preview of how your file naming will appear just below the Document Name field (shown circled here).

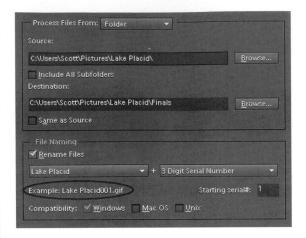

Step Four:

In the Image Size section, you decide if you want to resize the images (by turning on the Resize Images checkbox), and you enter the width and height you want for your finished photos. You can also choose to change the resolution. If you want to change their file type (like from RAW to JPEG High Quality), you choose that in the bottom section—File Type. Just turn on the Convert Files To checkbox, and then choose your format from the pop-up menu. On the topright side of the dialog (seen in Step Two), there is a list of Quick Fix cosmetic changes you can make to these photos, as well, including Auto Levels (to adjust the overall color balance and contrast), Auto Contrast (this is kind of lame if you ask me), Auto Color (it's not bad), and Sharpen (it works well). Now, just click OK and Elements does its thing, totally automated based on the choices you made in this dialog. How cool is that!

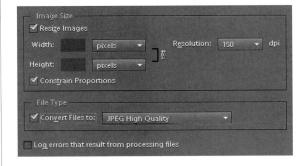

You really have to see this feature in action but, in a nutshell, you can resize one part of your image, while the important parts stay intact. For example, let's say you took a photo of a snowboarder that you want to print out as a 6x4. But when you go to print it, you realize you're going to have to crop it (since the 6x4 aspect ratio is not what your camera shoots in) and cut out a key part of the photo. With the Recompose tool, you can resize the background, without resizing the snowboarder. Like I said, you gotta see it in action.

Resizing Just Parts of Your Image Using the Recompose Tool

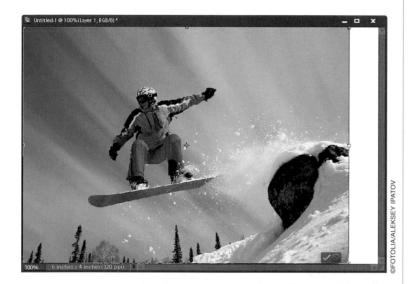

Step One:

One of the things I use the Recompose tool for most is making digital camera images fit in traditional photography sizes (like 8x10", 5x7", 4x6", etc.). You always have to crop the image, or leave white space, when resizing it to fit in one of these standard sizes (as shown here, where I dragged a digital camera image into a 6x4" document and then used Free Transform [Ctrl-T; Mac: Command-T] to position it). When you position it so you see the full image, it leaves a huge gap on the right.

Step Two:

Rather than leaving the gap, most folks try to just resize the photo (again, using Free Transform), so it fills the full 6x4" area, but you can see what happens when you do that—you no longer see the full image as you composed it. In our case—worse yet—it clips off part of the trees at the bottom.

Since the resizing from Step Two doesn't work, we'll go back to what we did in Step One, which at least gives you the full image, as you shot it. You could try just stretching the image by, again, using Free Transform—when the resizing handles appear, grab the right-side handle and drag to the right, as shown here—but that distorts everything and now you have a stretched-looking snow-boarder, so this really isn't an option either for most images.

Step Four:

This is where the Recompose tool comes in handy. Select the Recompose tool from the Toolbox (it's nested with the Crop tool, or just press **C** until you have it). The way the tool works is you tell Elements which areas of the photo you want to make sure it preserves and which areas of the photo are okay to remove/squish/expand/get rid of. This is all done using the four tools at the left end of the Options Bar.

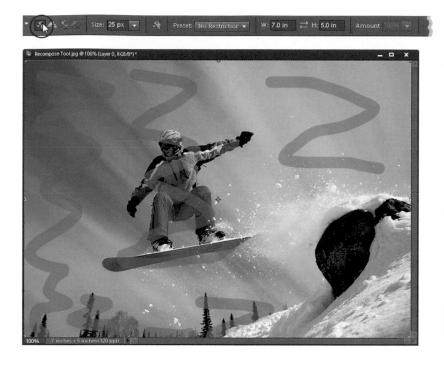

Step Five:

First, switch back over to your original image, then click on the Mark for Protection tool (the first icon on the left), and paint some loose squiggly lines over the areas of the photo you want to make sure Elements protects. These are the important areas that you don't want to see transformed in any way (here I painted over the clouds, the snowboarder, and the trees at the bottom). If you make a mistake and paint on something you didn't want to, just use the tool's corresponding Erase tool to the right of the Mark for Protection tool.

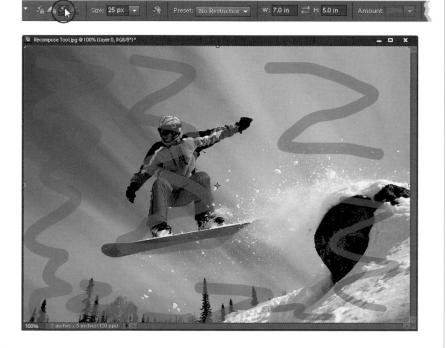

Step Six:

Now you have to tell Elements what parts of the photo are okay to get rid of. Click on the Mark for Removal tool in the Options Bar (the third icon from the left) and paint some lines over the non-essential areas of the photo. No need to go crazy here, a couple of quick brush strokes does just fine.

Step Seven:

Click on the right-middle handle and drag inward, until the Width setting in the top Options Bar reads 6 inches. You'll notice that it changes the appearance of the rock on the right, but not in a way that makes it look unnatural. Now, if you keep dragging inward (beyond what we've dragged here), it will start distorting other parts of the photo, so you can't just drag forever. Luckily, you see a live onscreen preview as you're dragging, so you'll know right away how far you can drag. Next, drag the top-middle handle downward until the Height setting in the Options Bar reads 4 inches. When you've dragged far enough, press the Enter (Mac: Return) key to lock in your change and you've got your 6x4. Now, let's look at another way to use the Recompose tool.

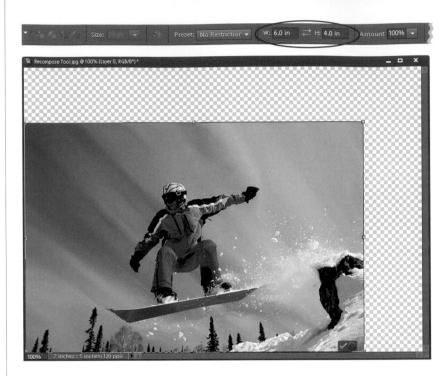

TIP: Use the Preset Pop-Up Menu

The Recompose tool has a Preset popup menu in the Options Bar with some common print sizes, so when you select one of them, it automatically recomposes your photo to that specific size.

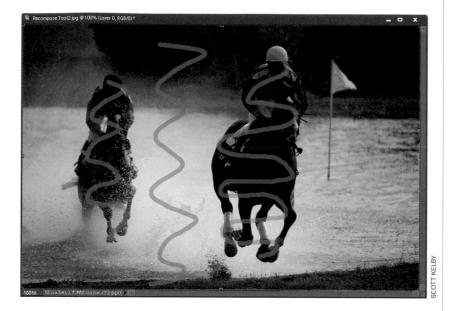

Step Eight:

Since you can make the Recompose tool aware of your subject, you can use it in other ways. For example, let's say you wanted these horses and jockeys to be closer together (this could be for artistic reasons, or maybe you have a photo book or some other layout that needs a smaller image. Choose the Mask for Protection tool in the Options Bar, and paint over the horses and jockeys. Then choose the Mark for Removal tool and paint between them.

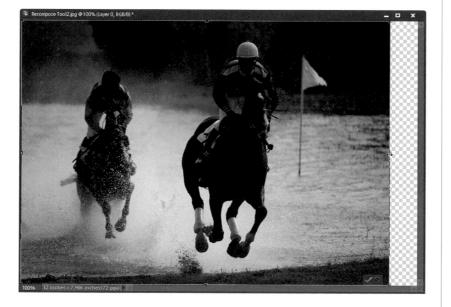

Step Nine:

Now, click on the right-side handle and drag over toward the left to squeeze the photo, bringing the horses and jockeys closer together. Again, Elements does a good job of removing the space between them without making them look like they were squished. As you can see, I can get away with plenty of squeezing here in this example, but even if you can't, I've got a trick for you in the next step.

TIP: Protecting Skin Tones

I wanted to point out another Recompose tool option and that is a button up in the Options Bar with a little person (shown circled here in red). You turn this Highlight Skintones option on when you have people in the photo you're about to resize and it tells the Recompose tool to automatically highlight people's skin tones for protection so they don't get, well, recomposed. Now, Elements will try to avoid those areas. It doesn't always work, but it usually helps.

Step 10:

Press Enter (Mac: Return) to lock in your recomposition, then press the **C** key to switch to the regular Crop tool, and crop away the excess background. Now, if you look closely enough, you'll see the Recompose tool made a jagged line and some deformities between the horses, and in the trees in the background (while it's a bit hard to see this here in print, you should be able to see it better on your computer screen). If this ever happens to you, don't feel like you have to abandon the Recompose tool altogether because of a small area. Instead, we can always try some of the retouching tools to clean that area up.

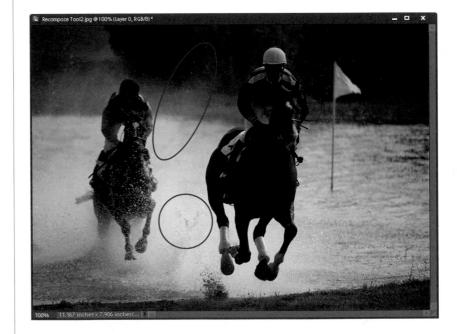

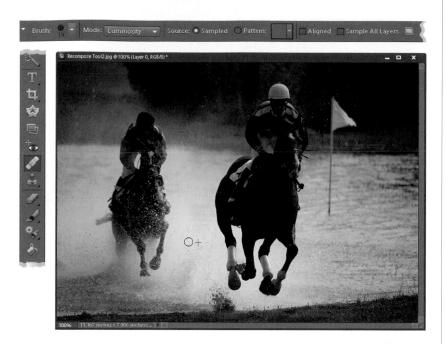

Step 11:

I think the Healing Brush tool will work great here, so go ahead and select it from the Toolbox (or just press J until you have it). In the Options Bar, set the Mode to Luminosity, so we only affect the lightness in the water. Now, Alt-click (Mac: Option-click) in a clear area next to the line in the water and sample from the background. Release the Alt key and paint over that line to remove it. You may need to Alt-click a few times and really zoom in while healing, so you don't sample from either of the horses. Now the horses and jockeys look really close and you've got a smaller image.

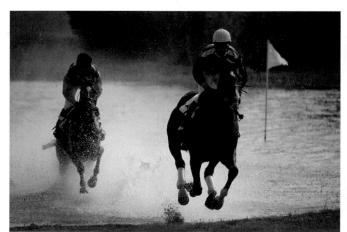

Before

After

Jonas Sees in Color

color correction secrets

As soon as I saw this album title, I knew I had to use it, because my five-year-old daughter is a big fan of the Jonas Brothers (which on some level should make the Jonas Brothers sad, not only because I doubt that their goal was a fan base that still rides a trike, but because by the time she's seven, they will already be "old news" to her, and when I bring up their name, she'll look at me like I'm "forty-a-hundred," which is how old she thinks I am anyway). Anyway, I knew this was a lock for the title, but then I clicked on the album cover, fully expecting to see Kevin, Joe, and Nick Jonas (familiar faces in our home), but instead it was a totally different band. In fact, the name of the band was also Jonas Sees in Color. You see, I "assumed" that because the word Jonas was in there, that it would be the title of a Jonas Brothers album. but that's what happens when you assume (what's that old saying, "When you assume,

that makes a sum of a and e"?). Anyway, I wondered on some level if, with that name. the band was trying to do the same thing with their name that some companies do with their product names, so someone not paying close attention might, for example, buy a Buckstar bag of coffee off the grocer's shelf, when they thought they were buying Starbucks, because of the sound-alike name and the package's similar look and feel. If that were the case, then someone looking to buy a Jonas Brothers song might actually buy one from Jonas Sees in Color, but in this case, it's entirely possible they might like the Jonas Sees in Color songs better (hey, don't bank your career on the attention span of a five-year-old). This got me to thinking, and long story short—that's precisely why I changed my pen name to J. Kelby Rowling, and my next book is titled Harry Porter and the Odor of the Pen Tool.

Before You Color Correct Anything, Do This First!

Okay, before you start along your merry color correcting way, there are a couple of settings that you should consider changing. These settings can definitely affect the results you get, so make sure you read this first. Also, keep in mind that these changes will remain as your defaults until you change them again, so you don't have to do this each time you open Elements.

Step One:

From the Edit menu, choose Color Settings (or press Ctrl-Shift-K [Mac: Command-Shift-K]).

Step Two:

In the Color Settings dialog, choose from the four options: No Color Management, Always Optimize Colors for Computer Screens, Always Optimize for Printing, or Allow Me to Choose. To a large degree, your choice will depend on your final output; but for photographers, I recommend using Always Optimize for Printing because it reproduces such a wide range (a.k.a. gamut) of colors using the Adobe RGB profile (if your photos don't already have a profile assigned), and it's ideal if your photos will wind up in print. Note: For more on color management, see Chapter 11.

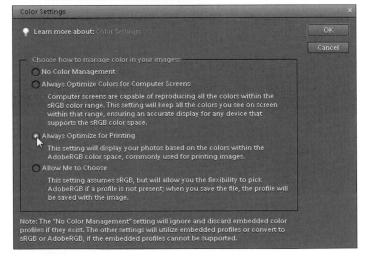

Now we're moving to a completely different area. Press the letter I to switch to the Eyedropper tool. In the Options Bar, the default Sample Size setting for this tool (Point Sample) is fine for using the Eyedropper to steal a color from within a photo and make it your Foreground color. However, Point Sample doesn't work well when you're trying to read values in a particular area (such as flesh tones), because it gives you the reading from just one individual pixel, rather than an average reading of the surrounding area under your cursor.

Step Four:

For example, flesh tones are actually composed of dozens of different colored pixels (just zoom way in and you'll see what I mean); and if you're color correcting, you want a reading that's representative of the area under your Eyedropper, not just a single pixel within that area, which could hurt your correction decisionmaking. That's why you need to go to the Options Bar, under the Sample Size pop-up menu, and choose 3 by 3 Average. This changes the Eyedropper to give you a reading that's the average of 3 pixels across and 3 pixels down in the area that you're sampling. Once you've completed the changes on these two pages, it's safe to go ahead with the rest of the chapter and start color correcting your photos.

The Advantages of Adjustment Layers

Before we really dive into color, we need to spend two minutes with the Adjustments palette. Of all the enhancements in Elements 8, the Adjustments palette was at the top of the list, because it streamlined our workflow so dramatically that even if you had never used adjustment layers before, you had to start working with them. In fact, from this point in the book on, we're going to try to use adjustment layers every chance we get, because of all the advantages they bring. Here's a quick look at them and why we need them:

Advantage One: Undos That Live Forever

By default, Elements keeps track of the last 50 things you've done in the Undo History palette (from the window menu, choose **Undo History** to open it), so if you need to undo a step, or two, or three, etc., you can press Ctrl-Z (Mac: Command-Z) up to 50 times. But, when you close your document, all those undos go away. However, when you make an edit using an adjustment layer (like a Levels adjustment), you can save your image as a layered file (just save it in Photoshop format), and your adjustment layers are saved right along with it. You can reopen that document days, weeks, or even years later, click on that adjustment layer, and either undo or change that Levels (or whatever other one you used) adjustment. It's like an undo that lives forever.

Advantage Two: Built-In Masks

Each adjustment layer comes with a built-in layer mask, so you can easily decide which parts of your photo get the adjustment just by painting. If you want to keep an area of your photo from having the adjustment, just get the Brush tool (B) and paint over it in black. There's more on layer masks to come. They offer tremendous flexibility, and since they don't actually affect the pixels in your image, they're always undoable.

Advantage Three: **Blend Modes**

When you apply an adjustment layer, you get to use the layer blend modes. So if you want a darker version of your adjustment, you can just change the layer blend mode of your adjustment layer to Multiply. Want a brighter version? Change it to Screen. Want to make a Levels adjustment that doesn't affect the skin tone as much? Change it to Luminosity. Sweet!

Advantage Four: **Everything Stays Live**

Back in previous versions of Elements, when you created an adjustment layer (let's say a Levels adjustment layer, for example), it would bring up the floating dialog (like the Levels dialog seen here). While it was onscreen, the rest of Elements was frozen—you couldn't make changes or do anything else until you closed the dialog by either applying your adjustment or clicking Cancel. But thanks to the Adjustments palette, everything stays live—you just go to the Adjustments palette (which will open when you add an adjustment layer) and make your changes there. There is no OK or Apply button, so you can change anything anytime. This will make more sense in the next step.

Step One:

The best way to understand this whole "live" thing is to try it, so go open any photo (it really doesn't matter which one), then click on the Create New Adjustment Layer icon at the bottom of the Layers palette (it's the half-black/ half-white circle) and choose Levels from the pop-up menu to open the Adjustments palette. Rather than bringing up the Levels dialog in front of your image (and freezing everything else), the Adjustments palette displays the Levels controls, so you can make your adjustments while everything stays live—you can adjust your Levels sliders, go up to the Layers palette and change the blend mode of a layer, or paint a few brush strokes, then grab another slider and adjust it. There's no OK button, and again, everything stays live. This is bigger than it sounds (ask anyone who has used an earlier version of Elements).

Step Two:

Let's delete our Levels adjustment layer by clicking-and-dragging it onto the Trash icon at the bottom of the Layers palette, and then let's add a Hue/Saturation adjustment layer by clicking on the Create New Adjustment Layer icon at the bottom of the palette again, but this time choose **Hue/Saturation** from the pop-up menu. When the Hue/Saturation controls appear in the Adjustments palette, drag the Saturation slider all the way over to the left to remove the color, for the look you see here.

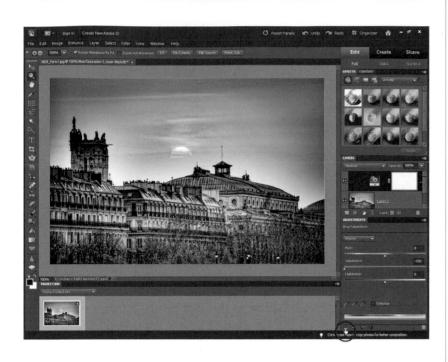

Now, the way adjustment layers work is this: they affect every layer below them. So, if you have five layers below your active layer, all five layers will have their color desaturated like this. However, if you want this adjustment layer to just affect the one single layer directly below the active layer (and not the others), then click on the clipping icon (it's the first icon on the left at the bottom of the Adjustments palette, shown circled here in red). This clips the adjustment layer to the layer directly beneath it and now the adjustment layer will only affect that layer.

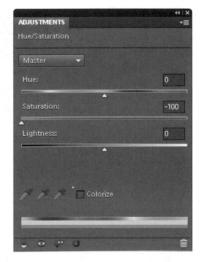

Step Four:

There are a some other options when working with adjustment layers: To edit any adjustment layer you've already created, just click on it once in the Layers palette and its controls will appear in the Adjustments palette. To hide any adjustment layer you've created, click on the Eye icon (either at the bottom of the Adjustments palette, or to the left of the adjustment layer itself in the Layers palette). To reset any adjustment layer controls to their default settings, click the round arrow icon (the fourth from the left) at the bottom of the Adjustments palette. To see a before/after of just your last adjustment layer change, click the icon to the left of the Reset icon.

Photo Quick Fix

Elements' Quick Fix does exactly what it says. It quickly fixes your photos and it's a great tool if you don't have a lot of experience with color correction or fixing lighting and tonal issues. Basically, if you know that something is wrong but you're not sure where to go, then give Quick Fix a try first. As you become more comfortable in Elements, you'll outgrow Quick Fix and want to use Levels and Unsharp Mask and all that cool stuff, but if you're new to Elements, Quick Fix can be a fantastic place to start.

Step One:

Open the photo that needs color correcting (in the example we'll use here, our photo [shown below] needs the works—color correction, more contrast, and some sharpening). So, click on Quick at the top of the Edit tab to go to Quick Fix mode.

Step Two:

The Quick Fix window will show you side-by-side, before-and-after versions of the photo you're about to correct (before on the top or left, after on the bottom or right). To see this view, go to the View pop-up menu at the bottom left of the window and select Before & After (Horizontal or Vertical). To the right of your side-by-side preview is a group of nested palettes offering tonal and lighting fixes you can perform on your photo. Start with the Smart Fix palette at the top. Click the Auto button and Smart Fix will automatically analyze the photo and try to balance the overall tone (adjusting the shadows and highlights), fixing any obvious color casts while it's at it. In most cases, this feature does a surprisingly good job. There's also a Fix slider within Smart Fix that you can use to increase (or decrease) the effect of the Smart Fix.

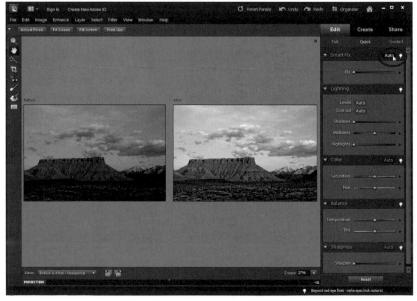

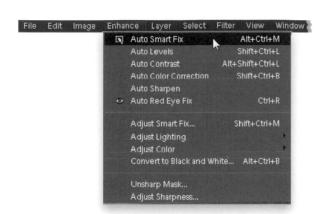

TIP: Auto Smart Fix

By the way, you can also access the Auto Smart Fix command without entering Quick Fix mode by going under the Enhance menu and choosing Auto Smart Fix (or just press the keyboard shortcut Ctrl-Alt-M [Mac: Command-Option-M]). However, there are two advantages to applying the Smart Fix here in Quick Fix mode: (1) you get the Fix slider, which you don't get by just applying it from the menu or the shortcut; and (2) you get a side-by-side, before-and-after preview so you can see the results as you're making your edits. So if it turns out that you need additional fixes (or Smart Fix didn't work as well as you'd hoped), you're already in the right place.

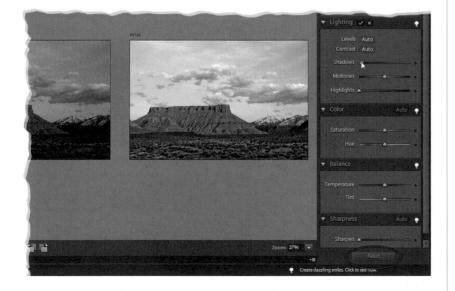

Step Three:

If you apply Smart Fix and you're not happy with the results, don't try to stack more "fixes" on top of that instead, click the Reset button that appears at the bottom of the Palette Bin to reset the photo to how it looked when you first entered Quick Fix mode. If the color in your photo looks a little flat and needs more contrast, try the Levels Auto button, found in the Lighting palette (the second palette down). I generally stay away from Auto Contrast, as Auto Levels seems to do a better job. There's another very powerful tool in this palette—the Shadows slider. Drag it to the right a little bit, and watch how it opens up the dark shadow areas in your photo (mainly in the rock and ground here). When you're done with the slider, click the Commit check mark in the palette header.

Step Four:

You'll notice a right-facing arrow to the right of each slider in Quick Fix. Just click on an arrow and a group of thumbnails will appear below the slider. As you hover your cursor over each thumbnail, you'll see a preview of your image with that setting, so you don't have to drag the slider back and forth. If you like one, but want just a little more (or less) of the setting, click-and-drag from side to side on a thumbnail to move the slider in increments of 1. This lets you adjust each setting in a more visual (and sometimes precise) way. Now, on to more Quick Fixing.

Step Five:

The next palette down, Color, has an Auto button that (surprisingly enough) tries to remove color casts and improve contrast like Smart Fix and Levels do, but it goes a step further by including a midtones correction that can help reduce color casts in the midtone areas. Hit the Reset button to remove any corrections you've made up to this point, and then try the Auto button in the Color palette. See if the grays in the photo don't look grayer and less red. In fact, with this photo, everything looks cooler and less red. Here's the thing, though: just because it looks cooler doesn't mean that it's right. Elements is just trying to neutralize the photo. In this case, I personally like the warmer feel, but it's a creative choice by you at this point. The Saturation and Hue sliders here are mostly for creating special color effects (try them and you'll see what I mean). You can pretty much ignore these sliders unless you want to get "freaky" with your photos. In the Balance palette, the Temperature and Tint sliders will let you manually remove color casts, but honestly, the Auto button in the Color palette is probably going to be your best bet.

Step Six:

After you've color corrected your photo (using the Auto buttons and the occasional slider), the final step is to sharpen your photo (by the way, to maintain the best quality, this should be the final step—the last thing you do in your correction process). Just click the Auto button in the Sharpness palette and watch the results. If the photo isn't sharp enough for you, drag the Sharpen slider to the right to increase the amount of sharpening, but be careful—oversharpening can ruin the photo by becoming too obvious, and it can introduce color shifts and "halos" around objects.

Step Seven:

There are a few other things you can do while you're here (think of this as a one-stop shop for quickly fixing images). Below the Preview area are icons you can click to rotate your photo (this photo doesn't need to be rotated, but hey, ya never know). In the Toolbox on the left, there's a Red Eye Removal tool, if your photo needs it. Just click-anddrag over the problem area in your After preview for red-eye control. The Toolbox also has tools for whitening teeth, making skies blue, and making your photo black and white, but you'll probably find you like other techniques shown in this book for those tasks better. You know what the Zoom and Hand tools do (they zoom you in, and then move you around), and you can also crop your photo by using the Crop tool within the After preview, so go ahead and crop your photo down a bit, if needed. Lastly, you can make a selection with the Quick Selection tool.

Step Eight:

Okay, you've color corrected, fixed the contrast, sharpened your image, and even cropped it down to size (if it needed it). So how do you leave Quick Fix mode and return to the regular Elements Editor? Just click on Full at the top of the Edit tab (the same area you went to, to get into Quick Fix mode). It basically applies all the changes to your photo and returns you to the normal editing mode.

Before

After

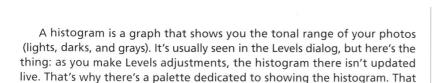

means you can have it open while you're making adjustments to your photos

and get a live reading of how your histogram is looking while you edit.

Getting a Visual Readout (Histogram) of Your Corrections

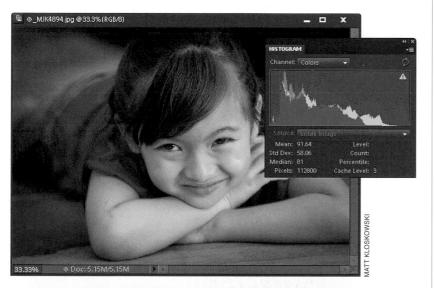

Step One:

Open the photo that needs a tonal adjustment. Now, go under the Window menu and choose **Histogram** to open the Histogram palette. (By the way, this palette is only available in Elements' Full Edit mode—not in Quick Fix mode.)

Step Two:

Go under the Enhance menu and choose **Auto Smart Fix**. Take a look in the Histogram palette and you'll see how the Auto Smart Fix command affected the photo's histogram. Note: If you see a small symbol in the upper right-hand corner of the graph that looks like a tiny yellow yield sign with an exclamation point in it (as seen in Step One), that's a warning that the histogram you're seeing is not a new histogram—it's a previous histogram cached from memory. To see a fresh histogram, click directly on that warning symbol and a new reading will be generated based on your current adjustment.

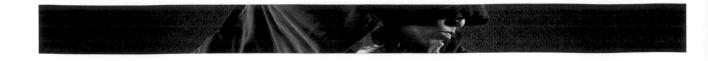

Color Correcting Digital Camera Images

Ever wonder why the term "color correction" gets thrown around so much? That's because every digital camera (and even most scanners used for capturing traditional photos) puts its little signature (i.e., color cast) on your photos. Most times it's a red cast, but it can also be blue or green. Don't get me wrong—they are getting better, but the color cast is still there. Here's how to help combat those color problems in Elements:

Step One:

Open the digital camera photo you want to color correct.

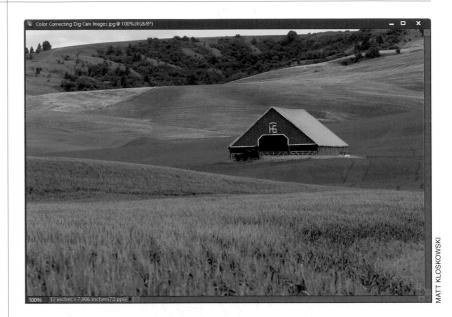

Step Two:

Go under the Enhance menu, under Adjust Lighting, and choose **Levels** (or press **Ctrl-L [Mac: Command-L]**). The dialog may look intimidating at first, but the technique you're going to learn here requires no previous knowledge of Levels, and it's so easy, you'll be correcting photos using Levels immediately.

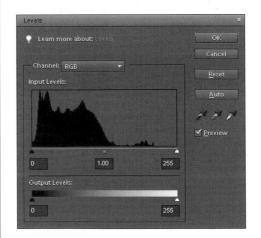

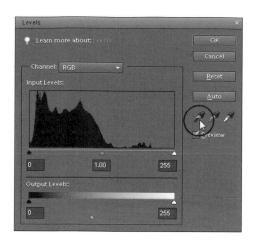

First, we need to set some preferences in the Levels dialog so we'll get the results we're after when we start correcting. We'll start by setting a target color for our shadow areas. To set this preference, in the Levels dialog, double-click on the black Eyedropper tool (it's on the right-hand side of the dialog, the first Eyedropper from the left). A Color Picker will appear asking you to "Select target shadow color." This is where we'll enter values that, when applied, will help remove any color casts your camera introduced in the shadow areas of your photo.

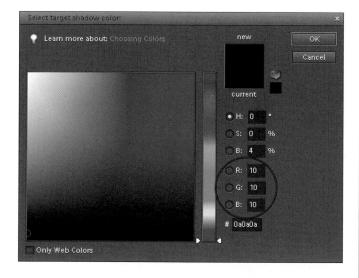

Step Four:

We're going to enter values in the R, G, and B (red, green, and blue) fields of this dialog.

For R, enter 10 For G, enter 10 For B, enter 10

TIP: Tab to Change Fields

To move from field to field, just press the **Tab key**.

Then click OK. Because these figures are evenly balanced (neutral), they help ensure that your shadow areas won't have too much of one color (which is exactly what causes a color cast—too much of one color).

Step Five:

Now we'll set a preference to make our highlight areas neutral. Double-click on the highlight Eyedropper (the third of the three Eyedroppers in the Levels dialog). The Color Picker will appear asking you to "Select target highlight color." Enter these values:

For R, enter 240 For G, enter 240 For B, enter 240

Then click OK to set those values as your highlight target.

Step Six:

Finally, set your midtone preference. You know the drill—double-click on the midtones Eyedropper (the middle of the three Eyedroppers) so you can "Select target midtone color." Enter these values in the R, G, and B fields (if they're not already there by default):

For R, enter 128 For G, enter 128 For B, enter 128

Then click OK to set those values as your midtone target.

Step Seven:

Okay, you've entered your preferences (target colors), so go ahead and click OK in the Levels dialog (without making any changes to your image). You'll get an alert dialog asking you if you want to "Save the new target colors as defaults?" Click Yes, and from that point on, you won't have to enter these values each time you correct a photo, because they'll already be entered for you—they're now the default settings.

Step Eight:

You're going to use these Evedropper tools that reside in the Levels dialog to do most of your correction work. Your job is to determine where the shadow. midtone, and highlight areas are, and click the right Eyedropper in the right place (you'll learn how to do that in just a moment). So remember your job find the shadow, midtone, and highlight areas and click the right Eyedropper in the right spot. Sounds easy, right? It is. You start by opening Levels again, and setting the shadows first, so you'll need to find an area in your photo that's supposed to be black. If you can't find something that's supposed to be the color black, then it gets a bit trickierin the absence of something black, you have to determine which area in the image is the darkest. If you're not sure where the darkest part of the photo is, you can use the following trick to have Elements tell you exactly where it is.

Step Nine:

Go to the bottom of the Layers palette and click on the half-black/half-white circle icon to bring up the Create New Adjustment Layer pop-up menu. When the pop-up menu appears, choose **Threshold**, which brings up the Adjustments palette with a histogram and a slider.

Step 10:

In the Adjustments palette, drag the Threshold Level slider under the histogram all the way to the left. Your photo will turn completely white. Slowly drag the slider back to the right, and as you do, you'll start to see some of your photo reappear. The first area that appears is the darkest part of your image. That's it—that's Elements telling you exactly where the darkest part of the image is. Now that you know where your shadow area is, make a mental note of its location. Next, find a white area in your image.

Step 11:

If you can't find an area in your image that you know is supposed to be white, you can use the same technique to find the highlight areas. With the Adjustments palette still open, drag the slider all the way to the right. Your photo will turn black. Slowly drag the slider back toward the left, and as you do, you'll start to see some of your photo reappear. The first area that appears is the lightest part of your image. Make a mental note of this area, as well (yes, you have to remember two things, but you have to admit, it's easier than remembering two PINs). You're now done with Threshold, so in the Layers palette, just click-and-drag the Threshold adjustment layer onto the Trash icon at the bottom of the palette, because you don't actually need it anymore.

Step 12:

Press Ctrl-L (Mac: Command-L) to bring up the Levels dialog again. First, select the shadow Eyedropper (the one halffilled with black) from the right side of the Levels dialog. Move your cursor outside the Levels dialog into your photo and click once in the area that Elements showed you was the darkest part of the photo (in Step 10). When you click there, you'll see the shadow areas correct. (Basically, you just reassigned the shadow areas to your new neutral shadow color—the one you entered earlier as a preference in Step Four.) If you click in that spot and your photo now looks horrible, you either clicked in the wrong spot or what you thought was the shadow point actually wasn't. Undo the setting of your shadow point by clicking the Reset button in the dialog and try again. If that doesn't work, don't sweat it; just keep clicking in areas that look like the darkest part of your photo until it looks right.

Step 13:

While still in the Levels dialog, click on the highlight Eyedropper (the one half-filled with white). Move your cursor over your photo and click once on the lightest part (the one you committed to memory in Step 11) to assign that as your highlight. You'll see the highlight colors correct.

Step 14:

Now that the shadows and highlights are set, you'll need to set the midtones in the photo. It may not look as if you need to set them, because the photo may look properly corrected, but chances are there's a cast in the midtone areas. You may not recognize the cast until you've corrected it and it's gone, so it's worth giving it a shot to see the effect (which will often be surprisingly dramatic). Unfortunately, there's no Threshold adjustment layer trick that works well for finding the midtone areas, so you have to use some good old-fashioned guesswork (or try "Dave's Amazing Trick for Finding a Neutral Gray" next in this chapter). Ideally, there's something in the photo that's gray, but not every photo has a "gray" area, so look for a neutral area (one that's obviously not a shadow, but not a highlight either). Click the middle (gray) Eyedropper in that area. If it's not right, click the Reset button and repeat Steps 12 through 14.

Step 15:

There's one more important adjustment to make before you click OK in the Levels dialog and apply your correction. Under the histogram (that's the black mountain-range-looking thing), click on the center slider (the Midtone Input Levels slider—that's why it's gray) and drag it to the right a bit to darken the midtones of the image. This is a visual adjustment, so it's up to you to determine how much to adjust, but it should be subtle—just enough to bring out the midtone detail. When it looks right to you, click OK to apply your correction to the highlights, midtones, and shadows, removing any color casts and brightening the overall contrast.

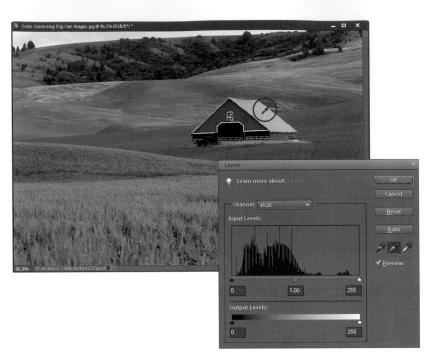

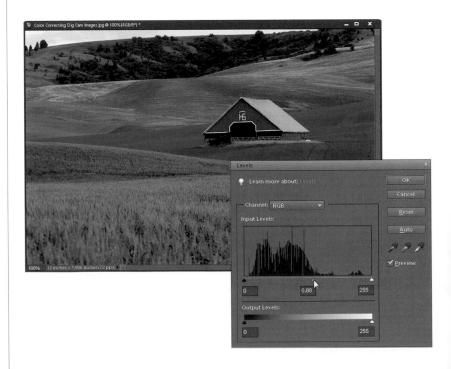

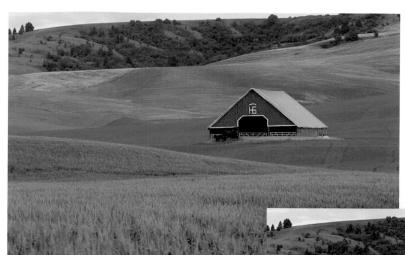

Before

After

Dave's Amazing Trick for Finding a Neutral Gray

If you read the previous tutorial and are saying to yourself, "But what about that middle gray eyedropper? How do I accurately set that point?" you're not alone. It has always been kind of tricky actually, but Dave Cross, Lead Instructor for the National Association of Photoshop Professionals (NAPP) and one of the Photoshop Guys, showed us this amazing trick. Being the friendly Canadian that he is, he even offered to let us include it in the book so everyone else can see it, as well.

Step One:

Open any color photo and click on the Create a New Layer icon at the bottom of the Layers palette to create a new blank layer. Then, go under the Edit menu and choose **Fill Layer**. When the Fill Layer dialog appears, in the Contents section, from the Use pop-up menu, choose **50% Gray**, and then click OK to fill your new layer with (you guessed it) 50% gray.

Step Two:

Now, go to the Layers palette and change the blend mode pop-up menu to **Difference**. Changing this layer's blend mode to Difference doesn't do much for the look of your photo (in fact, it rarely does), but just remember—it's only temporary.

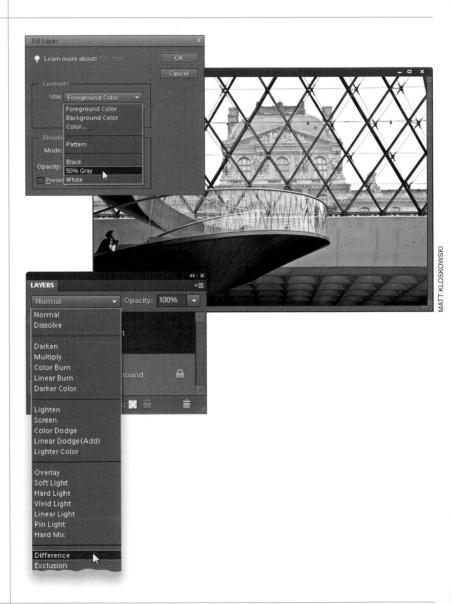

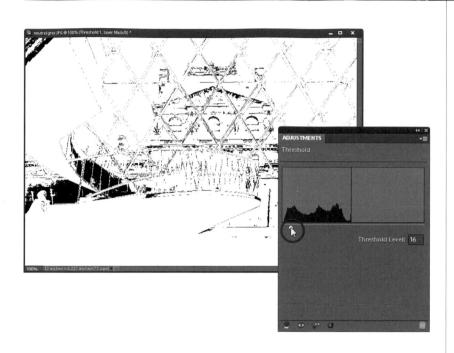

Choose **Threshold** from the Create New Adjustment Layer pop-up menu at the bottom of the Layers palette. When the Adjustments palette appears, drag the slider all the way to the left (your photo will turn completely white). Now, slowly drag the slider back to the right, and the first areas that appear in black are the neutral midtones. Make a mental note of where those grav areas are, and then click-and-drag the Threshold adjustment layer onto the Trash icon at the bottom of the palette, because you no longer need it. (In the example shown here, there are neutral midtones to the right of the woman in the bottom left of the image.)

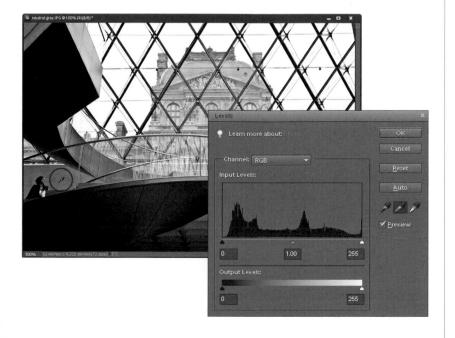

Step Four:

Now that you know where your midtone point is, go back to the Layers palette and drag the 50% gray layer onto the Trash icon (it's also done its job, so you can get rid of it, too). You'll see your full-color photo again. Now, press Ctrl-L (Mac: Command-L) to open Levels, get the midtones Eyedropper (it's the middle Eyedropper), and click directly on one of the neutral areas. That's it; you've found the neutral midtones and corrected any color within them. So, will this work every time? Almost. It works most of the time, but you will run across photos that just don't have a neutral midtone, so you'll have to either not correct the midtones or go back to what we used to do—guess.

Studio Photo Correction Made Simple

If you're shooting in a studio—whether it's portraits or products—there's a technique you can use that makes the color correction process so easy that you'll be able to train laboratory test rats to correct photos for you. In the back of this book, we've included a color swatch card (it's perforated so you can easily tear it out). After you get your studio lighting set the way you want it, and you're ready to start shooting, put this swatch card into your shot (just once) and take the shot. What does this do for you? You'll see.

Step One:

When you're ready to start shooting and the lighting is set the way you want it, tear out the swatch card from the back of this book and place it within your shot (if you're shooting a portrait, have the subject hold the card for you), and then take the shot. After you've got one shot with the swatch card, you can remove it and continue with the rest of your shoot.

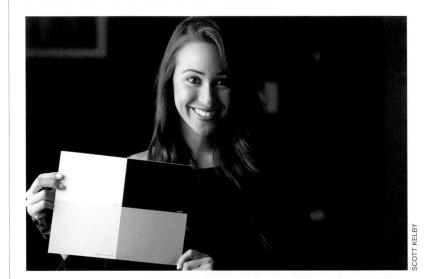

Step Two:

When you open the first photo taken in your studio session, you'll see the swatch card in the photo. By having a card that's pure white, neutral gray, and pure black in your photo, you no longer have to try to determine which area of your photo is supposed to be black (to set the shadows), which area is supposed to be gray (to set the midtones), or which area is supposed to be white (to set the highlights). They're right there in the card. Note: We've even included a Camera Raw White Balance swatch if you're working with RAW files. See "The Essential Adjustments: White Balance" in Chapter 2 for more info.

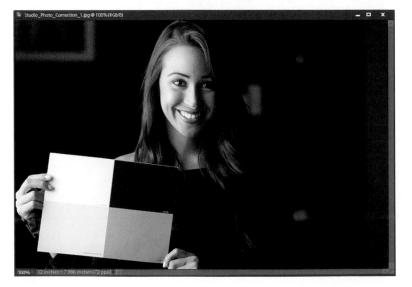

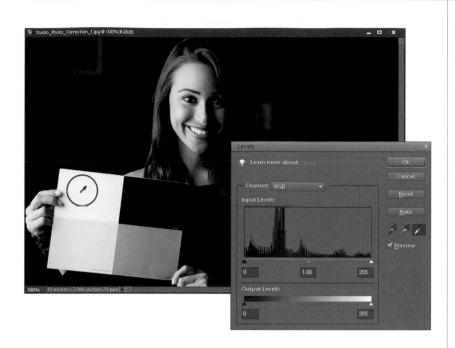

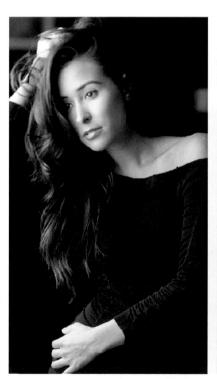

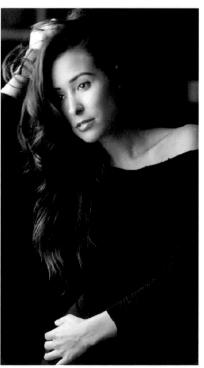

Before

After

Press Ctrl-L (Mac: Command-L) to bring up the Levels dialog. Click the black Eyedropper on the black panel of the card (to set shadows), the middle Eyedropper on the gray panel (for midtones), and the white Eyedropper on the white panel (to set the highlights), and the photo will nearly correct itself. No guessing, no using Threshold adjustment layers to determine the darkest areas of the image—now you know exactly which part of that image should be black and which should be white.

Step Four:

If you'd like to still use this photo, then get the Crop tool (C) and crop the card out of the image. However, the more likely situation is that you don't want to use this photo (since it does have a big card in it), but you'd like to apply this color correction to some other photos, as I've done here. Well, now that you have the Levels settings for the first image, you can correct the rest of the photos using the same settings. Just open the next photo and press Ctrl-Alt-L (Mac: Command-Option-L) to apply the exact same settings to this photo that you did to the swatch card photo.

TIP: Try a Color Checker Chart
If you want to take this process a
step further, many professionals use
a Munsell ColorChecker color-swatch
chart (from X-Rite; www.xrite.com),
which also contains a host of other
target colors. It's used exactly the
same way: just put the chart into
your photo, take one shot, and then
when you correct the photo, each
color swatch will be in the photo,
just begging to be clicked on.

Adjusting Flesh Tones

So what do you do if you've used Levels to properly set the highlights, midtones, and shadows, but the flesh tones in your photo still look too red? You can try this guick trick for getting your flesh tones in line by removing the excess red. This one small adjustment can make a world of difference.

Step One:

Open a photo that needs red removed from the flesh tones. If the whole image appears too red, skip this step and move on to Step Three. However, if just the flesh-tone areas appear too red, get the Quick Selection tool (A) and click on all the flesh-tone areas in your photo. (Press-and-hold the Alt [Mac: Option] key to remove any areas that were selected that shouldn't have been. such as the clothes and hair.)

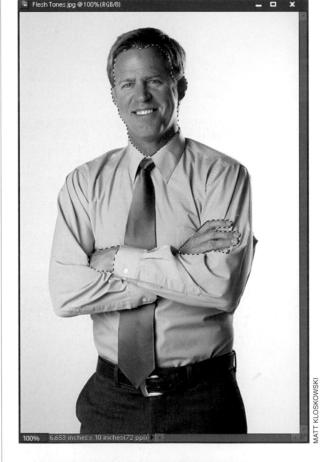

Step Two:

Go under the Select menu and choose Feather. Enter a Feather Radius of about 3 pixels, then click OK. By adding this feather, you're softening the edges of your selection, preventing a hard, visible edge from appearing around your adjustments.

Click on the Create New Adjustment Layer icon at the bottom of the Layers palette, and choose **Hue/Saturation** from the pop-up menu. Then, in the Adjustments palette, click on the pop-up menu near the top and choose **Reds**, so you're only adjusting the reds in your photo (or in your selected areas if you put a selection around the flesh tones).

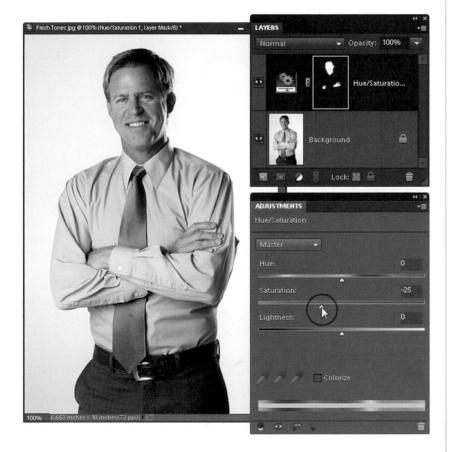

Step Four:

The rest is easy—you're simply going to reduce the amount of saturation so the flesh tones appear more natural. Drag the Saturation slider to the left to reduce the amount of red (I moved mine to -25, but you may have to go further to the left, or not as far, depending on how red your skin color is). The changes are live, so you'll be able to see the effect of reducing the red as you lower the Saturation slider. Also, if you made a selection of the flesh-tone areas, once you create the adjustment layer, it will hide the selection border from view and create a layer mask with your selection. When the flesh tones look right, you're done.

Before After

Warming Up (or Cooling Down) a Photo

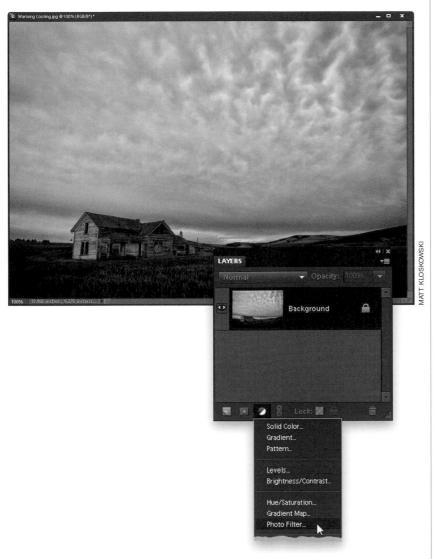

Step One:

Open the photo that needs cooling down (or warming up). In the example shown here, the photo is too warm and has a yellowish tint, so we want to cool it down and make it look more natural. Go to the Layers palette and choose **Photo Filter** from the Create New Adjustment Layer pop-up menu at the bottom of the palette (its icon looks like a half-black/half-white circle).

Step Two:

When the Photo Filter controls appear in the Adjustments palette, choose Cooling Filter (82) (or choose a Warming Filter if your image is too cool) from the Filter pop-up menu (this approximates the effect of a traditional screw-on lens filter). If the effect is too cool for you, drag the Density slider to the left to warm the photo up a little. I dragged mine to 18%.

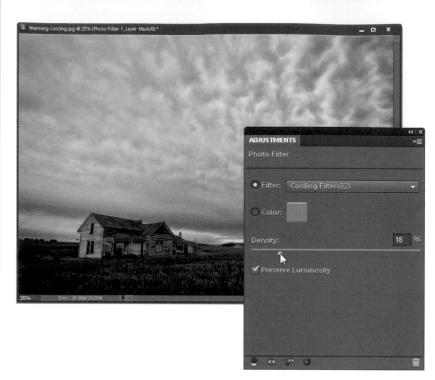

Step Three:

Because this Photo Filter is an adjustment layer, you can edit where the cooling is applied, so press B to switch to the Brush tool. In the Options Bar, click on the brush thumbnail and choose a soft-edged brush in the Brush Picker. Then, press X to make black your Foreground color, and begin painting over any areas that you don't want to be cool (for example, if you wanted to keep the warmth in the field and house in the foreground, you'd paint over those areas). The original color of the image will be revealed wherever you paint.

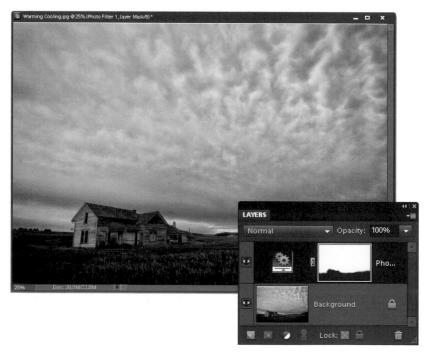

Color Correcting One Problem Area Fast!

Step One:

Open the image that has an area of color you would like to enhance, such as the sky.

Step Two:

Go to the bottom of the Layers palette and choose **Hue/Saturation** from the Create New Adjustment Layer pop-up menu (it's the half-black/half-white circle icon). A new layer named "Hue/Saturation 1" will be added to your Layers palette and the Hue/Saturation controls will appear in the Adjustments palette. (*Note:* If you prefer using the Smart Brush tool [covered in Chapter 5], you'll find it has a Blue Skies option that also works pretty well in cases like this.)

From the pop-up menu at the top of the Adjustments palette, choose the color that you want to enhance (Blues, Reds, etc.), then drag the Saturation slider to the right. You might also choose Cyans, Magentas, etc., from the pop-up menu and do the same thing drag the Saturation slider to the right, adding even more color, until your image's area looks as enhanced as you'd like it. In the example here, I increased the saturation of the Blues to 51.

Step Four:

Your area is now colorized, but so is everything else. That's okay; you can fix that easily enough. Press the letter X to set your Foreground color to black, then press Alt-Backspace (Mac: Option-Delete) to fill the Hue/Saturation layer mask with black. Doing this removes all the color that you just added, but now you can selectively add (actually paint) the color back in where you want it.

Step Five:

Press the letter B to switch to the Brush tool. In the Options Bar. click on the brush thumbnail, and in the Brush Picker, choose a large, softedged brush. Press X again to toggle your Foreground color to white, and begin painting over the areas where you want the color enhanced. As you paint, the version of your enhanced photo will appear. For well-defined areas, you may have to go to the Brush Picker again in the Options Bar to switch to a smaller, hard-edged brush.

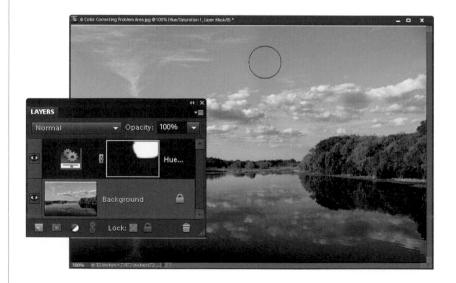

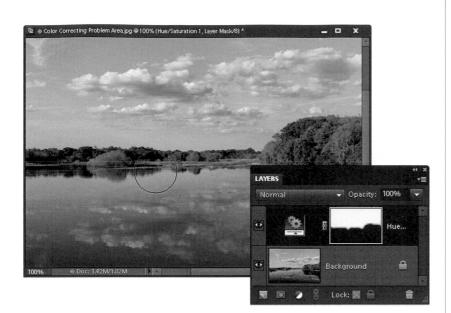

TIP: Fixing Mistakes

If you make a mistake and paint over an area you shouldn't have (like the trees in the background)—no problem—just press **X** again to toggle your Foreground color to black and paint over the mistake—it will disappear. Then, switch back to white and continue painting. When you're done, the colorized areas in your photo will look brighter.

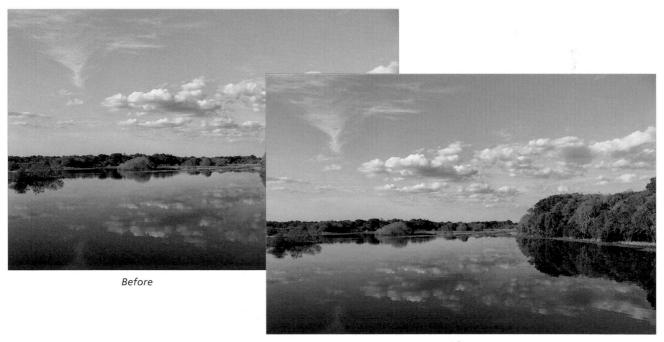

After

and White

I've run into a lot of digital photographers that use the Remove Color function or change the mode to Grayscale in Elements to convert from color to black and white. Nearly every single one of them is disappointed with the results. That's because Elements simply removes the color from the photo and leaves a very bland looking black-and-white image. Plus, there are no settings, so you can't customize your black-and-white photo in any way. Here's a great technique that creates a better black and white and gives you plenty of control to really customize the way it looks.

Step One:

Open the color photo you want to convert to black and white. Press **D** to set your Foreground and Background to the default black and white.

Step Two:

To really appreciate this technique, it wouldn't hurt if you went ahead and did a regular conversion to black and white, just so you can see how lame it is. Go under the Image menu, under Mode, and choose **Grayscale**. When the "Discard color information?" dialog appears, click OK, and behold the somewhat lame conversion. Now that we agree it looks pretty bland, press **Ctrl-Z** (**Mac: Command-Z**) to undo the conversion, so you can try something better.

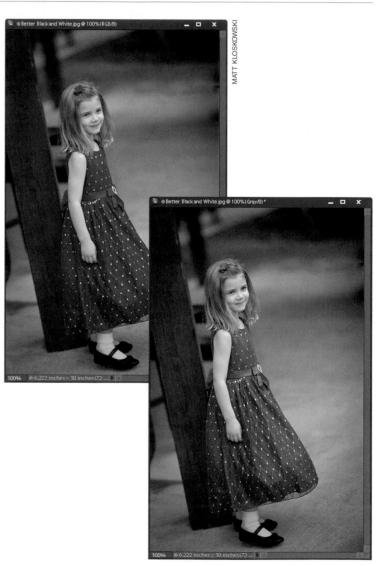

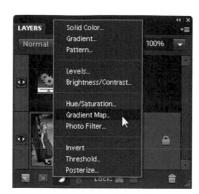

ADJUSTMENTS Gradient Map Dither Reverse

Step Three:

Go to the bottom of the Layers palette and choose **Levels** from the Create New Adjustment Layer pop-up menu (it's the half-black/half-white circle icon). The Levels controls will appear in the Adjustments palette and a new layer will be added to your Layers palette named "Levels 1." Press **X** to set your Foreground color to black, then go to the bottom of the Layers palette and choose **Gradient Map** from the Create New Adjustment Layer pop-up menu. This brings up the Gradient Map options in the Adjustments palette.

Step Four:

Just choosing Gradient Map gives you a black-and-white image (and doing just this, this one little step alone, usually gives you a better black-and-white conversion than just choosing Grayscale from the Mode submenu. Freaky, I know). If you don't get a black-towhite gradient, it is because your Foreground and Background colors were not set at their defaults. Click-and-drag the Gradient Map adjustment layer onto the Trash icon at the bottom of the palette, press D, then add your Gradient Map adjustment layer again. This adds another layer to the Layers palette (above your Levels 1 layer) named "Gradient Map 1."

Step Five:

In the Layers palette, click on the Levels 1 layer to bring up the Levels controls in the Adjustments palette again. In the pop-up menu at the top of the palette, you can choose to edit individual color channels (kind of like you would with Photoshop's Channel Mixer). Choose the **Red** color channel.

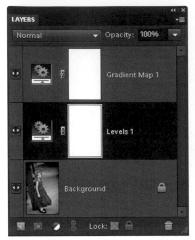

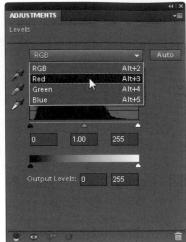

Step Six:

You can now adjust the Red channel, and you'll see the adjustments live onscreen as you tweak your black-and-white photo. (It appears as a black-and-white photo because of the Gradient Map adjustment layer above the Levels 1 layer. Pretty sneaky, eh?) You can drag the middle gray midtone Input Levels slider to the left to open the shadowy areas, especially in the skin, as shown here.

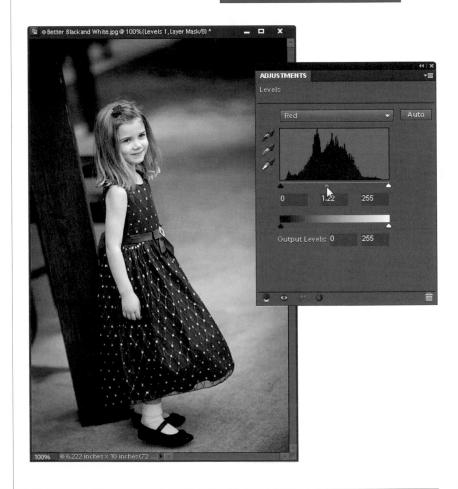

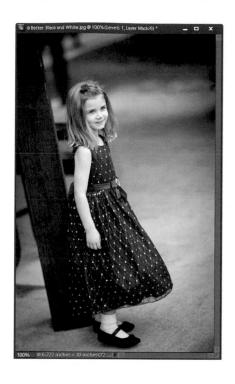

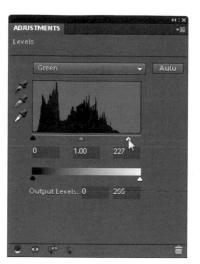

Step Seven:

Now, switch to the **Green** channel in the pop-up menu at the top of the Adjustments palette. You can make adjustments here, as well. Try increasing the highlights in the Green channel by dragging the white highlight Input Levels slider to the left, as shown here.

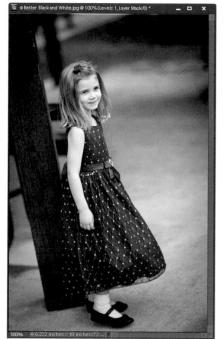

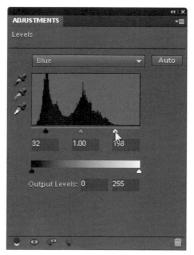

Step Eight:

Now, choose the **Blue** channel from the pop-up menu, and try increasing the highlights quite a bit and the shadows just a little by dragging the Input Levels sliders (the ones below the histogram that we've been using). These adjustments are not standards or suggested settings for every photo; I just experimented by dragging the sliders, and when the photo looked better, I stopped dragging. When the blackand-white photo looks good to you (good contrast, and good shadow and highlight details), just stop dragging.

Step Nine:

To complete your conversion, go to the Layers palette, click on the flyout menu at the top right, then choose **Flatten Image** to flatten the adjustment layers into the Background layer. Although your photo looks like a blackand-white photo, technically, it's still in RGB mode, so if you want a grayscale file, go under the Image menu, under Mode, and choose **Grayscale**.

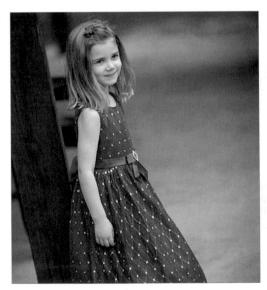

After (awesome adjustment layers conversion)

Users of the full professional version of Adobe Photoshop have had the benefit of using Curves since version 1, and it's the pros' choice for color correction without a doubt. There's only one problem—it's a bit hard for most folks to master. That's why you'll fall in love with the Color Curves adjustment—it makes using Curves so easy, it will actually make pro users of Photoshop jealous. Adobe has done a really brilliant job of giving us the power of Curves without the hassles and steep learning curve. Life is good.

Correcting Color and Contrast Using Color Curves

Step One:

Open the photo you want to adjust with Color Curves (a typical situation might be a photo that lacks contrast or has an obvious color cast, but in reality most photos can benefit from a short trip to Color Curves, so don't just save it for really messed up photos). Then go under the Enhance menu, under Adjust Color, and choose **Adjust Color Curves** (as shown here).

Step Two:

When the Adjust Color Curves dialog first appears, you've got two options for using it. First there's the simple fix (I know, it's not the official name, but it's what we call it). This simple fix lets you simply select what you'd like to do with your photo from a list of choices on the bottom-left side of the dialog (you can compare the before and after views to see if you're happy with the changes). Just click on a choice in the Select a Style list and it applies a color curve for you. Easy enough, right? (By the way, don't click on Solarize unless you've had a few glasses of Merlot first.) Note: You can only apply one curve at a time. If you want to apply more than one style adjustment, click OK, then reopen the Adjust Color Curves dialog and select another adjustment to add it.

So, you might get lucky and find a choice that works great for you right off the bat. Your photo will look better, and life will be good. However, to reveal the real power of these curves, you'll need to go to Adjust Sliders at the bottom right of the dialog. That's where you'll see four sliders and the curve itself. Now, as you drag the sliders, you'll see how the curve is affected. For example, drag the Adjust Highlights slider to the right, and you'll see the top-right curve point move upward. That's because the highlights are controlled by that upper-right point.

Step Four:

The center point represents the midtones in your photo. Try dragging the Midtone Brightness slider to the right, and look over at the curve. See how the center point moves upward? Now, drag the Midtone Contrast slider to the left, and watch how the contrast increases. Anytime you make the curve steeper, it adds contrast to your photo, but you don't want it to get too steep, or your photo will lose quality. Lastly, drag the Adjust Shadows slider to the left. Notice how the shadow point on the curve (the far-left point) moves downward, darkening the shadow area. These sliders make it easy to adjust the tone and contrast in your photo without having to manually move points on the curve (like you do in the pro version of Photoshop).

Step Five:

Now, let's click the Reset button and start over from scratch. Let's fix the problem photo we have here, using nothing but Adjust Color Curves. First, let's start with the preset styles and see if any of them look better than our current photo. To me, the Increase Contrast style looks better than the original photo, so go ahead and click on that. It makes a great starting point for our correction.

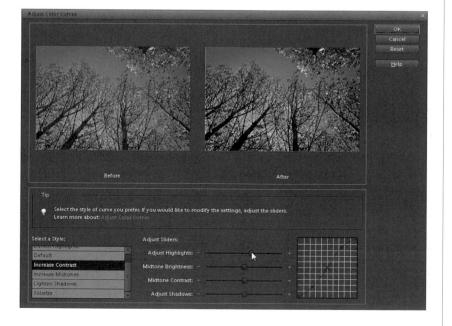

Step Six:

Okay, here's the problem (at least as I see it). Although we increased the contrast, and I think the photo certainly looks better than it did, it seems a little dark, and it looks like it's lacking highlights. So, drag the Adjust Highlights slider over to the right a little bit and see how that looks. Now, to me, that looks better (but hey, that's just me. There is no official government agency that determines whether your photo has enough highlights or not, so the choice is really up to you—the photographer). In fact, since it's up to you (or me, in this case), I think I might even drag it a little farther to the right, to really open up the highlights.

Step Seven:

Now, if it were me (and it is, by the way), I'd then drag the Midtone Contrast slider to the right a bit to add more contrast in the midtones. I won't do this for every photo, but for this photo, it seems to look better. That's the great thing about these sliders you can drag one to the left, and if your photo looks better, then great. If it doesn't, drag it to the right and see how that looks. If it looks better when you drag it to the right, then great. If not, drag it back to the center and leave it alone. In this case, I dragged both ways, and I like the way the midtone contrast looked when I had the slider dragged to the right a bit, so that's where I'm leaving it.

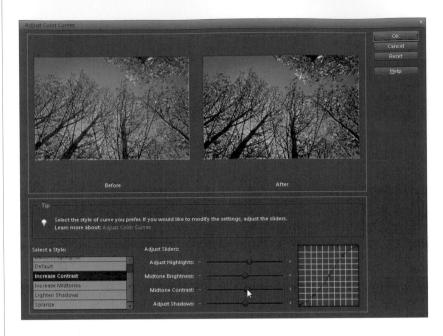

Step Eight:

My final two tweaks are to drag the Midtone Brightness slider to the left, then the right, to see which one looks better. I like the way it looks when I drag it to the left, so to the left it stays. I know this sounds like a really simplistic way to adjust your photos, but it's deeper than you think. If you drag a slider in either direction, and your photo looks better, then how could that be wrong? Lastly, let's drag the Adjust Shadows slider. Dragging just a little bit to the left seemed to make the shadow areas darker, while dragging it to the right made them look washed out. So, needless to say, I left it a little to the left. If you look at the curve itself, you'll see the classic "S" shape (known as the "S" curve), which is pretty common in curve correction, as that shape adds contrast and helps to make colors rich and saturated. So, in short, don't be afraid to slide those sliders.

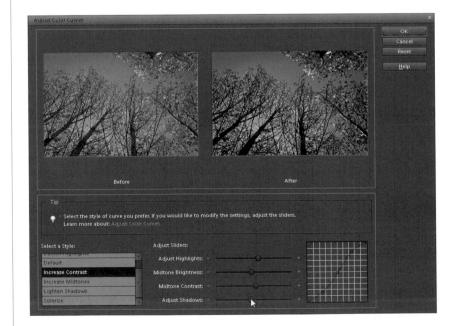

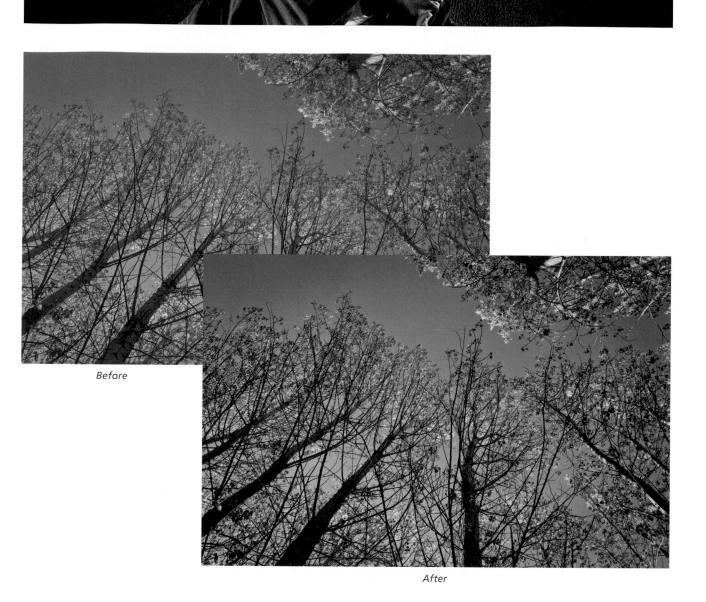

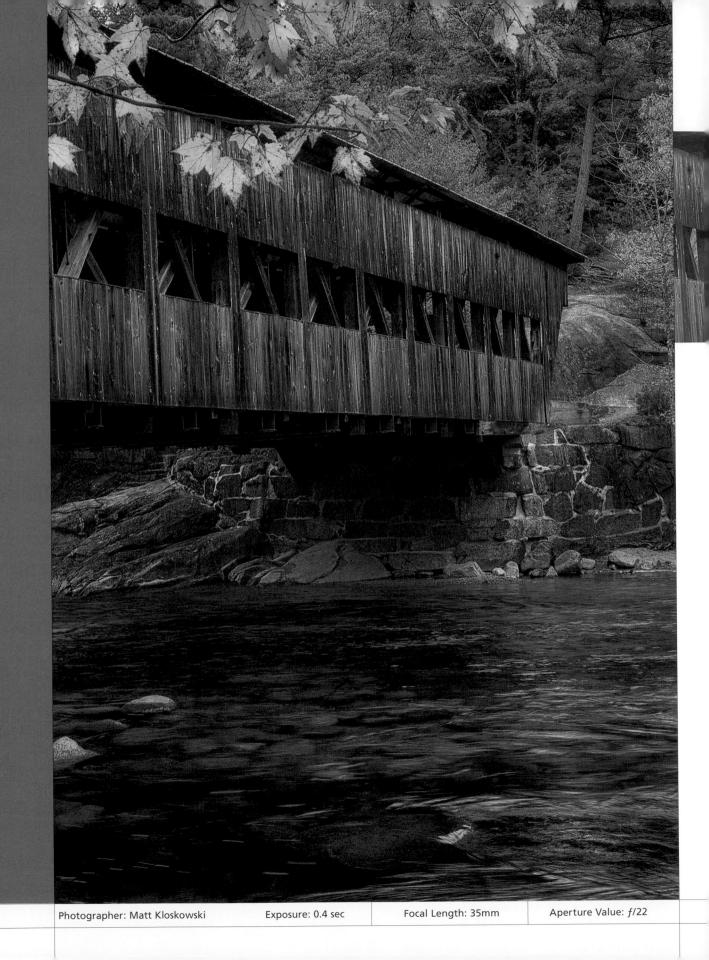

Little Problems

fixing common problems

The title for this chapter comes from the 2009 movie Little Problems (written and directed by Matt Pearson), but I could have just as easily gone with the 2008 short Little Problems (written and directed by Michael Lewen), but there was one big thing that made the choice easy: the first movie was about zombies. You just can't make a bad movie about zombies. It's a lock. Throw a couple of hapless teens (or in this case "an unlikely couple") into some desolate location with a couple hundred flesh-starved undead, and you've got gold baby, gold! Now, has anyone ever wondered, even for a second, why every zombie in the rich and colorful history of zombies, has an insatiable hunger for human flesh and only human flesh? Why can't there be zombies that have an insatiable hunger for broccoli? Then, in their bombed-out shell of a desolate vacant city, on every corner there would be other zombies selling broccoli the

size of azalea bushes. Anyway, it's just a little too coincidental that every zombie wants to eat you, but they don't want to eat something that might actually keep them alive, and is in ample and easily reproducible supply, like broccoli, or spring rolls, or chowder. Nope, it has to be human flesh, even though you know and I know (say it with me) it tastes like chicken (well, that's what I've been told, anyway). Another thing that drew me to the first Little Problems was the director's last name, seeing as all my books are published by subsidiaries of Pearson Education, a company who somehow chose to hire Ted Waitt as my editor, despite the fact that they were forewarned by the DCBGC (the Desolate City Broccoli Growers' Consortium) that Ted might not actually be the strict vegetarian he claimed to be in his resume. I probably shouldn't say anything bad about Ted, though. I don't want to bite the hand that feeds me.

Using the Smart Brush Tool to Select and Fix at the Same Time

Photoshop Elements includes a brush tool that lets you fix problem areas (as well as create some pretty cool effects) with just a brush stroke. It's called the Smart Brush tool, and it helps keep you from making complicated selections and then having to fix them in a separate step. Instead, you choose which effect you want to apply and just brush away. Let's check it out.

Step One:

Open a photo that has an area you want to enhance or fix. There's actually a huge list of things you can do with this brush, but let's concentrate on one area for now—the sky. A big digital image problem is that the sky never seems to look as vibrant and dramatic as it does when we're there photographing it. Well, the Smart Brush tool has an option to help fix this, so go ahead and select it from the Toolbox (it's the brush icon with a little gear to the left of it, right below the Brush tool and directly above the Paint Bucket tool) or just press the **F key**.

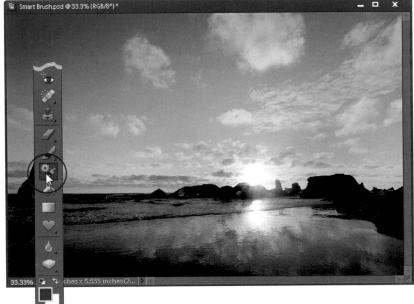

Step Two:

Once you select the tool, click on the thumbnail on the right side of the Options Bar to open the Preset Picker. As you change the preset pop-up menu and scroll through the Preset Picker, you'll see what I meant in Step One—there are indeed a bunch of things you can do here. Let's go ahead and choose **Nature** from the preset pop-up menu at the top, though, to narrow it down. Then click on the Cloud Contrast preset.

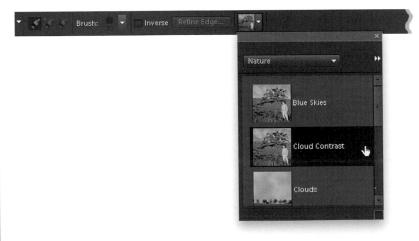

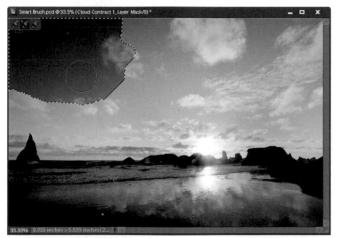

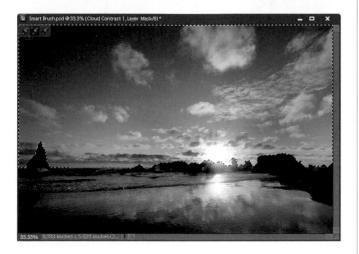

Now the main thing to remember about this tool is that it is still a brush, which means it has settings just like all other brushes (diameter, hardness, spacing, etc.). So, click on the down-facing arrow to the right of Brush in the Options Bar, and set your diameter to a size that'll help you paint over the area fairly quickly. In this example, I'm using a 200-pixel brush for the sky.

Step Four:

The rest is pretty simple—just clickand-drag on the sky to paint the effect on the photo. By the way, notice how Elements automatically started adding the Cloud Contrast effect to parts of the sky that you haven't even painted over yet? That's where the "smart" part of this brush comes into play. It automatically examines your photo for areas similar to what you clicked on and adds them to the selection.

Step Five:

Now keep brushing on the sky to get the rest of it. Each time you click, you're adding to the selection, so there's no need to press-and-hold any keys or change tools to widen the effect to other parts of the photo.

Step Six:

Okay, this brush is pretty cool, right? But it's not perfect. There will inevitably come a time (probably sooner than later) where the "smartness" of the brush isn't as smart as it thinks it is, and it bleeds into a part of the photo you didn't want it to (like some of the rocks on the right here). When that happens, press-andhold the Alt (Mac: Option) key to put the brush into subtract mode. Then paint over the areas you didn't want to apply the effect to. Again, Elements will do a lot of the work for you and wipe away the areas, even if you don't paint directly on them. Note: Decrease the size of your brush and zoom in on the area, if needed, to help remove it from the selection.

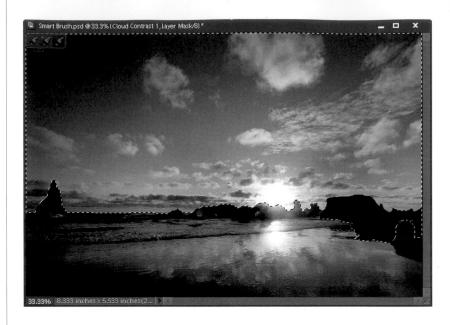

Step Seven:

Here's another really cool part about the Smart Brush tool: it's non-destructive to your photo. This means you can always go back and change (or even delete) the effects. You'll see this in two ways: First, you'll notice that the Smart Brush tool automatically adds a new adjustment layer to the Layers palette. If you ever find the effect is too harsh, you can always reduce the opacity of the layer to reduce the effect.

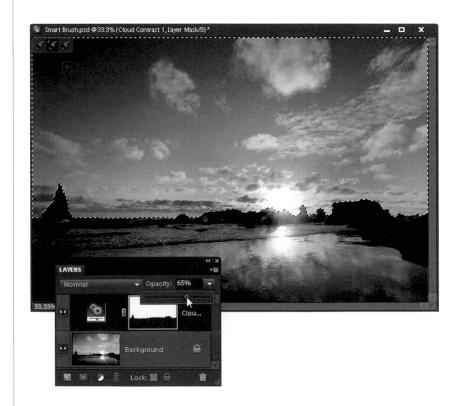

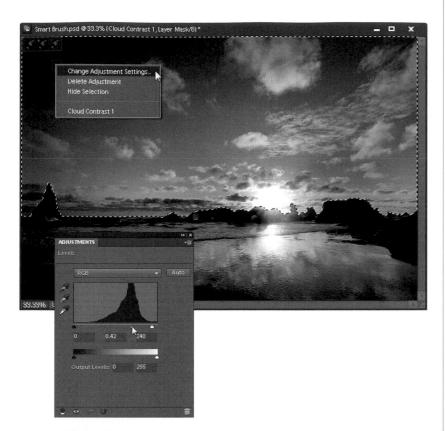

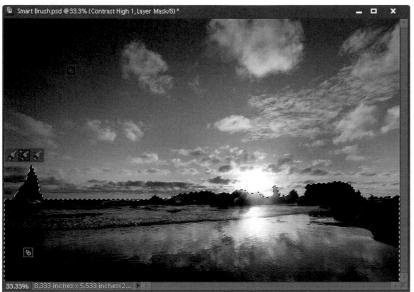

Step Eight:

Also, you may have noticed a tiny red box on your photo where you started to paint with the Smart Brush tool. This is the adjustment marker letting you know you've applied a Smart Brush adjustment to the photo. If you Right-click on it, you'll see you can delete it if you want or you can change the adjustment settings. Clicking Delete Adjustment does just what you think it does—the adjustment will be removed totally. But try clicking Change Adjustment Settings instead. It brings up the Adjustments palette with the controls for whatever adjustment Elements used to achieve your effect. If you're familiar with the Adjustments palette, you can always try tweaking the settings. In this case, Levels was used, so the Levels controls appeared in the palette. If I wanted to try to make the sky even darker, I could drag that middle gray slider below the histogram toward the right a little.

Step Nine:

You can also add multiple Smart Brush adjustments to different parts of the photo. If you notice, the sky in this photo looks a lot better, but now the foreground looks a little flat in comparison. Press Ctrl-D (Mac: Command-D) to Deselect the current Smart Brush adjustment in the sky. Then, go to the Preset Picker in the Options Bar and choose the Lighting presets in the pop-up menu. Now, click on the Contrast High preset in the list, and paint on the foreground to add some contrast to the beach and water.

Step 10:

One more thing: the Smart Brush tool is so smart that you can not only change the adjustment settings, but you can also totally change the Smart Brush adjustment you've applied. For example, let's say we want to see what the Blue Skies adjustment looks like. Just click back on your Cloud Contrast layer in the Layers palette, then click on the Blue Skies preset in the Options Bar and Elements will swap out the Cloud Contrast adjustment with the Blue Skies one. If you like it, then keep it; if not, then just click back on the first preset you chose or try a new one altogether. Once you're finished, just choose Flatten Image from the Layers palette's flyout menu.

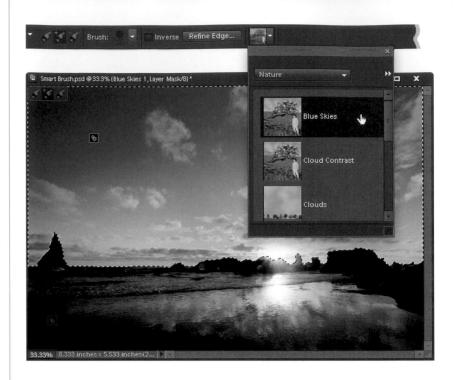

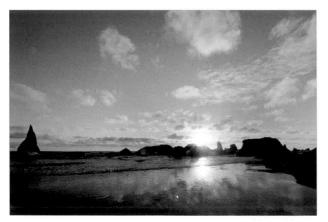

Before

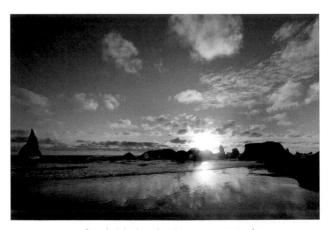

After (with the Cloud Contrast preset)

Digital noise is that stuff (or junk) that you see throughout your photo if you shoot with a high ISO (it also happens when you use a low-quality camera). It typically pops up in low-light photos, but can really rear its ugly head at other times, too. While you can't remove all of this noise in Photoshop Elements, you can reduce its appearance with a filter. Here's how:

Removing Digital Noise

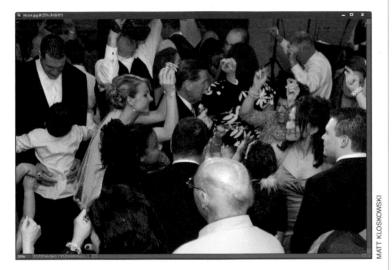

Step One:

Open the photo that was taken in low lighting (or using a high ISO setting) and has visible digital noise. This noise will be most obvious when viewed at a magnification of 100% or higher (noise appears throughout this photo, but is most visible on the black suit jackets and dark hair closest to the camera, and the white wall in the background, although it's hard to see at the small size of the image here). *Note:* If you view your photos at smaller sizes, you may not notice the noise until you make your prints.

Step Two:

Go under the Filter menu, under Noise, and choose **Reduce Noise**. The default settings usually aren't too bad, but if you're having a lot of color aliasing (dots or splotchy areas of red, green, and blue), like we have here, drag the Reduce Color Noise slider to the right. If it still looks splotchy, try dragging the Preserve Details slider to the left.

One thing to watch out for when using this filter is that, although it can reduce noise, it can also make your photo a bit blurry, and the higher the Strength setting and the higher the amount of Reduce Color Noise, the blurrier your photo will become. If the noise is really bad, you may prefer a bit of blur to an incredibly noisy photo, so you'll have to make the call as to how much blurring is acceptable, but to reduce the amount of blur a bit, drag the Preserve Details slider to the right.

TIP: See a Before/After

To see an instant before/after of the Reduce Noise filter's effect on your photo without clicking the OK button, click your cursor within the Reduce Noise dialog's preview window. When you click-and-hold within that window, you'll see the before version without the filter (zoom in if you need to). When you release the mouse button, you'll see how the photo will look if you click the OK button.

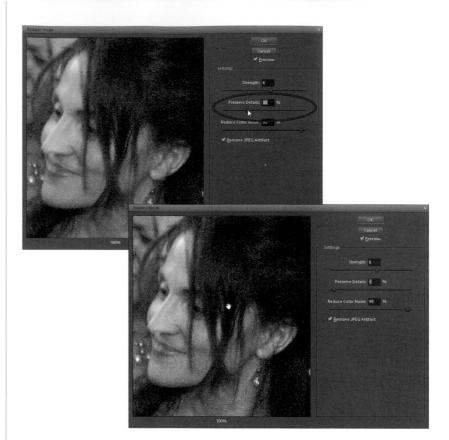

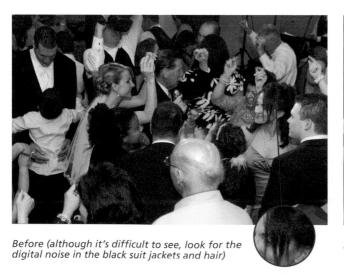

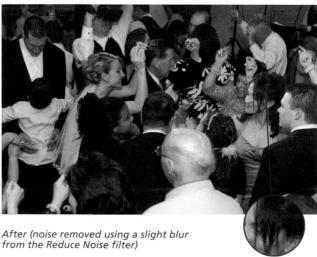

I've got some bad news and some good news (don't you hate it when people start a conversation like that?). The bad news first (yeah, I like it that way, too): Elements' Dodge and Burn tools are kind of lame. The pros don't use them and, after you read this tutorial, I hope you won't either. The good news...there is a great method the pros do use to dodge and burn and it's totally non-destructive. It's flexible and really quite easy to use. See, isn't it better to end on a good note (with the good news, that is)?

Focusing Light with Digital Dodging and Burning

Step One:

In this tutorial, we're going to dodye areas to add some highlights, then we're going to burn in the background a bit to darken some of those areas. Start by opening the photo you want to dodge and burn.

Step Two:

Go to the Layers palette, click on the down-facing arrow at the top right, and from the flyout menu, choose **New Layer** (or just **Alt-click [Mac: Option-click]** on the Create a New Layer icon at the bottom of the palette). This accesses the New Layer dialog, which is needed for this technique to work.

In the New Layer dialog, change the Mode to **Overlay**, then right below that, turn on the checkbox for Fill with Overlay-Neutral Color (50% Gray). This is normally grayed out, but when you switch to Overlay mode, this choice becomes available. Click the checkbox to turn it on, then click OK.

Step Four:

This creates a new layer, filled with 50% gray, above your Background layer. (When you fill a layer with 50% gray and change the Mode to Overlay, Elements ignores the color. You'll see a gray thumbnail in the Layers palette, but the layer will appear transparent in your image window.)

Step Five:

Press **B** to switch to the Brush tool, and choose a medium, soft-edged brush from the Brush Picker (which opens when you click on the brush thumbnail in the Options Bar). While in the Options Bar, lower the Opacity to approximately 30%.

Step Six:

Press **D**, then **X** to set your Foreground color to white. Begin painting over the areas that you want to highlight (dodge). As you paint, you'll see light gray strokes appear in the thumbnail of your gray transparent layer, and in the image window, you'll see soft highlights.

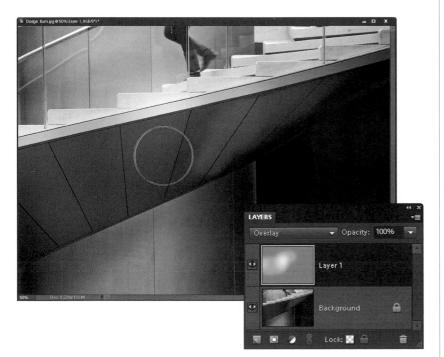

Step Seven:

If your first stab at dodging isn't as intense as you'd like, just release the mouse button, click again, and paint over the same area. Since you're dodging at a low opacity, the highlights will "build up" as you paint over previous strokes. If the highlights appear too intense, just go to the Layers palette and lower the Opacity setting of your gray layer until they blend in.

Step Eight:

If there are areas you want to darken (burn) so they're less prominent (such as the background or the wall to the right of the person, where I'm painting here), just press **D** to switch your Foreground color to black and begin painting in those areas. Okay, ready for another dodging-and-burning method? Good, 'cause I've got a great one.

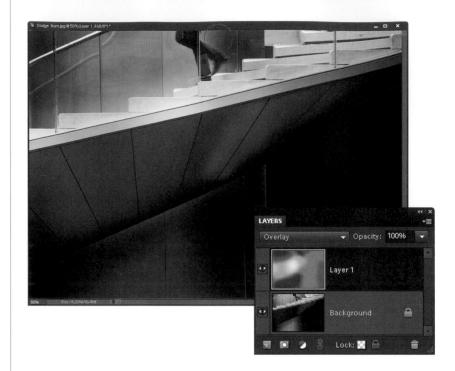

Alternate Technique:

Open the photo that you want to dodge and burn, then just click on the Create a New Layer icon in the Layers palette and change the blend mode to **Soft Light**. Now, set white as your Foreground color and you can dodge right on this layer using the Brush tool set to 30% Opacity. To burn, just as before, switch to black. The dodging and burning using this Soft Light layer appears a bit softer and milder than the previous technique, so you should definitely try both to see which one you prefer.

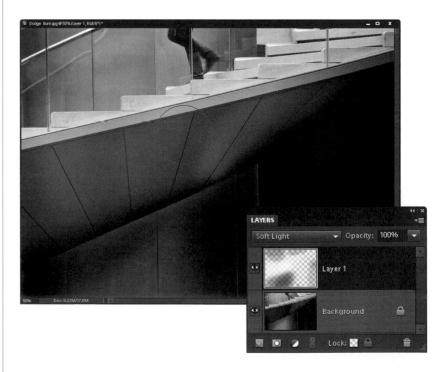

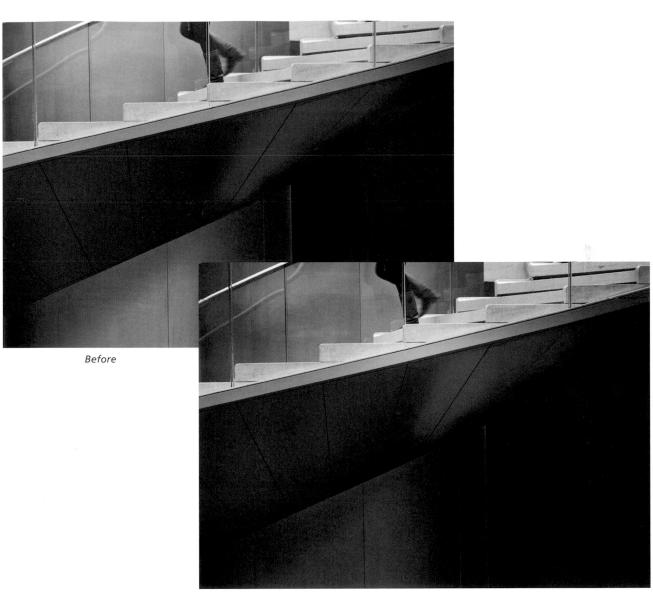

After

Opening Up Shadow Areas That Are Too Dark

One of the most common problems you'll run into with your digital photos is that the shadow areas are too dark. Fortunately for you, since it is the most common problem, digital photo software like Elements has gotten really good at fixing this problem. Here's how it's done:

Step One:

Open the photo that needs to have its shadow areas opened up to reveal detail that was "lost in the shadows."

Step Two:

Go under the Enhance menu, under Adjust Lighting, and choose **Shadows/Highlights**.

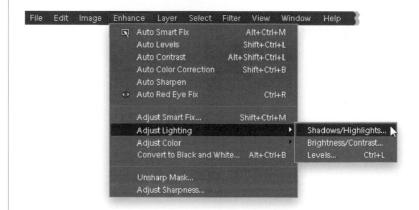

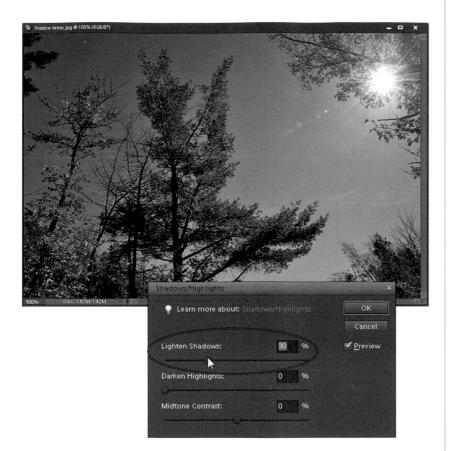

When the dialog appears, it already assumes you have a shadow problem (sadly, most people do but never admit it), so it automatically opens up the shadow areas in your document by 25% (you'll see that the Lighten Shadows slider is at 25% by default [0% is no lightening of the shadows]). If you want to open up the shadow areas even more, drag the Lighten Shadows slider to the right. If the shadows appear to be opened too much with the default 25% increase, drag the slider to the left to a setting below 25%. When the shadows look right, click OK. Your repair is complete.

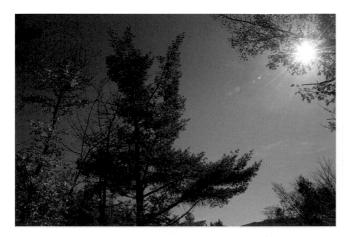

After

Fixing Areas That Are Too Bright

Although most of the lighting problems you'll encounter are in the shadow areas of your photos, you'll be surprised how many times there's an area that is too bright (perhaps an area that's lit with harsh, direct sunlight, or you exposed for the foreground but the background is now overexposed). Luckily, this is now an easy fix, too!

Step One:

Open the photo that has highlights that you want to tone down a bit. *Note*: If it's an individual area (like the sun shining directly on your subject's hair), you'll want to press the **L key** to switch to the Lasso tool and put a loose selection around that area. Then go under the Select menu and choose **Feather**. For low-res, 72-ppi images, enter 2 pixels and click OK. For highres, 300-ppi images, try 8 pixels.

Step Two:

Now go under the Enhance menu, under Adjust Lighting, and choose **Shadows/Highlights**.

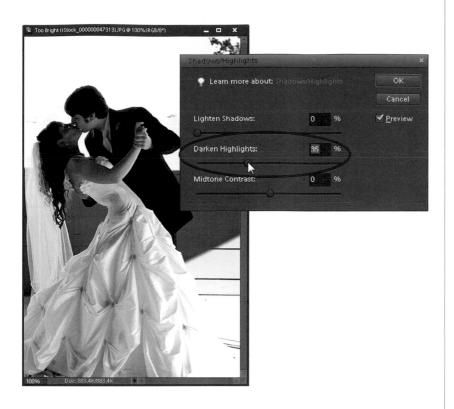

When the dialog appears, drag the Lighten Shadows slider to 0% and drag the Darken Highlights slider to the right, and as you do, the highlights will decrease, bringing back detail and balancing the overall tone of your (selected) highlights with the rest of your photo. (You'll mainly see it in the dress, veil, and background here. They were just white before and now they've got more detail.) Sometimes when you make adjustments to the highlights (or shadows), you can lose some of the contrast in the midtone areas (they can become muddy or flat looking, or they can become oversaturated). If that happens, drag the Midtone Contrast slider (at the bottom of the dialog) to the right to increase the amount of midtone contrast, or drag to the left to reduce it. Then click OK. Note: If you made a selection, you'll need to press Ctrl-D (Mac: Command-D) to Deselect when you're finished.

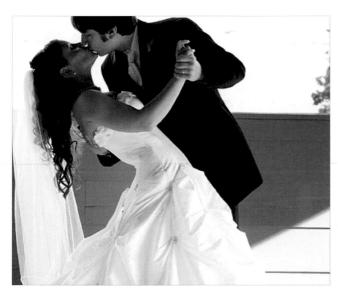

After

When Your **Subject Is Too Dark**

Sometimes your subject is too dark and blends into the background: maybe there just wasn't enough light, or you forgot to use fill flash, or a host of other reasons that could have caused this. You could go and retake the photo if you realize it right away. However, you don't always realize it immediately, so you'll need to get Elements to help out. For those times, there's a really clever way in Elements to essentially paint your light onto the subject after the fact.

Step One:

Open a photo where the subject(s) of the image appears too dark.

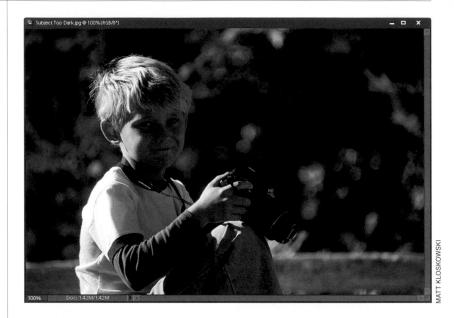

Step Two:

Click on the Create New Adjustment Layer icon at the bottom of the Layers palette (shown circled here), and choose Levels. This will add a Levels adjustment layer above your Background layer, and open the Adjustments palette with the Levels controls available.

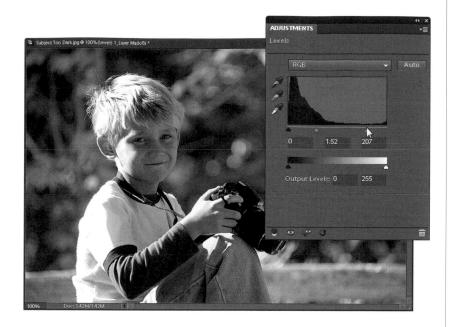

Drag the middle gray Input Levels slider (under the histogram) to the left until your subject(s) looks properly exposed. (Note: Don't worry about how the background looks—it will probably become completely blown out, but you'll fix that later—for now, just focus on making your subject look right.) If the midtones slider doesn't bring out the subject enough, you may have to increase the highlights as well, so drag the far-right (white) Input Levels slider to the left to increase the highlights.

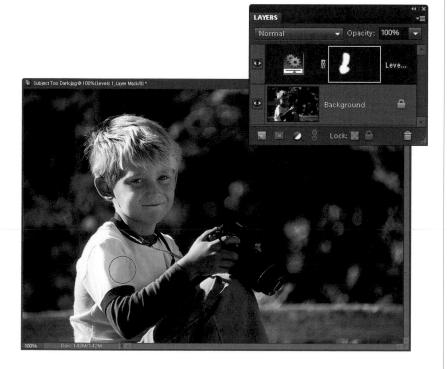

Step Four:

When your subject looks properly exposed, press **D** to set your Foreground color to white and your Background color to black. Then press Ctrl-Backspace (Mac: Command-Delete) to fill the layer mask with black and remove the brightening of the photo. Press B to switch to the Brush tool and click on the brush thumbnail in the Options Bar to open the Brush Picker, where you'll choose a soft-edged brush. Now, you'll paint (on the layer mask) over the areas of the image that need a fill flash with your newly created "Fill Flash" brush. The areas you paint over will appear lighter, because you're "painting in" the lightening of your image on this layer.

Step Five:

Continue painting until it looks as if you had used a fill flash. If the effect appears too intense, just lower the opacity of the adjustment layer by dragging the Opacity slider to the left in the Layers palette (as shown here).

TIP: Try the Smart Brush Tool Instead The Smart Brush tool (covered at the beginning of this chapter) has a Portrait preset called Lighten Skin Tones that also works pretty well in cases like this.

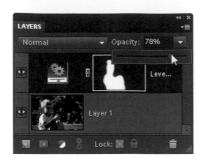

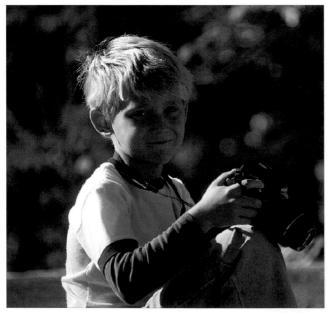

Before

After

194

If you just finished shooting an indoor event with lots of flash and low light, chances are you're going to have a ton of photos with red eyes. If you know this ahead of time, then the feature you're about to see comes in very handy. You can set up Elements to automatically remove red eye as your photos are being imported into the Organizer. No interaction by you is needed. Just let Elements do its work and by the time you see your photos onscreen, you'll never even know red eye existed.

Automatic Red-Eye Removal

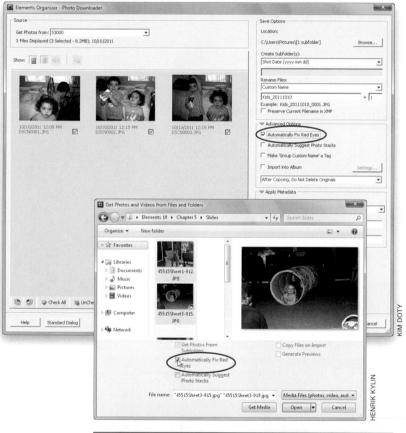

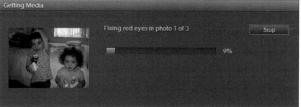

Step One:

First, we'll start with the fully automatic version, which you can use when you're importing photos into the Organizer. Here's how it works: When importing photos from your camera, the Elements Organizer-Photo Downloader dialog appears. On the right side of the dialog, in the Advanced Options section, there's a checkbox for Automatically Fix Red Eyes (if your dialog doesn't look like this, click on the Advanced Dialog button at the bottom). If you think some of the photos you're about to import will have red eye, just turn on this checkbox (shown circled here), and then click the Get Media button to start the importing and the red-eye correction. If you're importing photos already on your computer, you'll have the same option in the Get Photos and Videos from Files and Folders dialog.

Step Two:

Once you click the Get Media button, the Getting Media dialog will appear. In this dialog, there's a status bar indicating how many photos are being fixed. It also shows you a preview of each photo it's importing.

Once the process is complete, it automatically groups the original with the fixed version in a Version Set (you'll see an icon at the top right of the image thumbnail), so if you don't like the fix (for whatever reason), you still have the original. You can see both versions of the file by Right-clicking on the photo (in the Organizer) and in the pop-up menu, under Version Set, choosing **Expand Items in Version Set** (or by just clicking on the right-facing arrow to the right of the image thumbnail).

Step Four:

Here is one of the photos with red eye and with it automatically removed.

Step Five:

This really isn't a step; it's another way to get an auto red eye fix, and that's by opening an image in the Editor, or even in Quick Fix, and then going under the Enhance menu and choosing **Auto Red Eye Fix**. You can also use the keyboard shortcut **Ctrl-R (Mac: Command-R)**. Either way, it senses where the red eye(s) is, removes it automatically, and life is good.

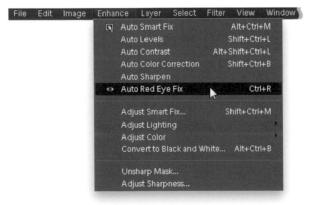

When you use the flash on your digital point-and-shoot camera (or even the on-camera flash on a digital SLR), do you know what you're holding? It's called an A.R.E.M. (short for automated red-eye machine). Yep, that produces red eye like it's going out of style. Studios typically don't have this problem because of the equipment and positioning of the flashes, but sometimes you don't have a choice—it's either an on-camera flash or a really dark and blurry photo. In those cases, just accept the red eye. Become one with it and know that you can painlessly remove it with a couple of clicks in Elements.

Instant Red-Eye Removal

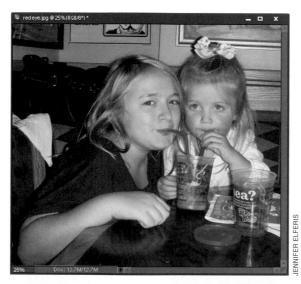

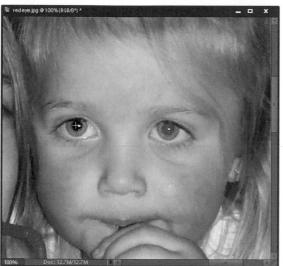

Step One:

Open a photo where the subject has red eye.

Step Two:

Press Z to switch to the Zoom tool (it looks like a magnifying glass in the Toolbox) and drag out a selection around the eyes (this zooms you in on the eyes). Now, press the letter Y to switch to the Red Eye Removal tool (its Toolbox icon looks like an eye with a tiny crosshair cursor in the left corner). There are two different ways to use this tool: click or click-and-drag. We'll start with the most precise, which is click. Take the Red Eve Removal tool and click it once directly on the red area of the pupil. It will isolate the red in the pupil and replace it with a neutral color. Instead, now you have "gray" eye, which doesn't look spectacular, but it's a heck of a lot better than red eye.

If the gray color that replaces the red seems too "gray," you can adjust the darkness of the replacement color by going to the Options Bar and adjusting the Darken Amount. To get better results, you may have to adjust the Pupil Size setting so that the area affected by the tool matches the size of the pupil. This is also done in the Options Bar when you have the Red Eye Removal tool selected. Now, on to the other way to use this tool (for really quick red-eye fixes).

Step Four:

If you have a lot of photos to fix, you may opt for this quicker red-eye fix—just click-and-drag the Red Eye Removal tool over the eye area (putting a square selection around the entire eye). The tool will determine where the red eye is within your selected area (your cursor will change to a timer), and it removes the red. Use this "drag" method on one eye at a time for the best results.

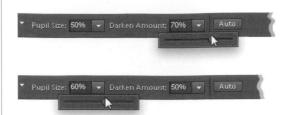

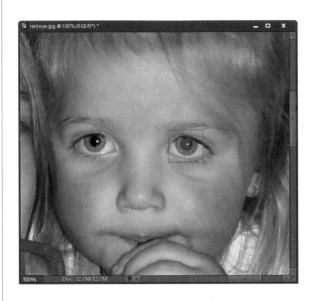

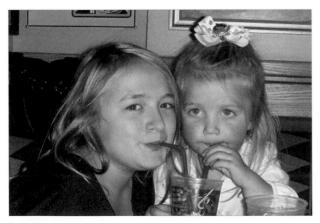

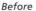

After

Back in Elements 5, Adobe introduced a filter called the Correct Camera Distortion filter. It is pretty much a one-stop shop for repairing the most common problems caused by the camera's lens, including pincushion and barrel distortion, horizontal and vertical perspective problems, and edge vignetting.

Fixing Problems Caused by Your Camera's Lens

Problem One: Perspective Distortion

Step One:

The first problem we're going to tackle is perspective distortion. In the example shown here, I captured this photo with a 14–24mm lens, so the church looks like it's leaning and all of the vertical walls appear at an angle.

Step Two:

To fix this problem (caused by the lens), go under the Filter menu and choose Correct Camera Distortion. When the dialog appears, turn off the Show Grid checkbox near the bottom right of the preview window (it's on by default), then go to the Perspective Control section (on the center-right side of the dialog) and drag the Vertical Perspective slider to the left until the building starts to look straight. When you make this correction, the filter pinches the bottom third of your photo inward, which leaves transparent gaps along the bottom and lower-side edges of your photo (you can see the checkerboard in these areas).

The Scale slider at the bottom of the dialog in the Edge Extension section lets you deal with these edge gaps caused by the perspective repair. Move the slider to the right to increase your image size in the frame, covering those gaps, so you don't have to crop your photo later.

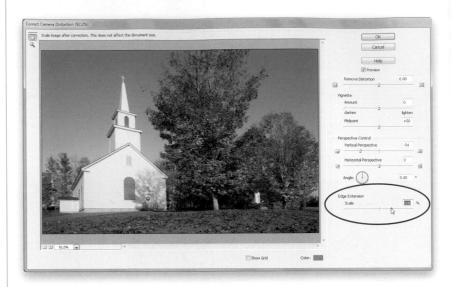

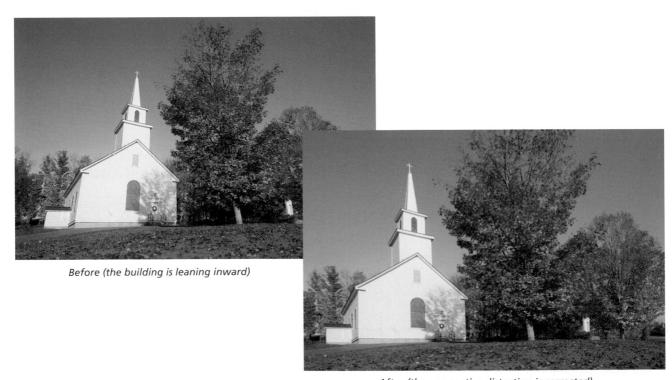

After (the perspective distortion is corrected)

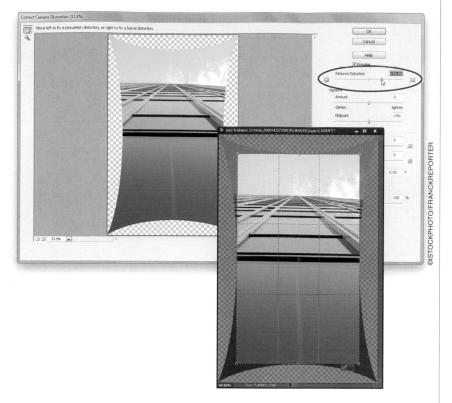

Problem Two: Barrel Distortion

Step One:

Another common lens correction problem is called barrel distortion, which makes your photo look bloated or rounded. So, open the Correct Camera Distortion filter again, but this time you're going to drag the Remove Distortion slider (in the top right of the dialog) slowly to the right to "pucker" the photo inward from the center, removing the rounded, bloated look. To remove pincushion distortion, in which the sides of your photo appear to curve inward, drag the slider to the left.

Step Two:

When you click OK, the correction will leave gaps around the edges, so get the Crop tool **(C)** and crop the image to hide the missing edges. It's hard to see the difference in the small images below, but try this technique, and you'll see the difference.

Before

After

Problem Three: Lens Vignetting

Step One:

Vignetting is a lens problem where the corners of your photo appear darkened. To remove this problem, go back to the Correct Camera Distortion filter.

Step Two:

In the Vignette section at the centerright side of the dialog, drag the Amount slider to the right, and as you do, you'll see the edges brighten. Keep dragging the slider until the edges match the brightness of the rest of the photo. The Midpoint slider (just below the Amount slider), determines how far into the photo your corner brightening will extend. In this case, you have to retract it just a little bit by dragging the slider to the right, then click OK.

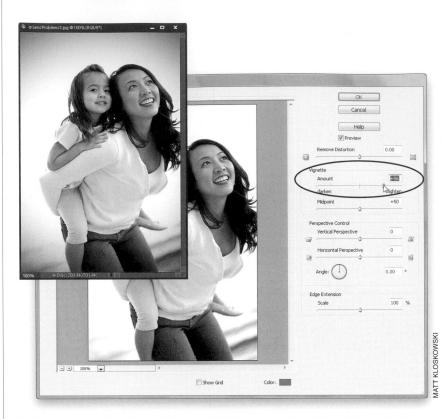

Before (you can see the dark vignetted areas in the corners)

After (the vignetting is completely removed)

Group shots can be a challenge. Everyone has to be looking and smiling at the right time. If one person isn't, then you have to shoot it again. The real problem comes from the fact that you really can't tell if everyone has their eyes open or is looking the right way from the small LCD on the back of your camera. So you get back and upload your photos only to find out that not one of them has everyone looking and smiling the way that they need to be. No sweat, with Elements' Group Shot feature. As long as you have a few photos to choose from, you can create the perfect group photo afterward.

The Elements Secret to Fixing Group Shots

Step One:

Here's a photo of co-worker Pete's three sons. As you can see, one of them isn't smiling as nice as the others (he isn't really smiling at all).

Step Two:

If you've ever taken group shots before, you're guilty of photographing until your group threatens to riot or otherwise destroy your gear. Chances are, you took more photos of the same group before such threats ensued. So here's another shot that has the same group in it, but this time the boy on the left is smiling. Sweet! However, this time the boy in the middle has his eyes closed. No problem. We're going to use the Group Shot feature to give us the best of both worlds and combine these photos.

At this point, you should have both photos open in the Editor. So, click on Guided on the Edit tab (on the top-right side of the Palette Bin).

Note: A quick rule of thumb when using the Group Shot feature is to pick the best photo of the group as the first photo selected. See, Elements uses the first photo as the bottommost layer in the Layers palette. You'll see in a few steps, that makes it easier for us to go back later and restore the best parts of the photo with the Eraser tool.

TIP: Using More Photos

Even though I'm only using two photos here, you can use the Group Shot feature with up to 10 photos of the same group. So, if everyone is looking the wrong way, not smiling, or has their eyes closed at some point, you'll have a better chance of fixing the photo with more than two shots.

Step Four:

Next, in the Guided Edit panel, go down to the Photomerge section and click on Group Shot. A dialog will open (shown above) asking you to go back and select from two to 10 photos from the Project Bin or to select Open All. Since these are the only two photos I have open in the Editor, I just clicked Open All.

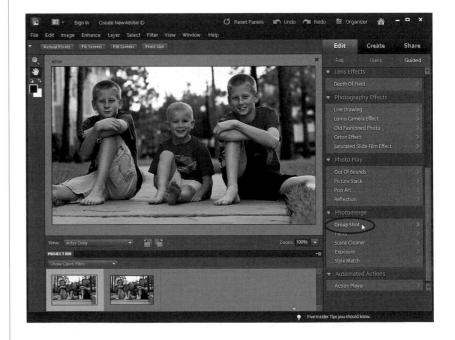

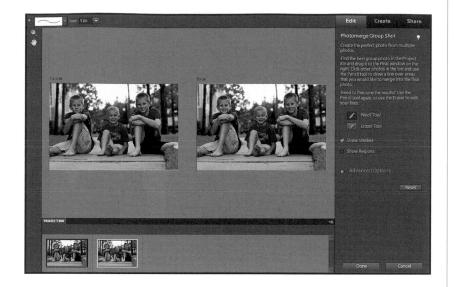

Step Five:

Now you're in the Photomerge Group Shot window. The first thing you need to do here is set up the photos as a source and a final. In the example here, I wanted the good photo of the boy in the middle (with his eyes open) on the Source side (if it wasn't, I would've just clicked on its thumbnail down in the Project Bin). Then, I went to the Project Bin and clicked-and-dragged the thumbnail of the photo where the boy has his eyes closed (but where the boy on the left is smiling) to the Final side. So basically, what I want to do is take the boy from the Source side (the one where his eyes are open) and use him to replace the boy on the Final side (where his eyes are closed).

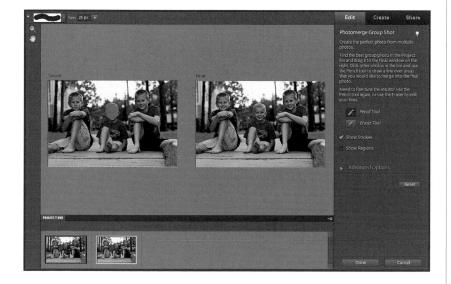

Step Six:

The rest is pretty easy: Make sure the Pencil tool is selected in the panel on the right-hand side. Then, paint on the area in the Source image that you want to appear in the Final image. In this example, I want the middle boy's eyes to be wide open, so I painted over the Source image where his face is. Elements will think for a moment, and magically replace the boy's face in the Final photo with the one from the Source photo.

TIP: Change Your Brush Size

Sometimes the default brush size is way too small and it takes you a while to paint in your source image. If that happens, then increase the Size setting in the Options Bar at the top of the window to something larger.

Step Seven:

At this point, if things look good (and trust me, things don't always look good here, although it may work on the first try), then click the Done button at the bottom right of the window, and click on Full at the top of the Edit tab to return to Full Edit mode. Your merged photo is in a new document with two layers (the original on the bottom and new merged photo on the top) in the Layers palette (use the Crop tool **[C]** to crop away any excess canvas).

TIP: Use the Eraser Tool to Fix It

If the Group Shot merge doesn't work perfectly, you can finesse it by painting with the Eraser tool **(E)** on the top layer to reveal the layer below. You'll want to zoom in really close, but it's a good trick to fix any flaws that remain.

Group Before 1

Before #1 (the boy in the middle has his eyes open, but the boy on the left isn't smiling)

Group Before 2

Before #2 (the boy on the left is smiling but now the boy in the middle has his eyes shut)

Group After

After (we've got the best of both worlds the boy on the left is smiling, and the boy in the middle has his eyes wide open, all in the same shot)

As an outdoor photographer, one of the biggest battles you face is balancing the details in the highlights and shadows. Usually, you have to make a choice and set the camera's exposure to capture detail in the shadows (which produces bright, blown-out skies), or set the exposure for the brighter areas (which makes the darker areas almost black). With the Photomerge Exposure feature, we can do both. If you've heard of HDR (High Dynamic Range) photography and software, it's similar—we take multiple photos with differing exposures and combine them together in Elements automatically (without a bunch of selections and layers).

Blending Multiple Exposures (a.k.a. Pseudo-HDR Technique)

Step One:

Open the photos you're going to merge together. Here are a couple of photos of the same subject. To make these photos, I set my camera on a tripod and just changed exposure settings to capture one photo with lots of details in the shadows (even though it looks really bright) and one photo with lots of detail in the highlight areas, such as the sky (even though the other areas look too dark).

TIP: Try This with Portraits, Too This doesn't just work on landscape photos. You can try this with people, too. The key here is to have them be as still as possible. Oh, and you don't always have to be on a tripod, but it sure helps you get a better result in the end.

Step Two:

Go to the File menu, choose New, and then choose **Photomerge® Exposure**. In the resulting dialog, click Open All.

This takes you into the Photomerge Exposure window. On the right side, you'll see two tabs: Automatic and Manual. Automatic has two modes in it: Simple Blending and Smart Blending. Manual mode has some settings, as well, but we'll check out Automatic first.

Step Four: Automatic Mode— Simple Blending

When you're in Automatic mode, Elements starts you out using the Smart Blending option. In this example (in the top capture), it looks pretty good, but try clicking on the Simple Blending option just to compare. It's not bad (the bottom capture). The foreground looks much brighter, and the sky has a little more detail in it than the original bright photo revealed. I do think the sky looks too bright, though. Elements has essentially taken the best parts of each photo and automatically blended them together. If you're happy with it, then just click Done near the bottom right of the window to return to the Editor (you may have to crop off some excess areas). The problem with this option, though, is that it has no settings at all (the sliders in the panel are not active). You get what you get and if you're not happy with it, well, you'll have to resort to another method. So, we'll look at the Smart Blending option next.

TIP: Using More Photos

Even though I'm only using two photos here, you can use Photomerge Exposure with up to 10 photos of the same scene. Honestly, 10 is kinda overkill, but if you had a really contrasty scene with lots of bright highlights and dark shadows (say, inside of a house with lots of windows on a bright, sunny day), you may want to take three or four of the same scene with different exposures.

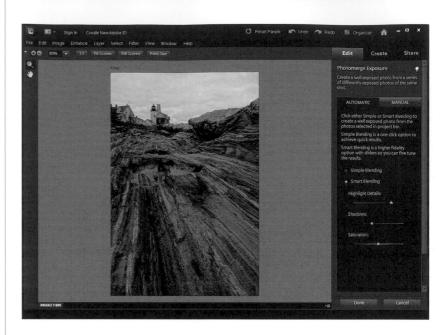

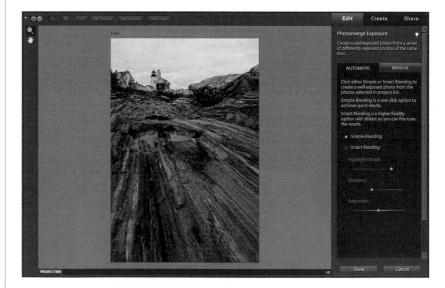

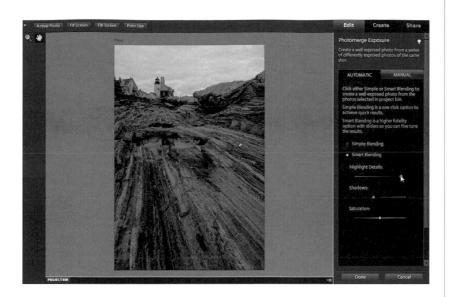

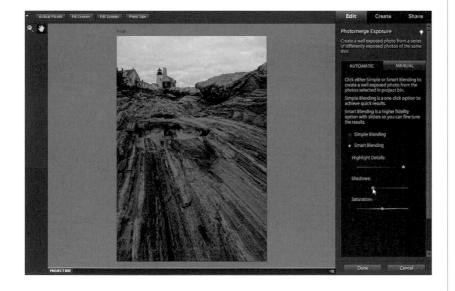

Step Five: Automatic Mode— Smart Blending

Okay, since the sky is just too bright using the Simple Blending option, let's switch back to Smart Blending by clicking on the Smart Blending radio button. Like we saw earlier, it does a pretty good job even though Elements is still trying to automatically blend the photos. However, in the Smart Blending mode, you'll see the three sliders are now available to help you get better results. The first one is Highlight Details. Move this slider if the highlights (or really bright parts of the photo) look too bright. In this example, I thought the sky and the clouds were looking a little too bright, so I moved the Highlight Details slider to the right to darken them a little.

Step Six:

Now take a look at the shadow areas, of the blended photo. If they look too bright or too dark, then you can move the Shadows slider to help out. Let's move it to the left to darken the foreground area here. Be careful of big moves either way, though. If you make your shadow areas too dark, then you won't be able to see what's there. If they're too bright, then things start to look fake. You won't immediately know what's wrong with the photo, but your mind just kinda knows something isn't right here, since it's not used to seeing nice bright skies and really bright foreground areas, as well.

TIP: Which Way to Drag

One way to know what dragging the Highlight Details or Shadows slider will do is to look at the slider itself—it goes from white to black. So, if you want to make something darker, drag the slider toward the dark part of the gradient, or toward the light part to make it lighter.

Step Seven:

When you're merging different exposures together, you'll often lose some saturation in the photo, so Adobe included a Saturation slider, as well, in case you need to bump it up a little. Be careful here, though. I've never run into a photo that needed a Saturation setting of more than 30–35. If you start moving it too far, your photo will end up looking radioactive. If you're not happy with the results, you can always hit the Reset button to get back to the default settings.

TIP: Read Chapter 4

The Saturation slider here is fine, but if you've read Chapter 4, you can skip this and use the techniques you learned there to really get some control over color and saturation in specific parts of your photo.

Step Eight: Manual Mode

So far, Elements has been doing most of the blending for us. Sure we had a few sliders to work with, but we really didn't have that much control. However, with Manual mode, you get a lot more control over exactly which parts of each photo you'd like to keep in your final image. So, click the Manual tab at the top of the panel area. First, click on the brighter photo (where the rocks look okay, but the sky is too light) in the Project Bin to put it into the Foreground window on the left. Then drag the photo where the sky looks good (but the rocks are too dark) to the Background window on the right.

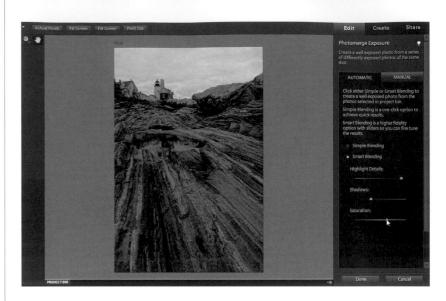

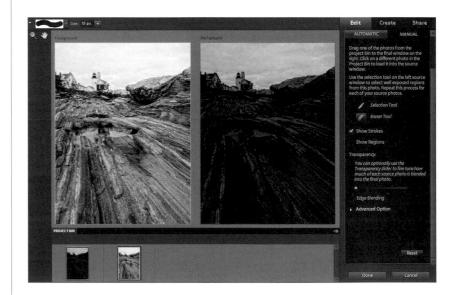

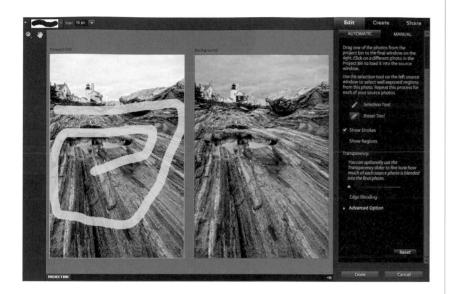

Step Nine:

Now, click on the Selection tool in the middle of the Manual tab, choose a brush size from the top of the window, and draw over the rocks on the bright photo (the one on the left) that you want to appear in the final image (the one on the right). Just a few quick scribbles over the rocks, and even the lighthouse, should do it here. If you happen to scribble too much, or Elements pulls too much over from the rocks photo, then click on the Eraser tool and use it to erase some of the scribbles.

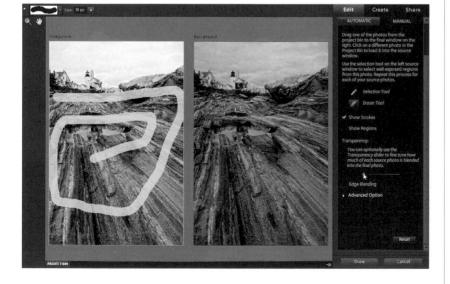

Step 10:

At this point, it probably looks really fake with the dark sky and brighter foreground. One way to combat this is to drag the Transparency slider (at the bottom of the Photomerge palette) to the right to reduce the brightness of the source image (the bright rocks up front) in the final (sky) image on the right. Give it a try here. I dragged mine to about 30 or so to darken the rocks a little.

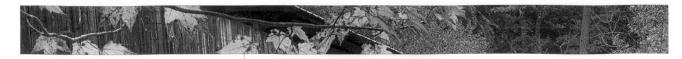

Step 11:

If you see a fringe along the edge of your selected area (I could see some at the top of the rocks), then try turning the Edge Blending checkbox on (below the Transparency slider) to blend them together. I'll be the first to say that sometimes I wonder if this checkbox is even tied to anything because it doesn't always appear to work (or do anything for that matter). But sometimes you'll see an improvement, so it's worth a quick try.

Below are the two before photos. Neither one of them look that great, and both would have needed some pretty heavy editing to turn them into what I actually "saw" when I took the shot.

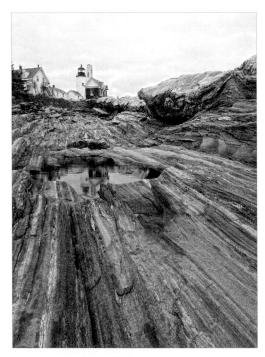

Before 2

Automatic mode: Simple Blending (no sliders available) Automatic mode: Smart Blending (using the few available sliders)

Here are the end results (I've compared both Automatic modes and the Manual mode).

ONE LAST TIP: If You Don't Shoot on a Tripod

If you didn't shoot on a tripod, the Photomerge feature can cause some pretty funky results in the final image, because Elements doesn't know which parts of the photos should overlap. In other words, if you laid them on top of each other, where the subject is in the top photo may not exactly match where it is in the bottom one. But you can help out by using the Alignment tool (the little blue target-looking thing at the bottom of the panel in Manual mode, under Advanced Option). Click on it to select the tool, then place three targets in key areas (corners, logos on a shirt, eyes, etc.) on the Foreground photo. Move over to the Background photo and do the same thing. Click the Align Photos button beneath the tool and Elements will do its best to align the photos with each other, so your end results look better.

Manual mode (a quick brush selection, but that's it. No major selections or layering needed)

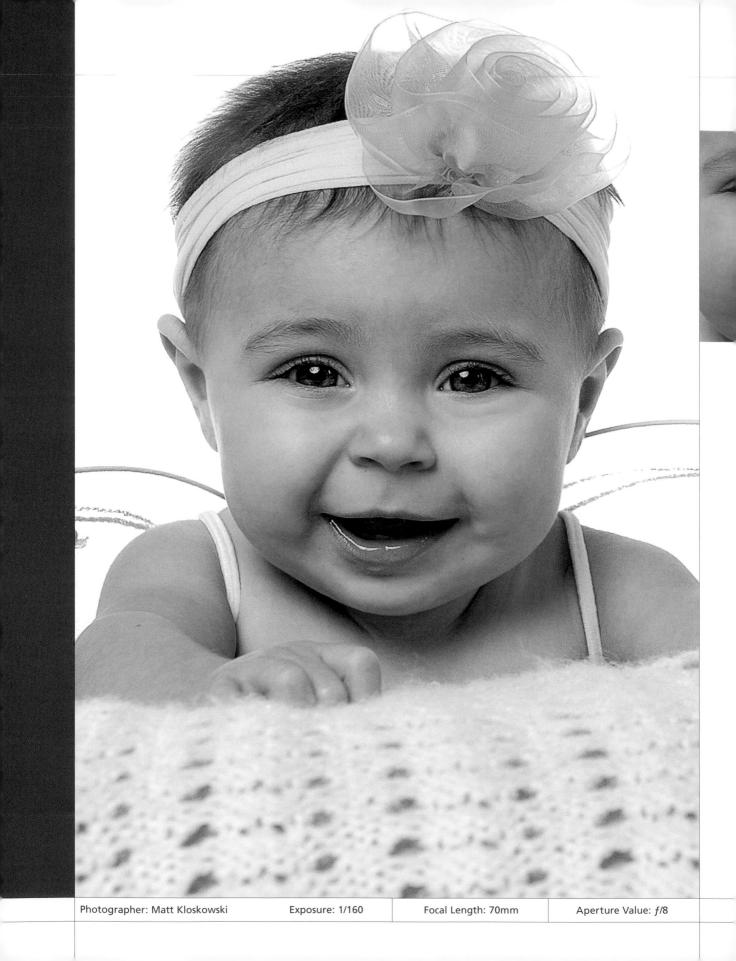

Chapter 6 Selection Techniques

Select Start

selection techniques

This chapter is actually named after the band Select Start, because the name of the song that came up when I searched on the iTunes Store for the word "Select" was their song, titled "She's Not a Hottie Hotty," but I thought that "She's Not a Hottie Hotty" would make a weird name for a chapter on how to make selections. I listened to "She's Not a Hottie Hotty" and it actually wasn't bad, but I really thought the song could use more references to making selections and fewer references to b-double-o-t-y. Okay, I have to be honest, I only listened to the free 30-second preview of the song, and I didn't actually hear the word "booty" per se, but seriously, what song that includes the word "hottie" doesn't have the word "booty" in there somewhere?

I mean, how many words are there that rhyme with hottie that aren't used regularly by a toddler (made ya stop and think for a moment, didn't I?). Anyway, Select Start (the band's name) is really a pretty good name for the chapter, because we start with teaching you how to make simple selections, and then take you through Elements' most important selection techniques, because being able to easily select and adjust just one particular area of your photo is really important. Once you've mastered selections, the next logical step is to learn how to break down people's names rap-style, like Fergie (F to the E-R-G-I-E), but if you just wondered, "Why would the Duchess of York talk like that?" we have any entirely different problem.

Selecting Square, Rectangular, or Round Areas

Selections are an incredibly important topic in Elements. They're how you tell Elements to affect only specific areas of your photos. Whether it's moving part of one photo into another or simply trying to draw more attention to or enhance part of a photo, you'll have so much more control if you know how to select things better. For starters, Elements includes quick and easy ways to make basic selections (square, round, rectangle). These are probably the ones you'll use most, so let's start here.

Step One:

To make a rectangular selection, choose (big surprise) the Rectangular Marquee tool by pressing the **M key**. Adobe's word for selection is "marquee." (Why? Because calling it a marquee makes it more complicated than calling it what it really is—a selection tool—and giving tools complicated names is what Adobe does for fun.)

Step Two:

We're going to start by selecting a rectangle shape, so click your cursor in the upper left-hand corner of the cabinets above the stove and drag down and to the right until your selection covers the entire shape, then release the mouse button. That's it! You've got a selection, and anything you do now will affect only the area within that selected rectangle (in other words, it will only affect the cabinets).

To add another area to your current selection, just press-and-hold the Shift key, and then draw another rectangular selection. In our example here, let's go ahead and select the entire recessed area, including the countertop, so press-and-hold the Shift key, drag out a rectangle around it, and release the mouse button. Now the entire recessed area is selected.

Step Four:

Now let's make an adjustment and you'll see that your adjustment will only affect your selected area. Click on the Create New Adjustment Layer icon at the bottom of the Layers palette, and choose Levels from the pop-up menu. In the Adjustments palette, drag the middle gray slider under the histogram to the right (or left), and you'll see the color of the recessed area changes as you drag. More importantly, you'll see that nothing else changes—just that area. This is why selections are so important—they are how you tell Elements you only want to adjust a specific area. You can also drag the white and black sliders to get the lighting you want. You'll notice your selection goes away when you add the adjustment layer.

Step Five:

Okay, you've got rectangles, but what if you want to make a perfectly square selection? It's easy—the tool works the same way, but before you drag out your selection, you'll want to hold the Shift key down. Let's try it: open another image, get the Rectangular Marquee tool, press-and-hold the Shift key, and then draw a perfectly square selection (around the black area inside of this fake Polaroid frame, in this case).

While your selection is still in place, open a photo that you'd like to appear inside your selected area and press Ctrl-A (Mac: Command-A); this is the shortcut for Select All, which puts a selection around your entire photo at once. Then press Ctrl-C (Mac: Command-C) to copy that photo into Elements' memory.

Step Seven:

Switch back to the Polaroid image, and you'll notice that your selection is still in place. Go under the Edit menu and choose Paste Into Selection. The image held in memory will appear pasted inside your square selection. If the photo is larger than the square you pasted it into, you can reposition the photo by just clicking-and-dragging it around inside your selected opening.

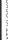

218

Step Eight:

You can also use Free Transform (press Ctrl-T [Mac: Command-T]) to scale the pasted photo in size. Just grab a corner point (press Ctrl-0 [zero; Mac: Command-0] if you don't see them), press-and-hold the Shift key (or turn on the Constrain Proportions checkbox in the Options Bar), and drag inward or outward. When the size looks right, press the Enter (Mac: Return) key and you're done. (Well, sort of—you'll need to press Ctrl-D [Mac: Command-D] to Deselect, but only do this once you're satisfied with your image, because once you deselect, Elements flattens your new image into your Background layer, meaning there's no easy way to adjust this image.) Now, on to oval and circular selections...

Step Nine:

Open an image with a circle shape you want to select (half of a lime here), and then press M to switch to the Elliptical Marquee tool (pressing M toggles you between the Rectangular and Elliptical Marquee tools by default). Now, just click-and-drag a selection around your circle. Press-andhold the Shift key as you drag to make your selection perfectly round. If your round selection doesn't fit exactly, you can reposition it by moving your cursor inside the borders of your round selection and clicking-and-dragging to move it into position. You can also press-and-hold the Spacebar to move the selection as you're creating it. If you want to start over, just deselect, and then drag out a new selection. *Hint:* With circles, it helps if you start dragging before you reach the circle, so try starting about 1/4" to the top left of the circle.

Step 10:

We'll change the lighting on the lime to really see the detail, so go under the Enhance menu, under Adjust Lighting, and choose **Shadows/Highlights**. Drag the Lighten Shadows slider to 0%. Then, move the Darken Highlights slider up to around 10%. Finally, take the Midtone Contrast slider down to –40%. That should bring out the detail in the lime. Now click OK, then deselect.

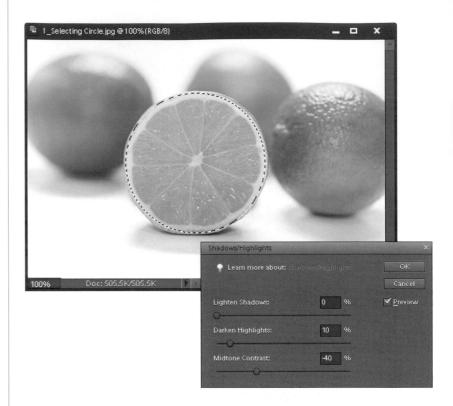

Step 11:

This isn't really a step, it's more of a recap: To make rectangles or ovals, you just grab the tool and start dragging. However, if you need to make a perfect square or a circle (rather than an oval), you press-and-hold the Shift key before you start dragging. You're starting to wish you'd paid attention in geometry class now, aren't you? No? Okay, me either.

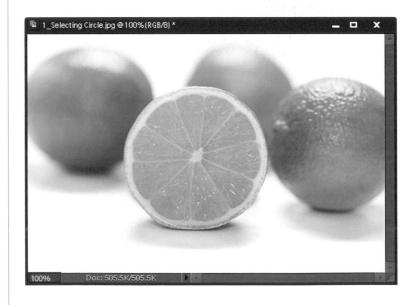

If you've spent 15 or 20 minutes (or even longer) putting together an intricate selection, once you deselect it, it's gone. (Well, you might be able to get it back by choosing Reselect from the Select menu, as long as you haven't made any other selections in the meantime, but don't count on it. Ever.) Here's how to save your finely-honed selections and bring them back into place anytime you need them.

Saving Your Selections

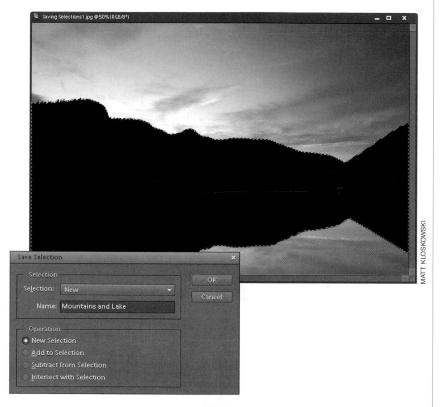

Step One:

Open an image and then put a selection around an object in your photo using the tool of your choice. Here I used the Quick Selection tool (A) to select the sky, then went under the Select menu and chose Inverse to select the mountains and lake. Then, | Alt-clicked (Mac: Option-clicked) on the sky's reflection to remove it from the selection. To save your selection once it's in place (so you can use it again later), go under the Select menu and choose Save Selection. This brings up the Save Selection dialog. Enter a name in the Name field and click OK to save your selection.

Step Two:

Now you can get that selection back (known as "reloading" by Elements wizards) at any time by going to the Select menu and choosing **Load Selection**. If you've saved more than one selection, they'll be listed in the Selection pop-up menu—just choose which one you want to "load" and click OK. The saved selection will appear in your image.

Softening Those Harsh Edges

When you make an adjustment to a selected area in a photo, your adjustment stays completely inside the selected area. That's great in many cases, but when you deselect, you'll see a hard edge around the area you adjusted, making the change look fairly obvious. However, softening those hard edges (thereby "hiding your tracks") is easy—here's how:

Step One:

Let's say you want to darken the area around the woman, so it looks almost like you shined a soft spotlight on her. Start by drawing an oval selection around her using the Elliptical Marquee tool (press **M** until you have it). Make the selection big enough so the woman and the surrounding area appear inside your selection. Now we're going to darken the area around her, so go under the Select menu and choose **Inverse**. This inverses the selection so you'll have everything but the woman selected (you'll use this trick often).

Step Two:

Click on the Create New Adjustment Layer icon at the bottom of the Layers palette, and choose **Levels**. In the Adjustments palette, drag the shadow Input Levels slider to the right to about 66. You can see the harsh edges around the oval, and it looks nothing like a soft spotlight—it looks like a bright oval. That's why we need to soften the edges so there's a smooth blend between the bright oval and the dark surroundings.

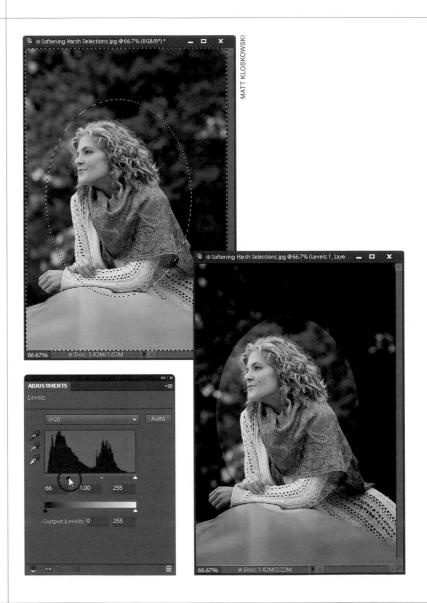

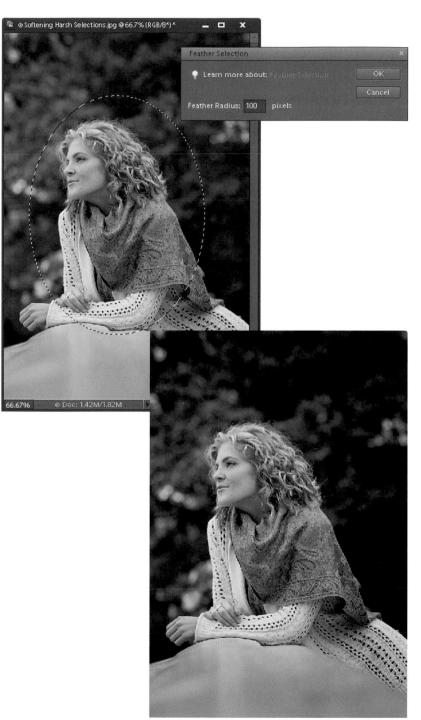

Press Ctrl-Z (Mac: Command-Z) three times so your photo looks like it did when you drew your selection in Step One (your selection should be in place—if not, drag out another oval). With your selection in place, go under the Select menu and choose Feather. When the Feather Selection dialog appears, enter 100 pixels (the higher the number, the more softening effect on the edges) and click OK. That's it—you've softened the edges. Now, let's see what a difference that makes.

Step Four:

Go under the Select menu and choose Inverse again. Add a Levels adjustment layer again, drag the shadow Input Levels slider to around 43, and you can see that the edges of the area you adjusted are soft and blending together smoothly, so it looks more like a spotlight. Now, this comes in really handy when you're doing things like adjusting somebody with a face that's too red. Without feathering the edges, you'd see a hard line around your person's face where you made your adjustments, and it would be a dead giveaway that the photo had been adjusted. But add a little bit of feather (with a face, it might only take a Feather Radius amount of 2 or 3 pixels), and it will blend right in, hiding the fact that you made an adjustment at all.

Selecting Areas by Their Color

So, would you select an entire solid-blue sky using the Rectangular Marquee tool? You probably wouldn't. Oh, you might use a combination of the Lasso and Rectangular Marquee tools, but even then it could be somewhat of a nightmare (depending on the photo). That's where the Magic Wand tool comes in. It selects by ranges of color, so instead of clicking-and-dragging to make a selection, you click once and the Magic Wand selects things in your photo that are fairly similar in color to the area you clicked on. The Magic Wand tool is pretty amazing by itself, but you can make it work even better.

Step One:

Open a photo that has a solid-color area that you want to select (in this case, it's the orange part of her dress). Start by choosing the Magic Wand tool from the Toolbox (or press the **W key**). Then, click it once in the solid-color area you want to select. You can see that part of the orange section is selected, but not all of it (because, although the section is orange, there are all different shades of orange in it, caused by shadows and highlights. That's why this is such a good example—sometimes one click is all it takes and the whole object will be selected, but more often than not, you'll need to do a little more Magic Wanding to get all of the color).

Step Two:

As you can see above, the first click didn't select the entire area, so to add other areas to what you already have selected, just press-and-hold the Shift key, and then click on those parts of the orange section that aren't selected. Keep holding down the Shift key and clicking on all the areas that you want to select until the entire orange section is selected, as shown here. It took about seven Shift-clicks with the Magic Wand for me to get this orange section selected.

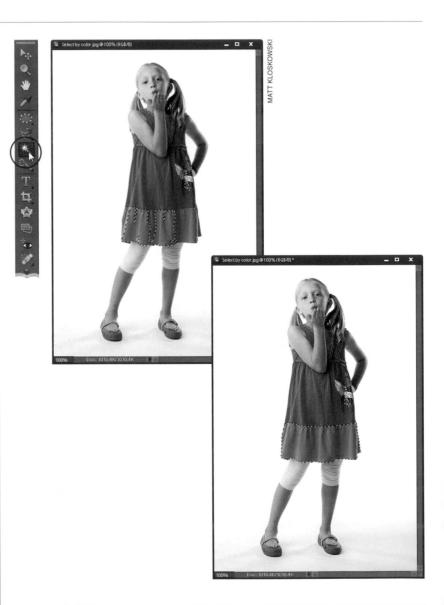

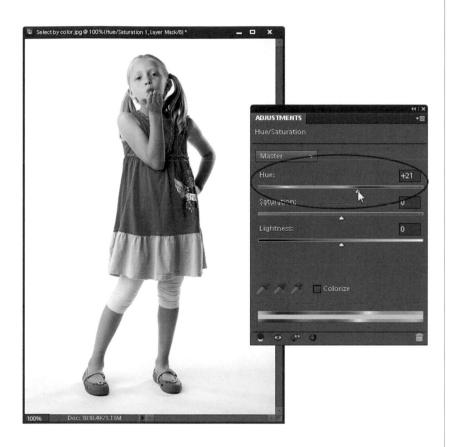

Now you can use a Hue/Saturation adjustment layer to change the color of the bottom section of her dress. Click on the Create New Adjustment Layer icon at the bottom of the Layers palette, and choose **Hue/Saturation**. In the Adjustments palette, drag the Hue slider until the bottom section of the dress looks the way you want it.

TIP: Increase the Tolerance

If you click in an area with the Magic Wand and not all of that area gets selected, then deselect (Ctrl-D [Mac: Command-D]), go to the Options Bar, increase the Tolerance setting, and try again. The higher the setting, the wider the range of colors it will select; so as a rule of thumb: if the Magic Wand doesn't select enough, increase the Tolerance amount. If it selects too much, decrease it.

Making Selections Using a Brush

A lot of people are more comfortable using brushes than using Marquee tools. If you're one of those people (you know who you are), then you're in luck—you can make your selections by painting over the areas you want selected. Even if this sounds weird, it's worth a try—you might really like it (it's the same way with sushi). A major advantage of painting your selections is that you can choose a soft-edged brush (if you like) to automatically give you feathered edges. Here's how it works:

Step One:

Choose the Selection Brush tool from the Toolbox (press the **A key** until you have it). Before you start, you'll want to choose your brush size by clicking on the brush thumbnail in the Options Bar to open the Brush Picker. If you want a soft-edged selection (roughly equivalent to a feathered selection), choose a soft-edged brush in the Picker or change your brush's Hardness setting in the Options Bar: 0% gives a very soft edge, while 100% creates a very hard edge.

Step Two:

Now you can click-and-drag to "paint" the area you want selected. When you release the mouse button, the selection becomes active. *Note*: You don't have to hold down the Shift key to add to your selection when using this brush—just start painting somewhere else and it's added. However, you can press-and-hold the **Alt (Mac: Option) key** while painting to deselect areas.

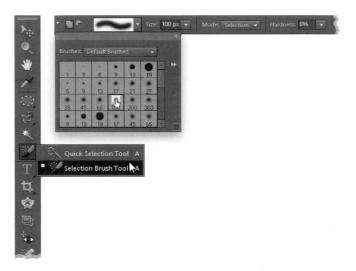

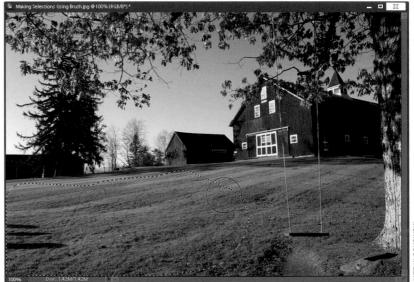

ATT KLOSKOWSKI

If you've ever tried the Lasso tool for making selections, then you know two things: (1) it's pretty useful, and (2) tracing right along the edge of the object you're trying to select can be pretty tricky. But you can get help in the form of a better tool called (are you ready for this?) the Magnetic Lasso tool! If the edges of the object you're trying to select are fairly well defined, this tool will automatically snap to the edges (as if they're magnetic), saving you time and frustration (well, it can save frustration if you know this technique).

Getting Elements to Help You Make Tricky Selections

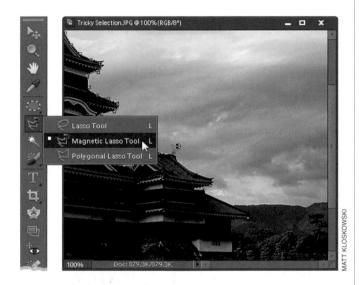

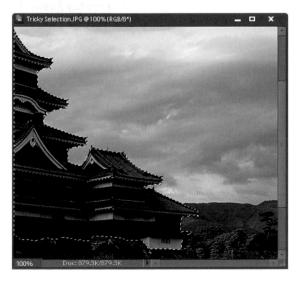

Step One:

Click-and-hold for a moment on the Lasso tool in the Toolbox and a menu will pop up where you can choose the **Magnetic Lasso Tool** (or just press the **L key** until you have it). Then, open an image in which you want to make a selection. Click once near the edge of the object you want to select. Without holding the mouse button, move the Magnetic Lasso tool along the edge of the object, and the selection will "snap" into place. Don't move too far away from the object; stay close to it for the best results.

Step Two:

As you drag, the tool lays down little points along the edge. If you're dragging the mouse and it misses an edge, just press Backspace (Mac: Delete) to remove the last point and try again. If it still misses, press-and-hold the Alt (Mac: Option) key and then hold down the mouse button, which temporarily switches you to the regular Lasso tool. Drag a Lasso selection around the trouble area, then release the Alt key and the mouse button, and BAMyou're back to the Magnetic Lasso tool to finish up the job. Note: You can also click the Magnetic Lasso tool to add selection points, if needed.

Easier Selections with the Quick Selection Tool

This is another one of those tools in Photoshop Elements that makes you think, "What kind of math must be going on behind the scenes?" because this is some pretty potent mojo for selecting an object (or objects) within your photo. What makes this even more amazing is that I was able to inject the word "mojo" into this introduction, and you didn't blink an eye. You're one of "us" now....

Step One:

Open the photo that has an object you want to select (in this example, we want to select the hat). Go to the Toolbox and choose the Quick Selection tool (or just press the **A**, for Awesome, **key**).

Quick Selection Tool A T Selection Brush Tool A 100% Doc: 1,00M/1,00M

Step Two:

The Quick Selection tool has an Auto-Enhance checkbox up in the Options Bar. By default, it's turned off. My line of thinking is this: when would I ever not want an enhanced (which in my book means better) selection from the Quick Selection tool? Seriously, would you ever make a selection and say, "Gosh, I wish this selection looked worse?" Probably not. So go ahead and turn on the Auto-Enhance checkbox, and leave it that way from now on.

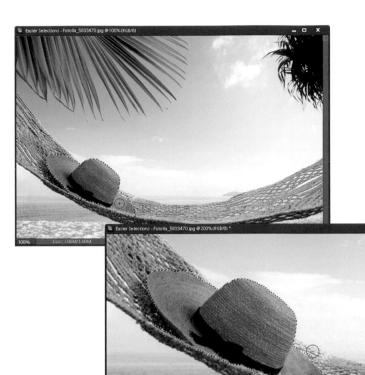

Take the Quick Selection tool and simply paint squiggly brush strokes inside of what you want to select. You don't have to be precise, and that is what's so great about this tool—it digs squiggles. It longs for the squiggles. It needs the squiggles. So squiggle.

Step Four:

As you paint, the Quick Selection tool makes your selection for you, based on the area that you painted over. If the selection includes areas you don't want, such as a little bit of the hammock here, simply press-and-hold the **Alt (Mac: Option) key** and paint over the unwanted part. This removes it from your selection.

Step Five:

Now that we've got it selected, we might as well do something to it, eh? How about this: let's leave the hat in color, and make the background black and white. You start by going under the Select menu and choosing **Inverse** (which inverses your selection so you've got everything selected but the hat). Go under the Enhance menu, under Adjust Color, and choose **Remove Color**. That's it. Now you can deselect by pressing **Ctrl-D** (**Mac: Command-D**).

Removing People (or Objects) from Backgrounds

One of the most requested selection tasks is how to remove someone (or something) from a background. Luckily, this task has been made dramatically easier thanks to a fairly amazing tool called the Quick Selection tool (and you know if they use the word "quick" it must be true, thanks to rigid enforcement of the truth in advertising laws).

Step One:

You'll find the Quick Selection tool in the Toolbox (as you might expect) nested with the Selection Brush tool (or you can press **A** to get it).

Step Two:

Here's how it works: Just take the brush and drag it over the person or object you want to select (in this case, I wanted to select the whole family from the background, so I dragged across them). The first time I tried it, it almost selected all of them. The key word here is "almost." Sometimes, it does a perfect job and other times, well...not so perfect. But more often than not, it really works wonders. Now, if you drag over an area, and it doesn't get the entire person, just drag again over (or just click on) any areas it missed the first time. So, be prepared to drag one or more times to get them all. If you get part of the background in your selection, press-and-hold the Alt (Mac: Option) key and paint over the area you want removed.

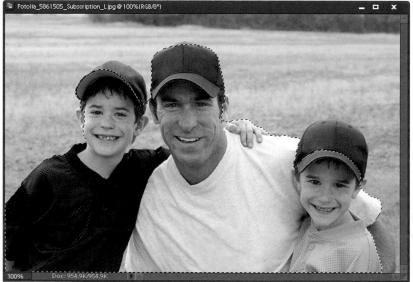

OTOLIA/SONYA ETCHISON

Here the family is selected after just a couple of paint strokes. Then I used the Zoom tool (Z) to zoom in, and removed a few areas in between the dad and boy that were selected accidentally.

Step Four:

Well, now that we've got a selection, we might as well have some fun with it. Open a different image (in this case, a baseball diamond), then go back to your selected family image (make sure all your windows are floating by going under Window, under Images). Press V to get the Move tool, and drag your selected family right over onto the baseball diamond photo. If the people are too big, press Ctrl-T (Mac: Command-T) to bring up the Free Transform bounding box, then pressand-hold the Shift key (or turn on the Constrain Proportions checkbox in the Options Bar), grab a corner handle, and drag inward to scale them down to size. Press Enter (Mac: Return) to lock in your resizing. Note: If you can't see the corner handles, press Ctrl-0 (zero; Mac: Command-0).

Step Five:

Since you're a photographer, you've probably already noticed a problem or two. First, the depth of field doesn't look realistic here. Generally, the people should be in focus in the photo and the background should be blurry. The people also look too "warm" for the surroundings, so we'll have to remove some of the blue tint from the background to make it look like the family is really in the scene. Let's take care of the depth of field first. Click on the baseball diamond layer (the Background layer). Go under the Filter menu and, under Blur, choose Gaussian Blur. Enter a setting of around 3 pixels and click OK. This should make the people look more like they were really there, as well as help them pop off the background.

Step Six:

Now, with the Background (baseball diamond) layer still selected in the Layers palette, go under the Filter menu, under Adjustments, and choose **Photo Filter**. From the Filter pop-up menu, choose **Warming Filter (85)**. If the effect isn't enough, increase the Density a little, and if it's too much, reduce the Density (I dragged it to 16%). Now the baseball diamond will better match the warmer tones of the family photo. Click OK and you're done.

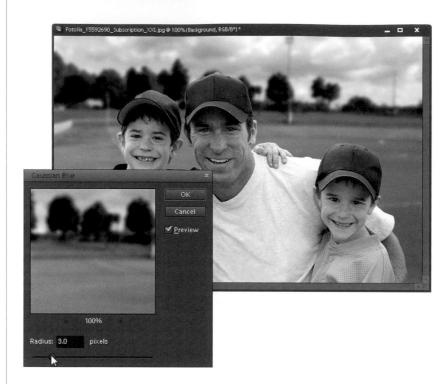

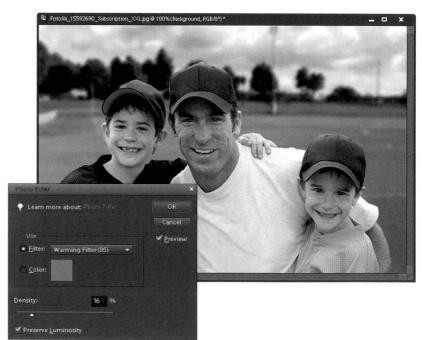

Before 1

Before 2

After

Retouch Me

retouching portraits

You gotta love it when you search the iTunes Store for the word "retouching" and a song called "Retouch Me" comes up. It's too perfect. Now, this chapter is about retouching, but it's not about making people look perfect—it's about making them look as good in a flat, two-dimensional photo as they do when you see them in person. There's something wonderful that happens when you see someone in person: your mind doesn't focus on their facial flaws, and wrinkles, and blemishes. Instead, your mind focuses on how big their nose is. It's a sad truth, that's been proven scientifically by a faux science group of unlicensed clinicians, that no matter how

smooth and silky their skin may be, no matter how alluring their eyes are, and no matter how toothy their teeth are, if they have a giant honker, they might as well be Jabba the Hutt. And their only chance of finding an actual date would be to either (a) have a crew of bounty hunters enslave a princess (or prince) when they least expect it, or (b) talk you into taking the retouching techniques you're about to learn in this chapter to retouch their eHarmony.com photo, so they look less like Jabba and more like George Clooney (or in other words...more like me, because I've been told numerous times I look like his identical twin. Well, except for the nose).

Quick Skin Tone Fix

In photos of people, the most important thing is that the skin tone looks good. That's because it's really hard for someone looking at your photo to determine if the grass is exactly the right shade of green or if the sky is the right shade of blue; but if the skin tone is off, it sticks out like a sore thumb (which would be red if it were really sore). Here's a quick fix to get your skin tones patched up in a hurry:

Step One:

Open an image in which the skin looks like it has a specific color cast to it. In this example, because of the lighting and the time of day, the girls' skin has a very bluish color to it. We'll want to add more yellow, since yellow will counteract the blue color (they're opposites on a color wheel), and make it look more lifelike and warm.

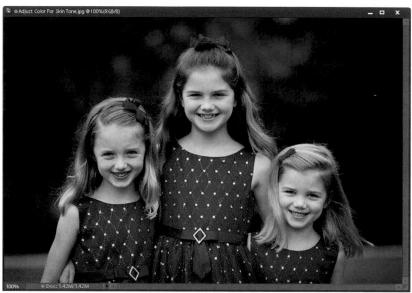

Step Two:

Go under the Enhance menu, under Adjust Color, and choose **Adjust Color for Skin Tone**.

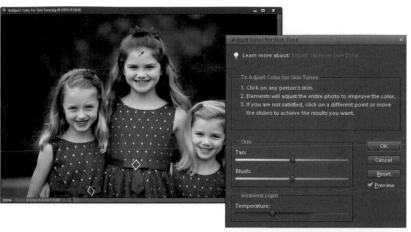

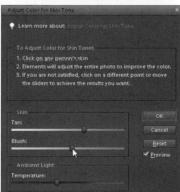

When the Adjust Color for Skin Tone dialog appears, move your cursor over an area of skin tone and click once to set the skin tone for the image. If you don't like your first results, click in a different area of skin tone until you find a skintone adjustment you're happy with.

Step Four:

You can also manually tweak the skin tone by using the Tan and Blush sliders, and you can control the overall tint of the light by dragging the Temperature slider to the left to make the skin tones cooler or to the right to make them warmer. Note: This skin-tone adjustment affects more than just skin—it usually warms the entire photo. If that creates a problem, use one of the selection tools (even the Lasso tool) to put a selection around the skin-tone areas first, add a 2-pixel Feather (under the Select menu), and then use the Adjust Color for Skin Tone command.

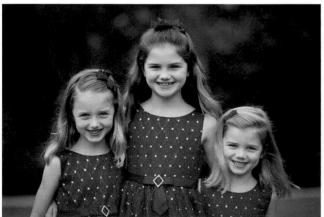

The Power of Layer Masks

One of the things that Elements never had that the full version of Photoshop did was layer masks. It was always one of the big features that people liked more about the full version of Photoshop. Well, I'm happy to be the bearer of good news: Elements now has layer masks. Yup, the same layer masks as Photoshop. These things are a huge help when it comes to working on your photos. Whether it's retouching, color correction, sharpening—you name it—layer masks play a key role. We'll give you a quick introduction here, but you'll see them pop up plenty of times throughout this chapter, and the rest of the book.

Step One:

In order to really take advantage of layer masks, you need to have at least two layers. So, go ahead and open two images that you'd like to combine in some way. In this example, we're going to put the photo of the snowboarder into the computer screen and make it look like a part of him is actually coming out of the screen.

Step Two:

Click on the photo of the snowborder, and press Ctrl-A (Mac: Command-A) to Select All. Then press Ctrl-C (Mac: Command-C) to copy the photo. Switch over to the photo of the laptop, and press Ctrl-V (Mac: Command-V) to paste the snowboarder on top of the laptop screen on a separate layer. Press Ctrl-T (Mac: Command-T) to go into Free Transform. With the Constrain Proportions checkbox turned on in the Options Bar, grab a corner handle and drag inward to make the image smaller, then move it so the bottom-left corner of the photo meets the white space at the bottom-left corner of the screen. Once you've got the snowboarder positioned like you see here, press Enter (Mac: Return) to lock in your changes, and close the original photo of him, so you're left with only the document with two layers.

Step Three:

There are two main ways to work with layer masks: selections and brushes. Let's look at selections first. Hide the top layer (the snowboarder) by clicking on the Eye icon to the left of it in the Layers palette, so you only see the laptop. Click on the Background layer, and use the Rectangular Marquee tool (M) to make a selection of the white area inside the laptop screen.

Step Four:

Now unhide the photo of the snow-boarder by clicking where the Eye icon used to be, and click on that layer to target it. When working with layer masks, a selection tells Photoshop that you want to keep that portion of a layer and hide the rest of it. Notice I said hide, not delete. Give it a try. Click on the Add Layer Mask icon at the bottom of the Layers palette and see what happens.

Step Five:

You should now see only the rectangular area (that was previously selected) of the photo. Again, when you have a selection active, a layer mask tells Photoshop that you want to keep the selected area visible and hide everything that isn't selected. In our case, a portion of the layer with the snowboarder on it was selected so that stays visible. But the rest of him (his hand and part of his arm) was hidden (again, not deleted—just hidden for now).

Step Six:

Now take a look at the layer itself. Notice it has a black-and-white thumbnail next to the image thumbnail? That's the layer mask. The layer mask is the same size as the layer. The white part of the thumbnail corresponds to the rectangular portion of the photo (snowboarder) that we see. The black part corresponds to the area we don't see. In other words, white shows you whatever is on the layer that the layer mask is attached to. Black hides that part of the layer and shows you whatever is below it in the layer stack (in this case, the laptop).

Step Seven:

The biggest advantage of layer masks is that nothing is permanent. Even though it looks like we've deleted the sky around the snowboarder, it's still there. Go ahead and look at the layer thumbnail (circled here) and you'll see it looks exactly the same. Nothing was deleted—just hidden. Layer masks are non-destructive and always give you a way out. Just to demonstrate really quickly, click once on the layer mask thumbnail (not the layer thumbnail) to select it. Then go under the Edit menu and choose Fill Layer. Set the Use pop-up menu to White and click OK to fill the whole mask with white again. Things are back to normal, as if nothing ever happened.

Step Eight:

Press Ctrl-Z (Mac: Command-Z) to undo that last step, so the black-andwhite layer mask is back again. Let's take a look at the other main way to work with layer masks: adjusting them after the fact with brushes. In our example, the snowboarder's hand and arm are cut off. We can fine-tune the mask to show them, though. Remember, layer masks just care about one thing: black and white. It doesn't matter how black and white get there. Earlier, we did it with a selection, but you can also use a brush to get the ultimate flexibility and control over the mask. Click on the mask thumbnail, then get the Brush tool (B) and choose a small, soft-edged brush. Set your Foreground color to white (remember, white allows us to keep whatever is on this layer visible) and paint over the areas that aren't showing (the hand and arm). You'll see them reappear, because they weren't permanently gone in the first place.

Step Nine:

Why all the trouble? If you're asking yourself, why not just erase away the unwanted areas, then read on. If not, skip to the next step. So, what would happen if we erased away the sky with the Eraser tool? Then we erased some more sky? At some point, maybe we'd erase away part of the snowboarder's hand. But then we'd continue to erase away sky until we got to the point where we were done, and we'd realize we'd erased part of the snowboarder's hand. Well, each one of those clicks of the mouse when we erase is a history state. They build up, so we'd have to undo all the work we did to get back to the point where we inadvertently erased the snowboarder's hand. Needless to say, that'd be a big pain in the neck. Plus, since layer masks are part of the layer, we can save our image as a PSD file and open it again tomorrow (or at some later date) and change it. Layer masks allow us to be non-destructive in our editing, so we can always come back and change something later if we need to.

Step 10:

You can see in Step Eight that I went a little overboard with the white brush and brought back parts of the sky, too. No sweat. Remember that black and white thing? We were painting with white to bring areas back into view, so if we switch to black, the opposite will happen. Press the letter **X** on your keyboard to switch your Foreground color to black. Then paint on the mask again to hide those sky areas and reveal the laptop and background under him.

Over the years, we've learned lots of different ways to remove hot spots, blemishes, and other imperfections on the skin. I believe the technique you're about to see here is the easiest and best way, though. It not only removes the blemishes, but it's flexible enough so you can maintain the original skin texture, as well. That way the skin looks real and not like the fakey, smooth skin that's always a dead giveaway the photo has been retouched in Elements.

Removing Blemishes and Hot Spots

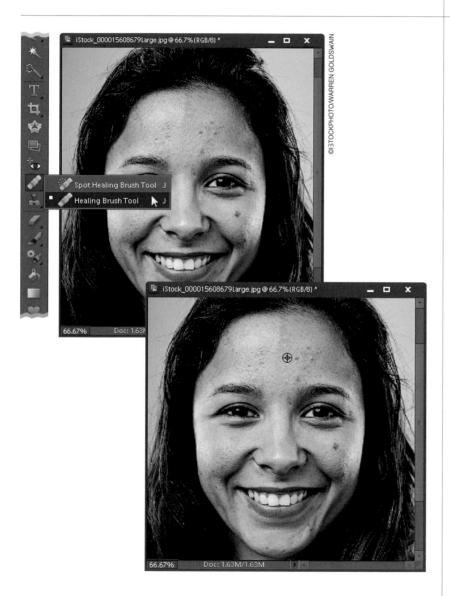

Step One:

Open a photo containing some skin imperfections you want to remove (in this example, we're going to remove a series of blemishes). Get the Zoom tool (Z) and zoom in, if needed, on the area you want to retouch, then get the Healing Brush tool (J) from the Toolbox (as shown here). You might be tempted to use the Spot Healing Brush tool because it's so easy to use (and it's the default healing tool in the Toolbox), but don't fall for it. Although it does a pretty good job on its own, you can do better and work faster with the Healing Brush because you won't have to redo anything (and you generally will have several redos using the Spot Healing Brush). Besides, you only save one click using the Spot Healing Brush over the regular Healing Brush.

Step Two:

The key to using the Healing Brush correctly is to find an area of skin to sample that has a similar texture to the area you want to repair (this is different than the Clone Stamp tool, where you're looking for matching color and shading, as well). Move your cursor over this "clean" area of skin, press-and-hold the Alt (Mac: Option) key, and click once to sample that area. Your cursor will momentarily change to a target as you sample (as shown here).

Now, just move the Healing Brush directly over the blemish or hot spot you want to remove and simply click. Don't paint—click. Once. That's it. That's the whole technique—BAM—the blemish is gone!

TIP: Resizing Your Brush

For the best results, use a brush size that is just a little bit larger than the blemish or hot spot you want to remove (use the **Left/Right Bracket keys** on your keyboard [they're to the right of the letter P] to change brush sizes). Also, you don't have to worry about sampling an area right near where the blemish or hot spot is—you can sample from another side of the face, even in the shadows—just choose a similar texture, that's the key.

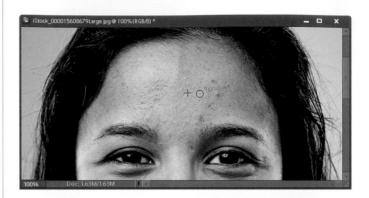

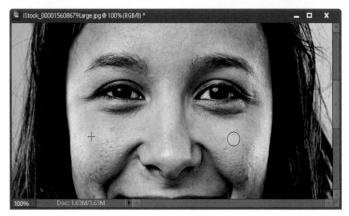

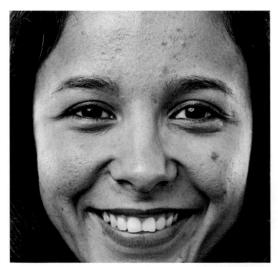

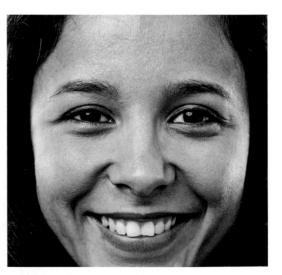

After

This technique is popular with senior class portrait photographers who need to lessen or remove large areas of acne, pockmarks, or freckles from their subjects. This is especially useful when you have a lot of photos to retouch and don't have the time to use the method shown previously, where you deal with each blemish individually.

Lessening Freckles or Facial Acne

Step One:

Open the photo that you need to retouch. Make a duplicate of the Background layer by going to the Layer menu, under New, and choosing Layer via Copy (or just pressing Ctrl-J [Mac: Command-J]). We'll perform our retouch on this duplicate of the Background layer, named "Layer 1."

Step Two:

Go under the Filter menu, under Blur, and choose **Gaussian Blur**. When the Gaussian Blur dialog appears, drag the slider all the way to the left, then drag it slowly to the right until you see the freckles blurred away. The photo should look very blurry, but we'll fix that in just a minute, so don't let that throw you off—make sure it's blurry enough that the freckles are no longer visible. Click OK.

Press-and-hold the Alt (Mac: Option) key and click once on the Add Layer Mask icon at the bottom of the Layers palette. This adds a black layer mask to your current layer (the blurry Layer 1), hiding the blurriness from view (and that's exactly what we want to do at this point).

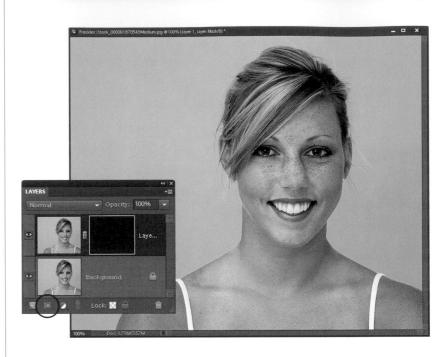

Opacity: 100% 🔻

Step Four:

In the Layers palette, make sure the layer mask is active (you'll see a white frame around its thumbnail), as you're going to paint on this layer. Press the letter **D** to set your Foreground color to white. Press the letter **B** to switch to the Brush tool, then click on the brush thumbnail in the Options Bar, and from the Brush Picker choose a soft-edged brush.

Step Five:

Lower the Opacity setting of your brush in the Options Bar to 50%, and change the Mode pop-up menu from Normal to Lighten. Now when you paint, it will affect only the pixels that are darker than the blurred state. Ahhh, do you see where this is going?

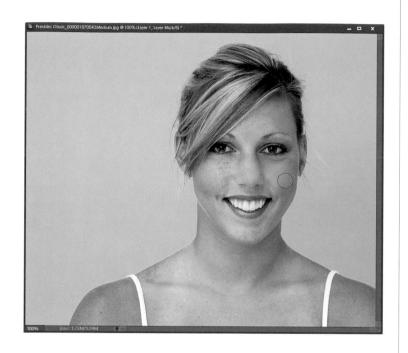

Step Six:

Now you can paint over the freckle areas, and as you paint, you'll see them diminish quite a bit. If they diminish too much, and the person looks "too clean," undo (Ctrl-Z [Mac: Command-Z]), then lower the Opacity of the brush to 25% and try again. If they don't diminish enough, paint over them again to build up the blurriness.

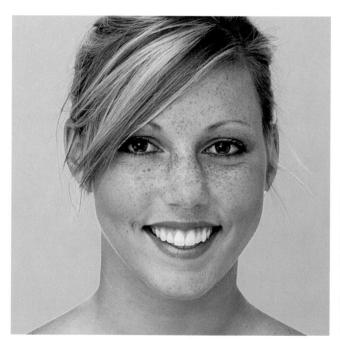

Before

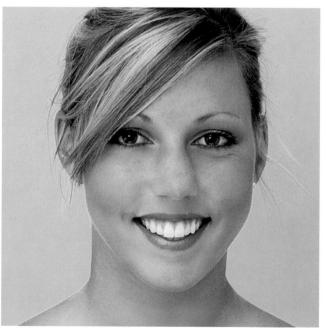

After

Removing Dark Circles Under Eyes

Here's a quick technique for removing or lessening dark circles under the eyes. It's one of those things that happen to a lot of people. It could be you've been working late (or, even better, partying late), or were just up late. Regardless of where they came from, there is a quick way to remove these dark circles.

Step One:

Open the photo that has the dark circles you want to remove or lessen. Select the Clone Stamp tool in the Toolbox (or press the **S key**). Then, click on the brush thumbnail in the Options Bar to open the Brush Picker and choose a soft-edged brush that's half as wide as the area you want to repair. *Note*: Press the letter **Z** to switch to the Zoom tool and zoom in if needed.

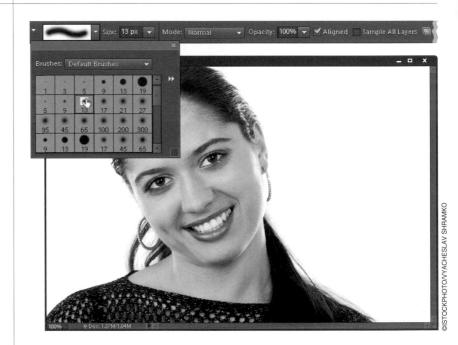

Step Two:

Go to the Options Bar and lower the Opacity of the Clone Stamp tool to 50%. Then, change the Mode pop-up menu to **Lighten** (so you'll only affect areas that are darker than where you'll sample from).

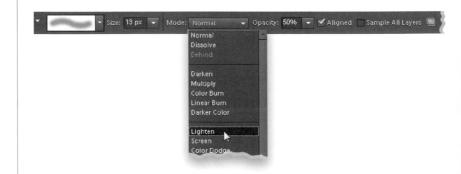

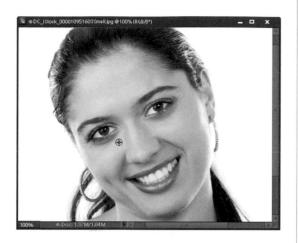

Press-and-hold the Alt (Mac: Option) key and click once in an area near the eye that isn't affected by the dark circles. If the cheeks aren't too rosy, you can click there, but more likely you'll click on (sample) an area just below the dark circles under the eyes.

Step Four:

Now, take the Clone Stamp tool and paint over the dark circles to lessen or remove them. It may take two or more strokes for the dark circles to pretty much disappear, so don't be afraid to go back over the same spot if the first stroke didn't work. *Note:* If you want the dark circles to completely disappear, try using the Healing Brush tool (J) from the Toolbox. Simply Alt-click (Mac: Option-click) the Healing Brush in a light area under the dark circles, and then paint the circles away.

Before

After

Removing or Lessening Wrinkles

This is a great trick for removing wrinkles, with a little twist at the end (courtesy of my buddy Kevin Ames) that helps make the technique look more realistic. This little tweak makes a big difference because (depending on the age of the subject) removing every wrinkle would probably make the photo look obviously retouched (in other words, if you're retouching someone in their 70s and you make them look as if they're 20 years old, it's just going to look weird). Here's how to get a more realistic wrinkle removal:

Step One:

Open the photo that needs some wrinkles or crow's-feet lessened or removed. Start by duplicating the Background layer by going to the Layer menu, under New, and choosing **Layer via Copy** (or pressing **Ctrl-J [Mac: Command-J]**). You'll perform your "wrinkle removal" on this duplicate layer, named "Layer 1" in the Layers palette.

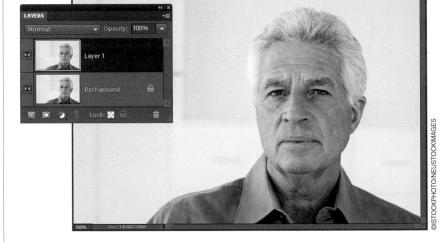

Step Two:

Get the Healing Brush tool from the Toolbox (or press the J key). Then, use the Left ([) and Right Bracket (]) keys to make your brush close to the size of the wrinkles you want to remove. Find a clean area that's somewhere near the wrinkles (perhaps the upper cheek if you're removing crow's-feet, or if you're removing forehead wrinkles, perhaps just above or below the wrinkle). Pressand-hold the Alt (Mac: Option) key and click once to sample the skin texture from that area. Now, take the Healing Brush tool and paint over the wrinkles. As you paint, the wrinkles will disappear, yet the texture and detail of the skin remains intact, which is why this tool is so amazing.

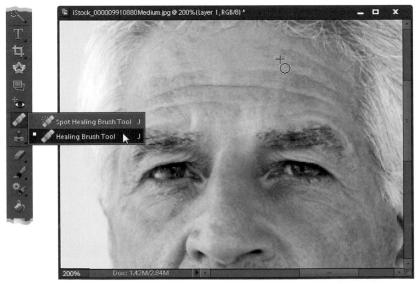

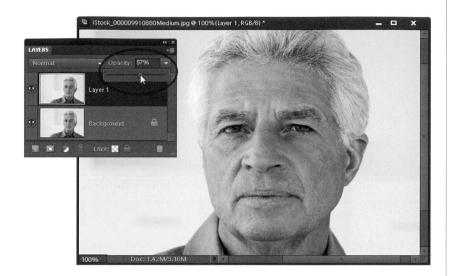

Now that the wrinkles are gone, it's time to bring just enough of them back to make it look realistic. Simply go to the Layers palette and reduce the Opacity of this layer to bring back some of the original wrinkles. This lets a small amount of the original photo (the Background layer, with all its wrinkles still intact) show through. Keep lowering the Opacity until you see the wrinkles, but not nearly as prominent as before.

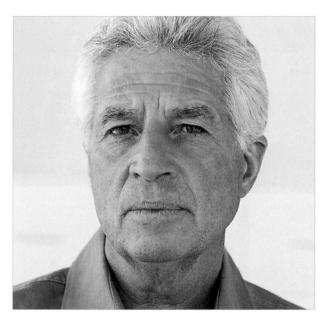

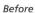

After

Brightening the Whites of the Eyes

This is a retouch that I do to every single photo where the subject's eyes are open. It seems like no matter how much light you get into the eyes during the shoot, the whites of the eyes end up off-white at best, but usually a light gray. This is one of those retouches that you just have to do once or twice—even if you think the eyes look white enough—because once you see the difference, you'll do this every single time. It makes that big a difference.

Step One:

In this example, the whites of her eyes look almost gray (or off-white at the very least). So, start by clicking on the Create New Adjustment Layer's icon at the bottom of the Layers palette and choosing **Levels** (as shown here). By the way, it doesn't really matter which adjustment you add at this point—we just need some adjustment layer, any adjustment layer, so we can change its blend mode. Why not just duplicate the Background layer? Because doing it this way doesn't add any size to your document, which keeps Elements running faster. Hey, it all adds up.

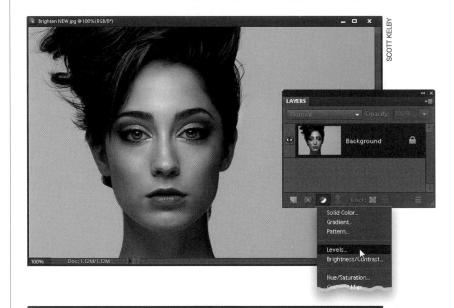

LAYERS Normal Normal Dissolve Darken Multiply Color Burn Linear Burn Darker Color Lighten Screen Color Dodge A Linear Dodge (Add)

Step Two:

At the top of the Layers palette, change your blend mode for this adjustment layer from Normal to **Screen**. The Screen blend mode makes your image much brighter (compare the brighter image shown here with the one in Step One and you'll see what I mean).

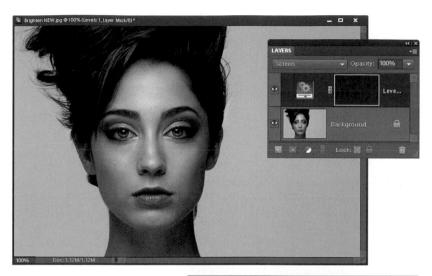

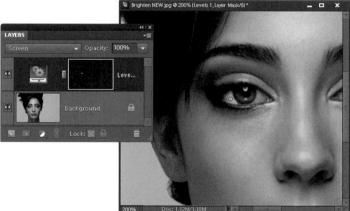

The problem with our image at this point is we only want the whites of her eyes brighter (and maybe her irises), but not her skin or anything else. So, we'll have to do some simple masking. Start by pressing **Ctrl-I (Mac: Command-I)**, which inverts the layer mask, making it black and hiding the brightening brought on by changing the blend mode to Screen.

Step Four:

Zoom in on one of the eyes, press **X** to switch your Foreground color to white, then press **B** to get the Brush tool. Choose a very small, soft-edged brush from the Brush Picker in the Options Bar, and begin painting over the whites of the eyes (as shown here, where I'm painting over the left side of the eye on the left). As you paint, this area becomes much brighter, because you're revealing the Screen layer you applied earlier.

Step Five:

The tricky part of this technique comes when you try to paint that little bit of white that appears right below the iris. It's just so tiny that getting in there and doing it without spilling over onto the edge of the iris, or the bottom eyelid, is really a pain. So, what's the solution? Don't worry about it—just paint right over the whites, and if your brush extends over onto the iris or the bottom evelid (like you see here), it's okay. The reason it's okay is I've found it's much easier to crase the spillover than it is to try to paint it just right with a supersmall brush. After all, you've already got a layer mask applied; to clean this up will be a five-second fix (as you'll see in the next step).

Step Six:

To get rid of the spillover (brightening of the iris or lower eyelid), just press the letter X to set your Foreground color to black, then paint over the spillover to remove it (as shown here). It couldn't be easier or faster. When you're done, just press X again to swap your Foreground and Background colors, making white your Foreground color again. Now, move over to the other eye and do the same thing.

Step Seven:

When you're done painting over both eyes, they'll probably look too white (giving your subject a freaky, possessed look), so in most cases, leaving the Opacity of this layer at 100% is unlikely. The best way to judge how white the whites of the eyes should be is to zoom out (like you see here), then lower the Opacity of this layer to around 50% and see how that looks. If it's still too bright, lower it a little bit more. The Opacity slider becomes your "whiteness amount slider," so just adjust it to where it looks natural, but brighter than it was before. A before/after is shown on the next page (I painted over the irises a little bit, too. They looked a little dark).

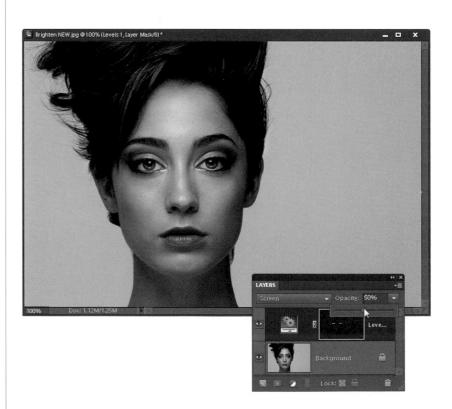

TIP: Brightening the Entire Eye Socket

If you need to lighten the entire eye socket area, you can use the Screen blend mode, but in a slightly different way. Press Ctrl-J (Mac: Command-J) to duplicate the Background layer, then change the blend mode to Screen to make the whole image brighter. Optionclick (PC: Alt-click) on the Add Layer Mask icon in the Layers panel to hide this brighter version behind a black mask. With your Foreground color set to white, get the Brush tool (B), and choose a medium-sized, soft-edged brush set to 100% Opacity. Now, paint over her eyes and the surrounding eye socket areas. I know she looks like she's been lying in the sun with sunglasses on, but we'll fix that by lowering the layer's Opacity until the brightening matches the rest of her face. If any edges look brighter, switch your Foreground color to black and paint right over them. Then, if the whites still need brightening, you can do the rest of this tutorial.

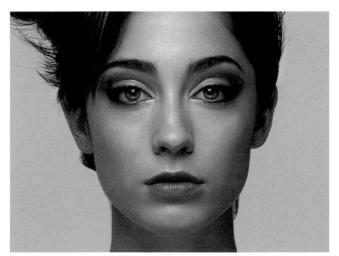

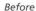

After

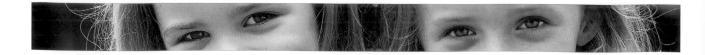

Making Eyes That Sparkle

This is another one of those 30-second miracles for enhancing the eyes. This technique makes the eyes seem to sparkle by accentuating the catch lights, and generally draws attention to the eyes by making them look sharp and crisp (crisp in the "sharp and clean" sense, not crisp in the "I-burned-my-retina-while-looking-at-the-sun" sense).

Step One:

Open the photo that you want to retouch. Make a duplicate of the Background layer by going under the Layer menu, under New, and choosing **Layer via Copy** (or pressing **Ctrl-J [Mac: Command-J]**), which creates a new layer named "Layer 1." *Note:* Press the **Z key** to switch to the Zoom tool and zoom in if needed.

Step Two:

Go under the Enhance menu and choose **Unsharp Mask**. (It sounds like this filter would make things blurry, but it's actually for sharpening photos.) When the Unsharp Mask dialog appears, enter your settings. (If you need some settings, go to the first technique, named "Basic Sharpening," in Chapter 10.) Here, we seem to be able to get away with a lot of sharpening (and I mean a lot), so I'm going to use Amount: 175, Radius: 1.5, and Threshold: 3. Then click OK to sharpen the entire photo.

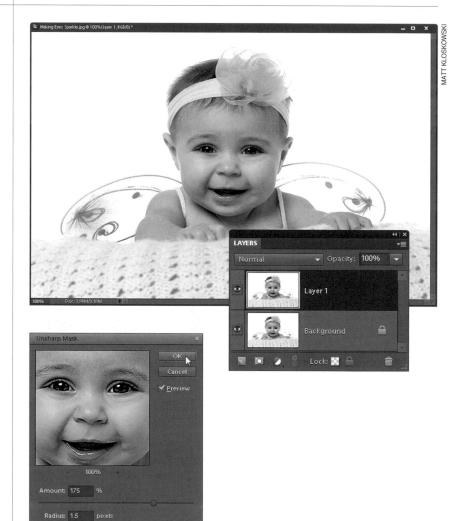

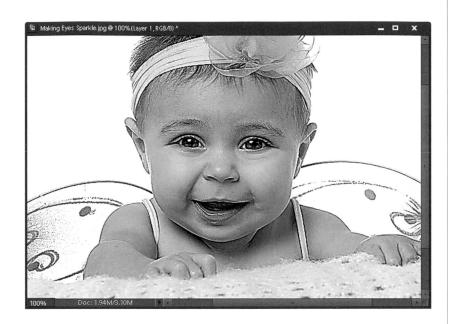

After you've applied the Unsharp Mask filter, apply it again using the same settings by pressing **Ctrl-F (Mac: Command-F)**. If you think it's still not enough, apply it one more time using the same keyboard shortcut. The eyes will probably look nice and crisp at this point, but the rest of the person will be severely oversharpened, and you'll probably see lots of noise and other unpleasant artifacts.

Step Four:

Press-and-hold the Alt (Mac: Option) key and click once on the Add Layer Mask icon at the bottom of the Layers palette. This adds a black layer mask to your sharpened layer, removing all the visible sharpness (at least for now). In the Layers palette, make sure the layer mask is active (you'll see a white frame around its thumbnail).

Step Five:

Press the letter **D** to set your Foreground color to white. Then, press **B** to switch to the Brush tool. Click on the brush thumbnail in the Options Bar to open the Brush Picker, and choose a soft-edged brush that's a little smaller than your subject's eyes. Now paint over just the irises and pupils of the eyes to reveal the sharpening, making the eyes really sparkle and completing the effect. If the effect seems too strong (it did here), just lower the Opacity of the layer with the layer mask.

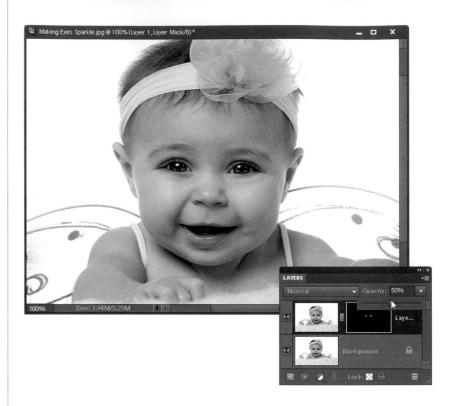

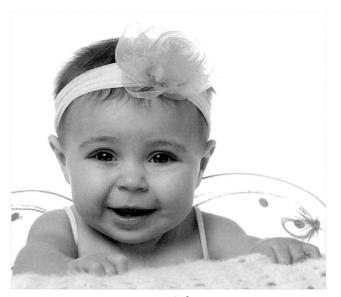

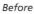

After

This really should be called "Removing Yellowing, Then Whitening Teeth" because almost everyone has some yellowing, so we remove that first before we move on to the whitening process. This is a simple technique, but the results have a big impact on the overall look of the portrait, and that's why I do this to every single portrait where the subject is smiling.

Whitening and Brightening Teeth

Step One:

Open the photo you need to retouch. Press **Z** to switch to the Zoom tool and zoom in if needed.

Step Two:

Press L to switch to the Lasso tool, and carefully draw a selection around the teeth, being careful not to select any of the gums or lips. If you've missed a spot, press-and-hold the Shift key while using the Lasso tool to add to your selection, or press-and-hold the Alt (Mac: Option) key and drag the Lasso to remove parts of the selection. If you've grown fond of the Quick Selection tool, then give that one a try here, as it works great too.

Go under the Select menu and choose **Feather**. When the Feather Selection dialog appears, enter 1 pixel and click OK to smooth the edges of your selection. That way, you won't see a hard edge along the area you selected once you've whitened the teeth.

Step Four:

Click on the Create New Adjustment Layer icon at the bottom of the Layers palette (it's the half-black/half-white circle icon) and choose **Hue/Saturation**. When the Hue/Saturation controls appear in the Adjustments palette, choose **Yellows** from the pop-up menu at the top. Then, drag the Saturation slider to the left to remove the yellowing from the teeth.

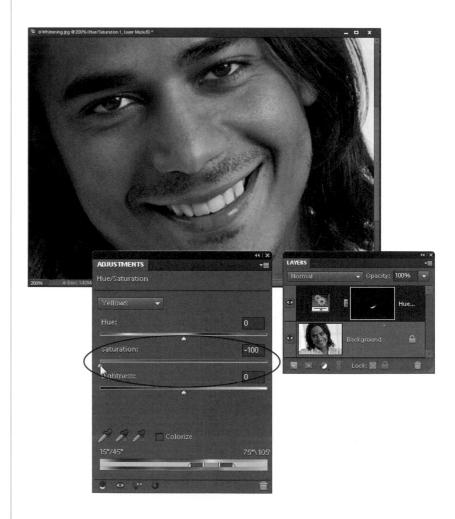

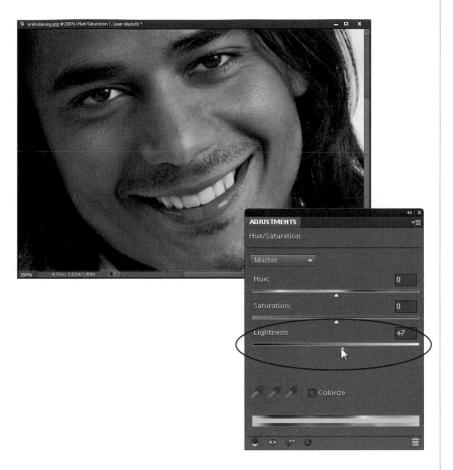

Step Five:

Now that the yellowing is removed, switch the pop-up menu back to Master, and drag the Lightness slider to the right to whiten and brighten the teeth. Be careful not to drag it too far, or the retouch will be obvious. Note: The Smart Brush tool (F) has an effect (under the Portrait preset in the pop-up menu) called Pearly Whites, which does pretty much the same thing but in a little different way. And if that one doesn't do the trick for you, then there's another effect called Very Pearly Whites (you think I'm kidding, don't you?) that does, well, the same thing but more intense.

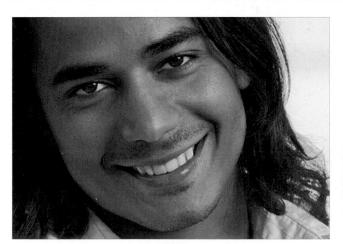

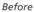

After

Repairing Teeth

Depending on your subject, this can be just a minor tweak, or a major reconstruction. Luckily, in most cases, you'll be able to fix most problems with teeth using the Liquify filter, but sometimes, you have to rebuild a tooth or two from scratch.

Step One:

Here's the image with teeth we want to retouch. First, let's evaluate what we need to do: the two front teeth look a little too long compared to the other teeth (they should only be a little longer than the surrounding teeth). So, that's one thing to fix. Then, I would remove the points from the canine teeth, and repair the gap on the canine tooth on the right. Lastly, I would straighten the bottom teeth.

Step Two:

Go under the Filter menu, under Distort, and choose Liquify. When the Liquify dialog appears, zoom in tight (press Ctrl-+ [Mac: Command-+] a few times). Then, select the first tool at the top of the Toolbox (on the left side of the dialog; it's called the Forward Warp tool, and lets you nudge things around like they were made of molasses). The key here is to make a number of very small moves—don't just get a big brush and push stuff around. Make your brush size (in the Brush Size field on the right) a little larger than what you're retouching (here, my brush is a little larger than one of the front teeth). Gently nudge the front teeth upward a few times each to shorten them, and once or twice between them to make them even. While you're there, flatten out the bottoms of them, too—just choose a smaller brush and gently nudge upward. It's already looking better.

Now, if you look closely, you can see that on the bottom of the front tooth on the right, there's a little indent that we can easily fix. Make your brush size really small (just a tiny bit bigger than the indent), and pull down on the indent until it lines up with the rest of the bottom of the tooth to make it nice and flat and smooth (as seen here). Let's now work on the two teeth on either side of the front two-same tool, same technique, smaller brush (because these teeth are smaller in size). Gently nudge these teeth downward a little to make them longer. Keep gently nudging them downward, until they're almost as long as the front two (but not quite as long).

Step Four:

Next, go to the canine tooth on the left (you can see my brush cursor there), and just push upward on the pointy part with the same tool (gently, gently, using a few little nudges—don't nudge it all at one time). This helps flatten it out a bit, but of course, now she won't be able to chew—hey, it's cheaper than buying caps. Once we're done in Liquify, we'll fix the gap on the other pointy canine tooth manually. But, you can go ahead and fix the other top teeth.

Step Five:

Using the same tool, we're now going to start straightening the bottom teeth. The bottom-middle tooth on the left is leaning toward the left, so with the Forward Warp tool, choose a brush size like the one you see here, click right on the line to the left of the tooth, then click-and-hold, and nudge that line over to the right to straighten it out a bit (like you see here). Now, the rest of this is going to be nudging the tops of the bottom teeth down, nudging the lines between them to the left or right to make them straighter, and pulling up where the teeth start to slant downward.

Step Six:

Again, you're going to use that same brush. Start by pushing the top right of that same bottom-middle tooth down along the right edge of the tooth, because it's extending upward too far. Again, just gently nudge it down using a few strokes. Do you see a pattern in this type of retouching? Most of the time, unless it's something very large you have to move, you're better off moving it a little, letting go of the brush, and moving it a little more, releasing, then doing it again and again—very small increments work best.

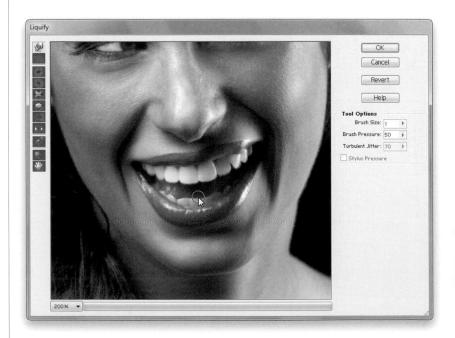

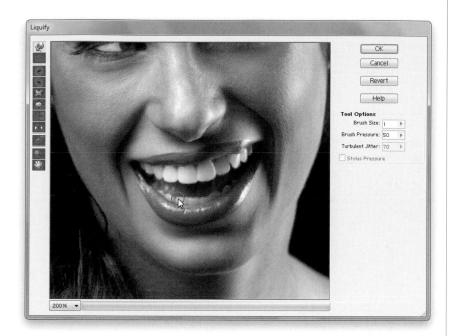

Step Seven:

If you look at the next tooth to the left, you'll see the left side of it slopes down a bit. So, you're going to have to pull that side up, so it's flat (as shown here) and aligns with the other bottom teeth. Same technique, same brush, just repeat what you've been doing with small, subtle nudges.

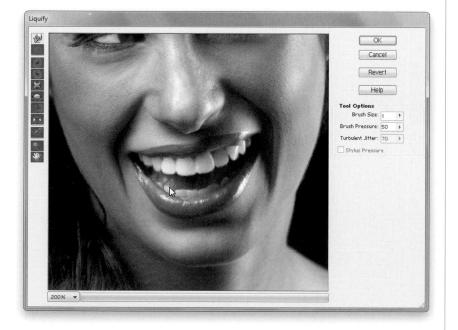

Step Eight:

Now, move to the next tooth to the left and build up the right side of the tooth (it's sloping downward), then nudge down the left side of the tooth. Just a little bit more Liquify work to go, but you can see the bottom row is already looking much better.

Step Nine:

Move to the next tooth on the left, and do the same thing, then move to the bottom teeth on the other side and fix those, as well (you kind of have to fix all of them in this image, though I usually just worry about the ones in front).

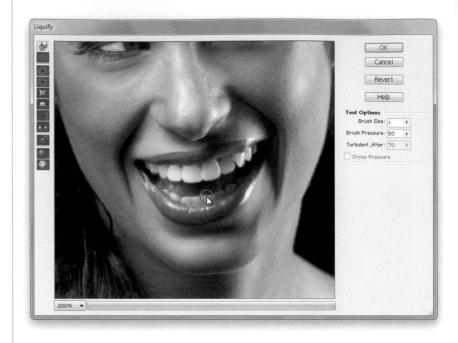

Step 10:

Now, we're going to work on that other pointy canine tooth in the top right, but first, we can do one last thing here in Liquify to make our job easier. Make the brush size larger, then remove the "pointyness" (yes, that's a word. Okay, it's not, but it should be) by nudging the bottom of the tooth upward a bit (as shown here). You can now click OK to apply all your Liquify filter changes, and we can get to work on filling that pointy tooth's gap.

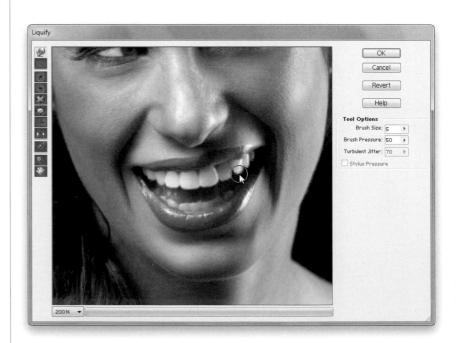

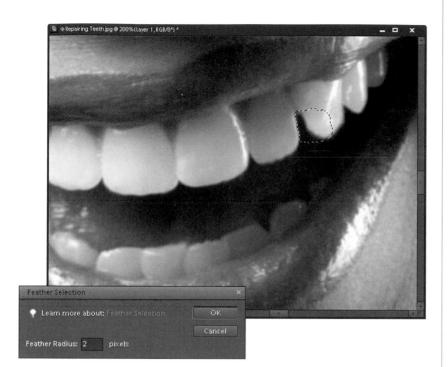

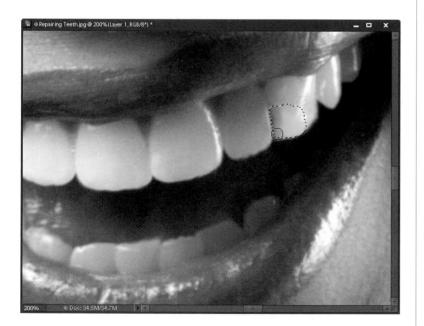

Step 11

You're going to need to make a selection in a shape that you want to add to the tooth, so I'm making a selection that covers the gap, and snuggles up against the other tooth (as seen here). I made this with the Lasso tool (L), but you can use any tool you're comfortable with (my first choice is usually the Pen tool, because making a precise path and turning that into a selection usually gives you the best results—it just takes a little longer. But, since I have a tablet and wireless pen, it was just too easy to draw this guick little selection with the Lasso tool). You're going to want to soften the edges of your selection (so it doesn't look harsh where your new tooth area meets the tooth beside it), so go under the Select menu and choose Feather. Enter 2 pixels in the Feather Selection dialog (shown here) for just a little softening, and click OK.

Step 12:

Create a new blank layer by clicking on the Create a New Layer icon at the bottom of the Lavers palette, and then get the Clone Stamp tool (S), so we can cover up that gap by cloning in some of the tooth from above the gap. In the Options Bar, make sure the Sample All Layers checkbox is turned on, and then from the Brush Picker, choose a small, soft-edged brush, and Alt-click (Mac: Option-click) on a highlight area on the tooth to sample that area for cloning. Move straight down and start painting over that gap. Don't worry, you won't accidentally paint over the other tooth. By putting a selection in place first, it's like putting up a fence you can't paint outside that fenced-in area. So, paint right across until it's all cloned in. Now, press Ctrl-D (Mac: Command-D) to Deselect and see your newly cloned tooth.

Step 13:

It looks like we're going to have to do the same thing to a couple of the bottom teeth to the right of center, as well. We can also use the Clone Stamp tool to make the tops of the bottom teeth more even. Just make your brush really small, sample a straight part of the top of a tooth, then move your brush over a little, and click to paint and straighten the rest of the top of the tooth. When you're finished, press Ctrl-E (Mac: Command-E) to merge the layers.

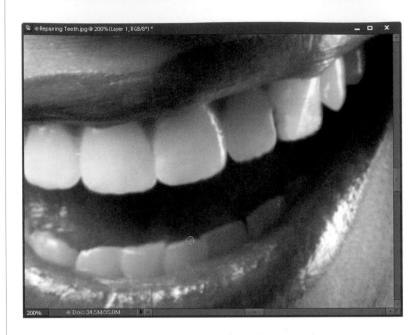

Step 14:

Now, in this particular case, the pointy tooth whose gap we fixed looks weird not because of the retouch, but because of how the real light falls on that tooth. It's brighter than the other teeth, and that brightness looks kind of yellow, so we'll need to deal with that. Again, you won't normally have to do this, but just in case this happens to you, at least you'll know what to do. Get the Lasso tool again (or the selection tool of your choice) and make a selection around that entire brighter, yellower tooth (as seen here). Add a 1-pixel feather, if you like, to slightly soften the edge.

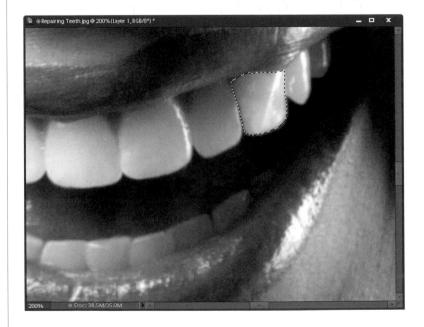

268

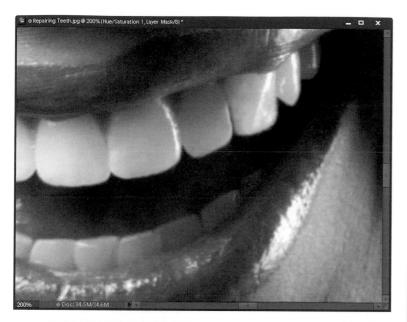

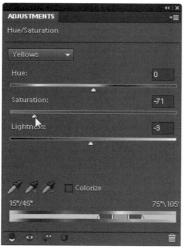

Step 15:

At the bottom of the Layers palette, click on the Create New Adjustment Layer icon and choose **Hue/Saturation** from the pop-up menu. From the pop-up menu at the top of the Adjustments palette, choose **Yellows**, then drag the Saturation slider to the left (as shown here) until the yellow in the tooth goes away (here, I had to drag it to -71 and then drag the Luminosity slider to -3 to get it to match the other teeth).

Step 16:

The last thing we're going to do here is to brighten the tooth to the left of the tooth we just fixed. It has a little bit of a shadow on it, and we want to make it look like it's more in line with the other teeth. So, get the Lasso tool again and make a selection of that tooth. Add a 2-pixel feather, to soften the edges a little. Then, click on the Create New Adjustment Layer icon again, but this time, choose Levels. Drag the gray midtones Input Levels slider, under the histogram, to the left a little to brighten the tooth. In this image, there is a lot of red in the shadow area, so next change the pop-up menu above the histogram to Red, and drag the midtones Input Levels slider to the right a little to reduce the reds and brighten the area. Each image will be different, so you'll just have to go through each color in the pop-up menu, and drag the midtones or shadows Input Levels slider until the color matches the surrounding teeth better.

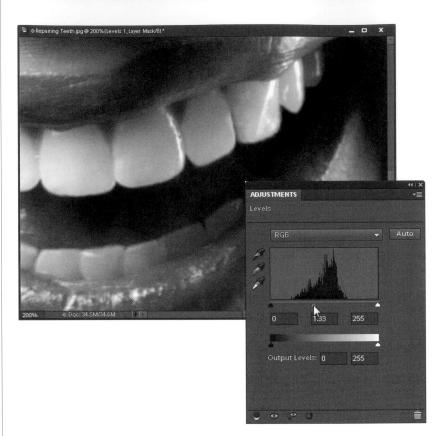

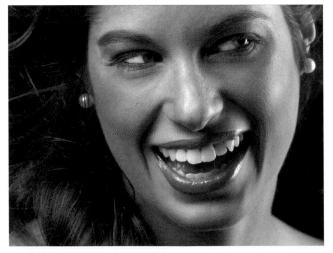

After

The tutorial you're about to read is perfect for (as Scott calls it) desnozilization, dehonkerizing, and unsnoutilation. The coolest part about it is that it uses a tool that you'd never think about using in your normal everyday Elements use. In fact, when you hear the name in Step Two you'll probably even laugh to yourself thinking we're going to play a joke on someone. Trust me, though—we're not. This tool has a ton of uses, and getting pro-quality retouching results is one of them.

Digital Nose Jobs Made Easy

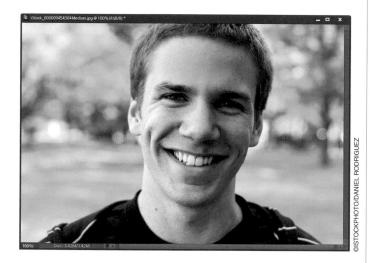

Step One:

Open the photo that you want to retouch. By the way, did you notice how gentle I was in that opening phrase, and how I made no mention whatsoever of a somewhat minor facial retouch that might be considered in this instance? (Wait for it...wait for it...no! I'm not going to do it! Not this time. Not here. Not now.) Let's continue, shall we?

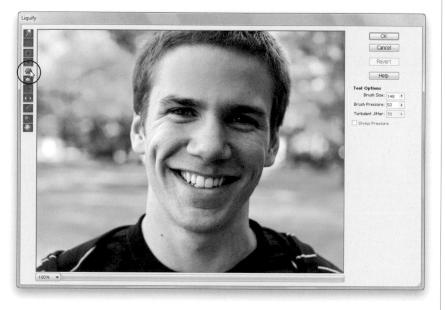

Step Two:

Go to the Filter menu and, under Distort, choose **Liquify**. When the Liquify dialog appears (as seen here), choose the fifth tool down from the top of the Liquify Toolbox (the Big Honker tool), shown circled here in red. Okay, I tried to slip one past you. Actually, the real name of this tool is the Bulbous Nasal Retractor, or BNR for short. (Aw, come on, that last one was pretty funny. Even I heard you giggling.) Okay, if you must know, the official "Adobe name" for the tool is the Pucker tool, and basically it "puckers in" the area where you click it. The more you click it, the more it puckers.

Take the tool and move it right over your subject's nose (as shown here), and make the brush size a little bigger than the entire nose itself. The quickest way to do that is to press-and-hold the **Shift key** and press the **Right Bracket** (1) key on your keyboard. Each time you press that, it will jump up 10 points in size. Once you have the size right, just click it a couple of times (don't paint—just click). Here, I clicked twice, for obvious reasons. (Sorry, I couldn't help myself.)

Step Four:

Move the center of the brush over his left nostril and click once or twice, then do the same to the right nostril. Move to the bridge of the nose and click once or twice there, and you're done. Here, the entire retouch took about five clicks (12 seconds—I timed it). Also, if you make any mistakes, you have multiple Undos by pressing **Ctrl-Z (Mac: Command-Z)**. When it looks good, click OK.

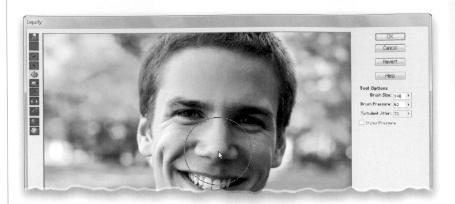

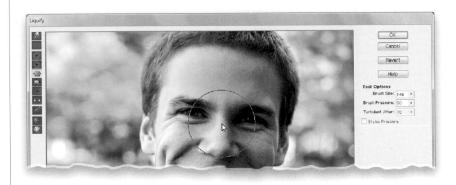

After

This is a pretty slick technique for taking a photo where the subject is frowning or grim and tweaking it just a bit to add a pleasant smile—which can often save a photo that otherwise would've been ignored.

Transforming a Frown into a Smile

Step One:Open the photo that you want to retouch.

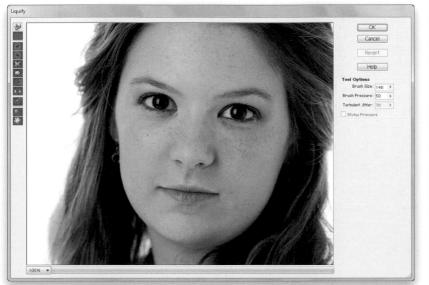

Step Two:

Go under the Filter menu, under Distort, and choose **Liquify**. When the Liquify dialog appears, choose the Zoom tool (it looks like a magnifying glass) from the Liquify Toolbox (found along the left edge of the dialog). Click it once or twice within the preview window to zoom in closer on your subject's face. Then, choose the Warp tool (it's the top tool in the Liquify Toolbox).

In the Tool Options on the right side of the dialog, choose a brush size that's roughly the size of the person's cheek. Place the brush at the base of a cheek and click-and-"tug" slightly up. This tugging of the cheek makes the corner of the mouth turn up, creating a smile.

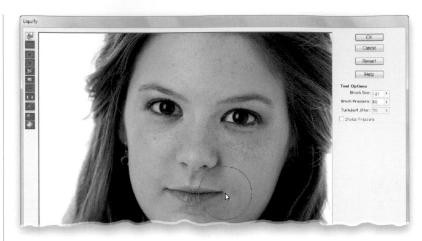

Step Four:

Repeat the "tug" on the opposite side of the mouth, using the already tugged side as a visual guide as to how far to tug. Be careful not to tug too far, or you'll turn your subject into the Joker from *Batman Returns*. Click OK in Liquify to apply the change, and the retouch is applied to your photo.

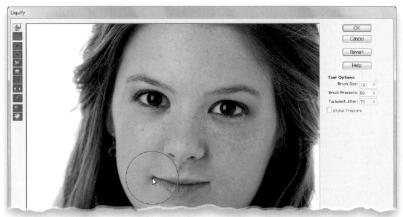

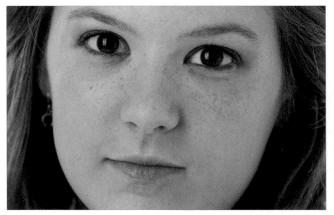

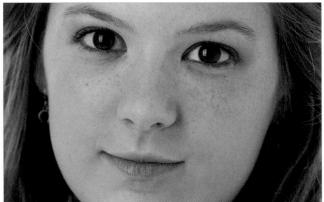

Before

After

This is an incredibly popular technique because it consistently works so well, and because just about everyone would like to look about 10 to 15 pounds thinner. I've never applied this technique to a photo and (a) been caught, or (b) not had clients absolutely love the way they look. The most important part of this technique may be not telling the client you used it.

Slimming and Trimming

Step One:

Open the photo of the person that you want to put on a quick diet.

Step Two:

Click on the bottom-right corner of your image window and drag it out so you see some gray background behind your image. Now, press **Ctrl-A** (**Mac: Command-A**) to put a selection around the entire photo. Then, press **Ctrl-T** (**Command-T**) to bring up the Free Transform command. The Free Transform handles will appear at the corners and sides of your photo.

Grab the right-center handle and drag it horizontally toward the left to slim the subject. The farther you drag, the slimmer the subject becomes.

Step Four:

How far is too far (in other words, how far can you drag before people start looking like they've been retouched)? Use the Width field in the Options Bar as a guide. You're pretty safe to drag inward to around 95%, although I've been known to go to 94% or even 93% once in a while (it depends on the photo). I settled on 94.1% for this photo, though.

Step Five:

Press Enter (Mac: Return) to lock in your transformation. Then, before you deselect, go to the Image menu and choose Crop. That'll crop to the selection you had and remove the background area that is now visible on the right side of your photo (you could always use the Crop tool, too). Then hit Ctrl-D (Mac: Command-D) to Deselect. You can see how effective this simple little trick is at slimming and trimming your subject. Also, notice that because we didn't drag too far, the subject still looks very natural.

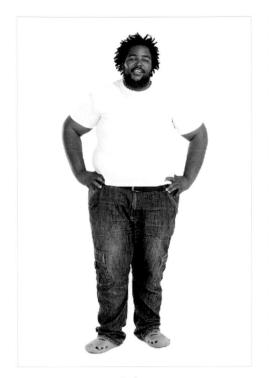

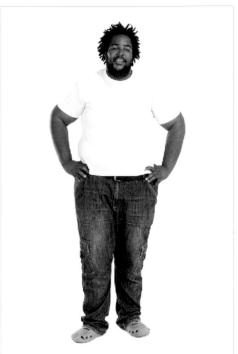

Before

After

Advanced Skin Softening

Although this technique has a number of steps, it's actually very simple to do and is worth every extra step. It breaks away from the overly soft, porcelainskin look that is just "so 2006" to give you that pro skin-softening look, along with keeping some of the original skin texture, which makes it much more realistic. This "keeping some of the original skin texture" look is totally "in" right now, so it's worth spending an extra two minutes on. I also want to give credit to Ray 12, whose article on RetouchPro.com turned me on to the texture mask, which I now use daily.

Step One: Start by pressing Ctrl-J (Mac: Command-J) to duplicate the Background layer, as shown here. (See? I told you these steps were going to be simple.)

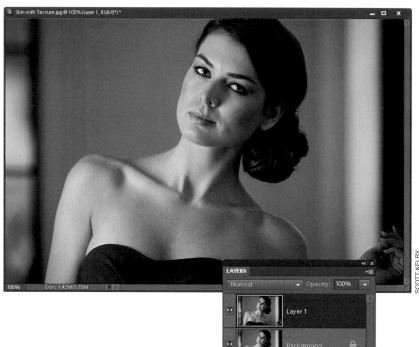

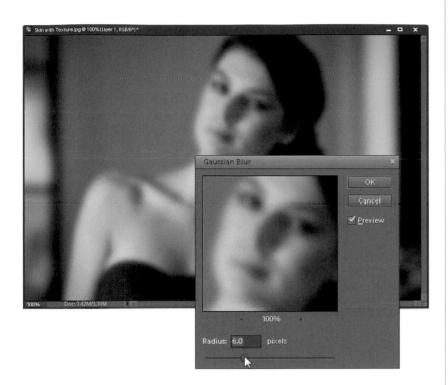

Step Two:

Go under the Filter menu, under Blur, and choose **Gaussian Blur**. For a low-resolution photo, like this one, try a 6-pixel blur, then click OK. For high-resolution photos (from a 6- to 10-megapixel camera), apply a 20-pixel blur, or for 12 megapixels or higher, try 25 pixels. This blurs the living daylights out of the photo (as seen here). Sure, it's blurry, but boy is her skin soft! (Okay, that was lame. Continue.)

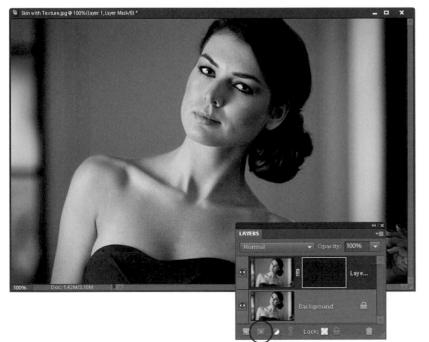

Step Three:

Press-and-hold the Alt (Mac: Option) key and click once on the Add Layer Mask icon at the bottom of the Layers palette. This adds a black layer mask to your current layer (the blurry Layer 1). Doing this removes all the blurriness from view (and that's exactly what we want to do at this point). The idea is to reveal the blurry layer just where you want it (on her skin), while avoiding all the detail areas (like her eyes, hair, clothing, eyebrows, nostrils, lips, jewelry, etc.). That's what we'll do next.

Step Four:

In the Lavers palette, make sure the layer mask is active (you'll see a white frame around its thumbnail), as you're going to paint on this layer. Press the letter **D** to set your Foreground color to white. Get the Zoom tool (Z) and zoom in on her face. Then get the Brush tool (B), choose a medium-sized, soft-edged brush from the Brush Picker up in the Options Bar, and begin painting over her skin (as shown here). You're not actually painting over the photo-you're painting in white on the layer mask, and as you paint, it reveals that part of the blurry layer that it's linked to. Remember the rule: don't paint over detail areas avoid the eyes, hair, etc., as I mentioned earlier. In the example shown here, I have only painted over (softened) the left side of her face and upper body, so you can see the effect of the skin softening.

Step Five:

Continue painting on both sides of her face until you've carefully covered all the non-detail areas of her face. You'll have to vary the size of the brush to get under her nose, and carefully between the eyes and the eyebrows.

TIP: Resizing Your Brush

You can use the Bracket keys on your keyboard to change brush sizes—the **Left Bracket key ([)** makes the brush size smaller; the **Right Bracket key (])** makes it larger. By the way, the Bracket keys are to the right of the letter P. Well, if you're using a U.S. English keyboard anyway.

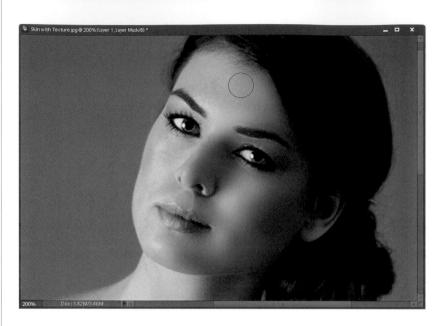

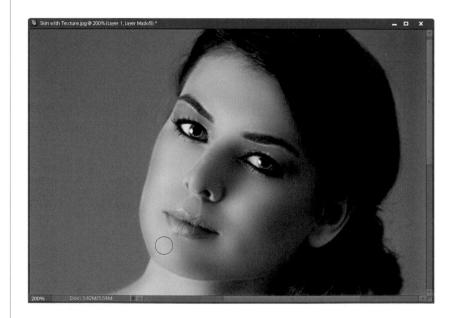

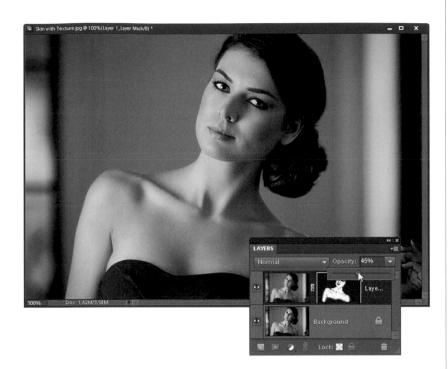

Step Six:

Continue to paint over all the other areas that need softening, and I know I sound like a broken record but avoid those detail areas, like her hair, and her evebrows, and her lips, etc. Now, you can see that at this point we do have the porcelain-skin look. If you like this look, but you think it's just a little too soft, then simply go to the Layers palette and lower the Opacity of Layer 1 (with the layer mask) to around 50% and see how that looks. That will lighten the softening pretty significantly, and it might be just the amount you're looking for. If 50% is still too much, try 40%, or even 30%. So, you could be done right here. But, if you want something even better, continue on.

Step Seven:

Let's first make sure you haven't missed any areas, so press-and-hold the **Alt** (**Mac: Option) key**, and in the Layers palette, click directly on the layer mask thumbnail (as shown here). This displays just the layer mask itself, and you'll see instantly whether you missed any areas or not. In this case, you can see I missed areas on both her cheeks, as well as some on her upper lip and forehead.

Step Eight:

These missed areas are really easy to fix—just take your Brush tool and paint right over them. Now, to get back to your regular view, Alt-click (Mac: Option-click) on the layer mask again and things will be back to normal, so you'll see your image again.

Step Nine:

Now that you can see your full-color image again, you're going to load your white brush strokes as a selection (it's easier than it sounds). Just pressand-hold the Ctrl (Mac: Command) key and click once directly on the layer mask thumbnail. This loads it as a selection, as seen here.

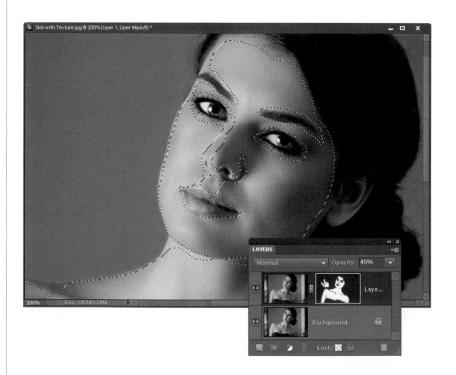

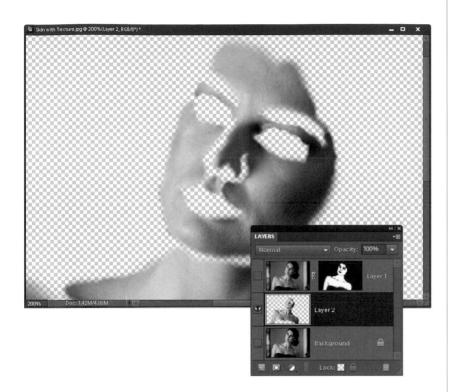

Step 10:

Now, click on the Background layer (your selection will still be in place), then press **Ctrl-J (Mac: Command-J)** to take those selected areas of your Background layer and put them up on their own separate layer (as shown here in the Layers palette). Go ahead and hide the top layer (with the layer mask) and the Background layer from view (click on the little Eye icons to the left of each of those layers, or **Alt-click [Mac: Option-click]** on the Eye icon for your new layer), and you'll see the awful-looking thing you see here.

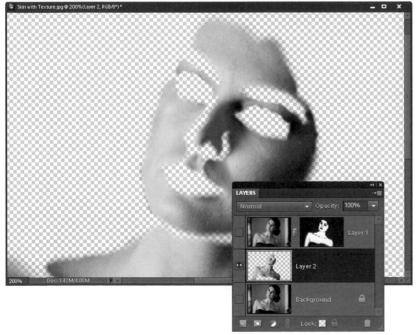

Step 11:

You'll need to remove the color from this layer, so go under the Enhance menu, under Adjust Color, and choose **Remove Color**. This removes the color from just your current layer (as shown here). I know, it looks pretty creepy. Retouching isn't pretty. Well, at least not until you're done.

Step 12:

Now, to bring the texture, highlights, and shadows back into the skin, go under the Filter menu, under Other, and choose **High Pass** to bring up the High Pass filter dialog (seen here). Drag the Radius slider all the way to the left (as shown) to make the image pretty flatlooking. Don't click OK quite yet.

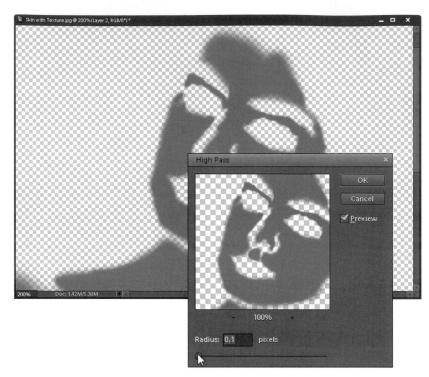

Step 13:

Now drag the Radius slider to the right until some of the texture, highlights, and shadows start to return to the image (as shown here). I can't give you an exact number to dial in every time, so just drag it until your image looks somewhat like the one you see here, then click OK.

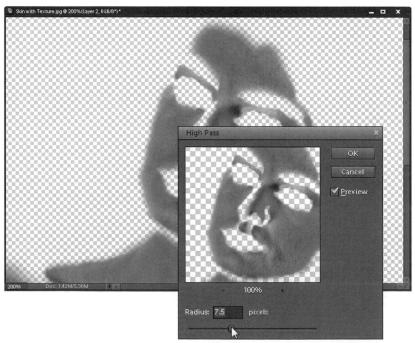

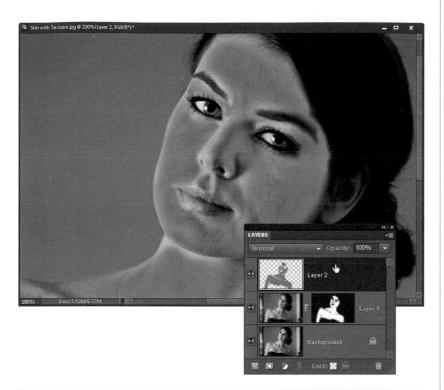

Step 14:

Next, make the other layers visible again (by Alt-clicking [Mac: Option-clicking] on the Eye icon for the layer you were just working on), then drag your gray texture layer to the top of the layer stack (as shown here). Okay, it's still not looking that great yet. Be patient, we're almost there.

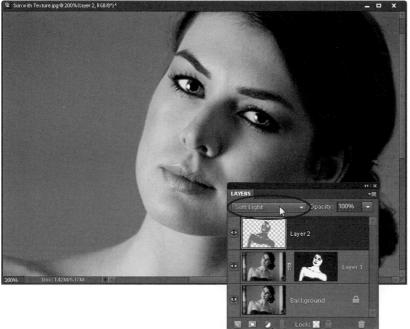

Step 15:

Now to bring her original skin texture and highlights back into our photo, you're going to change the layer blend mode of this top layer (the gray texture layer) from Normal to **Soft Light**, in the pop-up menu at the top left of the Layers palette (as shown here). When you first do this, it brings back the skin texture with a vengeance, which is not our goal. Okay, it's not as much as the original texture, because there is some softening on the layers below it, but it's too intense at this point.

Step 16:

So (and here's where the cool part is), you're going to dial in the exact amount of original skin texture you'd like visible by lowering the Opacity setting of this texture layer. The lower you make the opacity, the less skin texture is visible. For this particular photo, lowering the Opacity to 30% looks like it gives about the right balance between softening and texture. Compare the before and after photos below.

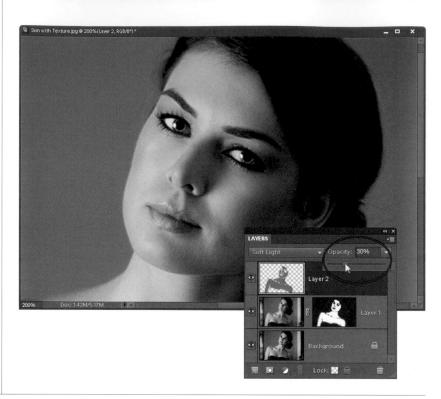

Before

After

I used to cringe when someone asked how to remove reflections from glasses. It took the better part of an hour sitting there cloning and erasing, and cloning and erasing some more. Put simply, it was a total pain in the butt. Now, with Elements, it's a snap to fix. So if you've ever spent an hour cloning away reflections, you'll love this. If you haven't removed reflections before, then just be thankful that it's really easy now and you'll never know the pain that we once felt.

Fixing Reflections in Glasses

Step One:

First, open the photo that has a reflection on the glasses. This is a photo of a co-worker with her glasses on.

Step Two:

When I shot this photo, I could see that I was going to have a reflection in the glasses, so I told her after the shot not to move her head, but just to reach up and remove her glasses, and then I got another photo without the glasses on. So, open the photo without the glasses. Then, click on Guided on the Edit tab at the top of the Palette Bin. In the Project Bin, Ctrl-click (Mac: Command-click) on the photo with the glasses, then on the one without the glasses. In the Guided Edit palette on the right, under Photomerge, choose Group Shot (I know it's not really a group shot, but it works great anyway).

You'll probably see a progress bar telling you that Elements is aligning the photos. When it's done, you'll be in the Photomerge Group Shot feature. First, click-and-drag the photo with the glasses from the Project Bin over to the Final side of the preview window, then click on the photo without the glasses down in the Project Bin. Now you should have the photo without the glasses on the left side and the photo with the glasses on the right side.

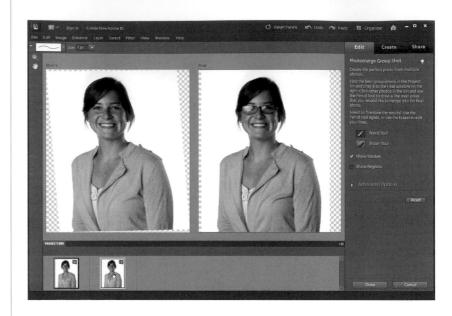

Step Four:

Next, use the Zoom tool (Z) to zoom in, then use the Pencil tool to paint over one of the eyes on the Source photo (you can set the size up in the Options Bar). Be careful not to go too far outside of the eyes, though. Elements will use that source area to replace the coinciding destination area on the Final image. This will replace the eye and probably most of the eyeglass rim around it. If it doesn't, then paint again until you see most of the eyeglass rim disappear. Then do the same thing for the other eye.

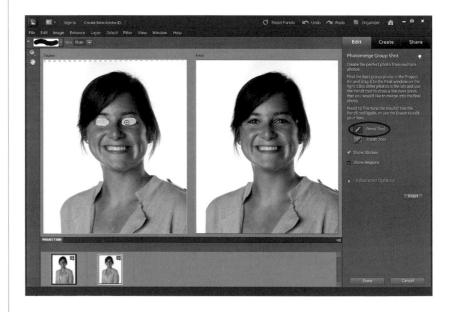

Step Five:

When you see the eyes and just the sides of the eyeglasses, click the Done button at the bottom right. Then click back on Full on the Edit tab at the top right of the window to take you into Full Edit mode again. You should see your image just as it looked in Group Shot, but you'll also see two layers in the Layers palette. Use the Crop tool **(C)** to crop away any extra white canvas.

Step Six:

So that takes care of getting rid of the reflection. Unfortunately, it got rid of part of the eyeglasses too, right? No sweat. We've got a really neat trick to help fix that problem. First, check out the Layers palette. The top layer is the Final image you saw back in the Photomerge Group Shot window and the bottom layer is the original glarey (is that even a word?) eyeglass photo. So what we need to do here is combine the best of both of them.

Step Seven:

Click once on the top layer to make it active, and change the layer blend mode to **Difference**. Curiously enough, the Difference blend mode actually shows you just that—the difference between the top layer and the bottom one. Areas that appear black are pretty much exactly the same between the two layers. Any other areas (such as the eyes here) show you things that aren't the same.

Step Eight:

Now use the Zoom tool (Z) to zoom in on the eyes. To complete the effect, just select the Eraser tool (E), with a small, hard-edged brush that isn't much thicker than the eyeglass rim itself, and erase over the outline you see in Difference mode on the top layer (as shown here). The rimless eyes from the top layer will be erased and reveal the rim from the original glasses layer, and your reflection problems are gone. Be careful not to erase too much into the lenses themselves, though, because you don't want to reveal any of the glare from the layer below.

Step Nine:

Try switching the top layer's blend mode back to **Normal** to see your progress and make sure you chose a small enough brush.

Step 10:

Go ahead and change the blend mode to Difference again and finish up the erasing on the top layer. Then change the blend mode back to Normal and you'll see how the reflections are totally gone. Better yet—if the person has large eyeglass frames, it also will fix the fall-off that makes a person's eyes look smaller (where you can see the side of the face in the outside edge of the lens).

Before (notice the reflection—most visible in the right eye)

After (the reflection is gone)

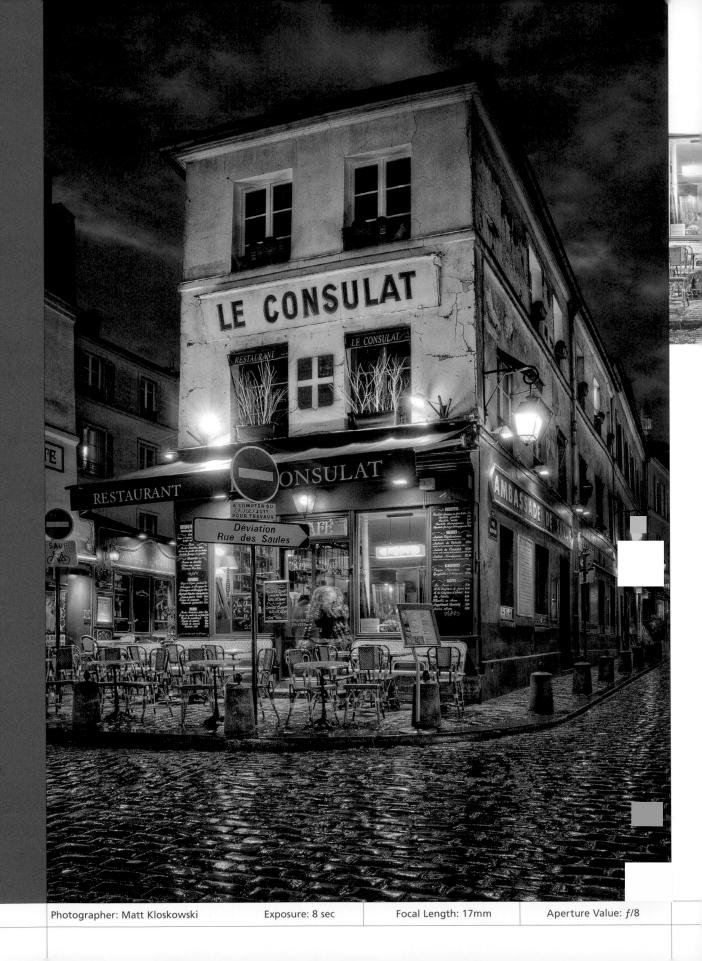

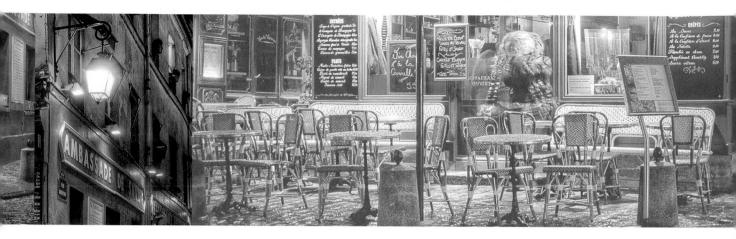

Clone Wars removing unwanted objects

Have you ever taken a photo of some majestic landscape and when you open the photo in Elements, only then do you notice a crushed beer can just off to the side of the image? Or you see some really ugly power lines you didn't see when you took the shot. Or, maybe it's a crushed beer can balanced on top of some really ugly power lines (okay, that last one was a stretch, but you get the idea). At this point, you have to make an ethical and moral decision. Now, this is an easy decision if you're a photojournalist—you have to maintain the total integrity of the image, so that beer can and those power lines stay. But what if you're not a photojournalist? You're an artist, which means your job is to create the most beautiful, pleasing image you can. In that case, as an artist, you have full license to remove those unwanted, distracting

elements from the scene, and then clone in a stock photo of a Ferrari in the background that you downloaded from the Web. Errr... I mean, perhaps you should consider using Elements' tools, like the Spot Healing Brush and the Clone Stamp tool, to remove those unwanted objects in order to return the scene to how it looked when you were actually there. Now, there is a third alternative: when you're taking the photo, pick up the crushed beer can and put it in the trash. However, this is actually frowned upon in the photo community because it breaks the sacred rule of all photographers, which is to expend as little physical energy as possible, so we're fully rested when called upon to gently press the shutter button on the top of our cameras. Hey, I'm sorry I had to be the one to tell you, but that's how we roll.

Cloning Away Distractions

The Clone Stamp tool has been the tool of choice for removing distracting or other unwanted objects in photos for years now. Although the Healing Brush in many ways offers a better and more realistic alternative, there are certain situations where the Clone Stamp tool is still the best tool for the job. Here's an example of how this workhorse removes unwanted objects:

Step One:

Nothing ruins a nice shot like distracting objects or people. Here we have a nice photo of a lighthouse, but the people in the top right take away from the photo. I don't want to crop them out, because I like the rocks in that area so we'll use the Clone Stamp tool to remove them.

Step Two:

Use the Zoom tool (Z) to zoom in if you need to. Then, press S to get the Clone Stamp tool. In the Options Bar, click on the brush thumbnail to the left of the Size pop-up menu and choose a small, soft-edged brush in the Brush Picker. Now, press-and-hold the Alt (Mac: Option) key and click once in an area to the left of the people. This is called "sampling." You just sampled a clean area of clouds, and in the next step, you're going to clone that area over the people to completely cover them. (By the way, when you sample, a little "target" cursor appears letting you know you're sampling, as you see here.)

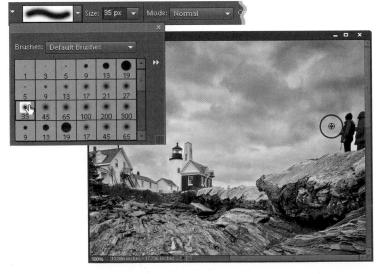

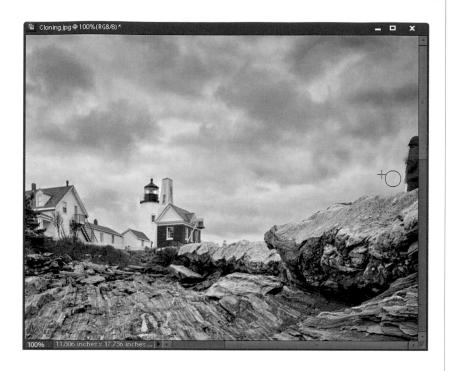

Move directly over the person on the left and begin painting with the Clone Stamp tool. As you paint over them, the clouds you sampled are cloned right over them, so it looks like they have disappeared. But what if you're not able to clone the whole distraction in one brush stroke? Read on to the next page, and I'll show you a little trick.

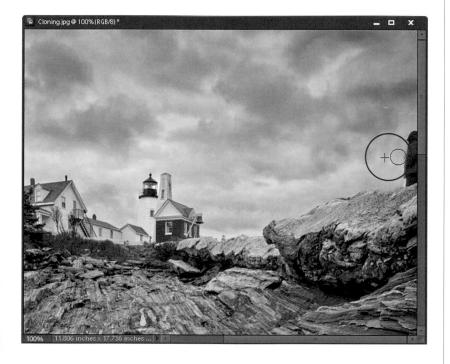

TIP: Sample a Similar Area

The key technique to remember is to sample in an area where the basic light and texture are the same (next to the people), then move straight over the people. Note: The little plus-sign cursor (the area where you sampled) is immediately to the left of the circular brush cursor (where you're painting now). By keeping them next to each other, you're making sure you don't pick up patterns or colors from other parts of the photo that would make your cloning look obvious (you'll want to Alt-click [Mac: Option-click] in different but nearby areas to sample the same overall brightness and texture).

Step Four:

Now, what happens if you can't clone all the way over the people in one brush stroke? This actually happens a lot. In my example here, if I continue to paint with one brush stroke over the person on the right, my sample point starts going over the original person on the left and I wind up cloning over the person on the right with more of the person on the left.

Step Five:

Here's the trick: You'll need to release your mouse button and click to paint again. Each time you release your mouse button, Elements resamples the area you're cloning from and basically resets it. This lets you paint a little more of the clouds over the people each time. Just keep an eye on that little crosshair as you're cloning. If it starts going over a part of the people where they once existed, then weird things are going to happen. So, release the mouse button often, let the source reset itself on the clean clouds, and paint smaller areas at a time, instead of one large area.

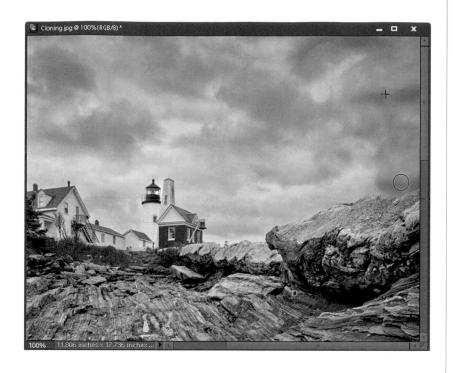

Step Six:

One more thing: You'll want to sample from an area similar to what you're removing. For example, try this: Alt-click (Mac: Option-click) at the very top of the photo where the clouds are darker. Then go back and start cloning over the people. Look how much darker (and more obvious) the cloning looks (as shown here). That's why you usually have to sample very close to where you clone. If not, it's a dead giveaway. And you want to sample often, so you don't get a repeating pattern from using the same sample point each time you paint.

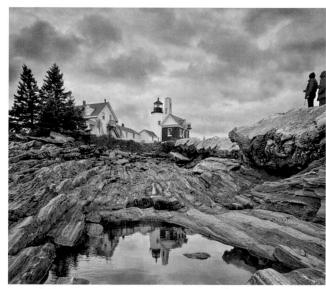

Before

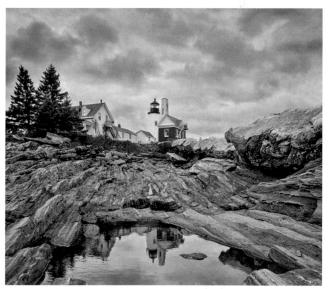

After

Removing Spots and Other Artifacts

Elements has a tool, the Spot Healing Brush tool, which is just about perfect for getting rid of spots and other artifacts. (By the way, the term "artifacts" is a fancy "ten-dollar" word for spots and other junk that wind up in your photos.) Believe it or not, it's even faster and easier to use than the regular Healing Brush, because it's pretty much a one-trick pony—it fixes spots.

Step One:

Open a photo that has spots (whether they're in the scene itself or are courtesy of specks or dust on either your lens or your camera's sensors). In the photo shown here, there are all sorts of distracting little spots in the sky.

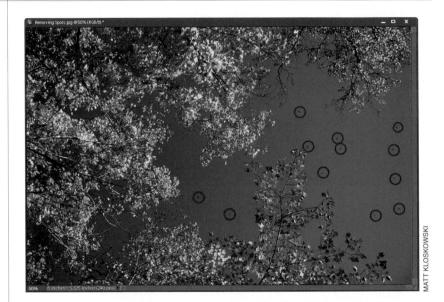

Step Two:

Press **Z** to get the Zoom tool and zoom in on an area with lots of spots (here, I zoomed in on the sky). Now get the Spot Healing Brush tool from the Toolbox (or just press the letter **J**).

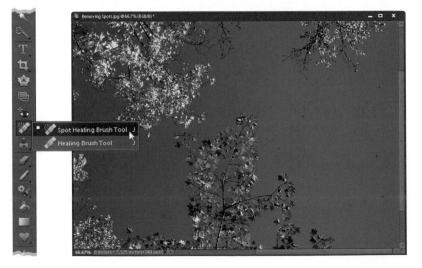

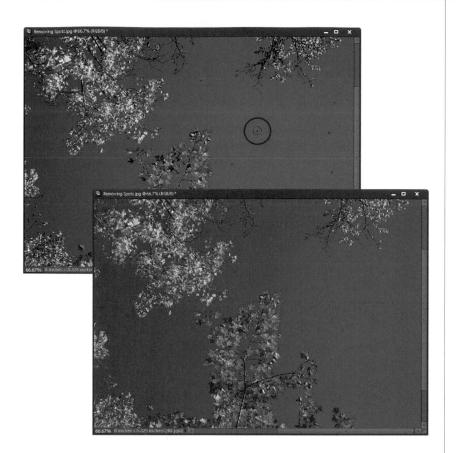

Position the Spot Healing Brush directly over the spot you want to remove and click once. That's it. You don't have to sample an area or Alt-click anywhere first—you just move it over the spot and click, and the spot is gone.

Step Four:

You remove other spots the same way—just position the Spot Healing Brush over them and click. I know it sounds too easy, but that's the way it works. So, just move around and start clicking away on the spots. Now you can "despot" any photo, getting a "spotless" version in about 30 seconds, thanks to the Spot Healing Brush.

After

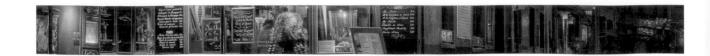

Removing **Distracting Objects** (Healing Brush)

The Healing Brush is ideal for removing spots, little rips, stains, and stuff like that because it keeps more of the original texture and the fixes look more realistic, but it isn't as good as the Clone Stamp tool at removing larger, unwanted objects. For example, if the thing you want to remove is all by itself (it's not overlapping or touching anything else in your photo), then it works great. If not, it "frays" the ends and looks messy. So here you'll see how it works, why it doesn't always work, and a great trick for making it work most of the time (with some help from the Clone Stamp tool).

Step One:

In this example, we're going to remove the creases and cracks in this old photo, so it looks like new. We're going to use a combination of the Healing Brush and a little bit of the Clone Stamp tool to clean it up.

Step Two:

First we'll look at how the Healing Brush works, and then you'll see what its limitations are. Start by pressing **Z** to get the Zoom tool and zoom in to an area you want to fix (in this case, we'll start with the crack in the top right). Press J until you get the Healing Brush, and then Alt-click (Mac: Option-click) in a clean area near the object you're removing (here, I'm Alt-clicking in a clean area of background just above the crack). At this stage, the Healing Brush works kind of like the Clone Stamp tool, so I'll just click-and-drag on the crack (you'll have to Alt-click a few times to resample as you move over it). See, it's almost gone. Piece of cake so far.

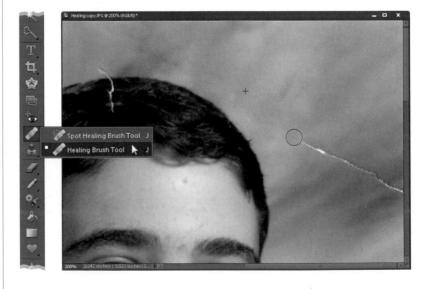

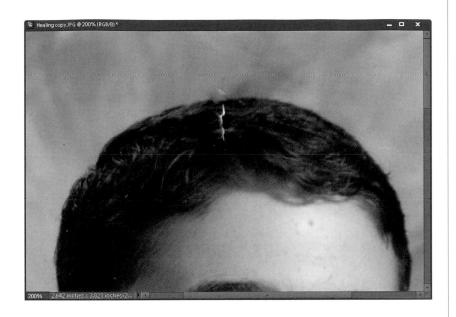

Now you're going to see the main limitation of the Healing Brush—when objects touch or are near an edge. Look at the crack in his hair, where his head meets the background. That's trouble. Watch what happens when I Alt-click anywhere near that part of the photo and try to use the Healing Brush to remove that area. Ahh, now you see the problem: Where his head meets the background, it's all smudged. The Healing Brush only gives you a clean removal if you can paint around the entire object without hitting an edge.

Step Four:

Press **5** to get the Clone Stamp tool from the Toolbox, and then Alt-click (Mac: Option-click) once just to the right of the smudged area. Now paint a stroke right over the smudge, where the hair meets the background, to remove it. Then, switch back to the Healing Brush and finish removing the crack in his hair. In the example here, the plus-sign cursor shows where I sampled, and the circular brush cursor shows where I've painted over.

Step Five:

Next, remove the crease on his jaw. First, sample the background and paint over the crease right up to (but not actually touching) his face. Then, sample again on his jaw and paint another stroke right to the edge of his face. Again, don't paint on to the edge or it'll smear.

Step Six:

Switch to the Clone Stamp tool once more, zoom in on the tiny bit of the crease that's left over, and sample the edge of his face just above the remaining crease. Then, paint over whatever is left and you'll have a much cleaner looking result than if you had just used the Healing Brush. So, basically, if you don't mind using the Clone Stamp tool just a little bit, you can turn the Healing Brush into a real power tool for removing larger, unwanted objects.

Before

After

The Magic of Content-Aware Fill

Content-Aware Fill is probably one of the best-kept secrets of Photoshop Elements, and it's just incredibly amazing. It was a huge hit in the full version of Photoshop, but few people know that it exists in Elements, too. Anyway, as amazing as it is, it's also incredibly simple to use, so don't let the fact that it only took four pages here in the book to cover it throw you off. What makes the feature even more amazing is that you have to do so little—Elements does all the heavy lifting. Here are a couple of examples of ways to use it to remove distracting things you wish weren't in the photo:

Step One:

Open a photo that has something distracting that you'd like to remove. In this case, we have a telephone wire leading into the church.

ATT KLOSKOWS

Step Two:

For starters, just to show you how magical this feature is, let's see what life was like without it. Press J to get the Spot Healing Brush tool and click on the Proximity Match radio button in the Options Bar (instead of Content-Aware). Now, resize your brush so it's significantly larger than the wire in this photo and start painting over the wire from the top of the photo all the way down to the church. When you're done, look at the mess you've left. Not good, right? It may have removed the wire, but it left a blurry streak running through the photo.

Now, let's see what Content-Aware will do. Normally, you'd think we'd have to spend some time cloning it, and even some extra time sampling, because part of the wire is over the sky and part of it is over the trees. But with Content-Aware Fill, we just let the tool do all the work. With the Spot Healing Brush tool still selected, click on the Content-Aware radio button in the Options Bar.

Step Four:

Paint with the tool over the wire all the way from the top to the edge of the church. Yep, the whole thing. Don't worry about getting too close to the edge of the church roof, either. Just paint. When you release your mouse button, sit back, and prepare to be amazed. I know—it's freaky. Look at how it replaced the sky and trees all in one brush stroke. The color looks spot on, and the texture in the trees looks like it's a perfect match. This is the essence of being "contentaware" and being totally aware of what's around it. The more I use it, the more it amazes me, but part of using this effectively is learning its weaknesses, and how to get around them when possible.

Step Five:

For example, while Content-Aware removed the wire almost flawlessly from this photo, there is one little spot that it didn't leave perfect—right near the edge of the church roof, where it meets the sky. You can see it where I've zoomed in on it here.

Step Six:

If this ever happens, I try one of two things: First, I'll zoom in real close and try painting over it again with the Spot Healing Brush (again, with Content-Aware turned on). Most of the time, that does the trick right away (and in this example it worked great). If it picks up areas you don't want, just press Ctrl-Z (Mac: Command-Z) to Undo and try again. If that doesn't work, then I simply resort to the Clone Stamp tool to get a little more precise in that one spot. But, I'd still try Content-Aware first. It may not take care of removing the distraction in one brush stroke, but it sure gets you about 90% of the way there in a fraction of the time that cloning and healing would.

Before After

Automatically Cleaning Up Your Scenes (a.k.a. The Tourist Remover)

If you've ever tried to photograph a popular landmark or national monument, you'll know that it's pretty unlikely you'll be there alone. Unless you're willing to get up really early in the morning (when most people are still sleeping), you're bound to get a tourist or two (or 20) in your photos. In this tutorial, you'll learn a few tricks to help clean up those scenes and remove the tourists with just a few brush strokes.

Step One:

The first step starts in the camera. You'll need to photograph at least two shots of the same scene (but you can use up to 10 if you'd like). So, if you're in one of those situations where you just can't get a photo with no people in it, then take a few photos in the hope that the people move around a little (even if they don't ever exit the area completely).

Step Two:

Here, I realized it was going to be really difficult for me to get a photo when someone wasn't walking by in the background. But, I knew that I had a feature that could fix this available to me in Elements, so I decided to take another photo. As you can see, I wasn't able to capture a photo with no one walking by, but at least I had another one where they had moved.

TIP: Keep Your Camera Steady

I wasn't on a tripod when I shot this, but Elements does a great job of autoaligning photos. If you can't shoot on a tripod, the key is to try to be as steady as possible, so the actual photo doesn't change too much.

Go ahead and open the photos you've taken (remember, you'll need at least two but can use up to 10. In this example, I'm only using two) in the Elements Editor. Then select them down in the Project Bin by clicking on the first one and Shift-clicking on the last one. Now, go under the File menu, under New, and choose **Photomerge® Scene Cleaner**. This will take you into Photomerge.

ADVANCED TIP: Try the Advanced Options

Here's a follow-up to the previous tip. In fact, just file this tip away, because you may or may not need it. If you didn't shoot on a tripod, and you're not getting good results from Photomerge, then click on the Advanced Options section at the bottom of the Photomerge palette. Use the Alignment tool to place three markers in the Source window and three in the Final window, on similar places in the photos. Then click Align Photos, and Elements will do its best to align the photos based on those markers. This helps the Scene Cleaner give more predictable results. Again, give Step Three through Step Seven a try first and see how things work out. If everything looks good, then you don't need the Advanced Options.

Step Four:

The Source window on the left will automatically be populated with the first photo you chose. You'll need to create a Final photo though, so drag the other photo from the Project Bin into the Final window on the right.

Now look over at the Source window and find the clean areas from this photo that you'd like copied over to the Final photo. In this example, it's the clean area of carpet right below the men (where they are about to walk).

Step Six:

All right, let's get rid of these guys. First, use the Pencil tool to paint on the Source image (on the left) in the area where the men are in the Final image to get rid of them there. It doesn't have to be perfect, so just paint a small area, and when you release your mouse button, you'll see the Scene Cleaner automatically remove the men from the background in the Final image on the right. You can use the Zoom tool (the one that looks like a magnifying glass in the Toolbox on the left) to zoom in to the area if you need to. If you don't get the results you're looking for, grab the Eraser tool (it's right under the Pencil tool on the right) and click to erase away some of the blue pencil marks in the Source image on the left. When you're done cleaning up the image, click the Done button to return to the Editor.

TIP: Getting Rid of the Pencil Marks If you move your mouse over the Final image, you'll see the blue pencil marks on it, too. If you want to see your Final image without the blue pencil marks over it, just move your mouse away from it and they'll disappear. If you want to see the Source image without the blue marks, then turn off the Show Strokes checkbox in the Photomerge palette on the right.

Step Seven:

If Photomerge left some extra white canvas around your final image, first flatten your image by choosing **Flatten Image** from the Layers palette's flyout menu, then just use the Crop tool **(C)** to remove the extra white canvas.

After

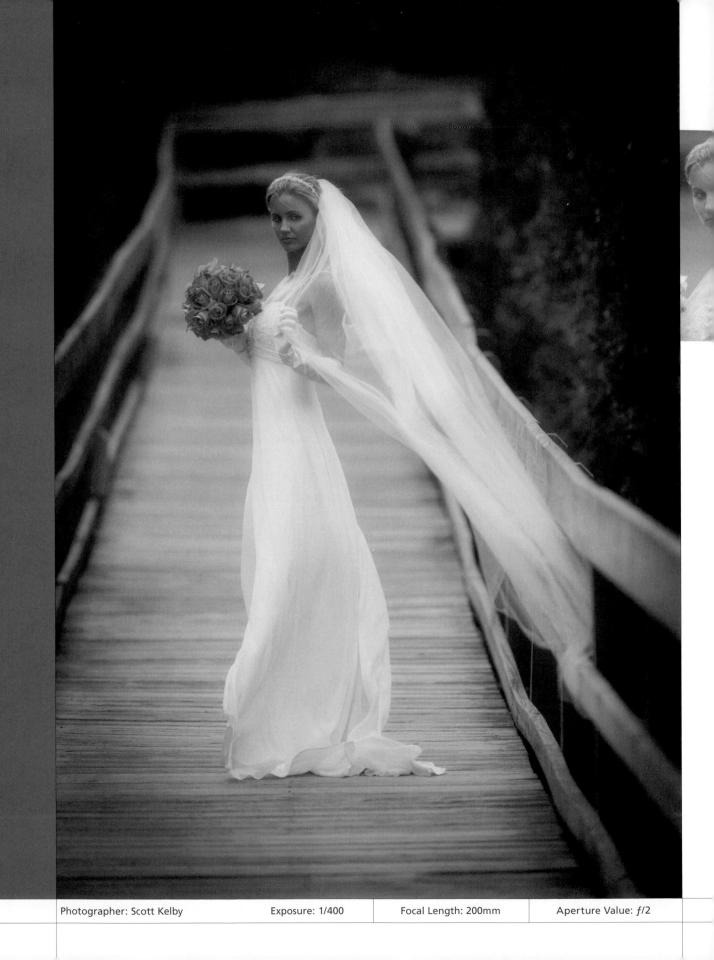

Chapter 9 Special Effects for Photographers

Side Effects special effects for photographers

The name of this chapter comes from the 2009 movie short Side Effects (it's less than 20 minutes long, which is probably why you can buy it for only \$1.99 in the iTunes Store. It's either that, or it's so cheap because of its lack of zombies). Anyway, here's how they describe Side Effects (say this in your best movie voice-over guy voice): "An ordinary guy becomes a human guinea pig in an experimental drug test and meets the girl of his dreams..." Sounds like a pretty typical everyday story. At least the human guinea pig in an experimental drug test part. Anyway, I looked at the movie poster, and the guys in the poster all have this creepy-looking bluish/green color cast that makes them look kind of sickly, but then the female lead's photo looks fine, with regularlooking flesh tones, and that's when I realized why this guy thinks he's found the woman of his dreams. She doesn't have a creepy bluish/

green color cast. I mean, think about it. If all the girls around you had a serious white balance problem, and then all of sudden you meet a girl carrying around her own 18% gray card, and so she looks correctly color balanced in any lighting situation, wouldn't you fall in love with her, too? Exactly. I'll bet in the last 10 minutes of the movie, you find out that this guy actually starts an online business for people using dating sites like eHarmony, or Match.com, or HandsomeStalker.com, where he offers to remove bluish/green color casts from your profile photo for a price. Things are going pretty well for him for a while, but then in about the eighteenth minute, the experimental drug wears off, and he finds himself trapped in a dank, dimly-lit room, forced to write nonsensical chapter intros late into the night, until his wife comes in and says "Honey, come to bed," but right then, he notices she has a bluish/green color cast, and....

Automatic Special Effects

Before we dive into the special effects you can apply to your photos, I wanted to show you some effects that come with Elements. If you go to the Guided Edit tab in the Elements Editor, which has been updated in Elements 10, and scroll near the bottom, you'll see Lens Effects, Photography Effects, and Photo Play. We'll take a guick look at one of the Photography Effects here, and in the next few tutorials, we'll look at some of the other effects.

Step One:

In the Editor, open the photo you'd like to work with and click on Guided at the top of the Edit tab. Near the bottom of the Palette Bin, you'll see three palettes with special effects. Here, there's everything from an old-fashioned photo effect to the Lomo camera effect to a reflection effect, and even a pop art effect.

Step Two:

For starters, click on the effect you'd like to apply. They're all pretty selfexplanatory once you get into the actual effect and Elements walks you through each one. I chose the Lomo Camera Effect here, where you only get two buttons: First, click the Cross Process Image button to apply a greenish tint to your photo (you can click multiple times to increase the effect). Then, as a finishing touch, click the Apply Vignette button to darken the edges (which is a classic trademark of the Lomo effect). Click Reset if you want to start over, and click the Done button when you're finished to return to the Editor. There aren't a ton of options, but that's the point of Guided Edit—Elements takes care of most of the work for you.

A new effect was added in Elements 10, in the Photo Play palette (which is also new) in the Guided Edit tab of the Editor, called Picture Stack. The idea is to take one photo and make it look like it was cut up into smaller photos with white borders stacked on top of each other. The effect looks pretty cool and is a fun way to show off your photos. Plus, it even goes so far as to add shadows under each photo, so it really looks like they're lying on top of each other.

Creating a Picture Stack Effect

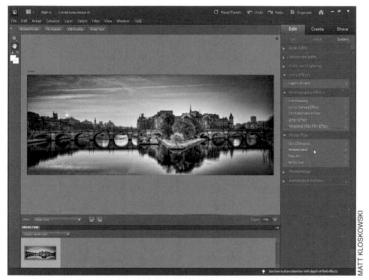

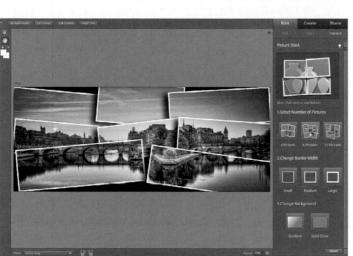

Step One:

In the Editor, open the photo that you want to use for the Picture Stack effect. I usually find landscape and travel photos look good here. You can use photos of people, too, but sometimes Elements will cut the photo right in the middle of someone's face, so you have to watch out when using these. Click on Guided at the top of the Edit tab and then go down to the Photo Play palette and click on Picture Stack.

Step Two:

First, you'll choose how many pictures you want your photo to be chopped up into. My favorite is 8 Pictures. To me, 4 Pictures doesn't look like enough and 12 Pictures makes the photo look too busy. The good thing is that you don't really have to commit to too much at this point. So, click on the 8 Pictures button on the right and Elements will go to work. It takes a minute, but you'll eventually see your photo cut into smaller square/rectangular pieces.

If you want to see what it looks like using four or 12 pictures, then just click on one of those buttons and Elements will redo the stack. It's pretty easy to figure out which one looks best for your photo by just trying out each option.

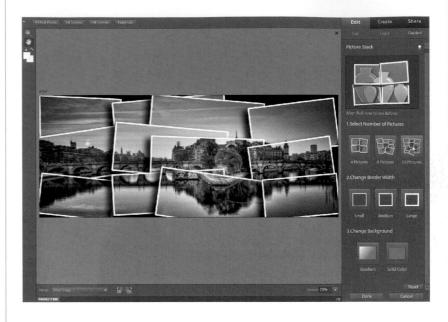

Step Four:

You'll notice that each photo has a white border around it and in section 2 you can control the width of that border. I usually go with the Medium setting here, as the Small setting is too thin, so I barely ever use it, and the Large setting isn't bad—sometimes it's a little overpowering, but sometimes it looks cool. Just like with selecting the number of pictures, this one is easy to experiment with, so click on the three border buttons to see which one you like better.

Lastly, you can change the background color and style (I switched back to eight photos with a medium border here). You have a choice between a gradient or just a simple solid-color background— I usually stick with a solid color. While the default black looks pretty cool, let's try a white background. Click on the Solid Color button and when the New Layer dialog appears, click OK. In the Color Picker, choose white and then click OK. I kinda like white, because it lets you see the shadows under the photos. It gives the image a little more depth, so each picture in the stack really looks like it's lying on the background.

Step Six:

When you've settled on your background color, just click the Done button at the bottom of the Palette Bin.

TIP: Edit the Layers

If you switch back to Full Edit mode and look in the Layers palette, you'll see the behind-the-scenes work that went on. Elements adds quite a few layers to your document. If you're brave enough, you can go into the separate layers and adjust them. The drop shadows, the outline around each photo—they each have their own layer, so if there's something you want to change, you can do so right on the layer.

The Orton Effect

Another new built-in special effect in Elements 10 is called the Orton Effect. The technique comes from traditional photography, where a photo was created by "sandwiching" two photos, one in focus and one out of focus, together. It adds a semi-soft focus, an almost dreamy style, to your photo, while still looking like the photo is sharp.

Step One:

Open a photo in the Editor to apply the effect to. You can use it on just about any photo, but I find photos that have a softer look to them work best. Portraits tend to get too blurry, but hey, you can always give it a try. In this photo, the late-afternoon feeling of the sun and trees works really well. Click on Guided at the top of the Edit tab, scroll down to Photography Effects, and click on Orton Effect.

Step Two:

You'll see the Palette Bin on the right side of the window change to show all of the settings you have control over for the effect. The first thing you'll want to do is click the Add Orton Effect button. This adds an overall contrasty feel to your photo and it also makes the colors look a little more saturated.

Next, move the Increase Blur slider to the right a little, and when I say "a little," I mean a little. Be careful when cranking this slider up, as things can get bad really quickly. Just drag it over slightly—somewhere between 5 and 10 should do it.

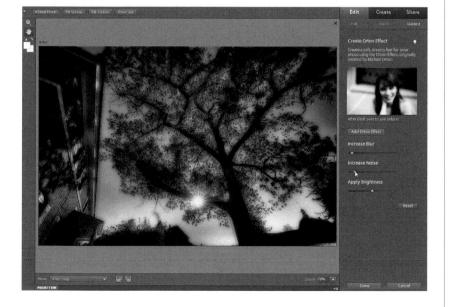

Step Four:

The Increase Noise setting is totally optional here. It gives a slightly more nostalgic film grain look to the photo. I dragged to around 500 here. Unless you really zoom in on the photo, it's kinda hard to see, but you should be able to see a little texture.

Another characteristic of the Orton effect is overexposure (the photos were deliberately overexposed before they were sandwiched together). This part is also optional, but you'll usually find that what we did in Step Two (clicking the Add Orton Effect button) darkened the photo a little, so I always increase the Apply Brightness setting a little. Somewhere between 20 and 30 works well here.

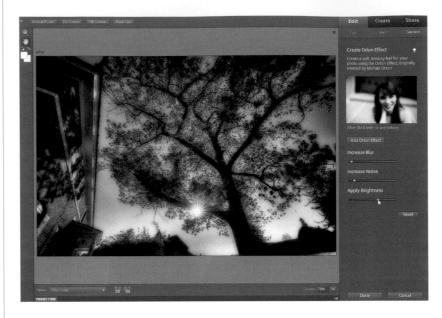

Step Six:

When you're ready, click the Done button at the bottom right. If you then click on Full at the top of the Edit tab and look in the Layers panel, you'll see Elements has added a couple of layers here: one layer adds the blur and the other layer works more with the overall focus and brightness of the image. Since the whole effect is layer based, you can always reduce the opacity of either of the layers to pull back the overall effect if you find it's too strong.

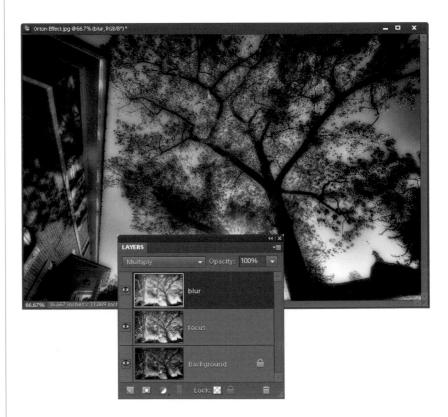

After

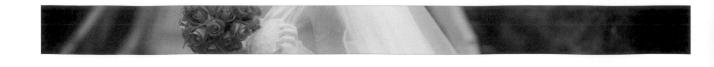

Enhancing Depth of Field

Depth of field is a great way to really make your subjects stand out from the background by blurring it. Sure, we can do a lot of this work in-camera with our lens and f-stop choice, but sometimes the creative idea doesn't strike until the photo hits the computer. The new Depth Of Field lens effect in Elements 10 will help you fix that, though.

Step One:

In the Editor, open a photo that has a busier background than you'd care for, or just one where you'd like to draw attention to a specific part of the image. In this example, we'll keep the flowers in focus and blur the couple and everything else in the background. Click on Guided at the top of the Edit tab, scroll down to Lens Effects, and click on Depth Of Field.

Step Two:

You'll see this effect has two modes: Simple and Custom. Let's start by clicking on the Simple button. Elements pretty much walks you through what to do in Simple mode. First, click the Add Blur button at the top to simply add some blur to the entire photo. At this point, you haven't defined the subject yet, so Elements will blur everything in the photo.

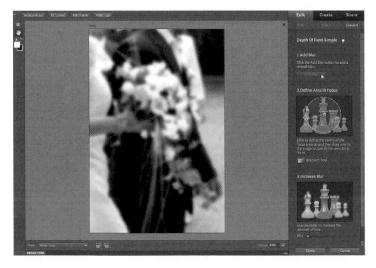

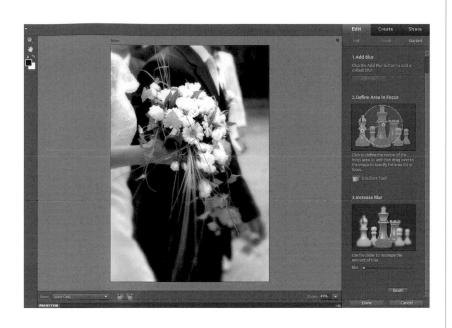

Next, you need to tell Elements what parts of the photo you want in focus. So, start by clicking on the Gradient tool in section 2, then click in the middle of whatever you want to be in focus and drag outward. The farther out from the center you drag, the smoother your sharp-to-blur transition will be.

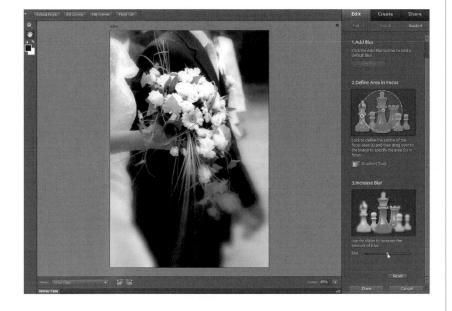

Step Four:

Once you've defined the part of the photo you want sharp, you can go down to section 3 and add more blur if you want. I dragged my slider to around 10 to make the background even blurrier. Now, if you haven't realized yet, the simple method is, well, simple, but it's limited because of the way it fades the blur away. Like most things in Elements, however, this effect gives you a simple way and a more custom way to do things. We'll take a look at the custom method next.

I've got another photo open here in the Editor. In this example, the kids and the parents are all in focus, but I'd like to make it so the kids seem like the center of attention. So, once again, in the Guided options of the Edit tab, go down to the Lens Effects palette, and click on Depth of Field. This time, though, click on the Custom button.

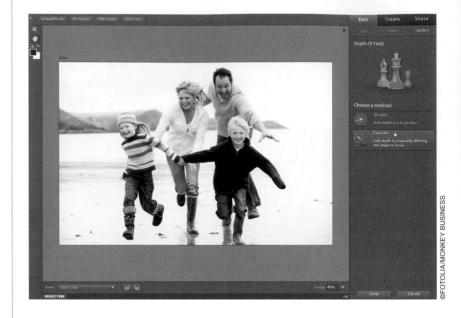

Step Six:

The first thing we'll do here is define our subject (the part of the photo that we don't want to blur). We did it before using a gradient tool, which didn't give us too much control, but in the Custom options, we get to make a selection. So, click on the Quick Selection tool (by the way, we covered this tool in greater detail back in Chapter 6), and then just start painting over the kids in the photo. Don't worry if you select part of the background, though, because we'll take care of that in the next step.

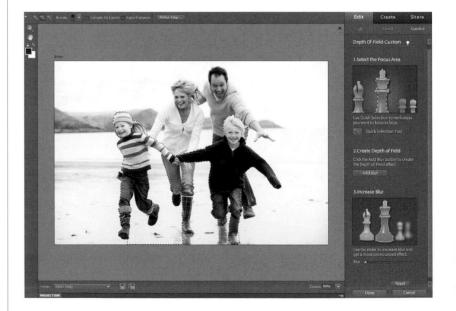

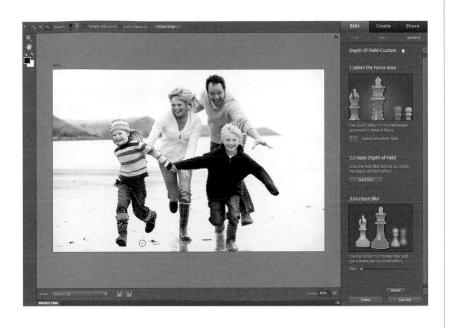

Step Seven:

Chances are that you've probably selected something you didn't want to during your first pass with the Quick Selection tool. No sweat. Just pressand-hold the **Alt (Mac: Option) key** to put the tool into Subtract mode and click on any areas you didn't want selected. When things were looking pretty good, I clicked a few times on the ground under the kids' feet, too, to make sure I selected it. Remember, if this were real depth of field, not only would the kids be in focus, but the ground they were running on would be, too.

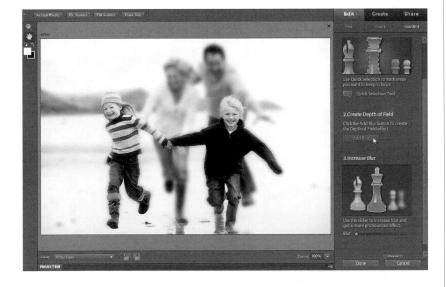

Step Eight:

The rest is a piece of cake. Just click on the Add Blur button in section 2 to blur everything that wasn't selected in the photo. Now the kids should really stand out from the parents and background behind them. Just like before, if you want to add more blur to the background, just drag the Blur slider in section 3 to the right some. If you find the blur is too intense (when using either the Simple or Custom method), click the Done button, then click Full at the top of the Edit tab, and lower the blurred layer's opacity.

This is just about the hottest Photoshop portrait technique out there right now, and you see it popping up everywhere, from covers of magazines to CD covers, from print ads to Hollywood movie posters, and from editorial images to billboards. It seems right now everybody wants this effect (and you're about to be able to deliver it in roughly 60 seconds flat using the simplified method shown here!).

Step One:

Open the photo you want to apply this trendy desaturated portrait effect to. Duplicate the Background layer by pressing **Ctrl-J (Mac: Command-J).** Then duplicate this layer using the same shortcut (so you have three layers in all, which all look the same, as shown here).

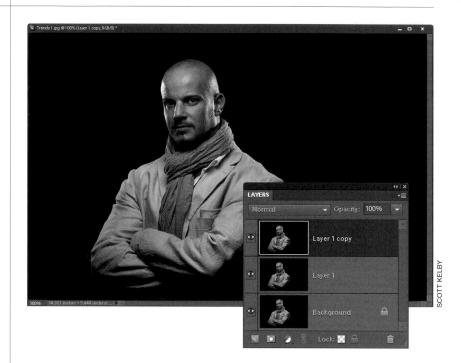

Step Two:

In the Layers palette, click on the middle layer (Layer 1) to make it the active layer, then press **Ctrl-Shift-U** (**Mac: Command-Shift-U**) to desaturate and remove all the color from that layer. Of course, there's still a color photo on the top of the layer stack, so you won't see anything change onscreen (you'll still see your color photo), but if you look in the Layers palette, you'll see the thumbnail for the center layer is in black and white (as seen here).

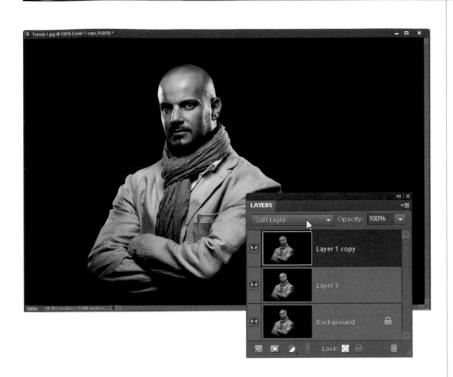

In the Layers palette, click on the top layer in the stack (Layer 1 copy), then switch its layer blend mode from Normal to **Soft Light** (as shown here), which brings the effect into play. Now, Soft Light brings a very nice, subtle version of the effect, but if you want something a bit edgier with even more contrast, try using Overlay mode instead. If the Overlay version is a bit too intense, try lowering the Opacity of the layer a bit until it looks good to you.

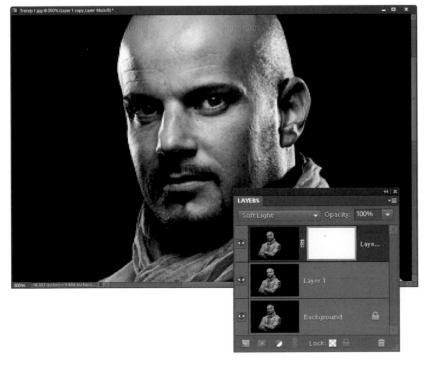

Step Four:

Fairly often, you'll find that the person's eyes really stand out when you see this effect, and that's usually because it brings the original eye color and intensity back (this is an optional step, but if your subject has blue or green eyes, it's usually worth the extra 15 seconds of effort). It's just two quick steps: Start by clicking on the Add Layer Mask icon at the bottom of the Layers palette (for more on layer masks, see Chapter 7). Then get the Brush tool (B), choose a small, soft-edged brush from the Brush Picker up in the Options Bar, press D, then **X** to set your Foreground color to black, and paint right over both eyes (not the whites of the eyes—just the irises and the pupils). This will seem kind of weird, because since you knocked a hole out of the eyes on this layer, you're now only seeing the eyes on the B&W layer below it, but you're going to fix that in the next step.

To knock the exact same hole out of the B&W layer (which means there will be "eye holes" knocked out of the top two layers, so you'll see the original eyes from the Background layer), just pressand-hold the Ctrl (Mac: Command) key, and click directly on the layer mask thumbnail itself on the top layer to put a selection around the eyes you just painted on the mask. Then, click on the middle layer, and click on the Add Layer Mask icon again to create an exact copy of the top layer's layer mask on your middle layer (as shown here). Now you're seeing the original full-color unretouched eyes from the Background layer. Pretty neat little trick, eh?

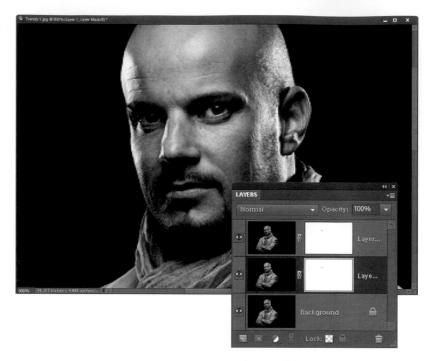

Step Six:

Flatten the image by clicking on the down-facing arrow in the top-right of the Layers palette and choosing Flatten Image from the palette's flyout menu. The final step is to add some more noise, so go under the Filter menu, under Noise, and choose Add Noise. When the Add Noise filter dialog appears (seen here), set the Distribution to Gaussian, and turn on the Monochromatic checkbox (or your noise will appear as little red, green, and blue specks, which looks really lame). Lastly, dial in an amount of noise that, while visible, isn't overly noisy. This is a very low-resolution photo, so I only used 4%. On a high-res digital camera photo, you'll probably have to use between 10% and 12% to see much of anything. You can see the before/ after on the next page. Beyond that, I gave you examples of how this effect looks on other portraits.

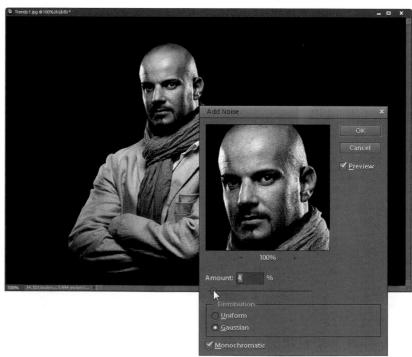

Before

After

Before

After

Step Seven:

Here's another example using the exact same technique and you can see how different the effect looks on a completely different image. I particularly love the almost bronze skin tone it creates in this image.

TIP: Don't Add Too Much Noise Be careful not to add too much noise, because when you add an Unsharp Mask to the image (which you would do at the very end, right before you save the file), it enhances and brings out any noise (intentional or otherwise) in the photo.

ANOTHER TIP: Try It on a Background I once saw this effect used in a motorcycle print ad. They applied the effect to the background, and then masked (knocked out) the bike so it was in full color. It really looked very slick (almost eerie, in a cool eerie way).

Step Eight:

Here's the same technique applied to a photo of a woman.

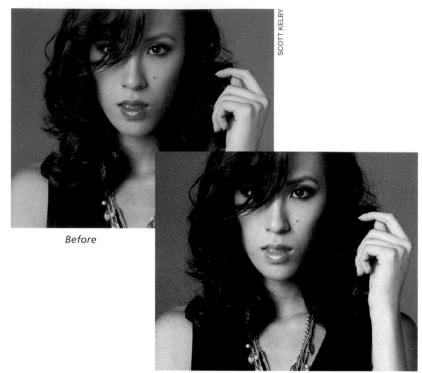

After

TIP: Vary the Opacity

Here are a couple of variations you can try with this effect: If the effect seems too subtle when you first apply it, of course you could try Overlay mode as I mentioned earlier, but before you try that, try duplicating the Soft Light layer once and watch how that pumps up the effect (as shown here). You can lower the opacity of that layer if it's too much. Another trick to try is to lower the opacity of the original Soft Light layer to 70%, which brings back some color with almost a tinting effect. Give it a shot and see what you think.

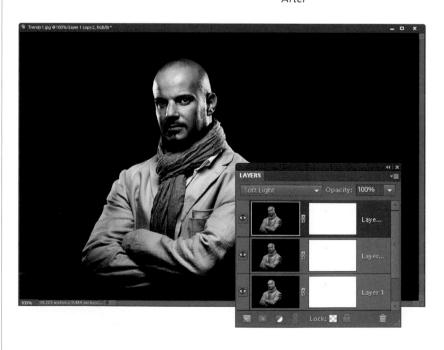

332

High-Contrast Look

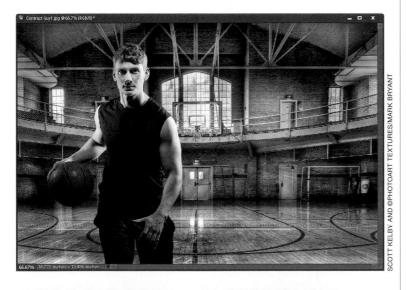

Step One:

Open the image you want to apply a high-contrast look to.

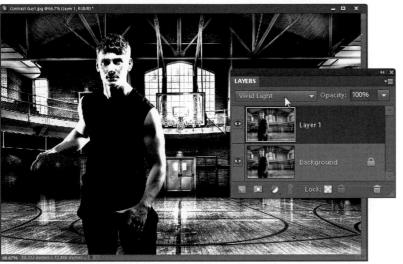

Step Two:

Make a copy of your Background layer by pressing **Ctrl-J** (**Mac: Command-J**). Then, change the blend mode of this duplicate layer to **Vivid Light** (I know it doesn't look pretty now, but it'll get better in a few more moves).

Now press **Ctrl-I (Mac: Command-I)** to Invert the layer (it should look pretty gray at this point). Next, go under the Filter menu, under Blur, and choose **Surface Blur**. When the dialog appears, enter 40 for the Radius and 40 for the Threshold, and click OK (it takes a while for this particular filter to do its thing, so be patient. If you're running this on a 16-bit version of your photo, this wouldn't be a bad time to grab a cup of coffee. Maybe a sandwich, too).

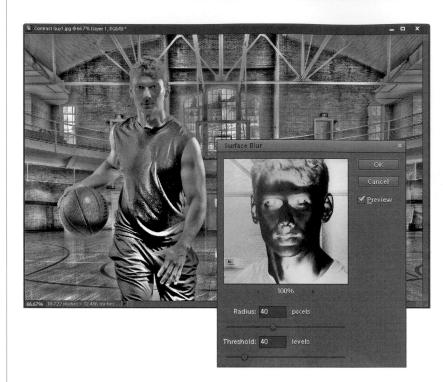

Step Four:

We need to change the layer's blend mode again, but we can't change this one from Vivid Light or it will mess up the effect, so instead we're going to create a new layer, on top of the stack, that looks like a flattened version of the image. That way, we can change its blend mode to get a different look. This is called "creating a merged layer," and you get this layer by pressing Ctrl-Alt-Shift-E (Mac: Command-Option-Shift-E).

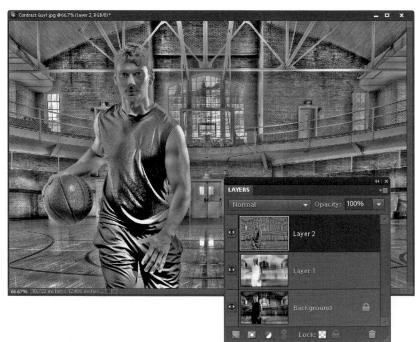

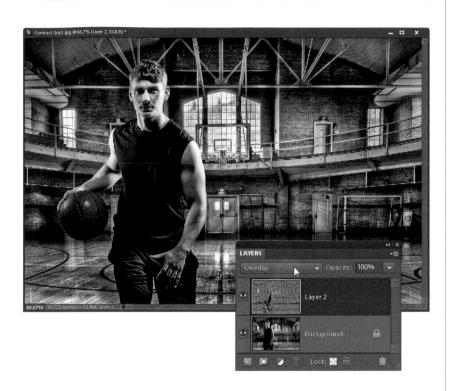

Now that you have this new merged layer, you need to delete the middle layer (the one you ran the Surface Blur upon), so drag it onto the Trash icon at the bottom of the Layers palette. Next, change the blend mode of your merged layer (Layer 2) to **Overlay**, and now you can start to see the effect taking shape (although we still have a little to do to bring it home).

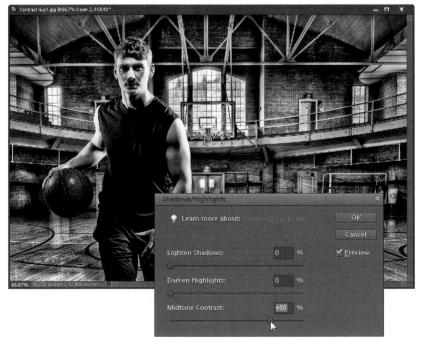

Step Six:

Go under the Enhance menu, under Adjust Lighting, and choose Shadows/ Highlights. When the dialog appears, drag the Lighten Shadows slider down to 0. Then, you're going to add what amounts to Camera Raw's Clarity by increasing the amount of Midtone Contrast on this Overlay layer. Go to the bottom of the dialog and drag the Midtone Contrast slider to the right, and watch how your image starts to get that crispy look (crispy, in a good way). Of course, the farther to the right you drag, the crispier it gets, so don't go too far, because you're still going to sharpen this image. Here, I dragged to 150%. Now click OK, then go to the Layers palette's flyout menu and choose Flatten Image. Next, you're going to add a popular finishing touch to this type of look—an edge vignette.

Step Seven:

Duplicate the Background layer again, and change the blend mode to **Multiply** (to make the layer darker). Get the Rectangular Marquee tool **(M)** and draw a rectangular selection about ½" to 1" from the edge of the photo (as shown here).

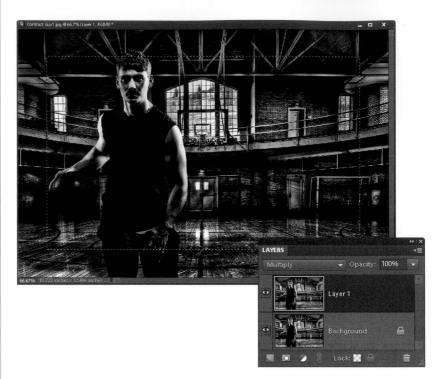

Step Eight:

To soften the edges of your selection, go under the Select menu and choose **Refine Edge** to bring up the Refine Edge dialog. By default, you should still see your full-color image, but if you don't, click on the far-left icon below the sliders. Now, drag the Feather slider all the way to 100 pixels (for a high-res file, you'll drag to 200 pixels), and click OK. Press the **Backspace (Mac: Delete) key** on your keyboard to knock a softedged hole out of your darker Multiply layer, giving you an edge vignette (as seen here).

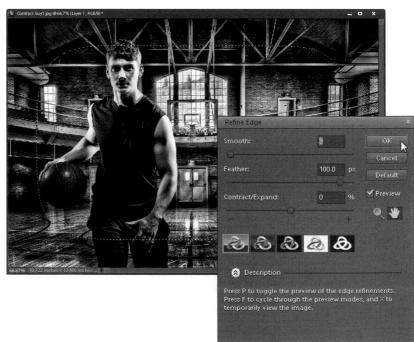

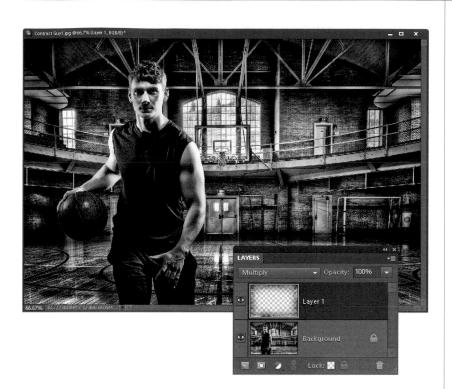

Step Nine:

Press Ctrl-D (Mac: Command-D) to Deselect. If your vignette is too close to your subject at the top, you can always grab the Eraser tool (E), choose a soft-edged brush, and erase that part of your Multiply layer. If the vignette doesn't seem dark enough, simply duplicate your Multiply vignette layer. Flatten your layers, then the final step, which is optional, is to add megasharpening using the Edge Sharpening technique found in Chapter 10, flatten the image again, and you're done. A before/after is shown below.

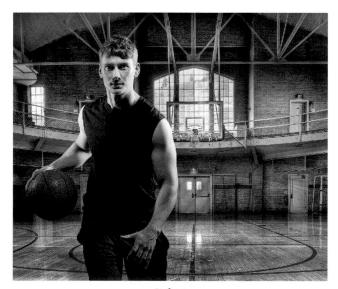

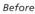

After

If you want that extreme contrast, grungy look, you can create it right within Camera Raw itself by just dragging a few sliders in the Basic panel, and then opening it in Elements and adding a vignette. And, since you're going to leave Camera Raw and go to Elements anyway, you should try poppin' some edge sharpening on this puppy. Shots like this, with lots of texture and metal, just love a little edge sharpening tossed on them, so give it a try. But let's not get ahead of ourselves—here's the grungy look made easy:

Step One:

Open a photo in Camera Raw. This is one of those effects that needs the right kind of image for it to look right. Photos with lots of detail, texture, along with anything metallic, and lots of contrast seem to work best (it also works great for sports portraits, cars, even some landscapes. In other words: I wouldn't apply this effect to a shot of a cute little fuzzy bunny). Here's the original RAW image open in Camera Raw. (Note: This effect actually seems to come out better when you run it on RAW images, rather than JPEG or TIFF, but it does work on all three.)

Step Two:

Set these four sliders all at 100: Recovery, Fill Light, Contrast, and Clarity (as shown here). This is going to make your image look kind of washed out (like you see here). The brightness for this photo looks okay, because it was kind of dark when we started, but if your image was already kind of bright in the first place, it's going to look really bright now. If that's the case, you can go ahead and lower the Exposure amount (just drag the Exposure slider to the left until the brightness looks normal. The image will still look washed out, but it shouldn't be crazy bright).

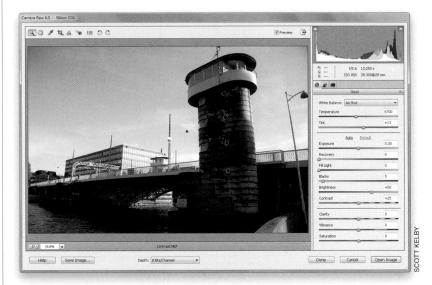

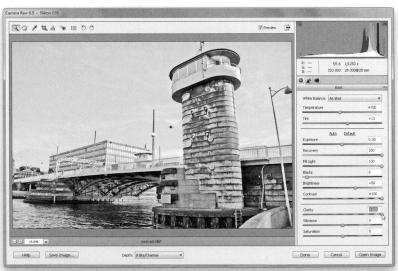

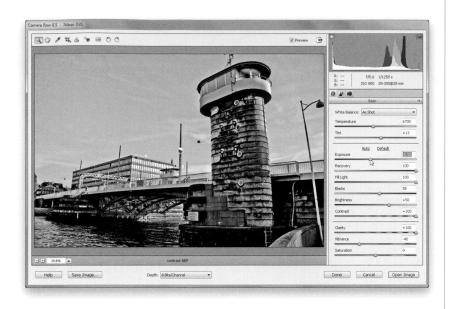

Now, you're going to bring back all the saturation and warmth to the color in the image by dragging the Blacks slider way up to the right. Keep dragging until the photo looks balanced (like it does here, where I dragged it over to +55). If the colors look too colorful and vibrant (and they probably will), just lower the Vibrance amount until it looks just a little desaturated (that's part of "the look"). Here, I lowered the Vibrance to -40. It did seem just a little bright at this point, so I also dragged the Exposure slider to -0.50.

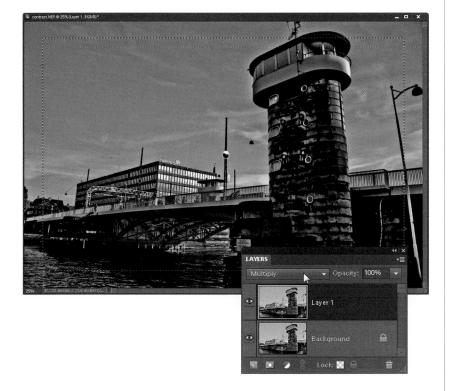

Step Four:

The finishing move for this effect is to add a dark edge vignette, like we did in the last technique. So, click on the Open Image button to open the photo in the Elements Editor, then press **Ctrl-J (Mac: Command-J)** to duplicate your Background layer, and change the new layer's blend mode to **Multiply**. Grab the Rectangular Marquee tool **(M)** and make a selection about ½" to 1" inside the edge of your photo (as shown here).

To soften the vignette, go to the Select menu and choose Refine Edge. In the Refine Edge dialog, click on the far-left icon below the sliders, so you'll continue to see your full-color photo. Then, drag the Feather slider over to 200 for a high-res photo like this (only drag to 100 for a low-res photo), and click OK. Press the Backspace (Mac: Delete) key to knock a soft-edged hole out of your Multiply layer (as shown here), and then press Ctrl-D (Mac: Command-D) to Deselect. Compare this to the original in the before/after below, and you can see the appeal of this effect, which almost looks a little like an HDR photo. Well, that's it—the whole grungy enchilada using Camera Raw. (But, I gotta ask ya—is this baby screamin' for some edge sharpening, or what? See the next chapter for more on that.)

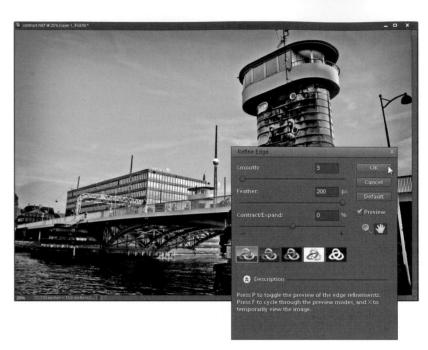

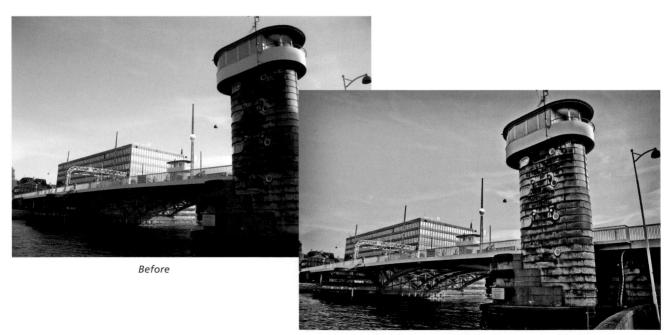

After

click, you can do it. Here's how it's done:

want your color photo converted into black and white. It's a very visual way to make the jump from color to black and white, and if you can point-and-

Converting to Black and White

Step One:

Open the color photo you want to convert to black and white (yes, you need to start with a color photo), and then go under the Enhance menu and choose **Convert to Black and White** (as shown here).

Step Two:

When you choose Convert to Black and White, a dialog appears and your photo (behind the dialog) is converted to black and white on the spot (in other words, you get a live preview of your changes). At the top of the dialog is a before and after, showing your color photo on the left, and your black-and-white conversion on the right, which honestly is of little help, especially since you can see your full-sized photo behind the dialog. Anyway, your first step is to choose which style of photo you're converting from the list of styles on the lower-left side of the dialog. These styles are really just preset starting points that are fairly well-suited to each type of photo. The default setting is Scenic Landscape, which is a fairly non-exciting setting. Since I'm generally looking to create high-contrast, black-and-white photos with lots of depth, I recommend the Vivid Landscapes style, which is much punchier. Go ahead and choose that now, just so you can see the difference.

Whether you stay with the default Scenic Landscape, or try my suggested Vivid Landscapes (or any of the other styles to match the subject of your photo), these are just starting places—you'll need to tweak the settings to really match your photo, and that's done by dragging the four Adjust Intensity sliders that appear on the bottom-right side of the dialog. The top three (Red, Green, and Blue) let you tweak ranges of color in your photo. So, for example, if you'd like the rocks darker, you'd drag the Red slider to the left, as shown here. If you want the water brighter, which is mostly blue, you'd drag the Blue slider to the right. There's green in the rocks, too, so moving the Green slider to the left will also darken the rocks.

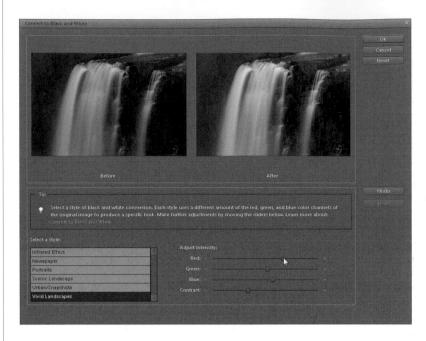

Step Four:

So, basically, you use those three sliders to come up with a mix that looks good to you. You don't have to use these sliders, but if you can't find one of the presets that looks good to you, find one that gets you close, and then use the Red, Green, and Blue sliders to tweak the settings. The fourth slider, Contrast, does just what you'd expect it would—if you drag to the right, it adds contrast (and to the left removes it). I'm very big on high-contrast blackand-white prints, so I wouldn't hesitate to drag this a little to the right just to create even more contrast (so, personally, I'm more likely to start with a preset, like Vivid Landscapes, and then use the Contrast slider, as shown here, than I am to spend much time fooling with the Red, Green, and Blue sliders. But hey, that's just me).

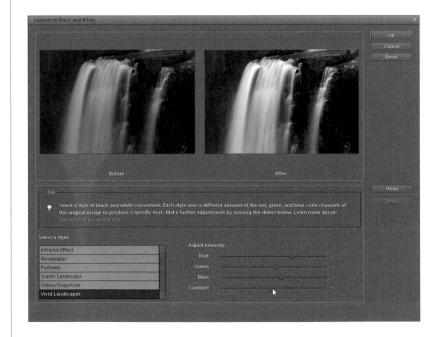

Panoramas Made Crazy Easy

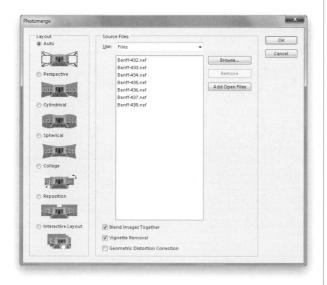

Step One:

Select the individual pieces of your pano in the Organizer. Here, I chose seven separate photos we're going to stitch together into a panorama. Go under the File menu, under New, and choose **Photomerge® Panorama**, or simply open all seven photos in the Editor, then go under the File menu, under New, and choose Photomerge® Panorama.

Step Two:

In the Photomerge dialog, click on the button for Add Open Files, and your photos for the pano will appear in the center column. We'll look at the Layout part in the next step, and jump down below that center column. Leave the Blend Images Together checkbox turned on. There are two other options you may need, depending on how you shot your pano: (1) If you have lens vignetting (the edges of your images appear darkened), then turn on Vignette Removal (as I did here), and although it will take a little longer to render your pano, it will try to remove the vignetting during the process (it does a pretty decent job). If you're using a Nikon, Sigma, or Canon fisheye lens to shoot your panos, turn on the Geometric Distortion Correction checkbox at the bottom to correct the fisheye distortion.

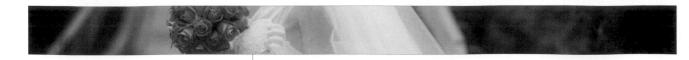

In the Layout section on the left, the default setting is Auto (as seen in Step Two), and I recommend leaving that set to Auto to get the standard wide pano we're looking for. The five Layout choices below Auto (Perspective, Cylindrical, Spherical, Collage, and Reposition) all give you...well...funky looking panos not the nice wide pano most of us are looking for—and the Interactive Layout brings back the "old" semi-manual way of stitching panos. So, let's just stick with Auto. Click OK, and within a few minutes (depending on how many photos you shot for your pano), your pano is seamlessly stitched together (as seen here), and you'll see status bars that let you know that Elements is aligning and blending your layers to make this minimiracle happen.

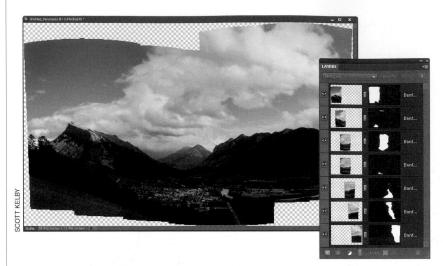

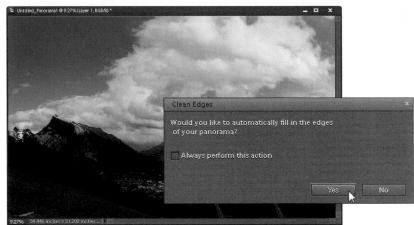

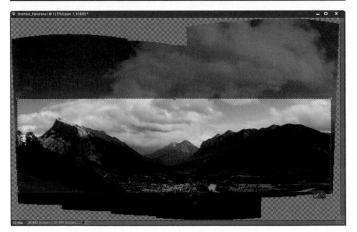

Step Four:

To make your pano fit perfectly together, Photomerge has to move and rearrange things in a way that will cause you to have extra canvas around your final pano. That's why the Clean Edges dialog will pop up. With it, you can have Elements try to fill in the blank space based on the image—it does an amazingly good job, although you may have to use the Clone Stamp tool (S) to finish it off. Or, you can click No, get the Crop tool (C), and drag out your cropping border (encompassing as much of the pano as possible without leaving any gaps).

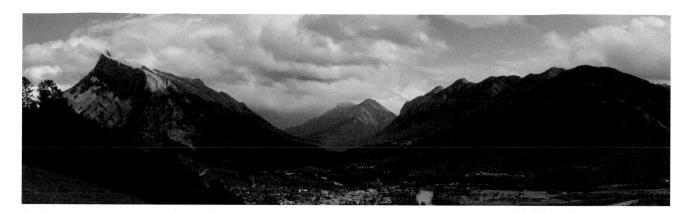

Creating Drama with a Soft Spotlight

This is a great technique that lets you focus attention by using dramatic, soft lighting. The technique I'm showing you here, I learned from famous nature photographer Vincent Versace. I had been getting a similar look by filling a layer with black, making an oval selection, feathering the edges significantly, and then knocking a hole out of the layer (as you'll see in the next technique), but Vincent's technique, using the Lighting Effects filter, is so much easier that it's just about all I use now.

Step One:

Open the RGB photo to which you want to apply a soft spotlight effect. In this example, I want to focus attention on the bride by darkening the area around her. Next, press **Ctrl-J** (**Mac: Command-J**) to duplicate the Background layer.

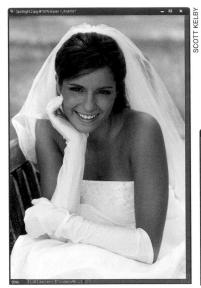

Step Two:

Go under the Filter menu, under Render, and choose **Lighting Effects**. I have to tell you, if you haven't used this filter before, it's probably because its interface (with all its sliders) looks so complex, but luckily there are built-in presets (Adobe calls them "Styles") that you can choose from, so you can pretty much ignore all those sliders. Once you ignore the sliders, the filter is much less intimidating, and you can really have some fun here. The small preview window on the left side of the dialog shows you the default setting, which is a large oval light coming from the bottom right-hand corner.

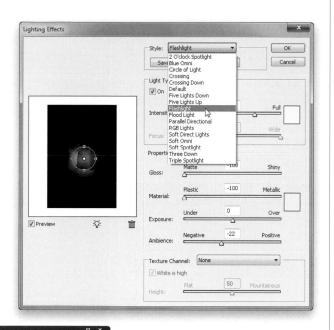

For this effect, we're going to use a very soft, narrow beam, so go under the Style pop-up menu at the top of the dialog (this is where the presets are) and choose **Flashlight**.

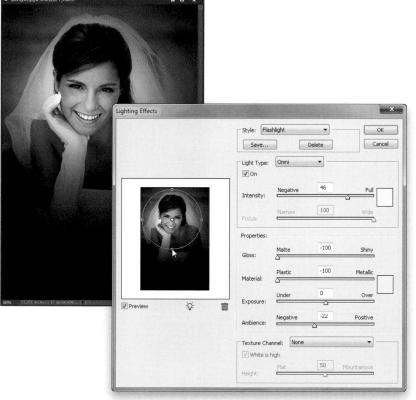

Step Four:

Once you choose Flashlight, look at the preview window and you'll see a small spotlight in the center of your image. Click on the center point (inside the circle) and drag the light into the position where you want it. If you want the circle of light a little bit larger, just click on one of the side points and drag outward. When you click OK, the filter applies the effect, darkening the surrounding area and creating the soft spotlight effect you see here.

Step Five:

If the Lighting Effects filter seems too intense, you can remedy it immediately after the fact by lowering the Opacity setting in the Layers palette to reduce the effect of the filter. The lower the setting, the less the intensity of the effect. Then, while in the Layers palette, change the blend mode of this layer to **Darken**, so the Flashlight effect doesn't make the colors seem too saturated.

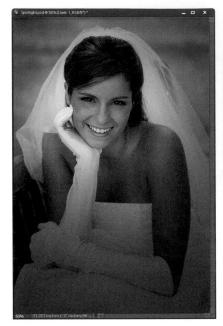

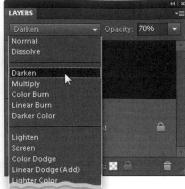

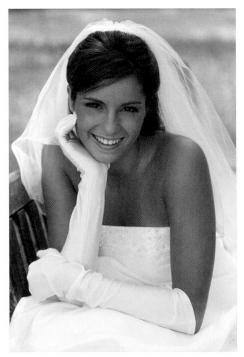

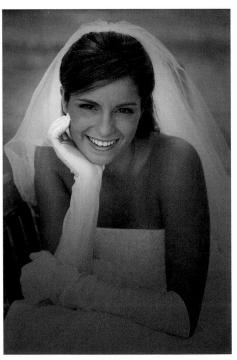

After

Burned-In Edge Effect (Vignetting)

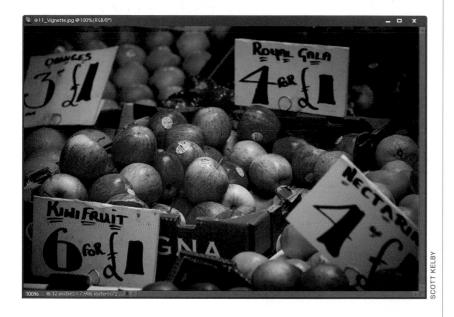

Step One:

Open the photo to which you want to apply a burned-in edge effect. Just so you know, what we're doing here is focusing attention through the use of light—we're burning in all the edges of the photo (not just the corners, like lens vignetting, which I usually try to avoid), leaving the visual focus in the center of the image.

Step Two:

Go to the Layers palette and add a new layer by clicking on the Create a New Layer icon at the bottom of the palette. Press the letter **D** to set your Foreground color to black, and then fill your new layer with black by pressing **Alt-Backspace (Mac: Option-Delete)**.

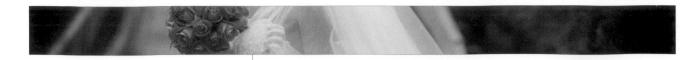

Press **M** to get the Rectangular Marquee tool and drag a selection about 1" or so inside the edges of your photo. Then, to greatly soften the edges of your selection, go under the Select menu and choose **Feather**. When the dialog appears, enter 50 pixels for a low-res photo (or 170 pixels for a high-res, 300-ppi photo), and click OK.

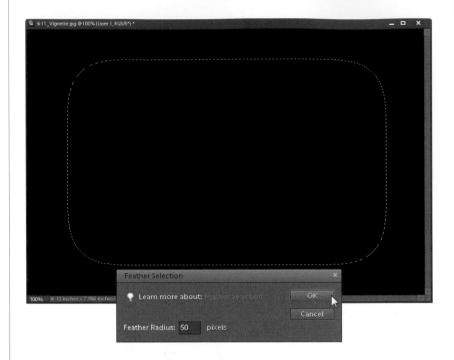

Step Four:

Now that your edges have been softened, all you have to do is press **Backspace (Mac: Delete)**, and you'll knock a soft hole out of your black layer, revealing the photo on the Background layer beneath it. Now press **Ctrl-D (Mac: Command-D)** to Deselect. *Note:* If the edges seem too dark, you can go to the Layers palette and lower the Opacity of your black layer (in the example shown here, I lowered the Opacity to 70%).

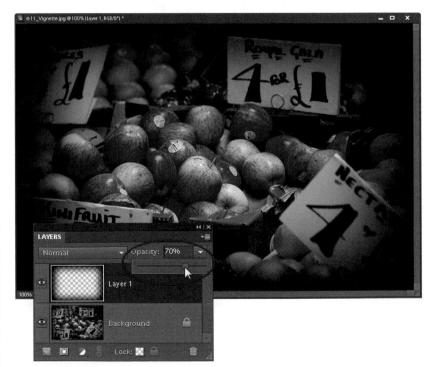

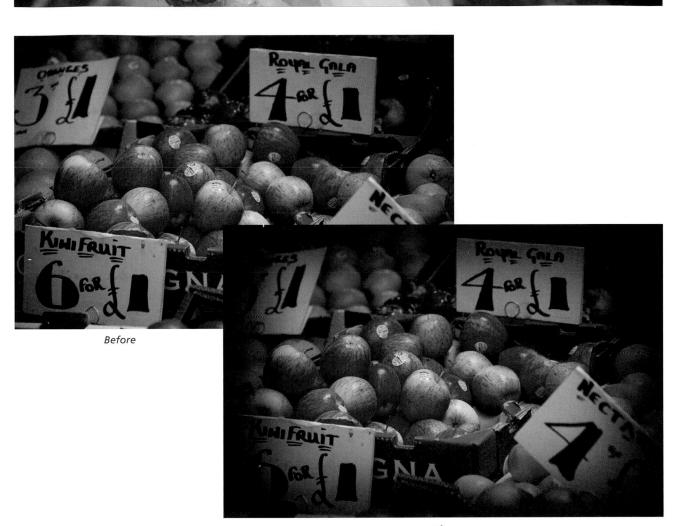

After

Using Color for Emphasis

This is a popular technique for focusing attention by the use of color (or really, it's more like the use of less color—if everything's in black and white, anything that's in color will immediately draw the viewer's eye). As popular as this technique is, it's absolutely a breeze to create. Here's how:

Step One:

Open a photo containing an object(s) you want to emphasize through the use of color. Go under the Layer menu, under New, and choose **Layer via Copy** (or just press **Ctrl-J [Mac: Command-J]**). This will duplicate the Background layer onto its own layer (Layer 1).

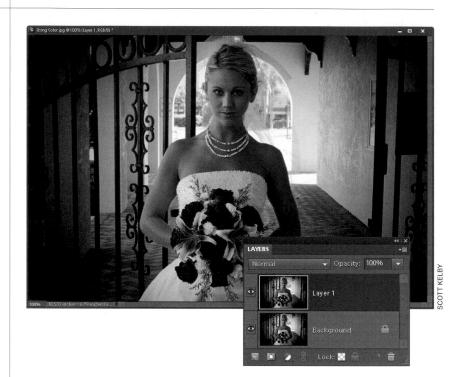

Step Two:

Press **B** to get the Brush tool from the Toolbox and choose a medium, softedged brush from the Brush Picker in the Options Bar (just click on the brush thumbnail to open the Picker). Also in the Options Bar, change the Mode popup menu to **Color** for the Brush tool.

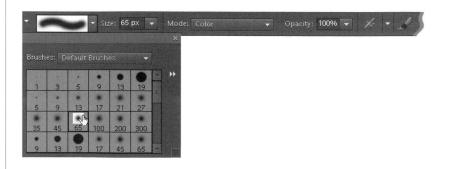

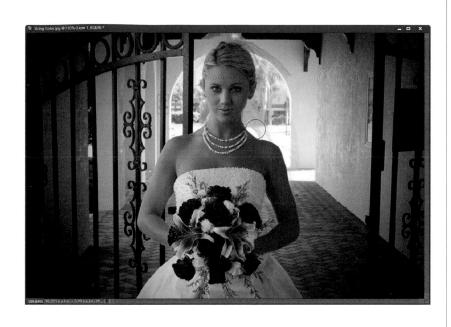

Set your Foreground color to black by pressing the letter **D** and begin painting on the photo. As you paint, the color in the photo will be removed. The goal is to paint away the color from all the areas except the areas you want emphasized with color.

TIP: Fixing Mistakes

If you make a mistake while painting away the color or later decide that there was something else that you really wanted to keep in color, just switch to the Eraser tool by pressing the **E key**, paint over the "mistake" area, and the original color will return as you paint. (What you're really doing here is erasing part of the top layer, which is now mostly black and white, and as you erase, it reveals the original layer, which is still in full color.)

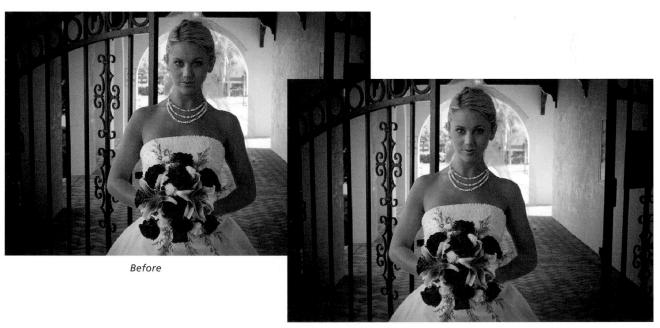

After

This is another one of those effects that has grown in popularity over the years, and it takes just a few steps to totally nail the look. By the way, you could add an optional Polaroid-look border when you're done, place it into a frame from the Content palette, or download an antique-look frame border from a stock photo website to finish it off.

Step One:

Start with the photo you want to apply the technique to (we're going to use a photo of an old car here. You can download the same photo from the book's companion website. In fact, you can download most of the key images used in the book, so you can follow right along. The Web address is in that introduction in the front of the book that you skipped).

COTT KELE

Step Two:

First, you're going to add a very warm, yellowish tint to the image (while still leaving it in color) by going under the Enhance menu, under Adjust Color, and choosing **Color Variations**. When the dialog appears, in the first section, at the bottom left, make sure Midtones is selected. Then, in the second section, leave the Amount slider set in the middle. Now, click on the Increase Red thumbnail in the third section.

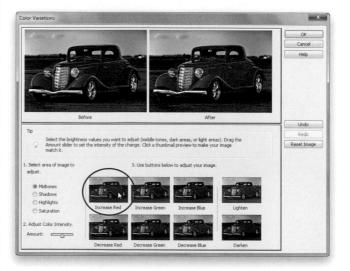

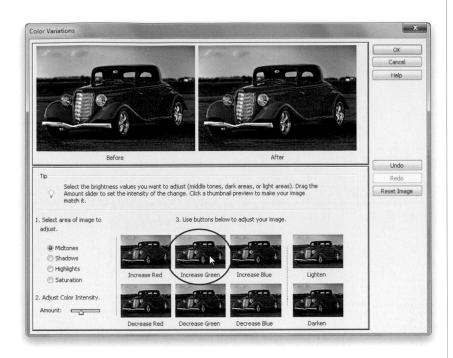

To make it more yellow, we'll have to add two more Color Variations changes. So, go back to the second section, and drag the Adjust Color Intensity Amount slider to the left one increment. Then, click on the Increase Green thumbnail.

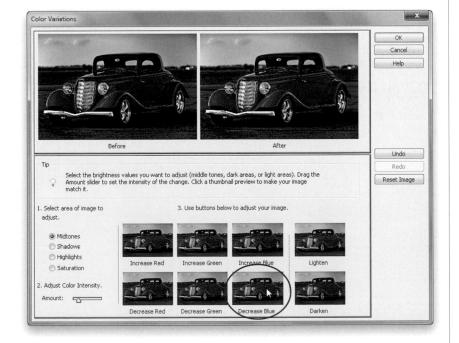

Step Four:

Now we need to take some of the blue out of the green we just added, so drag the Adjust Color Intensity Amount slider one more increment to the left, and click on the Decrease Blue thumbnail, then click OK.

Step Five:

You'll need to desaturate the colors a bit (remember, those old, faded photos didn't have the bright, punchy colors we have today), so go under the Enhance menu, under Adjust Color, and choose **Adjust Hue/Saturation** (or press **Ctrl-U [Mac: Command-U]**). When the dialog appears, drag the Saturation slider to –70 (as shown here) to remove some, but not all, of the color from the image. Now click OK.

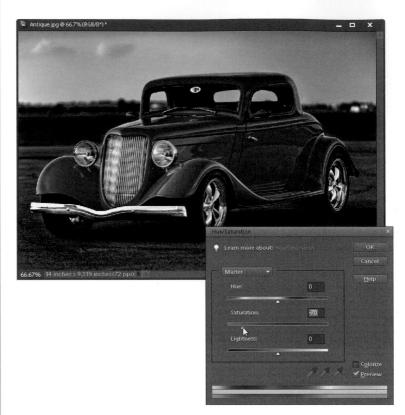

Step Six:

Press Ctrl-J (Mac: Command-J) to duplicate the Background layer, then change the blend mode of this duplicate layer to Screen (as shown here), which makes the whole photo very bright and a little blown out (it's all part of the effect). Now press Ctrl-E (Mac: Command-E) to flatten the two layers into one.

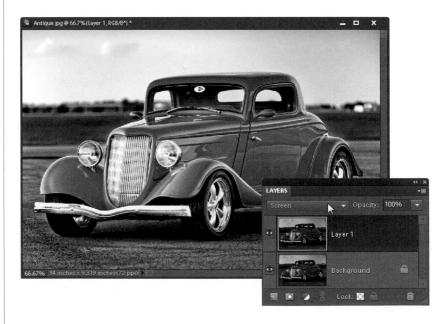

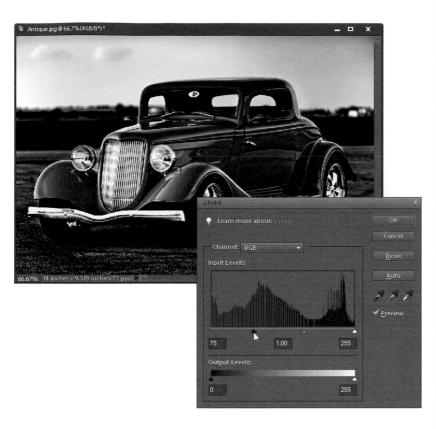

Step Seven:

Press Ctrl-L (Mac: Command-L) to bring up the Levels dialog, and drag the shadows Input Levels slider (the black triangle under the far-left side of the histogram graph) to the right a bit (as shown here) to darken in the shadow areas, so there's a big difference between the bright areas and the dark areas. Click OK.

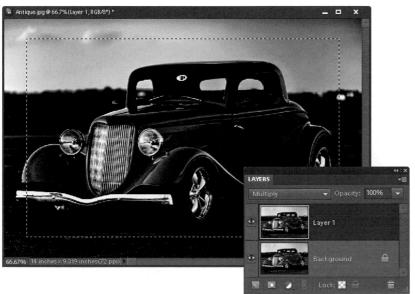

Step Eight:

Now you're going to darken the edges of the photo on all sides, to give it that burned-in edge look. So, duplicate your Background layer again, and change the new layer's blend mode to **Multiply**. Grab the Rectangular Marquee tool **(M)** and make a selection about ½" to 1" inside the edge of your photo (as shown here).

Step Nine:

To soften the vignette, go to the Select menu and choose **Refine Edge**. In the Refine Edge dialog, click on the far-left icon below the sliders, so you'll continue to see your full-color photo. Then, drag the Feather slider over to 100 for a low-res photo like this (drag to 200 for a high-res photo), and click OK.

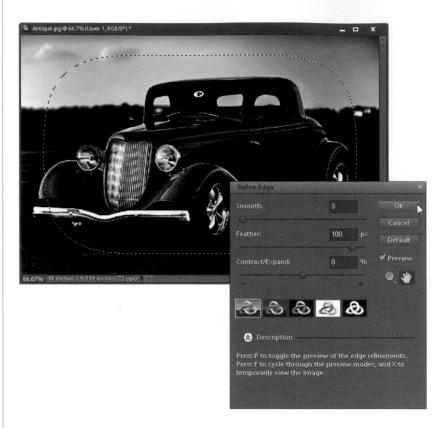

Step 10: Press the Backspace (Mac: Delete) key to knock a soft-edged hole out of your Multiply layer (as shown here), and then press Ctrl-D (Mac: Command-D) to Deselect. Now, flatten your layers again.

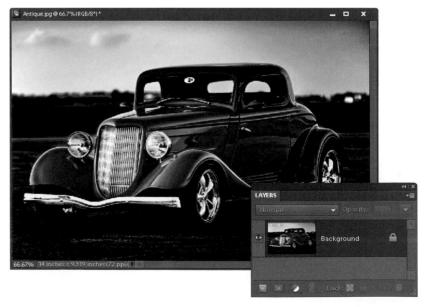

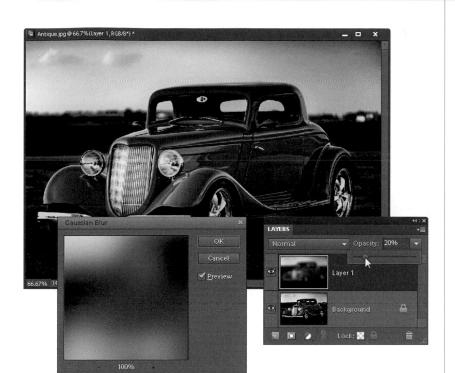

Step 11:

The final step is to add a bit of overall softening (you don't want the photo to be super-crisp), so duplicate the Background layer one last time, then go under the Filter menu, under Blur, and choose **Gaussian Blur**. When the filter dialog appears onscreen, enter 25 pixels for your blur, then click OK. Lastly, go back to the Layers panel and lower the Opacity for this layer to 20% (as shown here) to finish off the effect. A before/after is shown below.

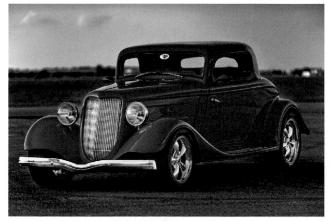

Before

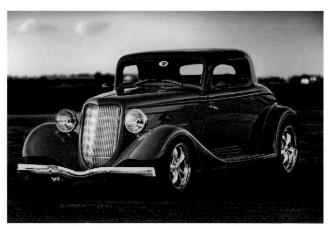

After

Matching Photo Styles

Now that I've given you some special effects you can apply to your images, I'll show you a feature in Elements that lets you match the style of one photo to another. For example, let's say you see a photo that has a really cool color treatment. Well, you can use the Photomerge Style Match feature to take the "look" from that photo and apply it to your own. Here's how it works:

Step One:

Open the photo you'd like to add an effect to, then click on Guided at the top of the Edit tab and scroll down to the Photomerge palette. Go ahead and click on Style Match to begin.

Step Two:

The next screen is fairly consistent with the other Photomerge features in Elements. On the left you pick a source image, and on the right is your final image. In this case, we need to choose the image that we want to style our photo (the photo on the right) after. Elements comes with a few style images already, and you'll find them in the Style Bin at the bottom of the window.

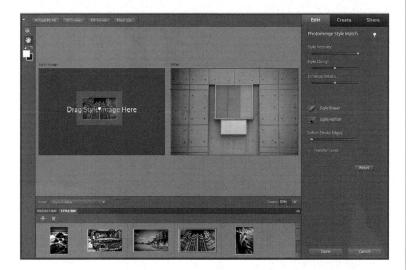

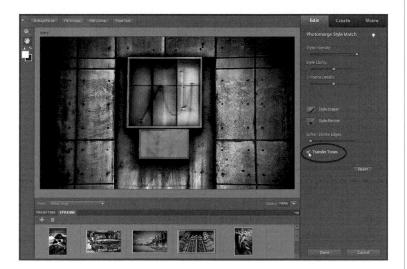

You can also add your own style images. Let's say you have a cool sepia-tinted photo that you'd like to use. Just click on the small green plus icon at the top left of the Style Bin. Then, choose where you'd like to import the photo from (it could be the Organizer, or any place on your hard drive). Once you've imported the photo, it shows up at the end of the Style Bin images.

Step Four:

After you've decided which photo you want to style your photo after, drag it from the Style Bin to the left side of the window under Style Image (I used one of the black-and-white included photos in my example). You'll also see the image on the right change to include some style elements from this photo. *Note:* If you want to see your After photo larger, just click on the View pop-up menu at the bottom left of the preview area, and choose **After Only**, then zoom in with the Zoom tool or the pop-up menu at the bottom right of the preview area.

Step Five:

Now, you may be totally happy with the way your photo looks. If so, just click Done. But if you want to experiment a little, Elements has some settings on the right side that'll let you change the look and feel of your photo. For starters, the first thing I always do is turn on the Transfer Tones checkbox at the bottom. I know it's at the bottom, so you typically don't think to start there, but it's one of the key settings for me whenever I'm using this feature (especially if your style image is black and white or sepia).

Step Six:

Next, we'll move to the top to the Style Intensity slider. This one is like an opacity slider. In our black-and-white example, reducing the intensity leaves us with a semi-saturated photo. As you move it all the way to the left, the style image eventually has no effect on the final.

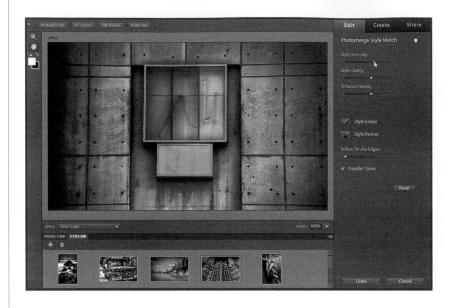

Step Seven:

The next slider, Style Clarity, works like a contrast slider. The further you move it toward the right the more contrasty the photo becomes. If you move it too far to the left, then the photo becomes kinda flat and loses a lot of the snap that it had before (which is why I rarely move it to the left).

Step Eight:

Enhance Details is like an ultra-contrast/sharpening slider. It takes whatever was dark and pushes it toward black. Then it takes whatever was lighter, and pushes it toward white. Be careful with this one, though. It tends to have some really strong effects, even if you just move it in small amounts (as seen here).

Step Nine:

Below the sliders are two icons: Style Eraser and Style Painter. Click the Style Eraser if you want to erase the style from a specific area of the photo. Then click Style Painter if you wanted to paint it back in. These are brushes just like what you have in Full Edit mode, so make sure your brush Mode is set to Normal in the Options Bar. When you're done, just click the Done button at the bottom and then click Full at the top of the Edit tab to return to Full Edit mode. At that point your photo is on a layer just like any other photo and you're free to edit and retouch like usual.

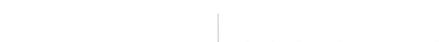

Replacing the Sky

When shooting outdoors, there's one thing you just can't count on—the sun. Yet, you surely don't want a photo of your house on a dreary day, or a photo of your car on a gray overcast day. That's why it's so important to have the ability to replace a gloomy gray sky with a bright sunny sky. Is it cheating? Yes. Is it easy? You betcha. Do people do it every day? Of course.

Step One:

Open the photo that needs a new, brighter, bluer sky.

Step Two:

You have to make a selection around the sky. Usually, you can click in the sky area with the Magic Wand tool (W) or the Quick Selection tool (A) to select most of it, and then choose Similar from the Select menu to select the rest of the sky—but as usual, it likely selected other parts of the image besides just the sky. So use the Lasso tool (L) while pressing-and-holding the Alt (Mac: Option) key to deselect any excess selected areas on your image. If needed, press-and-hold the Shift key while using the Lasso tool to add any unselected areas of the sky. You can use any combination of selection tools you'd like—the key is to select the entire sky area.

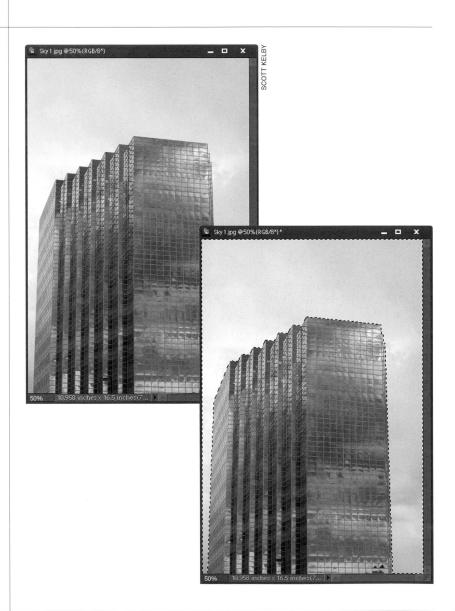

Shoot some nice blue skies and keep them handy for projects like this, or steal a sky from another photo. Simply open one of those "blue sky" shots, and then go under the Select menu and choose **All** to select the entire photo, or use the Magic Wand, Quick Selection, or Lasso tool as you did in the previous step to select just the sky you want. Then, press **Ctrl-C (Mac:Command-C)** to copy this sky photo into memory.

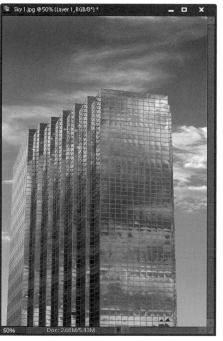

Step Four:

Switch back to your original photo (the selection should still be in place). Create a new layer by clicking on the Create a New Layer icon at the bottom of the Layers palette, then go under the Edit menu and choose Paste Into Selection. The new sky will be pasted into the selected area on your new layer, appearing over the old sky. If the clouds look too large, press Ctrl-T (Mac: Command-T) to go into Free Transform. Press-and-hold the Shift key (or turn on the Constrain Proportions checkbox in the Options Bar), grab a corner handle, and scale the new sky down. Press Enter (Mac: Return) to lock in your changes, then press Ctrl-D (Mac: Command-D) to Deselect.

Step Five:

If the sky seems too bright for the photo, simply lower the Opacity of the layer in the Layers palette to help it blend in better with the rest of the photo. That's it—newer, bluer sky.

neutral density gradient filter, because often (espeaially when shooting scenery, like sunsets) you wind up with a bright sky and a dark foreground. A neutral density gradient lens filter reduces the exposure in the sky by a stop or two, while leaving the ground unchanged (the top of the filter is gray, and it graduates down to transparent at the bottom). Well, if you forgot to use your ND gradient filter when you took the shot, you can create your own ND gradient effect in Photoshop Elements.

Neutral Density Gradient Filter

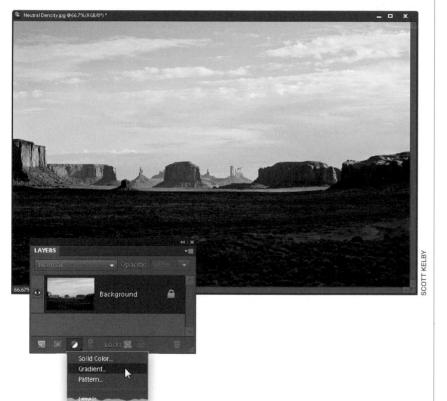

Step One:

Open the photo (preferably a landscape) where you exposed for the ground, which left the sky too light. Press the letter **D** to set your Foreground color to black. Then, go to the Layers palette and choose **Gradient** from the Create New Adjustment Layer pop-up menu (it's the half-white/half-black circle icon) at the bottom of the palette.

Step Two:

When the Gradient Fill dialog appears, click on the little, white downward-facing arrow (it's immediately to the right of the Gradient thumbnail) to bring up the Gradient Picker. Double-click on the second gradient in the list, which is the gradient that goes from Foreground to Transparent. Don't click OK yet.

By default, this puts a dark area on the ground (rather than the sky), so turn on the Reverse checkbox to reverse the gradient, putting the dark area of your gradient over the sky and the transparent part over the land. Your image will look pretty awful at this point, but you'll fix that in the next step, so just click OK.

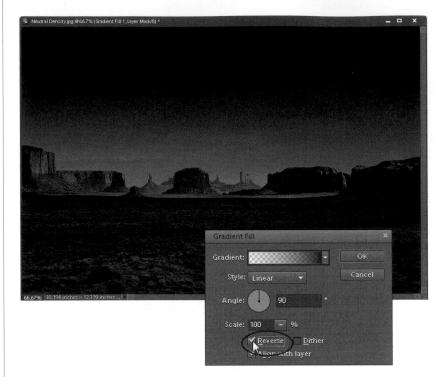

Step Four:

To make this gradient blend in with your photo, go to the Layers palette and change the blend mode of this adjustment layer from Normal to **Overlay**. This darkens the sky, but it gradually lightens until it reaches land, and then it slowly disappears. So, how does it know where the ground is? It doesn't. It puts a gradient across your entire photo, so in the next step, you'll basically show it where the ground is.

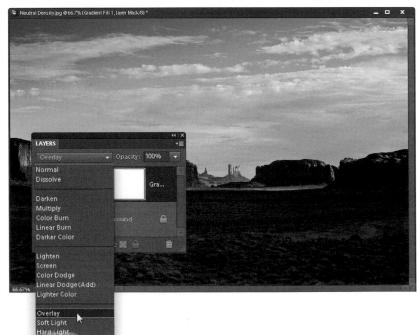

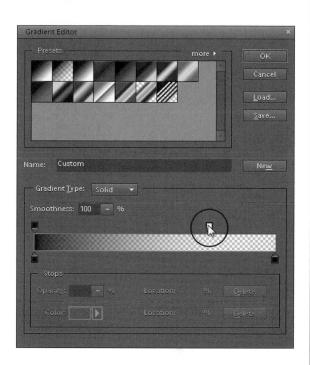

Step Five:

In the Layers palette, double-click on the thumbnail for the Gradient adjustment layer to bring up the Gradient Fill dialog again. To control how far down the darkening will extend from the top of your photo, just click once on the Gradient thumbnail at the top of the dialog. This brings up the Gradient Editor. Grab the top-right white Opacity stop above the gradient ramp near the center of the dialog and drag it to the left; the darkening will "roll up" from the bottom of your photo, so keep dragging to the left until only the sky and the rock formations are affected, and then click OK in the Gradient Editor.

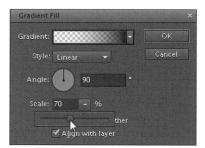

Step Six:

By default, the gradient you choose fills the entire image area, smoothly transitioning from a dark gray at the top center to transparent at the very bottom. It's a smooth, "soft-step" gradient. However, if you want a quicker change from black to transparent (a hard step between the two), you can lower the Scale amount in the Gradient Fill dialog.

Step Seven:

Also, if the photo you're working on doesn't have a perfectly straight horizon line, you might have to use the Angle control by clicking on the line in the center of the Angle circle and dragging slowly in the direction that your horizon is tilted. This literally rotates your gradient, which enables you to have it easily match the angle of your horizon. When it looks good to you, click OK to complete the effect.

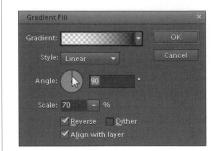

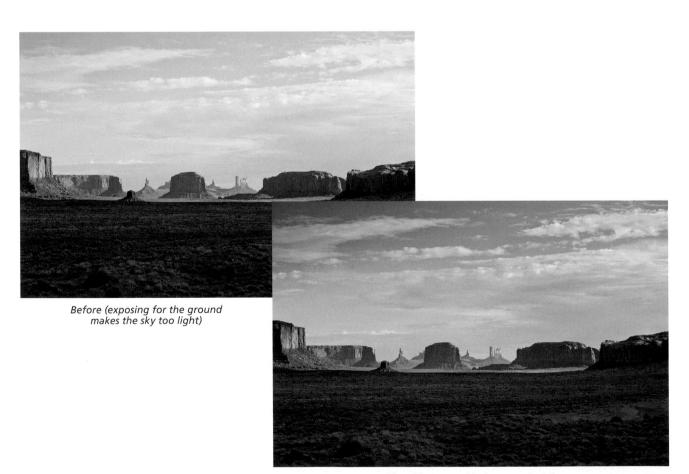

After (the ground is the same, but the sky is now bluer and more intense)

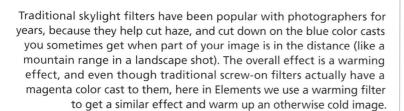

Skylight Filter Effect

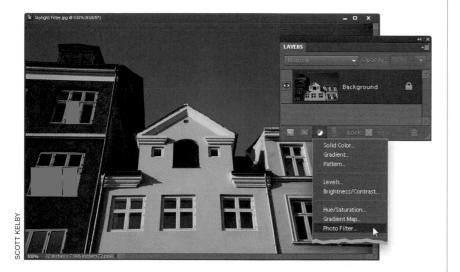

Step One:

Open the color photo you want to apply a skylight filter effect to in Elements. Click on the Create New Adjustment Layer icon at the bottom of the Layers palette, and choose **Photo Filter**.

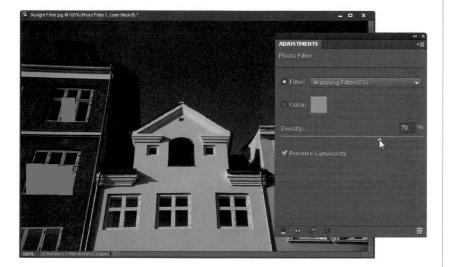

Step Two:

In the Adjustments palette, choose **Warming Filter (81)** from the popup menu, then increase the Density amount to 70% (as shown here).

Now go to the Layers palette and change the blend mode of this layer to Soft Light at the top left to complete the effect. Note: Changing the blend mode to Soft Light adds a bit of contrast, as well, so if it looks too contrasty after making this change, just lower the Opacity setting for this layer (at the top right of the Layers palette) until it looks about right (start at 50% and see what that looks like. In the After photo shown below, the added contrast looks good, so I only lowered it to 80%, but depending on the photo, you might have to tweak that Opacity setting a little bit).

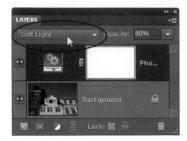

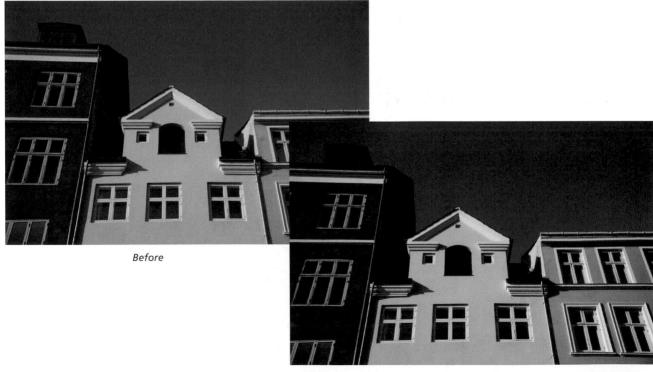

After

Luckily, it's pretty easy to tame and refocus the light in Elements.

Taming Your Light

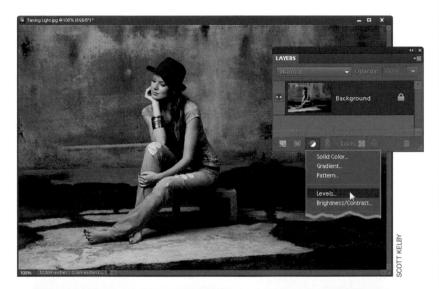

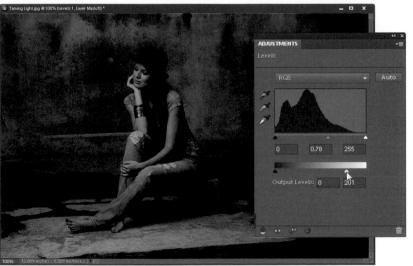

Step One:

As I mentioned above, here's the shot where the model is equally as bright as the background, which is not a good thing (in fact, the background may even be a little brighter, and is drawing your attention away from her face, which is absolutely not what you want). So, we're going to tame our light using a very simple Levels move. Choose **Levels** from the Create New Adjustment Layer pop-up menu at the bottom of the Layers palette (as shown here).

Step Two:

The changes I make in the Levels controls of the Adjustments palette will affect the entire photo, but since adjustment layers come with their own built-in layer masks, we'll be able to tweak things very easily after the fact. At this point, you want to darken the background, so drag the middle gray slider (right below the histogram) to the right a bit to darken the midtones (and the background), and then drag the bottom-right Output Levels slider to the left a little bit to darken the overall photo. One downside is that this oversaturates the colors quite a bit, which can also draw attention away from the face, but that's easy to fix.

First, to reduce the oversaturation caused by our Levels move, go to the Layers palette and change the blend mode of the Levels adjustment layer from Normal to **Luminosity**. This keeps the darkening without oversaturating the color. Next, press Ctrl-I (Mac: Command-I) to Invert the layer mask, which hides the darkening added by our Levels move behind a black mask. Now, get the Brush tool (B), press X to set your Foreground color to white, then with the layer mask active, paint over everything in the photo except for the model. As you paint, it darkens those areas (as shown here, where I'm darkening the background, so now the model is the focus).

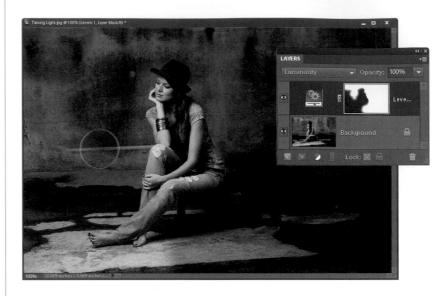

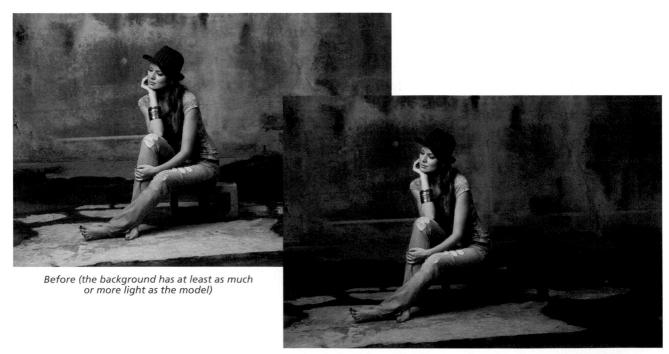

After (everything else is darkened, leaving the model nicely lit and making her the visual focus of the portrait)

Creating Photo Collages

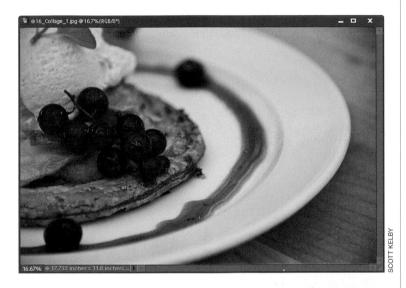

Ruglen Ruglen

Step One:

Open the photo that you want to use as your base photo—this will serve as the background of your collage. (*Note:* Make sure you have the Allow Floating Documents in Full Edit Mode checkbox turned on in your General Preferences, found under the Edit menu on a PC or the Photoshop Elements menu on a Mac.) Now, open the first photo that you want to collage with your background photo.

Step Two:

Press **V** to switch to the Move tool, and then click-and-drag the photo from this document right onto your background photo, positioning it where you want it. It will appear on its own layer (Layer 1) in the Layers palette of your background image.

Step Three:

Click on the Add Layer Mask icon (shown circled here) at the bottom of the Layers palette to add a layer mask to your new layer. Press the letter **D**, then **X** to set your Foreground color to black.

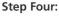

Switch to the Gradient tool by pressing **G**, and then press **Enter (Mac: Return)** to bring up the Gradient Picker (it appears below the gradient thumbnail in the Options Bar). Choose the second gradient in the Picker (this is the Foreground to Transparent gradient) and press Enter again to close the Picker.

Step Five:

Click on the layer mask in the Layers palette to make sure it's active (you'll see a little white frame around it). Now, click the Gradient tool near the left side of the top photo and drag toward the right. The point where you first clicked on the top layer will be transparent, and the point where you stopped dragging will be at 100% opacity. Everything else will blend in between. If you want to start over—easy enough—just press **Ctrl-Z (Mac: Command-Z)** to Undo and click-and-drag again.

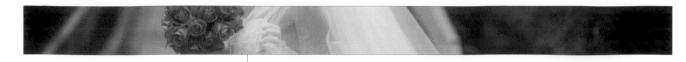

Step Six:

To blend in another photo, click-and-drag that image onto your collage, add a layer mask to that new layer in the Layers palette, then start again from Step Four. Add as many images as you'd like. *Note:* If you need to reposition your backgorund photo (as I've done here), just double-click on your Background layer, click OK in the New Layer dialog, and now you can use the Move tool to reposition it.

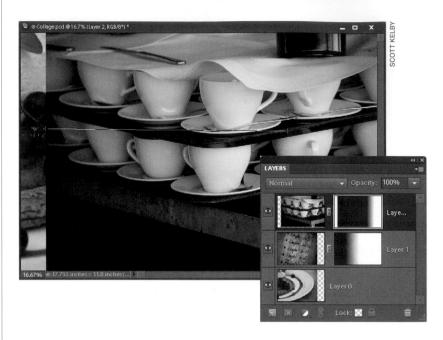

Final

Scott's Three-Step Portrait Finishing Technique

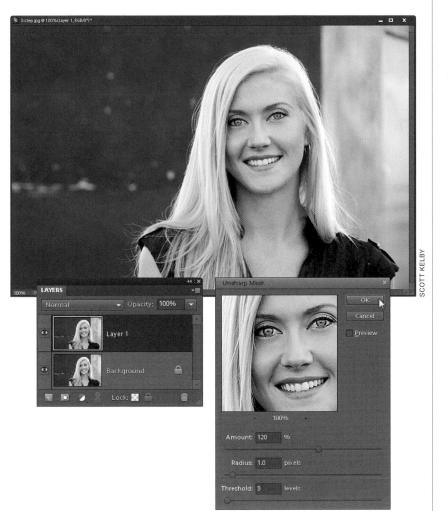

Step One:

Once you've color corrected the photo, done any retouching, etc., that's when you add these three finishing steps. The first step is to add a lot of sharpening to the photo (because in the second step, you're going to blur the entire photo). I always use luminosity sharpening for this, so start by pressing Ctrl-J (Mac: Command-J) to duplicate the Background layer. Then, go under the Enhance menu and choose **Unsharp** Mask. The settings I use are pretty strong—Amount: 120%, Radius: 1, and Threshold: 3—but you generally need it. With a small, low-resolution file like this, you might need to lower the Amount to 80%. Click OK.

Step Two:

Now go to the Layers palette and change the layer blend mode of this sharpened layer to **Luminosity** (as shown here), so your sharpening is applied to just the luminosity (lightness details) of the photo, not the color areas. Doing this allows you to apply more sharpening to the photo without getting unwanted halos. Next, press **Ctrl-E** (**Mac: Command-E**) to merge this layer down into the Background layer.

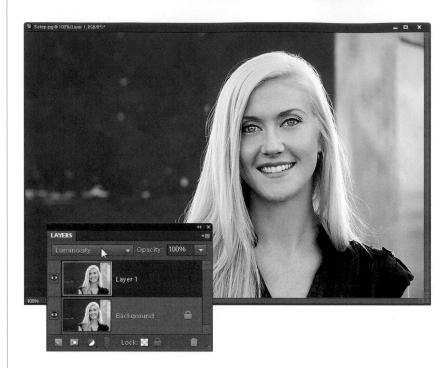

Step Three:

Duplicate the Background layer again, then you're going to apply a pretty significant Gaussian Blur to this layer. So, go under the Filter menu, under Blur, and choose **Gaussian Blur**. When the dialog appears, enter 6 pixels for a low-res photo (for a regular high-res digital camera file, use 20 pixels), then click OK to apply the blur to this layer.

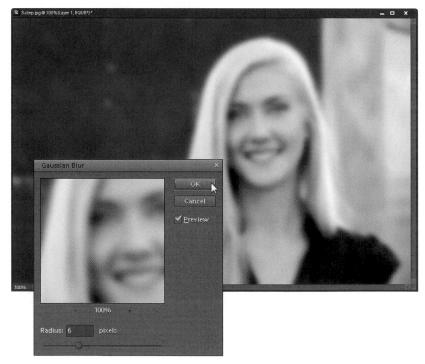

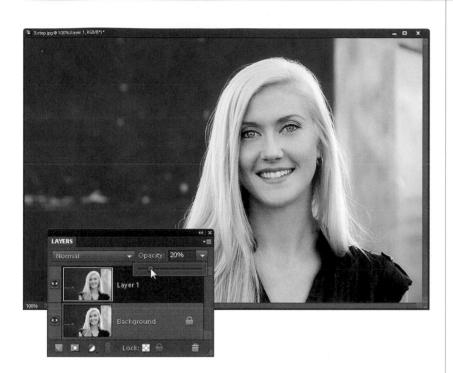

Step Four:

Now, in the Layers palette, lower the layer Opacity of this blurry layer to just 20% (as shown here), which gives the photo almost a glow quality to it, but the glow is subtle enough that you don't lose sharpness (look at the detail in the hair and eyes).

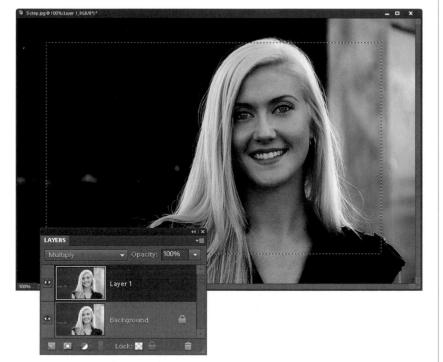

Step Five:

Press Ctrl-E again to merge those two layers together and flatten the photo. Now, you're going to add an edge vignette effect (which looks great for portraits), so start by duplicating the Background layer again. Once you duplicate the layer, change the blend mode of the layer to **Multiply** (which makes the layer much darker). Then get the Rectangular Marquee tool **(M)** and draw a rectangular selection that is about ½" to 1" inside the edges of your photo (as shown here).

Step Six:

Now you're going to majorly soften the edges of your rectangular selection, so go under the Select menu and choose Refine Edge to bring up the Refine Edge dialog (shown here). Below the three sliders, click on the icon on the left, so you view your photo as a full-color composite image (as shown here). Now, to soften the edges, drag the Feather slider all the way to 100 pixels (if you're using a high-res file, feather it 200 pixels), and click OK. One advantage of this Refine Edge dialog is you can see the amount of feathering as you move the slider.

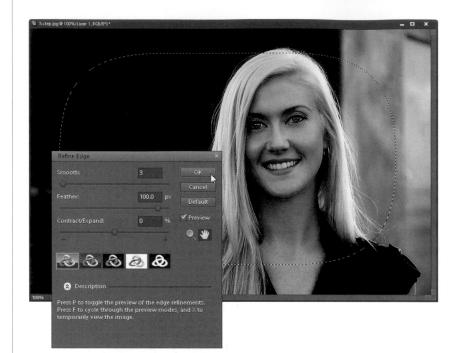

Step Seven:

Now press the Backspace (Mac: Delete) key on your keyboard to knock a soft-edged hole out of your darker Multiply layer. Press Ctrl-D (Mac: Command-D) to Deselect, and you'll see the effect is like a really soft spotlight aimed at your subject. If the edge darkening actually is close enough to the subject's face to matter, get the Eraser tool (E), choose a soft-edged brush, and simply paint over the top of the head and hair (as shown here) to remove the edge vignetting in just that area. The final photo is seen on the next page. Notice the general overall sharpness, but there's also a general overall softness, enhanced even more by that soft spotlight vignette added at the end.

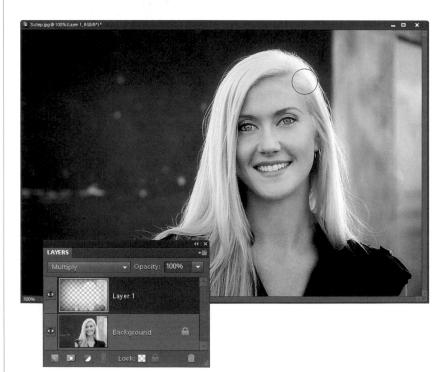

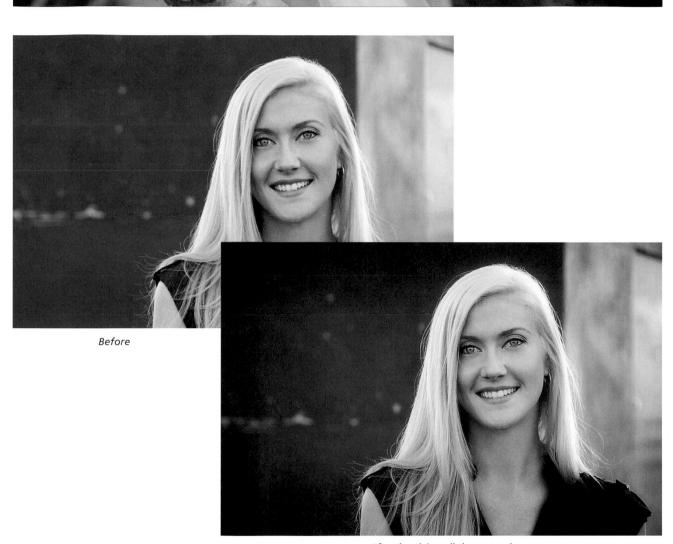

After (applying all three steps)

Fake Duotone

The duotone tinting look is all the rage right now, but creating a real two-color duotone, complete with curves, that will separate in just two colors on press is a bit of a chore. However, if you're outputting to an inkjet printer, or to a printing press as a full-color job, then you don't need all that complicated stuff—you can create a fake duotone that looks at least as good (if not better).

Step One:

Open the color RGB photo that you want to convert into a duotone (again, I'm calling it a duotone, but we're going to stay in RGB mode the whole time). Now, the hard part of this is choosing which color to make your duotone. I always see other people's duotones, and think, "Yeah, that's the color I want!" but when I go to the Foreground color swatch and try to create a similar color in the Color Picker, it's always hit or miss (usually miss). That's why you'll want to know this next trick.

Step Two:

If you can find another duotone photo that has a color you like, you're set. So I usually go to a stock photo website (like iStockphoto.com) and search for "duotones." When I find one I like, I return to Elements, press I to get the Eyedropper tool, click-and-hold anywhere within my image area, and then (while keeping the mouse button held down) I drag my cursor outside Elements and onto the photo in my Web browser to sample the color I want. Now, mind you, I did not and would not take a single pixel from someone else's photo—I'm just sampling a color.

DISTOCKPHOTO/SLOBO

Step Three:

Return to your image in Elements. Go to the Layers palette and click on the Create a New Layer icon. Then, press **Alt-Backspace (Mac: Option-Delete)** to fill this new blank layer with your sampled color. The color will fill your image area, hiding your photo, but we'll fix that.

Step Four:

While still in the Layers palette, change the blend mode of this sampled color layer to **Color**.

Step Five:

If your duotone seems too dark, you can lessen the effect by clicking on the Background layer, and then going under the Enhance menu, under Adjust Color, and choosing **Remove Color**. This removes the color from your RGB photo without changing its color mode, while lightening the overall image. Pretty sneaky, eh?

Film Grain

There's a big difference between digital noise and film grain. Digital noise (those red, green, and blue dots that appear when shooting at high ISOs) is what we want to avoid (or, at the very least, make less noticeable), because it ruins the image. However, simulating the look of traditional film grain (which doesn't have those colored dots) is really becoming a popular effect. In fact, there are third-party plug-ins you can buy that specialize in recreating it, but I still do it myself, right in Elements (but I don't use the lame Film Grain filter, which to me never actually looks like film grain). Here's what I do:

Step One:

Open the photo that you want to add a film grain look to. Go to the Layers palette and **Alt-click (Mac: Option-click)** on the Create a New Layer icon at the bottom of the palette to access the New Layer dialog. When the dialog appears, choose **Soft Light** from the Mode pop-up menu. When you choose Soft Light, you'll see the Fill with Soft-Light-Neutral Color (50% Gray) option (right under the Mode pop-up menu) is now available. Turn on its checkbox and click OK.

Step Two:

This creates a new blank layer filled with gray, but because you set the Mode to Soft Light first, this layer will be seethrough. So, if it's see-through, why did we need it in the first place? Well, it's because some filters in Elements won't run on an empty, transparent layer (you'd get a "there's nothing there" warning). So, this way, it fools the filter into working, and then we can not only apply the filter to a transparent layer, we can control it after the fact. Sneaky. I know.

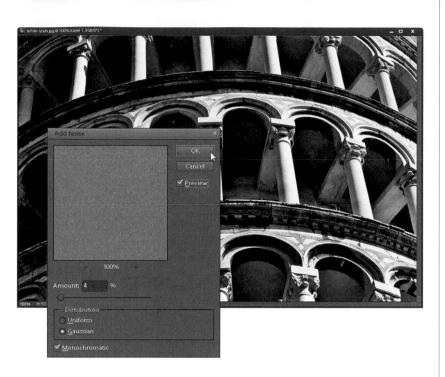

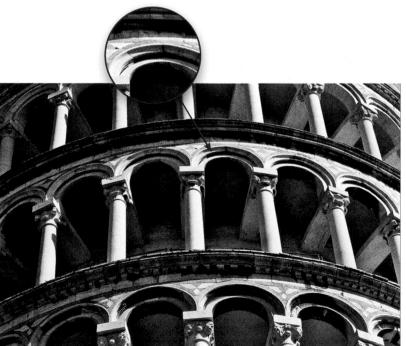

Step Three:

Now, go under the Filter menu, under Noise, and choose Add Noise. When the Add Noise filter dialog appears, we want to make sure that the noise we add doesn't have little red, green, and blue dots, so first choose Gaussian as vour Distribution method, then turn on the Monochromatic checkbox at the bottom. Now, lower your Amount to around 4% (or 5% for 12-megapixel images), then click OK. This applies a noise pattern to your gray layer, and since this layer is transparent, you now see this film-grain-like look on your photo (if you don't see it right away zoom in to 50% or 100%).

Step Four:

If the simulated film grain effect looks a bit too heavy, you can lower the Opacity of this noise layer in the Layers palette, until it blends in nicely (you are supposed to actually see the noise). Also, if you're going to be making a print of this image, let the grain be a little heavier onscreen, because when you print it, much of that grain will be hidden in the printing process. So, if I know I'm going to be printing, I go a little heavier with the Opacity amount, or even go back and redo it with a higher Amount setting (like 5% or 6%, which I did for this example) in the Add Noise filter. If you really want to make the noise more apparent (for effect), in the Layers palette, change the Layer Blend mode of this layer to Overlay (also done here), and it will become much more pronounced (again, don't forget you can control it afterward using the Opacity slider on that layer). By the way, Overlay mode supports the whole "gray is transparent" trick, too! That's it—simulated film grain made easy.

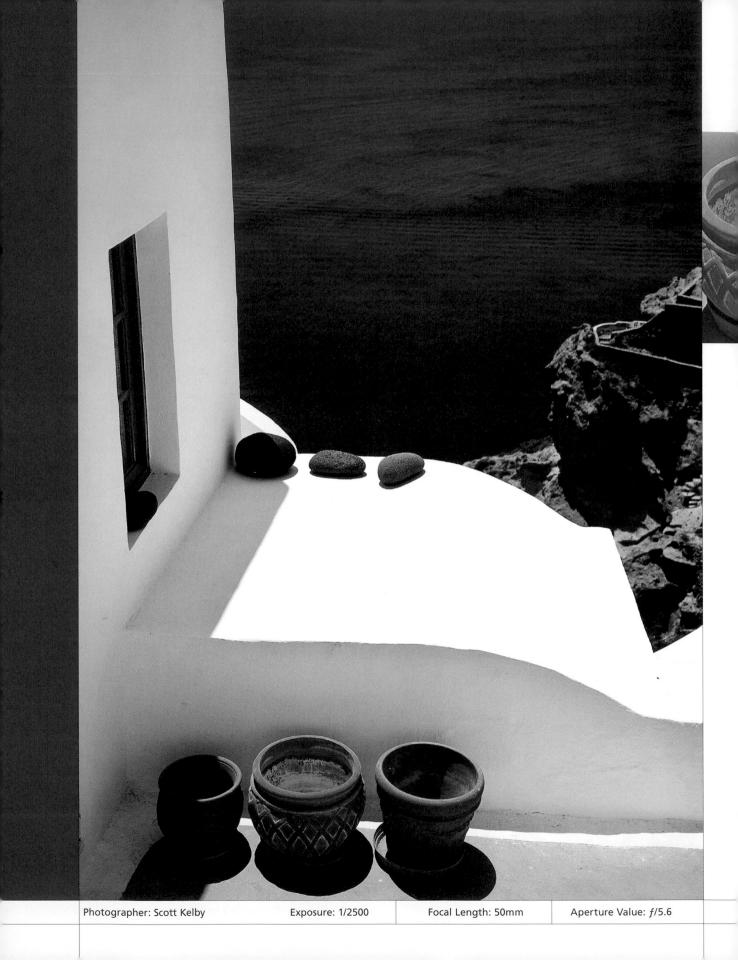

Sharpen Your Teeth

sharpening techniques

I had two really good song titles to choose from for this chapter: "Sharpen Your Teeth" by Ugly Casanova or "Sharpen Your Sticks" by The Bags. Is it just me, or at this point in time, have they totally run out of cool band names? Back when I was a kid (just a few years ago, mind you), band names made sense. There were The Beatles, and The Turtles, and The Animals, and The Monkees, and The Flesh Eating Mutant Zombies, and The Carnivorous Flesh Eating Vegetarians, and The Bulimic Fresh Salad Bar Restockers, and names that really made sense. But, "The Bags?" Unless this is a group whose members are made up of elderly women from Yonkers, I think it's totally misnamed. You see, when I was a kid, when a band was named The Turtles, its members looked and acted like turtles. That's what made it great (remember their hit single "Peeking Out of My Shell," or who could forget "Slowly Crossing a Busy Highway" or my favorite "I Got Hit Crossing

a Busy Highway"?). But today, you don't have to look ugly to be in a band named Ugly Casanova, and I think that's just wrong. It's a classic bait-andswitch. If I were in a band (and I am), I would name it something that reflects the real makeup of the group, and how we act. An ideal name for our band would be The Devastatingly Handsome Super Hunky Guys with Six-Pack Abs (though our fans would probably just call us TDHSHGWSPA for short). I could picture us playing at large 24-hour health clubs and Gold's Gyms, and other places where beautiful people (like ourselves) gather to high-five one another on being beautiful. Then, as we grew in popularity, we'd have to hire a manager. Before long, he would sit us down and tell us that we're living a lie, and that TDHSHGWSPA is not really the right name for our band, and he'd propose something along the lines of Muscle Bound Studs Who Are Loose With Money, or more likely, The Bags.

Basic Sharpening

After you've color corrected your photos and right before you save your files, you'll definitely want to sharpen them. I sharpen every digital camera photo I take, either to help bring back some of the original crispness that gets lost during the correction process, or to help fix a photo that's slightly out of focus. Either way, I haven't met a digital camera (or scanned) photo that didn't need a little sharpening. Here's a basic technique for sharpening the entire photo:

Step One:

Open the photo that you want to sharpen. Because Elements displays your photo in different ways at different magnifications, choosing the right magnification (also called the zoom amount) for sharpening is critical. Because today's digital cameras produce such large-sized files, it's now pretty much generally accepted that the proper magnification to view your photos during sharpening is 50%. If you look up in your image window's title bar, or down in the bottom-left corner of the window, it displays the current percentage of zoom (shown circled here in red). The quickest way to get to a 50% magnification is to press Ctrl-+ (plus sign; Mac: Command-+) or Ctrl-- (minus sign; Mac: Command--) to zoom the magnification in or out.

Once you're viewing your photo at 50% size, go under the Enhance menu and choose Unsharp Mask. (If you're familiar with traditional darkroom techniques, you probably recognize the term "unsharp mask" from when you would make a blurred copy of the original photo and an "unsharp" version to use as a mask to create a new photo whose edges appeared sharper.)

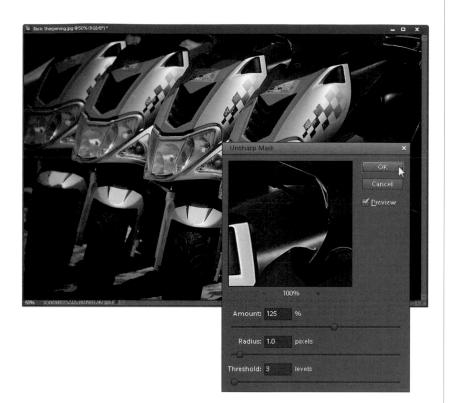

Step Three:

When the Unsharp Mask dialog appears, you'll see three sliders. The Amount slider determines the amount of sharpening applied to the photo; the Radius slider determines how many pixels out from the edge that the sharpening will affect; and the Threshold slider determines how different a pixel must be from the surrounding area before it's considered an edge pixel and sharpened by the filter. Threshold works the opposite of what you might think—the lower the number, the more intense the sharpening effect. So, what numbers do you enter? I'll give you some great starting points on the following pages, but for now, we'll just use these settings: Amount: 125%, Radius: 1, and Threshold: 3. Click OK and the sharpening is applied to the photo.

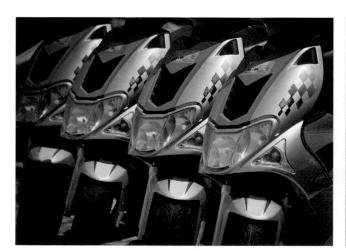

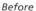

After

Sharpening Soft Subjects:

Here are the Unsharp Mask settings—Amount: 150%, Radius: 1, Threshold: 10—that work well for images where the subject is of a softer nature (e.g., flowers, puppies, people, rainbows, etc.). It's a subtle application of sharpening that is very well suited to these types of subjects.

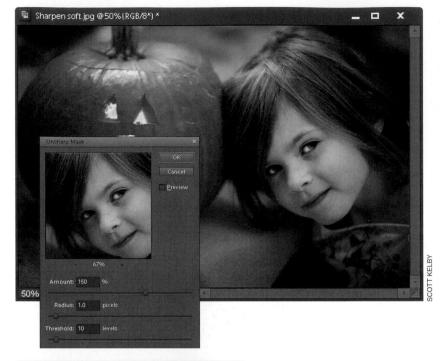

Sharpening Portraits:

If you're sharpening a close-up portrait (head-and-shoulders type of thing), try these settings—Amount: 75%, Radius: 2, Threshold: 3—which applies another form of subtle sharpening.

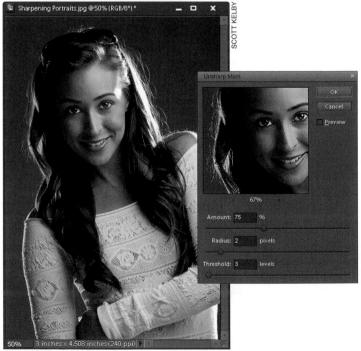

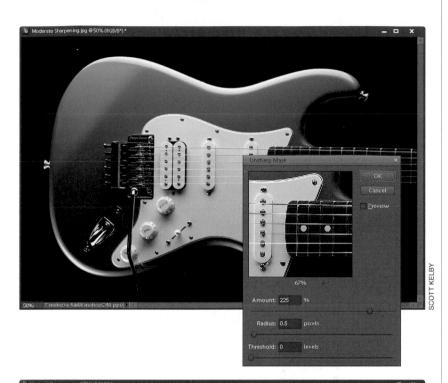

Moderate Sharpening:

This is a moderate amount of sharpening that works nicely on product shots, photos of home interiors and exteriors, and landscapes. If you're shooting along these lines, try applying these settings—Amount: 225%, Radius: 0.5, Threshold: 0—and see how you like it (my guess is you will).

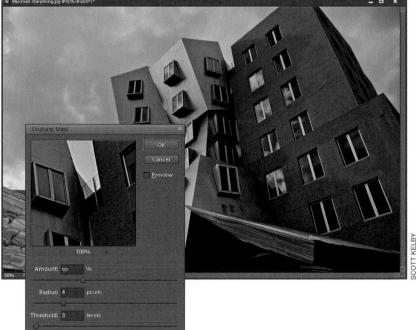

Maximum Sharpening:

I use these settings—Amount: 65%, Radius: 4, Threshold: 3—in only two situations: (1) The photo is visibly out of focus and it needs a heavy application of sharpening to try to bring it back into focus; or (2) the photo contains lots of well-defined edges (e.g., buildings, coins, cars, machinery, etc.).

All-Purpose Sharpening:

These are probably my all-around favorite sharpening settings—Amount: 85%, Radius: 1, Threshold: 4—and I use these most of the time. It's not a "knock-you-over the-head" type of sharpening—maybe that's why I like it. It's subtle enough that you can apply it twice if your photo doesn't seem sharp enough after the first application (just press **Ctrl-F [Mac: Command-F]**), but once will usually do the trick.

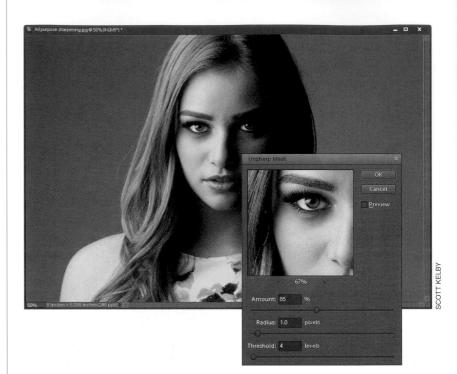

Web Sharpening:

I use these settings—Amount: 400%, Radius: 0.3, Threshold: 0—for Web graphics that look blurry. (When you drop the resolution from a high-res, 300-ppi photo down to 72 ppi for the Web, the photo often gets a bit blurry and soft.) I also use this same sharpening on out-of-focus photos. It adds some noise, but I've seen it rescue photos that I would have otherwise thrown away. If the effect seems too intense, try dropping the Amount to 200%.

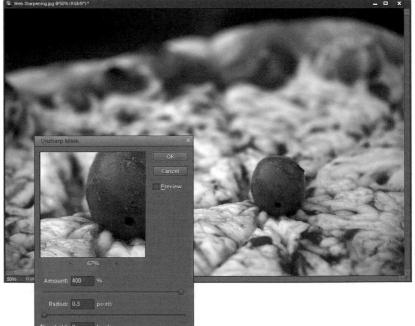

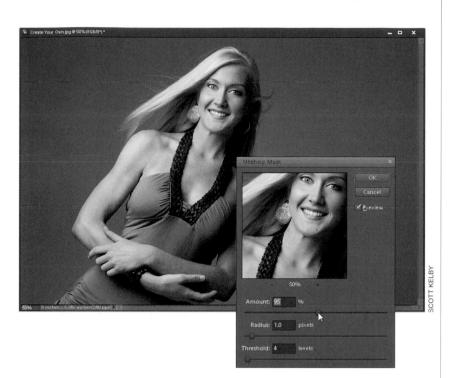

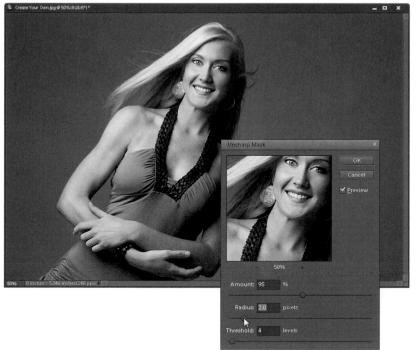

Coming Up with Your Own Settings: If you want to experiment and come up

with your own custom blend of sharpening settings, I'll give you some typical ranges for each adjustment so you can find your own sharpening "sweet spot."

Amount

Typical ranges go anywhere from 50% to 150%. This isn't a rule that can't be broken. It's just a typical range for adjusting the Amount, where going below 50% won't have enough effect, and going above 150% might get you into sharpening trouble (depending on how you set the Radius and Threshold). You're fairly safe to stay under 150%.

Radius

Most of the time, you'll use just 1 pixel, but you can go as high as (get ready)—2. I gave you one setting earlier for extreme situations, where you can take the Radius as high as 4, but I wouldn't recommend it very often. I once heard a tale of a man in Cincinnati who used 5, but I'm not sure I believe it.

Threshold

A pretty safe range for the Threshold setting is anywhere from 3 to around 20 (3 being the most intense, 20 being much more subtle. I know, shouldn't 3 be more subtle and 20 more intense? Don't get me started). If you really need to increase the intensity of your sharpening, you can lower the Threshold to 0, but keep a good eye on what you're doing (watch for noise appearing in your photo).

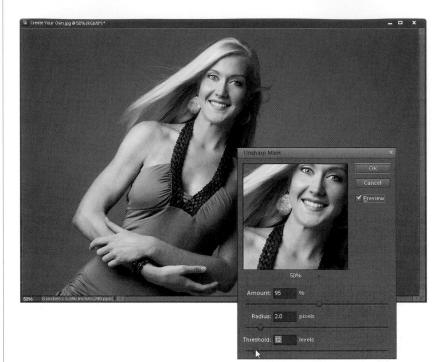

The Final Image

For the final sharpened image you see here, I used the Portrait sharpening settings I gave earlier, and then I dragged the Amount slider to the right (increasing the amount of sharpening), until it looked right to me (I wound up at around 95%), and I increased the Threshold to 12. If you're uncomfortable with creating your own custom Unsharp Mask settings, then start with this: pick a starting point (one of the set of settings I gave on the previous pages), and then just move the Amount slider and nothing else (so, don't touch the Radius and Threshold sliders). Try that for a while, and it won't be long before you'll find a situation where you ask yourself, "I wonder if lowering the Threshold would help?" and by then, you'll be perfectly comfortable with it.

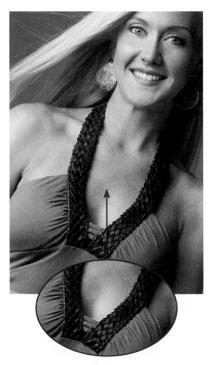

Before

After

One of the problems we face when trying to make things really sharp is that things tend to look oversharpened, or worse yet, our photos get halos (tiny glowing lines around edges in our images). So, how do we get our images to appear really sharp without damaging them?

With a trick, of course. Here's the one I use to make my photos look extraordinarily sharp without damaging the image:

Creating Extraordinary Sharpening

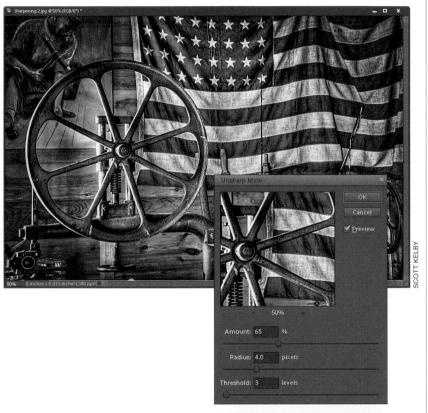

Step One:

Open your Image, and then apply the Unsharp Mask filter (found under the Enhance menu) to your image, just as we've been doing all along. For this example, let's try these settings—Amount: 65%, Radius: 4, and Threshold: 3—which will provide a nice, solid amount of sharpening.

Step Two:

Press Ctrl-J (Mac: Command-J) to duplicate the Background layer. Because we're duplicating the Background layer, the layer will be already sharpened, but we're going to sharpen this duplicate layer even more in the next step.

Step Three:

Now apply the Unsharp Mask filter again, using the same settings, by pressing Ctrl-F (Mac: Command-F). If you're really lucky, the second application of the filter will still look okay, but it's doubtful. Chances are that this second application of the filter will make your photo appear too sharp you'll start to see halos or noise, or the photo will start looking artificial in a lot of areas. So, what we're going to do is hide this oversharpened layer, then selectively reveal this über-sharpening only in areas that can handle the extra sharpening (this will make sense in just a minute).

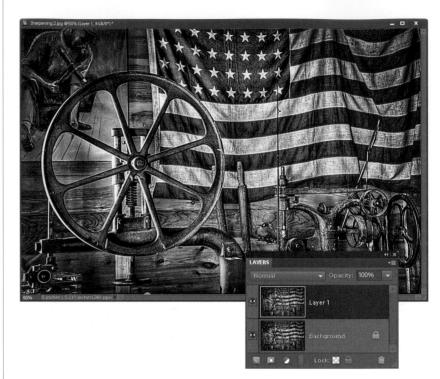

Step Four:

Go to the Layers palette, press-and-hold the Alt (Mac: Option) key, and click on the Add Layer Mask icon at the bottom of the palette (shown circled here in red). This hides your oversharpened layer behind a black layer mask (as seen here). *Note:* To learn more about layer masks, see Chapter 7.

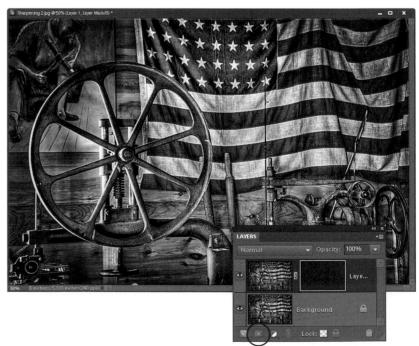

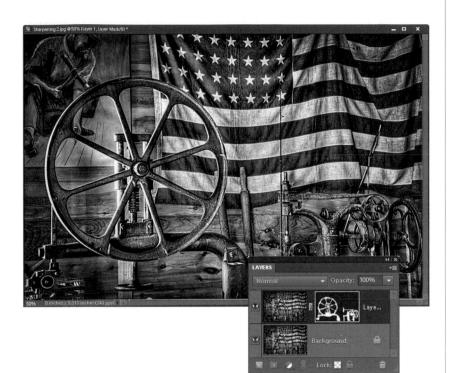

Step Five:

Here's the fun part—the trick is to paint over just a few key areas, which fool the eye into thinking the entire photo is sharper than it is. Here's how: Press B to get the Brush tool, and in the Options Bar, click on the brush thumbnail to open the Brush Picker and choose a soft-edged brush. With your Foreground color set to white, and with the layer mask active in the Layers palette (you'll see a little white frame around it), start painting on your image to reveal your sharpening. (Note: If you make a mistake, press X to switch your Foreground color to black and paint over the mistake.) In this example, I painted over the boot repairing machines. Revealing these few sharper areas, which immediately draw the eye, makes the whole photo look sharper.

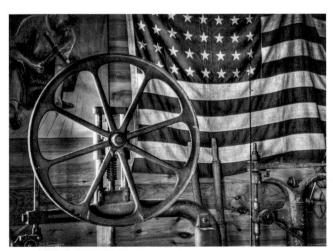

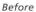

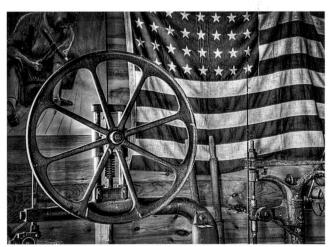

After

Luminosity Sharpening

Okay, you've already learned that sharpening totally rocks, but the more you use it, the more discerning you'll become about it (you basically become a sharpening snob), and at some point, you'll apply some heavy sharpening to an image and notice little color halos. You'll grow to hate these halos, and you'll go out of your way to avoid them. In fact, you'll go so far as to use this next sharpening technique, which is fairly popular with pros shooting digital (at least with the sharpening-snob crowd).

Step One:

Open a photo that needs some moderate to serious sharpening.

Step Two:

Duplicate the Background layer by going under the Layer menu, under New, and choosing **Layer via Copy** (or pressing **Ctrl-J [Mac: Command-J]**). This will duplicate the Background layer onto a new layer (Layer 1).

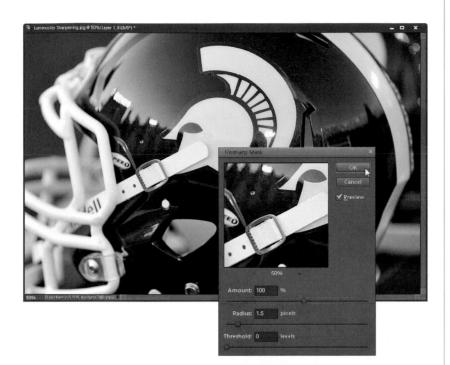

Step Three:

Go under the Enhance menu and choose **Unsharp Mask**. (*Note:* If you're looking for some sample settings for different sharpening situations, look at the "Basic Sharpening" tutorial at the beginning of this chapter.) After you've input your Unsharp Mask settings, click OK to apply the sharpening to the duplicate layer.

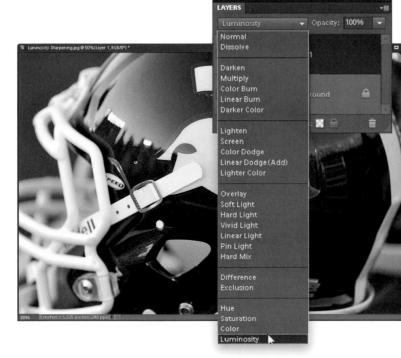

Step Four:

Go to the Layers palette and change the layer blend mode of this sharpened layer from Normal to **Luminosity**. By doing this, it applies the sharpening to just the luminosity (lightness details) of the image, and not the color. This enables you to apply a higher amount of sharpening without getting unwanted halos. You can now choose **Flatten Image** from the Layers palette's flyout menu to complete your Luminosity sharpening.

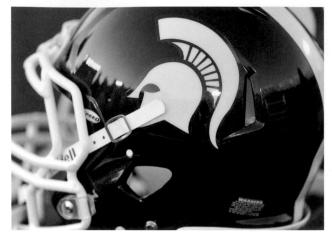

Before

After

This is a sharpening technique that doesn't use the Unsharp Mask filter, but still leaves you with a lot of control over the sharpening, even after it's applied. It's ideal to use when you have an image that can really hold a lot of sharpening (a photo with a lot of edges) or one that really needs a lot of sharpening.

Edge Sharpening Technique

Step One:Open a photo that needs edge sharpening.

Step Two:

Duplicate the Background layer by going under the Layer menu, under New, and choosing **Layer via Copy** (or pressing **Ctrl-J [Mac: Command-J]**). This will duplicate the Background layer onto a new layer (Layer 1).

Step Three:

Go under the Filter menu, under Stylize, and choose **Emboss**. You're going to use the Emboss filter to accentuate the edges in the photo. You can leave the Angle and Amount settings at their defaults (135° and 100%), but if you want more intense sharpening, raise the Height amount from its default setting of 3 pixels to 5 or more pixels (in the example here, I left it at 3). Click OK to apply the filter, and your photo will turn gray, with neoncolored highlights along the edges.

Step Four:

In the Layers palette, change the layer blend mode of this layer from Normal to **Hard Light**. This removes the gray color from the layer, but leaves the edges accentuated, making the entire photo appear much sharper.

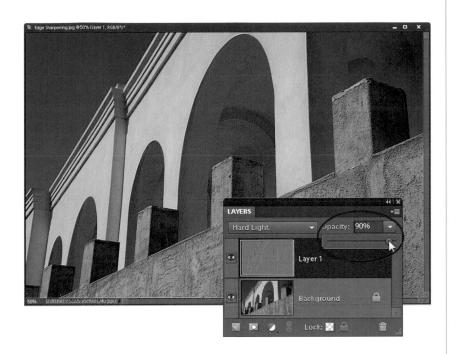

Step Five:

If the sharpening seems too intense, you can control the amount of the effect by simply lowering the Opacity of this top layer in the Layers palette.

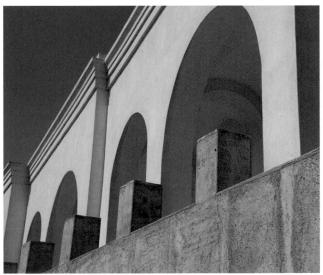

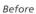

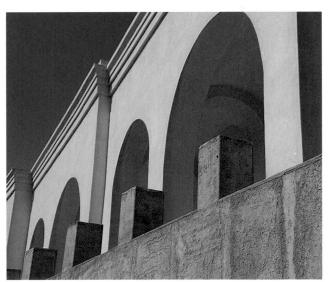

After

Advanced Sharpening Using Adjust Sharpness

Sometimes, I'll turn to the Adjust Sharpness control, instead of the Unsharp Mask filter, to sharpen my photos. Here's why: (1) it does a better job of avoiding those nasty color halos, so you can apply more sharpening without damaging your photo; (2) it lets you choose different styles of sharpening; (3) it has a much larger preview window, so you can see your sharpening more accurately; (4) it has a More Refined feature that applies multiple iterations of sharpening; and (5) it's just flat out easier to use.

Step One:

Open the photo you want to sharpen using the Adjust Sharpness control. (By the way, although most of this chapter focuses on using the Unsharp Mask filter, I only do that because it's the current industry standard. If you find you prefer the Adjust Sharpness control, from here on out, when I say to apply the Unsharp Mask filter, you can substitute the Adjust Sharpness control instead. Don't worry, I won't tell anybody.)

OTT KELBY

Step Two:

Go under the Enhance menu and choose **Adjust Sharpness**. When the dialog opens, you'll notice there are only two sliders: Amount (which controls the amount of sharpening—sorry, my editors made me say that) and Radius (which determines how many pixels the sharpening will affect). I generally leave the Radius setting at 1 pixel, but if a photo is visibly blurry, I'll pump it up to 2. (Very rarely do I ever try to rescue an image that's so blurry that I have to use a 3- or 4-pixel setting.)

Step Three:

Below the Radius slider is the Remove pop-up menu, which lists the three types of blurs you can reduce using Adjust Sharpness. Gaussian Blur (the default) applies a brand of sharpening that's pretty much like what you get using the regular Unsharp Mask filter (it uses a similar algorithm). Another Remove menu choice is Motion Blur, but unless you can determine the angle of blur that appears in your image, it's tough to get really good results with this one. So, which one do I recommend? The other choice—Lens Blur. It's better at detecting edges, so it creates fewer color halos than you'd get with the other choices, and overall I think it just gives you better sharpening for most images. The downside? Choosing Lens Blur causes the filter to take a little longer to "do its thing." A small price to pay for better-quality sharpening.

Step Four:

Near the bottom of the dialog, there's a checkbox labeled More Refined. It gives you (according to Adobe) more accurate sharpening by applying multiple iterations of the sharpening. I leave More Refined turned on nearly all the time. (After all, who wants "less refined" sharpening?) Note: If you're working on a large file, the More Refined option can cause the filter to process slower, so it's up to you if it's worth the wait. I've also found that with the Adjust Sharpness control, I use a lower Amount setting than I would with the Unsharp Mask filter to get a similar amount of sharpening, so I usually find myself lowering the Amount to around 60% in most instances. But, for this image, I only lowered it to 90%.

After

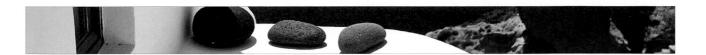

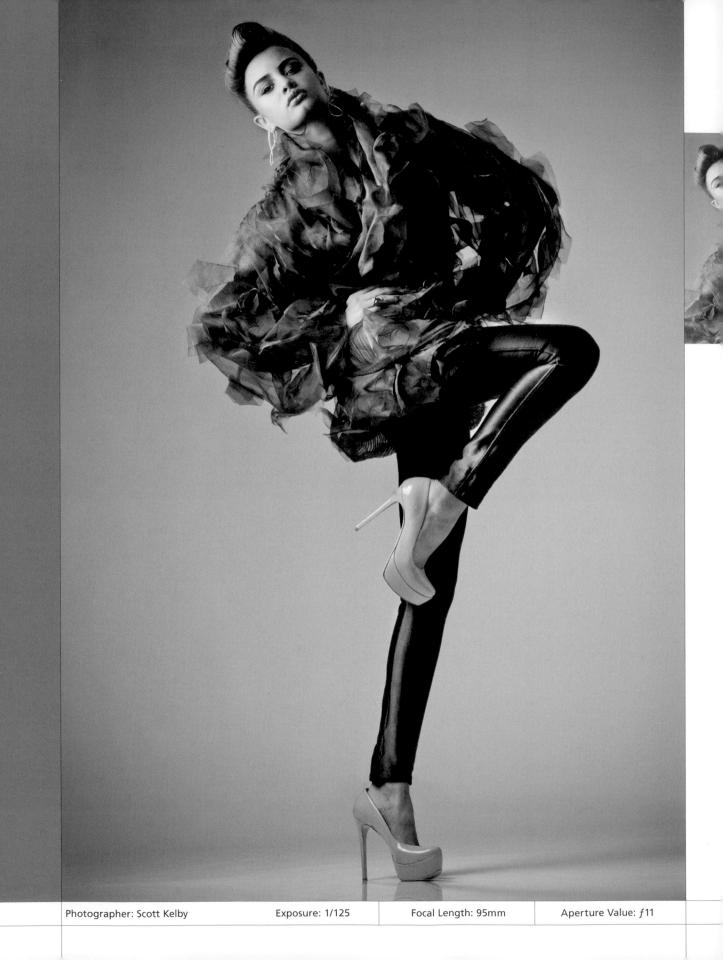

Fine Print

step-by-step printing and color management

There is nothing like a photographic print. It's the moment when your digitally captured image, edited on a computer, moves from a bunch of 1s and Os (computer code) into something real you can hold in your hand. If you've never made a print (and sadly, in this digital age, I meet people every day who have never made a single print—everything just stays on their computer, or on Facebook, or someplace else where you can "look, but don't touch"), today, all that changes, because you're going to learn, step by step, how to make your own prints. Now, if you don't already own a printer, this chapter becomes something else. Expensive. Actually, in all fairness, it's not the printer—it's the paper and ink, which is precisely why the printers aren't too expensive. But once you've bought a printer—they've got you. You'll be buying paper and ink for the rest of your natural life, and it seems like you go through ink cartridges faster than a gal-

Ion of milk. This is precisely why I've come up with a workflow that literally pays for itself—I use my color inkjet printer to print out counterfeit U.S. bills. Now, I'm not stupid about it—I did some research and found that new ink cartridges for my particular printer run about \$13.92 each, so I just make \$15 bills (so it also covers the sales tax). Now—again, not stupid here—I don't go around using these \$15 bills to buy groceries or lunch at Chili's, I only use them for ink cartridges, and so far, it's worked pretty well. I must admit, I had a couple of close calls, though, mainly because I put Dave Cross's face on all the bills, which seemed like a good idea at the time, until a sales clerk looked closely at the bill and said, "Isn't Dave Canadian?" (By the way, this chapter title comes from the song "Fine Print" by Nadia Ali. According to her website, she was born in the Mediterranean, which is precisely why you don't see her on my newly minted \$18.60 bills.)

Setting Up Your Color Management

Most of the color management decisions in Elements come later, in the printing process (well, if you actually print your photos), but even if you're not printing, there is one color management decision you need to make now. Luckily, it's a really easy one (and one you might have already made if you read Chapter 4).

Step One:

In the Elements Editor, go under the Edit menu and choose **Color Settings** (or just press **Ctrl-Shift-K [Mac: Command-Shift-K]**).

Step Two:

This brings up the Color Settings dialog. By default, Elements is set to Always Optimize Colors for Computer Screens, which uses the sRGB color space. However, if you're going to be printing to your own color inkjet printer (like an Epson, HP, Canon, etc.), you'll want to choose Always Optimize for Printing, which sets your color space to the Adobe RGB color space (the most popular color space for photographers), and gives you the best printed results. Now just click OK, and you've done it—you've configured Elements' color space for the best results for printing. Note: You only want to make this change if your final prints will be output to your own color inkjet printer. If you're sending your images out to an outside lab for prints (or your final images will only be viewed onscreen), you should probably stay in sRGB, because most labs are set up to handle sRGB files. Your best bet: ask your lab which color space they prefer.

To get what comes out of your color inkjet printer to match what you see onscreen, you have to calibrate your monitor in one of two ways: (1) buy a hardware calibration sensor that calibrates your monitor precisely; or (2) use free software calibration, which is better than nothing, but not by much since you're just "eyeing" it. Hardware calibration is definitely the preferred method of monitor calibration (in fact, I don't know of a single pro using freebie software). With hardware calibration, it's measuring your actual monitor and building an accurate profile for the exact monitor you're using, and yes—it makes that big a difference.

Calibrating Your Monitor

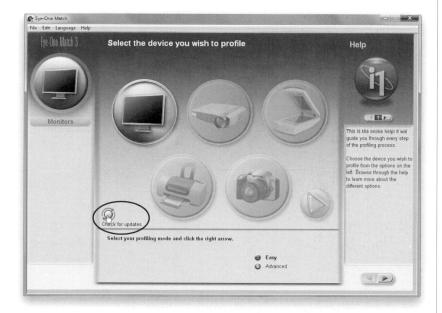

Step One:

To find the free software that comes with Windows 7, in the Control Panel. click on Appearance and Personalization, then click on Display, and click on Calibrate Color on the left. In Mac OS X, in the System Preferences dialog, click on Displays, then click on the Color tab to find it. You can also just search the Web for "download Gamma" to find other free programs. I use a hardware calibrator, X-Rite's Eye-One Display 2 (after hearing so many friends rave about it), and I have to say—I'm very impressed. It's become popular with pros thanks to the sheer quality of its profiles, its ease-of-use, and affordability (around \$115 street). After installing the Eye-One Match 3 software from the CD that comes with it (the current version was 3.6.2 for the PC and 3.6.3 for the Mac, as of the writing of this book), and launching it for the first time, click the Check for Updates button (as shown here) to have it check for a newer version, just in case. Once the latest version is installed, plug the Eye-One Display into your computer's USB port, then relaunch the software to bring up the main window (seen here). You do two things here: (1) you choose which device to profile (in this case, a monitor), and (2) you choose your profiling mode (where you choose between Easy or Advanced. If this is your first time using a hardware calibrator, I recommend clicking the Easy radio button).

Step Two:

After choosing Easy, click the Right Arrow button in the bottom right, and the Monitor Type screen will appear. Here you just tell the software which type of monitor you have: an LCD (a flat-panel monitor), a CRT (a glass monitor with a tube), or a laptop (which is what I'm using, so I clicked on Laptop, as shown here), then click the Right Arrow button again.

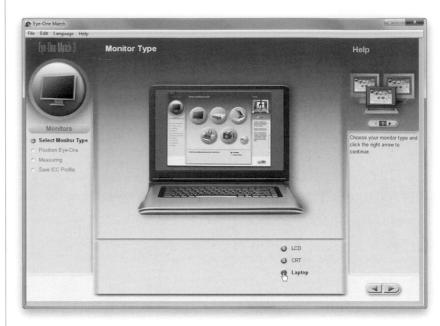

Step Three:

The next screen asks you to Place Your Eye-One Display on the Monitor, which means you drape the sensor over your monitor so the Eye-One Display sits flat against your monitor and the cord hangs over the back. The sensor comes with a counterweight you can attach to the cord, so you can position the sensor approximately in the center of your screen without it slipping down. There is a built-in suction cup for use on CRT monitors.

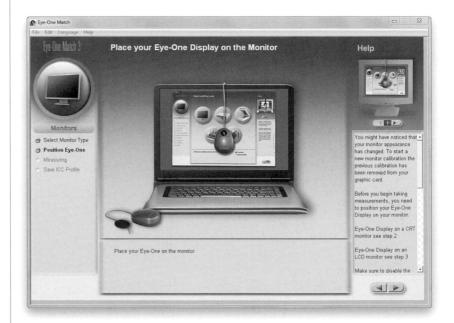

Step Four:

Once the sensor is in position (this takes all of about 20 seconds), click the Right Arrow key, sit back, and relax. You'll see the software conduct a series of onscreen tests, using gray and white rectangles and various color swatches, as shown here. (*Note:* Be careful not to watch these onscreen tests while listening to Jimi Hendrix's "Are You Experienced," because before you know it, you'll be on your way to Canada in a psychedelic VW Microbus with only an acoustic guitar and a hand-drawn map to a campus protest. Hey, I've seen it happen.)

Step Five:

This testing only goes on for around six or seven minutes (at least, that's all it took for my laptop), then it's done. It does let you see a before and after (using the buttons on the bottom), and you'll probably be shocked when you see the before/after results (most people are amazed at how blue or red their screen was every day, yet they never noticed). Once you've compared your before and after, click the Finish Calibration button and that's it—your monitor is accurately profiled, and it even installs the profile for you and then quits. It should be called "Too Easy" mode.

Getting Pro-Quality Prints That Match Your Screen

When you buy a color inkjet printer and install the printer driver that comes with it, it basically lets Elements know what kind of printer is being used, and that's about it. But to get pro-quality results, you need a profile for your printer based on the exact type of paper you'll be printing on. Most inkjet paper manufacturers now create custom profiles for their papers, and you can usually download them free from their websites. Does this really make that big a difference? Ask any pro. Here's how to find and install your custom profiles:

Step One:

Your first step is to go to the website of the company that makes the paper you're going to be printing on and search for their downloadable color profiles for your printer. I use the term "search" because they're usually not in a really obvious place. I use two Epson printers—a Stylus Photo R2880 and a Stylus Pro 3880—and I generally print on Epson paper. When I installed the 3880's printer driver, I was tickled to find that it also installed custom color profiles for all Epson papers (this is rare), but my R2880 (like most printers) doesn't. So, the first stop would be Epson's website, where you'd click on the Drivers & Support link for printers (as shown here). Note: Even if you're not an Epson user, still follow along (you'll see why).

Step Two:

Once you get to Drivers & Support, find your particular printer in the list. Click on that link, and on the next page, click on Drivers & Downloads (choose Windows or Macintosh). On that page is a link to the printer's Premium ICC Profiles page. So, click on that Premium ICC Profiles link.

Step Three:

When you click that link, a page appears with a list of ICC profiles for Epson's papers and printers. I primarily print on two papers: (1) Epson's Ultra Premium Photo Paper Luster, and (2) Epson's Velvet Fine Art paper. So, I'd download their ICC profiles under Glossy Papers (as shown here) and Fine Art Papers (in the middle of the list). They download onto your computer, then you just click the installer for each one, and they're added to your list of profiles in Elements (I'll show how to choose them in the Print dialog a little later). That's it—you download them, double-click to install, and they'll be waiting for you in Elements' print dialog. Easy enough. But what if you're not using Epson paper? Or if you have a different printer, like a Canon or an HP?

Continued

Step Four:

We'll tackle the different paper issue first (because they're tied together). I mentioned earlier that I usually print on Epson papers. I say usually because sometimes I want a final print that fits in a 16x20" standard pre-made frame, without having to cut or trim the photo. In those cases, I use Red River Paper's 16x20" UltraPro Satin instead. So, even though you're printing on an Epson printer, now you'd go to Red River Paper's site (www.redriverpaper.com) to find their color profiles for my other printer, the Epson 3880. (Remember, profiles come from the company that makes the paper.) On the Red River Paper homepage, click on the Click Here link for Premium Photographic Inkjet Papers. Then click on the Color Profiles link under Helpful Info on the left side of the page.

Step Five:

Under the section named Epson Wide Format, there's a direct link to the ICC profiles for the Epson Pro 3880 (as shown here), but did you also notice that there are ICC Color profiles for Canon printers? The process is the same for other printers, but although HP and Canon now both make proquality photo printers, Epson had the pro market to itself for a while, so while Epson profiles are created by most major paper manufacturers, you may not always find paper profiles for HP and Canon printers. At Red River, they widely support Epson, and have a bunch of Canon profiles, but there are only a few for HP. That doesn't mean this won't change, but as of the writing of this book, that's the reality.

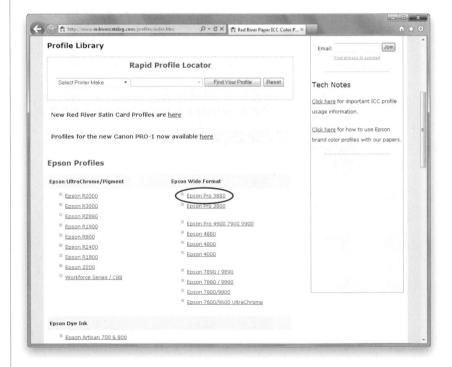

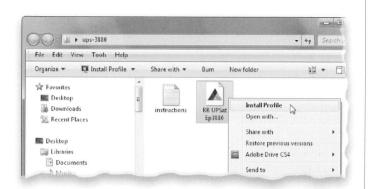

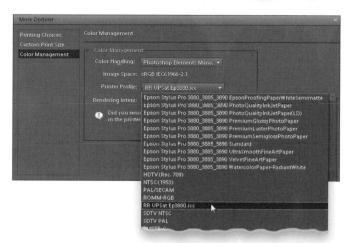

Step Six:

Although profiles from Epson's website come with an installer, with Red River (and many other paper manufacturers), you just get the profile (shown here) and instructions, so you install it yourself (it's easy). On a PC, just Rightclick on the profile and choose **Install Profile**. On a Mac, go to your hard disk, in your Library folder, and in your Color-Sync folder, to the Profiles folder. Just drag the file in there and you're set. You don't even have to restart Elements—it automatically updates.

Step Seven:

You'll access your profile by choosing Print from Elements' File menu. In the Print dialog, click on the More Options button in the bottom left, then click on Color Management on the left of the dialog. Change the Color Handling pop-up menu to Photoshop Elements Manages Color, then click on the Printer Profile pop-up menu, and your new color profile(s) will appear. Here, I'm printing to an Epson 3880 using Red River's UltraPro Satin paper, so that's what I'm choosing as my printer profile (it's named RR UPSat Ep3880.icc). That's it, but there's more on using these color profiles next in this chapter.

TIP: Custom Profiles for Your Printer

You can also pay an outside service to create a custom profile for your printer. You print a provided test sheet, overnight it to them, and they'll use an expensive colorimeter to measure your test print and create a custom profile, but it's only good for that printer, on that paper, with that ink. If anything changes, your profile Is worthless. You could do your own personal printer profiling (using something like one of X-Rite's Eye-One Pro packages), so you can reprofile each time you change paper or inks. It's really just up to you.

Making the Print

Okay, you've hardware calibrated your monitor (or at the very least—you "eyed it") and you've set up Elements' Color Management to use Adobe RGB (1998). You've even downloaded a printer profile for the exact printer model and style of paper you're printing on. In short—you're there. Luckily, you only have to do all that stuff once—now we can just sit back and print. Well, pretty much.

Step One:

Once you have an image all ready to go, just go under the Editor's File menu and choose **Print** (as shown here).

Step Two:

When the Print dialog appears, let's choose your printer and paper size first. At the top right of the dialog, choose the exact printer you want to print to from the Select Printer pop-up menu (I'm printing to an Epson Stylus Pro 3880). Next, choose your paper size from the Select Paper Size popup menu (in this case, a 13x19" sheet), choose your page orientation beneath that menu, and then from the Select Print Size pop-up menu (in the middle right), be sure that Actual Size is selected. In the middle of the Print dialog, you'll see a preview of how your photo will fit on the printed page, and at the bottom of the column on the right, there's an option for how many copies you want to print.

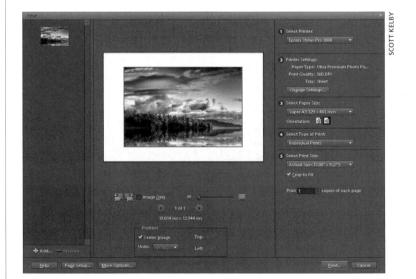

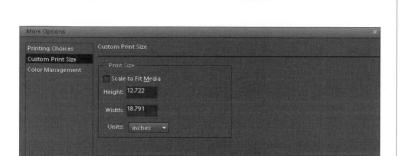

Step Three:

Click on the More Options button (at the bottom left) and then click on Custom Print Size on the left. Here you can choose how large the photo will appear on the page (if it's a photo that's too large to fit on the paper, just turn on the Scale to Fit Media checkbox and it will do the math for you, and scale the image down to fit).

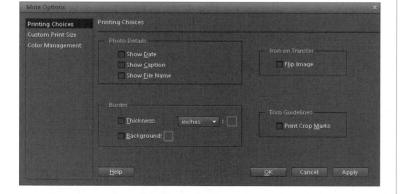

Step Four:

Now click on Printing Choices at the top left of the More Options dialog. Here you can choose if you want to have your photo's filename appear on the page, or change the background color of the paper, or add a border, or have crop marks print, or other stuff like that—you have but only to turn the checkboxes on (you like that "you have but only to" phrase? I never use that in normal conversation, but somehow it sounded good here. Ya know, come to think of itmaybe not). Anyway, I don't use these Printing Choices at all, ever, but don't let that stop you—feel free to add distracting junk to your heart's content. Now, on to the meat of this process.

Step Five:

Click on Color Management on the left to get the all-important Color Management options. Here's the thing: by default, the Color Handling is set up to have your printer manage colors. You really only want to choose this if you weren't able to download the printer/paper profile for your printer. So, basically, this is your backup plan. It's not your first choice, but today's printers have gotten to the point that if you have to go with this, it still does a decent job. However, if you were able to download your printer/paper profile and you want pro-quality prints (and I imagine you do), then do this instead: choose Photoshop Elements Manages Colors from the Color Handling pop-up menu (as shown here), so you can make use of the color profile, which will give you the best possible color match.

Step Six:

Below Rendering Intent, you'll see a warning asking if you remembered to disable your printer's color management. You haven't, so let's do that now. Click the Printer Preferences button that appears right below the warning (as shown here). (Note: On a Mac, once you click the Print button in the Elements Print dialog, the Mac OS X Print dialog will appear, where you can go under Printer Color Management and set it to Off [No Color Adjustment].)

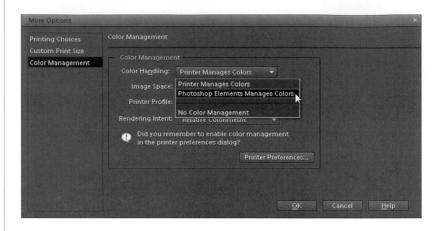

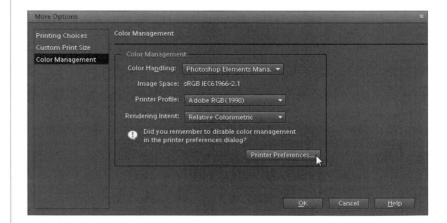

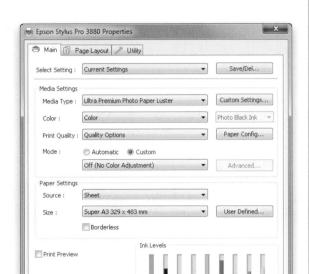

Show Settings...

Manual

OK Cancel Help

Reset Defaults(Y)

Step Seven:

In your printer's Properties dialog (which may be different depending on your printer), you will turn off your printer's color management, but you have other stuff to do here, as well (on a Mac, you will do this in the OS X Print dialog, as mentioned in the previous step). First, choose the type of paper you'll be printing to (I'm printing to Epson Ultra Premium Photo Paper Luster). Then for the Print Quality setting, choose Quality Options, then in the resulting Quality Options dialog, drag the slider at the top to 5 and click OK. Now, be sure that the Custom radio button is chosen and Off (No Color Adjustment) appears in the Mode pop-up menu. Click OK to save your changes and return to the More Options dialog.

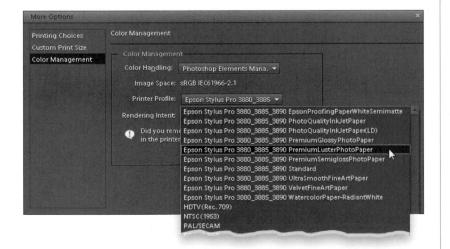

Step Eight:

After you've turned off your printer's color management (and chosen photo quality paper), you'll need to choose your color profile. Again, I'm going to be printing to an Epson Stylus Pro 3880 printer, using Epson's Premium Luster paper, so I'd choose that profile from the Printer Profile pop-up menu in the Color Management section. Doing this optimizes the color to give the best possible color print on that particular printer using that particular paper.

Step Nine:

Lastly, you'll need to choose the Rendering Intent. There are four choices here, but only two that I recommend—either Relative Colorimetric (which is the default setting) or Perceptual. Here's the thing: I've had printers where I got the best looking prints with my Rendering Intent set to Perceptual, but currently, on my Epson Stylus Pro 3880, I get better results when it's set to Relative Colorimetric. So, which one gives the best results for your printer? I recommend printing a photo once using Perceptual, then printing the same photo using Relative Colorimetric, and when you compare the two, you'll know. Just remember to add some text below the photo that tells you which one is which or you'll get the two confused. I learned this the hard way.

Step 10:

Now click the OK button, then click the Print button at the bottom of the Print dialog (this is where, on a Mac, you'll choose the options we talked about in Step Six and Step Seven).

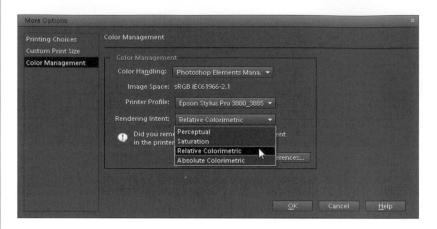

(well, in these five pages), might be really helpful, so here va go.

My Elements 10 Workflow from Start to Finish

Step One:

You start your workflow by importing your photos into the Organizer (we learned this in Chapter 1). While you're in the Photo Downloader (shown here), I recommend adding your metadata (your name and copyright info) during this import process. Also, while you're in the Photo Downloader, go ahead and rename your photos now, so if you ever have to search for them, you have a hope of finding them (searching for photos from your trip to Hawaii is pretty tough if you leave the files named the way your camera named them, which is something along the lines of "DSC 1751.JPG"). So give them a descriptive name while you import them. You'll thank me later.

Step Two:

Once your photos appear in the Organizer, first take a quick look through them and go ahead and delete any photos that are hopelessly out of focus, were taken accidentally (like shots taken with the lens cap still on), or you can see with a quick glance are so messed up they're beyond repair. Get rid of these now, because there's no sense wasting time (tagging, sorting, etc.) and disk space on photos that you're going to wind up deleting later anyway, so make your job easier—do it now.

Continued

Step Three:

Once you've deleted the obviously bad ones, here's what I would do next: go through the photos one more time and then create an album of just your best images (see Chapter 1 for how to create an album). That way, you're now just one click away from the best photos from your shoot.

Step Four:

There's another big advantage to separating out your best images into their own separate album: now you're only going to tag and worry about color correcting and editing these photos—the best of your shoot. You're not going to waste time and energy on photos no one's going to see. So, click on the album, then go ahead and assign your keyword tags now (if you forgot how to tag, it's back in Chapter 1). If you take a few minutes to tag the images in your album now, it will save you literally hours down the road. This is a very important step in your workflow (even though it's not a fun step), so don't skip it—tag those images now!

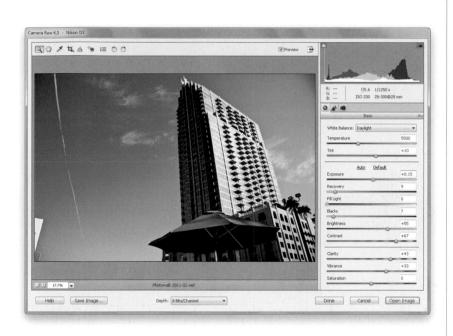

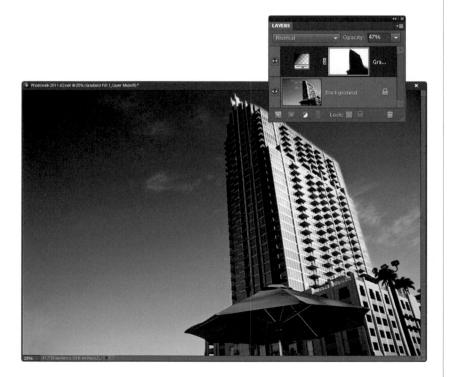

Step Five:

Now that you've got your best photos in an album and they're tagged, it's time to start editing the best images. So let's say you open an image that you can tell needs editing in the Elements Editor to look the way you want it to look. What do you do first? Generally. I try to deal with the biggest problem first (whatever you see as the biggest problem). If you feel like the photo is too dark, start with that. If it has a distracting color cast and you won't be able to concentrate on anything else, then fix that first. Underexposure, overexposure, your subject is in the shadows, white balance (color) problems (which this image had)—all that can be fixed within Camera Raw if your image is in RAW, JPEG, or TIFF format. So, I'd go there (see Chapter 2 for opening JPEGs and TIFFs in Camera Raw). If you'd prefer to skip Camera Raw, then go to the Editor to work on things like general color correction using the Enhance menu options or even Quick Fix.

Step Six:

After all your color correction is done, fix any problems that your image may have (using the techniques you learned in Chapter 8). Here, I used the Spot Healing Brush tool set to Content-Aware to remove the contrail in the sky, and then I used the Clone Stamp tool to remove the edge of the building on the bottom left. Now you can add any special effects or finishing moves like softening, or vignetting effects, or duotones (or basically any of the things found in Chapter 9). Here, I've added a Gradient adjustment layer (see "Neutral Density Gradient Filter"), and then I painted in black on the layer mask so that the adjustment only affected the sky.

Continued

Step Seven:

After all the effects you want have been added (Tip: Don't get carried away by using too many effects. When it comes to effects, less is more), it's time to sharpen the photo using either the Unsharp Mask filter or the Adjust Sharpness control (see Chapter 10 for settings). We save this until the final editing stage (after fixing problems, after color correction, after special effects). Now, the photo is essentially done and you can add border effects, frame edges, and other presentation effects (see the "How to Show Your Work" video on the website mentioned in the book's introduction) around or behind your photo (you normally don't have to sharpen them—just the photo, so you can add these after sharpening the photo).

Step Eight:

Lastly, now that you have a complete and final image, you can turn your final image into a creation (photo collage, online album, slide show, etc. [see the "How to Show Your Work" video on the book's companion website]), or just simply print your finished image on your color inkjet printer (see the "Making the Print" tutorial earlier in this chapter for a refresher on that). Well, there you have it, a Photoshop Elements 10 workflow from import to output, done in the same order I do it myself. Hope this helps. :-)

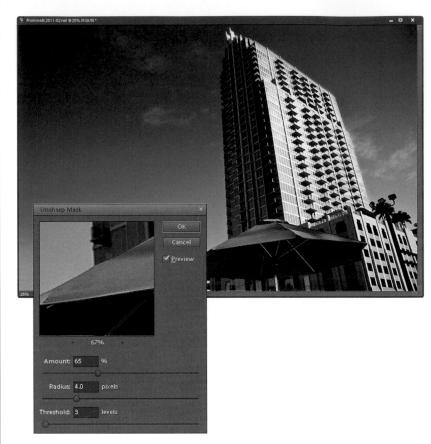

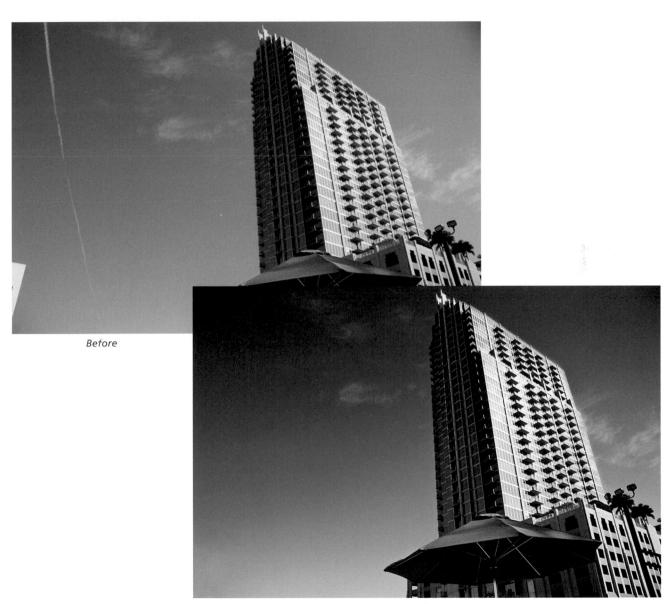

After

Index	in Camera Raw, 93–95
[1/8-1-1-2-2-2-2-2-2-2-2-2-2-2-2-2-2-2-2-2-	in Photoshop Elements, 164–168, 341–342
[] (Bracket keys), 92, 244, 280	Blacks slider, 65–66, 70, 94 blemish removal, 243–244
3D Pixelate transition, 42–43	blend modes, 135
50% Gray option, 152, 184, 386 50% magnification setting, 390	blending multiple exposures, 207–213
100% size view, 71, 82, 84	Blue Skies effect, 161, 180
_	blur
A	background, 232, 380
acne removal, 245–247	Depth Of Field effect, 324–327
Add Noise filter, 330, 387	Gaussian Blur filter, 232, 245, 279, 359, 380
Adjust Color Curves dialog, 169–172	options for removing, 407 Orton effect, 321
Adjust Color for Skin Tone dialog, 237	Surface Blur filter, 334
Adjust Highlights slider, 170, 171 Adjust Intensity sliders, 342	Blush slider, 237
Adjust Shadows slider, 170, 172	Bracket keys ([]), 92, 244, 280
Adjust Sharpness control, 406–408	bright areas, 190–191
adjustment layers, 134–137	Brightness slider, 67, 94
advantages of using, 134–135	Brush Picker
color corrections with, 136, 157, 225	Brush tool and, 91, 246
creating new, 136	Clone Stamp tool and, 248
how they work, 137	Selection Brush tool and, 226
retouching portraits with, 252, 260	Brush tool color correction and, 160, 162–163
selections and, 217, 222	dodging/burning and, 184–186
Adjustments palette, 134 color channel controls, 166–167	double processing and, 91–92
Gradient Map options, 165	emphasizing color using, 352–353
Hue/Saturation controls, 157, 161–162	fill flash technique and, 193–194
Levels controls, 136, 179	layer masks and, 241–242
Photo Filter controls, 160	portrait retouching and, 246–247, 253, 255, 258, 280–282
Threshold Level slider, 148, 153	sharpening process and, 399
Adobe RGB color space, 412	special effects and, 329, 374
Advanced Dialog button, 5	See also Healing Brush tool; Smart Brush tool
Album Details pane, 27	brushes making selections using, 226
albums, 27–29 creating, 27, 426	sizing/resizing, 92, 205, 244, 280
deleting, 31	burned-in edge effect, 349–351, 357–358
Smart, 28–29	burning and dodging method, 183–187
Albums palette, 27	•
Alignment tool, 213, 311	
all-purpose sharpening, 394	calibrating your monitor, 413–415
Ames, Kevin, 250	Camera Calibration icon, 56
Amount slider	Camera Profiles, 56–57 Camera Raw, 53–95
Adjust Sharpness control, 407, 408	Auto corrections, 68, 93
Camera Raw Sharpening section, 82 Correct Camera Distortion filter, 202	black-and-white conversions, 93–95
Unsharp Mask dialog, 391, 395	Blacks slider, 65–66, 70, 94
Angle controls, 370, 404	Brightness slider, 67, 94
antique photo effect, 354–359	Camera Profiles, 56–57
artifact removal, 300–301	Clarity slider, 71–72, 93
Aspect Ratio pop-up menu, 102, 106	clipping warning, 62–64
Auto corrections, Camera Raw, 68, 93	Contrast slider, 94
Auto Smart Fix command, 139, 143	Crop tool, 74–76 double processing in, 89–92
Auto White Balance setting, 58	Exposure slider, 62, 63–64, 94
Auto-Analyzer, 19–20 Auto-Enhance checkbox, 228	Fill Light slider, 69–70
automated processing, 121–122	Full Screen view, 82
Automatic Download checkbox, 4	high-contrast look created in, 338–340
automatic red-eye removal, 195–196	multiple photo editing in, 78–79
automatic special effects, 316	Noise Reduction section, 86
D	opening photos in, 54–55
В	Recovery slider, 64–65
backgrounds	Red Eye Removal tool, 87–88 Saturation slider, 73, 93
blurring, 232, 380	saving to DNG format from, 80
cropping to remove, 114 desaturation effect applied to, 331	Sharpening section, 81–85
selecting subjects from, 230–231	Straighten tool, 77
backing up photos, 6–7	Temperature slider, 59, 60
barrel distortion, 201	Tint slider, 60
basic sharpening, 390–396	Vibrance slider, 73
black-and-white conversions	White Balance settings, 58–61

See also RAW images	high-contrast look, 333–340
cameras. See digital cameras	RAW image adjustments, 71, 94
canvas area, 110–111	Contrast slider
Canvas Options pop-up menu, 114	Camera Raw, 94
captions	Photoshop Elements, 342 Convert to Black and White dialog, 341–342
adding to photos, 10, 33	Cookie Cutter tool, 107–109
finding photos using, 35 capture sharpening, 81	cooling down photos, 159–160
circular selections, 219–220	Cooling Filter, 160
Clarity slider, 71–72, 93	copying and pasting images, 239
Clean Edges dialog, 344	Correct Camera Distortion filter, 199–203
clipping	Amount slider, 202
highlights, 62–65, 66	Midpoint slider, 202
shadows, 66	Remove Distortion slider, 201
clipping warning, 62–64, 65	Scale slider, 200
Clone Stamp tool	Vertical Perspective slider, 199
portrait retouching and, 248–249, 267–268	Create Category dialog, 17
unwanted object removal and, 296–299, 303–304	Create Keyword Tag dialog, 17
Cloud Contrast effect, 176–177	Create Subfolder(s) pop-up menu, 2 Crop icon, 76
clutter, reducing, 46–47 collages, 375–378	Crop tool, 98
collections. See albums	Camera Raw, 74–76
color	canvas area added with, 110–111
changing in objects, 225	custom size options, 104–106
converting to black-and-white, 93–95, 164–168, 341–342	Overlay features, 100–101
emphasizing objects with, 352–353	standard size options, 102-103
noise reduction methods, 86, 181–182	cropping photos, 98–112
optimizing for printing, 132	canceling crops, 100
removing from layers, 283, 328	custom size options for, 104–106
sampling from duotones, 384	gang-scanned images and, 112
selecting areas by, 224–225	lens distortion fixes and, 201
Color blend mode, 352, 385	panorama stitching and, 344
color cast, 144	recomposing and, 128
color channels, 166–167	Rule of Thirds overlay for, 100–101 scene cleanup and, 313
color correction, 131–173 Color Curves for, 169–173	shading feature for, 98–99
converting images to B&W, 164–168	shapes used for, 107–109
cooling down photos, 159–160	slimming subjects and, 276
digital camera images and, 144	standard size options for, 102–103
finding neutral gray for, 152–153	steps in process of, 98–100
flesh tone adjustments, 156–158	straightening and, 114
Histogram palette and, 143	Cross, Dave, 152
Levels dialog and, 144–147, 149–150, 153, 155	Curves, Color, 169–173
problem areas and, 161–163	custom crop
Quick Fix mode for, 138–142	Camera Raw, 75
selection adjustments and, 225	size settings, 104–106
settings for, 132–133 steps in process of, 144–151	Custom Name option, 3 Custom Shape Picker, 107
studio photos and, 154–155	Custom Shape Ficker, 107
warming up photos, 159–160	D
Color Curves, 169–173	Daily Note option, 40
Adjust Sliders, 170–172	dark circle removal, 248-249
Reset button, 171	dark subject fixes, 192-194
color management, 412–419	Darken blend mode, 348
monitor calibration, 413–415	Darken Highlights slider, 191, 220
paper profiles and, 416–419, 423	date information
Photoshop Elements configuration, 412	adding to scanned photos, 14
printer configuration, 422–424	finding photos by, 15, 35, 39–40
color noise, 86, 181–182	sorting photos by, 13
Color palette, 140	Date View feature, 39–40
Color Picker, 145, 146	Delete Options, 3 deleting
Color Settings dialog, 132, 412 color space configuration, 412	duplicate photos, 38
color swatch card, 61, 154–155	keyword tags or albums, 31
Color Variations dialog, 354–355	photos from memory cards, 3
ColorChecker chart, 155	See also removing
comparing photos, 44–45	Density slider, 160
Content-Aware Fill, 306–309	Depth Of Field effect, 324–327
contrast	Desaturate command, 328
black-and-white image, 94, 342	desaturated portrait effect, 328–332
Color Curves corrections, 169–173	Deselect command, 219, 276

Detail slider, 83	special effects and, 337, 353, 382 Esc key, 45, 100
Difference blend mode, 152, 290	EXIF data, 13, 32
digital cameras	exporting keyword tags, 26
camera profiles, 56–57	exposure adjustments, 62-67
color cast issues, 144	Exposure slider, 62, 63–64, 94
lens distortion problems, 199–202	external hard drive, 6
Digital Negative (DNG) format, 76, 80	extraordinary sharpening, 397–399
digital photos backing up, 6–7	Eye icon, 137, 239, 283 eye retouching
color correcting, 131–173	brightening whites of eyes, 252–254
comparing, 44–45	dark circle removal, 248–249
cropping, 98–112	lightening eye sockets, 255
finding, 15, 34–40	sparkle added to eyes, 256–258
fixing problems in, 175–213	Eyedropper tool
importing, 2–5, 425	color correction and, 145–147, 149–150, 155
info added to, 33 metadata info for, 5, 32	fake duotone effect and, 384 neutral midtones and, 153
previewing, 11–12	sample size settings, 133
recomposing, 123–129	eyeglass reflections, 287–292
renaming, 3	Eye-One Display calibration, 413–415
saving, 5	F
sharing, 48–50	F
sharpening, 389–408	Facebook
sizing/resizing, 115–122	downloading friend list from, 24, 48
sorting, 13	sharing photos to, 48–50 face-recognition feature, 23–25
stacking, 38, 46–47 straightening, 113–114	facial retouching. See retouching portraits
tagging, 16–25	faded antique effect, 354–359
digital workflow, 425–429	fake duotone effect, 384–385
disc backups, 6–7	Feather Selection dialog
Display button , 11, 39, 41, 44	color correction and, 156
distortion problems, 199–202	portrait retouching and, 260, 267
barrel distortion, 201	selection edge softening and, 223, 350 files
lens vignetting, 202 perspective distortion, 199–200	automatically renaming, 122
distracting object removal, 302–309	processing multiple, 121–122
Clone Stamp tool for, 303–304	viewing names of, 13
Content-Aware Fill for, 306–309	fill flash technique, 193-194
Healing Brush tool for, 302–304	Fill Layer dialog, 152
Divide Scanned Photos option, 112	Fill Light slider, 69–70
DNG file format, 76, 80	Film Grain filter, 386
DNG Profile Editor, 57 Dodge and Burn tools, 183	film grain simulation effect, 386–387 filmstrip view, 12
dodging and burning method, 183–187	filters. See
double processing, 89–92	finding photos, 34–40
downsizing photos, 119–120	date info for, 15, 35, 39–40
duotone effect, 384–385	duplicate photos, 37–38
duplicate photos, 37–38	methods used for, 34–36
duplicating layers, 245, 250, 256, 352, 400	fixing image problems, 175–213
E	bright areas, 190–191 camera lens distortion, 199–202
Edge Blending checkbox, 212	dark subjects, 192–194
edge sharpening, 403–405	digital noise, 181–182
edge vignette effect, 335–337, 339–340, 381–382	focusing light, 183–187
Edit Keyword Tag dialog, 30	group shots, 203–206
editing	pseudo-HDR technique, 207–213
adjustment layers, 137	red-eye removal, 195–198
multiple photos, 78–79	shadow areas, 188–189
RAW images, 58–79 workflow for, 427–428	Smart Brush adjustments, 176–180, 194 Flashlight effect, 347–348
effects. See special effects	Flatten Image command, 168, 180, 313, 330, 335, 401
Elements Editor	Flatten Stack command, 47
cropping photos in, 98, 102, 104, 107	flesh tone adjustments, 156-158
Guided Edit feature, 204, 287, 316	focusing light, 183-187, 373-374
Elliptical Marquee tool, 219, 222	folders, watched, 9
Emboss filter, 404	Forward Warp tool, 262–266
Eraser tool eyeglass reflections and, 290	Fotolia.com website, xv freckle or acne removal, 245–247
Group Shot merge and, 206	Free Transform
scene cleanup and, 312	accessing the handles of, 118

resizing images using, 118, 120, 239	Crop, 76
selection scaling and, 219, 231, 365	keyword tag, 30
slimming subjects using, 275–276	Stack, 46, 47
rown-into-smile technique, 273–274	image files
ull Backup, 7	automatically renaming, 122
full Screen view	processing multiple, 121–122
Camera Raw, 82	See also digital photos
Elements Organizer, 11, 41, 44	Image Size dialog, 115–117
ull-screen previews, 11–12	importing digital photos, 2–5, 425
G	scanned photos, 8, 14
gang-scanned photos, 112	Incremental Backup, 7
Gaussian Blur filter	information
background blur and, 232	adding to photos, 33
faded antique effect and, 359	metadata, 5, 32
portrait finishing technique and, 380	inkjet printer profiles, 416–419
portrait retouching and, 245, 279	Input Levels slider, 193, 222
Gaussian Blur removal option, 407	Inverse command, 221, 222, 229
Get Photos from Scanner dialog, 8	Invert command, 334, 374
Getting Media dialog, 195	ISO setting, 86
plasses, reflections in, 287–292	iStockphoto.com website, xv, 384
Golden Ratio overlay, 100	•
Gradient Editor, 369	j
Gradient Fill dialog, 367–368, 369–370	JPEG photos
Gradient Map adjustment layer, 165	cropping in Camera Raw, 74, 76
Gradient Picker, 367, 377	opening in Camera Raw, 55
Gradient tool, 377	I/
Grayscale mode, 164, 168	K
Grid overlay, 100	kelbytraining.com website, xv
Group Shot feature, 203–206, 287–288	keyword tags, 16–26
grungy high-contrast look, 338–340	applying multiple, 22
Guided Edit feature, 204, 287, 316	assigning to photos, 16, 18, 21–22, 426
Ц	choosing icons for, 30
H	creating, 16–17
nalos, 83	deleting, 31
nard drive backups, 6–7	finding photos using, 34
Hard Light blend mode, 404	people recognition and, 23–25
nardware calibration, 413 415	removing from photos, 21
HDR (High Dynamic Range) photography, 207	selecting photos for, 21
Healing Brush tool	sharing, 26
distracting object removal and, 302–304 portrait retouching and, 243–244, 249, 250	Smart Tags, 19–20 Keyword Tags palette, 16, 19, 22, 26, 34
recomposed images and, 129	Keyword Tags palette, 16, 19, 22, 26, 34
See also Spot Healing Brush tool	
nigh ISO noise, 86	Lasso tool
High Pass filter, 284	image fixes and, 190
nigh-contrast look	portrait retouching and, 237, 259, 267, 268
Camera Raw technique for, 338–340	selections made with, 227, 364
Photoshop Elements technique for, 333–337	layer blend modes, 135
Highlight Details slider, 209	layer masks, 238–242
lighlight Skintones option, 128	adjustment layers and, 134
nighlights	advantages of using, 241
clipping warning for, 62–64, 65	blending images with, 91–92
color correcting, 146, 149	brushes and, 241–242
darkening, 190–191	photo collages and, 376, 377, 378
recovering, 64–65	retouching portraits with, 246, 257–258, 279–282
specular, 66	selections and, 239–240
listogram palette, 143	sharpening photos with, 398–399
nistory, finding photos by, 36	special effects and, 329–330
Hollywood, Calvin, 333	thumbnails for, 240
not spot removal, 243–244	viewing, 281
lue slider, 225	Layer via Copy command, 245, 250, 256, 352, 400
lue/Saturation adjustments	layers
color correction and, 136, 157, 161–162	creating merged, 334
faded antique effect and, 356	desaturating, 328
portrait retouching and, 260–261, 269	duplicating, 245, 250, 256, 352, 400
selections and, 225	See also adjustment layers
	Layers palette, 91, 194, 289
66 files 417 410	Lens Blur removal option, 407
CC profiles, 417, 418	lens distortion problems, 199–202
cons	barrel distortion, 201

perspective distortion 100, 200	negative Clarity adjustment, 72
perspective distortion, 199–200	neutral density gradient effect, 367–370
Lens Effects palette, 326	neutral gray, 61, 152–153
lens vignetting, 202	New Layer dialog, 183–184
Levels Auto button, 139	New Smart Album dialog, 28
Levels controls, Adjustments palette, 136	noise
black-and-white conversions and, 165, 166–167	adding, 321, 330, 331, 387
color correction and, 136	reducing, 86, 181–182
dark subject fixes and, 192	Normal blend mode, 291
portrait retouching and, 270	nose retouching, 271–272
selection techniques and, 217, 222	notes
taming light using, 373	adding to photos, 33, 40
Levels dialog	Daily Note option, 40
adjustment layers and, 135, 136	finding photos using, 35
color correction and, 144–147, 149–150, 153, 155	numbering photos, 122
special effects and, 357	_
light, focusing, 183–187, 373–374	0
Lighten blend mode, 246, 248	object removal
Lighten Shadows slider, 189, 191, 220, 335	Clone Stamp tool for, 296–299, 303–304
Lighten Skin Tones preset, 194	Content-Aware Fill for, 306–309
Lighting Effects filter, 346–348	Healing Brush tool for, 302–304
Lighting palette, 139	Quick Selection tool for, 230–231
Lightness slider, 261	See also unwanted object removal
Liquify adjustments	Opacity settings
frown-into-smile technique, 273–274	edge sharpening and, 405
nose size reduction, 271–272	fill flash technique and, 194
tooth repair, 262–266	portrait retouching and, 246, 248, 251, 254, 286
Load Selection dialog, 221	special effects and, 332, 348, 350, 381, 387
Luminosity blend mode, 129, 374, 380, 401	Open Settings Dialog button, 42
luminosity sharpening, 379, 400–402	Organizer, 1–50
	albums in, 27–29
M	backup options in, 6–7
Macintosh computers	comparing photos in, 44–45
color management options on, 422, 423	Date View feature, 39–40
Organizer functions on, xiv	exporting tags from, 26
Magic Wand tool, 224–225	finding photos in, 15, 34–40
Magnetic Lasso tool, 227	full-screen previews in, 11–12
magnification settings, 390	importing photos into, 2–5
Mark for Protection tool, 125	info added to photos in, 33
Mark for Removal tool, 125, 127	Mac computers and, xiv
marquees. See selections	scanning images into, 8, 14
Mask for Protection tool, 127	sharing photos from, 48–50
Masking slider, 84	sizing thumbnails in, 10
matching photo styles, 360–363	slide show option, 41–43
Maximize Mode, 110	sorting photos by date in, 13
maximum sharpening, 393	stacking photos in, 38, 46–47
Media Browser button, 39	tagging photos in, 16–25
memory cards	viewing metadata info in, 32
deleting photos on, 3	Watch Folders feature, 9
importing photos from, 2–5	Orton effect, 320–323
merging	output sharpening, 81
layers, 334–335	oval selections, 219–220
multiple exposures, 207–213	overexposure, 190–191, 322
metadata information, 5, 32, 425	Overlay blend mode, 184, 329, 335, 368, 387
Midpoint slider, 202	Overlay features, Crop tool, 100–101
Midtone Brightness slider, 170, 172	Overlay leatures, Crop tool, 100-101
	Р
Midtone Contrast slider, 170, 172, 191, 220, 335	
midtones	palettes
adjusting in Camera Raw, 67	Adjustments, 134
color correcting, 146, 150	Albums, 27
finding neutral, 152–153	Color, 140
moderate sharpening, 393	Histogram, 143
monitor calibration, 413–415	Keyword Tags, 16, 19, 22, 26, 34
Motion Blur removal option, 407	Layers, 91, 194, 289
Move tool, 231, 376	Lens Effects, 326
Multiply blend mode, 336, 339, 357, 381	Lighting, 139
	Photo Play, 317
N	Properties, 32, 33
naming/renaming	Quick Edit, 41, 44
imported files, 3, 425	Quick Organize, 41, 44
multiple files automatically, 122	Sharpness, 141
,	

Smart Fix, 138	High Pass filter dialog, 284
Undo History, 134	Unsharp Mask dialog, 391, 395
panoramas, 343–345	RAW images, 53–95
paper profiles, 416-419, 423	auto correcting, 68, 93
paper size options, 420	camera profiles, 56–57
Paste Into Selection command, 218, 365	color vibrance in, 73
Pearly Whites effect, 261	converting to black-and-white, 93–95
Pen tool, 267	cropping, 74–76
Pencil tool, 205, 288, 312	double processing, 89–92
people-recognition feature, 23–25	editing multiple, 78–79
perspective distortion, 199–200	exposure adjustments, 62–67
Photo Downloader, 2, 5, 195, 425	fill light used in, 69–70
Photo Filter adjustments, 159–160, 232, 371	highlight adjustments, 62–65
Photo Play palette, 317	noise reduction, 86
photographs	opening in Camera Raw, 54–55
scanning into Organizer, 8, 14	punch added to, 71
See also digital photos	red-eye removal, 87–88
Photomerge Exposure feature, 207–213	saving in DNG format, 80
Automatic modes, 208–210, 213	shadow adjustments, 65–66
Manual mode, 210–213	sharpening, 81–85
Simple Blending option, 208, 213	softening effect, 72
Smart Blending option, 209–210, 213	white balance settings, 58–61
Photomerge Group Shot feature, 204–205, 287–288	See also Camera Raw
Photomerge Panorama feature, 343–345	Recompose tool, 123, 124–128
Photomerge Scene Cleaner, 311–313	Recovery slider, 64–65
Photomerge Style Match feature, 360–363	Rectangular Marquee tool
Picture Stack effect, 317–319	selection techniques and, 216, 218, 239
pin-registered photos, 90	vignette effects and, 336, 339, 350, 357, 381
plus-sign cursor, 297	rectangular selections, 216–217
portraits	Red Eye Removal tool
color correcting, 154–155 desaturation effect, 328–332	Camera Raw, 87–88
finishing technique, 379–383	Photoshop Elements, 197–198
pseudo-HDR technique, 207	red-eye removal, 195–198
sharpening, 379, 392	automatic process of, 195–196
See also retouching portraits	Camera Raw feature for, 87–88 instant method for, 197–198
Preferences dialog, 4	Reduce Noise filter, 181–182
Preserve Current Filename in XMP checkbox, 3	Refine Edge dialog, 336, 340, 358, 382
Preserve Details slider, 182	reflections in eyeglasses, 287–292
preset crop sizes, 102	Remove Color command, 164, 229, 283, 385
Preset Picker, 176, 179	Remove Distortion slider, 201
previewing thumbnails, 11–12	Remove Keyword Tag option, 21
Print dialog, 420–424	removing
printing process	blur from photos, 407
optimizing colors for, 132, 412	color from layers, 283, 328
paper profiles for, 416–419, 423	distracting objects, 302–309
setting options for, 420–424	eyeglass reflections, 287–292
Process Multiple Files dialog, 121–122	keyword tags, 21
profiles	red-eye, 87–88, 195–198
camera, 56–57	spots and artifacts, 300-301
printer, 416–419, 423	subjects from backgrounds, 230–233
Project Bin, 204, 205, 288	unwanted objects, 295–313
Properties palette, 32, 33	See also deleting
pseudo-HDR technique, 207–213	renaming. See naming/renaming
Pucker tool, 271–272	Rendering Intent options, 424
•	Resample Image option, 116, 117, 119
Q	Reset button, 139, 171
Quick Edit palette, 41, 44	resizing. See sizing/resizing
Quick Fix mode, 138–142	resolution
Quick Organize palette, 41, 44	increasing, 115–117
Quick Selection tool, 228–229	viewing size and, 120
Auto-Enhance checkbox, 228	retouching portraits, 235–292
color correction and, 156	blemish removal, 243–244
making selections with, 221, 229, 230–231	brightening whites of eyes, 252–254
portrait retouching and, 259	dark circle removal, 248–249
special effects and, 326–327	eye socket brightening, 255
R	eyeglass reflection removal, 287–292
	freckle or acne removal, 245–247
Radius slider Adjust Sharpness control, 407	frown-into-smile technique, 273–274
Camera Raw sharpening section, 83	layer masks and, 246, 257–258, 279–282
Camera have snarpenning section, 05	nose size reduction, 271–272

repairing teeth, 262–270	Shadows/Highlights dialog, 189, 191, 220, 335
skin tone fix, 236–237 slimming/trimming technique, 275–277	shapes cropping photos into, 107–109
softening skin, 278–286	selections based on, 216–220
sparkle added to eyes, 256–258	sharing
whitening teeth, 259–261	keyword tags, 26
wrinkle removal, 250–251	photos to Facebook, 48–50
RetouchPro.com website, 278	sharpening techniques, 389–408
round selections, 219–220	Adjust Sharpness control, 406–408
Rule of Thirds overlay cropping photos using, 100–101	basic sharpening, 390–396 Camera Raw, 81–85
hiding, 102, 105	color correction and, 141
rulers, 115	edge sharpening, 403–405
C	extraordinary sharpening, 397–399
S	layer masks and, 398–399
"S" curve, 172	luminosity sharpening, 400–402
sampling, 133, 296, 299, 384 Saturation slider	portrait sharpening, 379, 392 sample settings, 85, 391–396
B&W conversion and, 93	soft subjects and, 392
color correction and, 157, 162	Web graphics and, 394
Photomerge Exposure and, 210	workflow order and, 428
portrait retouching and, 260, 269	Sharpness palette, 141
RAW images and, 73	Show Strokes checkbox, 313
special effects and, 356	showing your work, xv, 41, 428
Save Options dialog, 80	Simple Blending option, 208, 213 simulated film grain effect, 386–387
Save Selection dialog, 221 saving	sizing/resizing
automated processing and, 121–122	automated, 122
digital photos, 5	brushes, 92, 205, 244, 280
keyword tags, 26	cropped photos, 102-106
RAW files, 80	digital camera photos, 115–122
selections, 221	downsizing process and, 119–120
Scale slider, 200	dragging between documents and, 120
Scale to Fit Media checkbox, 421 scaling selections, 219, 231	Free Transform handles for, 118, 120 parts of images, 123–129
scanned photos	thumbnails, 10
date/time settings, 14	skies
dividing gang-scanned images, 112	color correcting, 161–163
importing into Organizer, 8	Smart Brush adjustment, 161, 176–180
scene cleanup, 310–313	technique for replacing, 364–366
Scenic Landscape style, 341	skin softening, 72, 278–286 skin tone fix, 236–237
Screen blend mode, 252, 255, 356 searching for photos. See finding photos	skylight filter effect, 371–372
Select Transition dialog, 42	slide shows, 41–43
Selection Brush tool, 226	presentation options, 42
selections, 215–233	transitions for, 42–43
brush for making, 226	video on creating, 41
changing color of, 225	slimming/trimming technique, 275–277
color-based, 224–225	Smart Albums, 28–29 Smart Blending option, 209–210, 213
layer masks and, 239–240 Quick Selection tool, 228–229, 230	Smart Brush tool, 176–180
rectangular, 216–217	adjustment settings in, 179
removing subjects from backgrounds, 230–233	presets in, 176, 179, 180, 194, 261
round or circular, 219–220	steps for using, 176–178
saving, 221	Smart Fix options, 138–139
scaling, 219, 231	Smart Tags, 19–20
snapping to edges of, 227	smiles, changing frowns into, 273–274
softening edges of, 222–223 square, 218–219	snap-to-edges feature, 227 Soft Light blend mode, 186, 285, 329, 372, 386
tricky, 227	soft spotlight effect, 346–348
Set Date and Time dialog, 14	soft subject sharpening, 392
Set Date Range dialog, 35	softening techniques
shadows	edges of selections, 222–223
adjusting in Camera Raw, 65–66	skin softening, 72, 278–286
clipping warning for, 66	vignettes, 340, 350, 382
color correcting, 145, 149 fill light for, 69–70	sorting photos, 13 sparkling eyes, 256–258
lightening, 188–189	special effects, 315–387
Shadows slider	automatic or built-in, 316
Lighting palette, 139	black-and-white conversions, 341–342
Photomerge Exposure feature, 209	burned-in edge effect, 349–351, 357–358

Camera Raw used for, 338–340 collage creation, 375–378 Depth Of Field effect, 324–327 desaturated portrait effect, 328–332 emphasizing objects with color, 352–353 faded antique effect, 384–385 high-contrast look, 333–340 matching photo styles, 360–363 neutral density gradient effect, 367–370 Orton effect, 320–323 panoramas, 343–345 Picture Stack effect, 317–319 portrait finishing technique, 379–383 simulated film grain effect, 386–387 sky replacement technique, 364–366 skylight filter effect, 371–372 soft spotlight effect, 346–348 taming your light, 373–374 vignetting, 349–351 workflow order and, 427–428 specular highlights, 66 Spot Healing Brush tool, 301–302, 306–308 spot removal, 300–301 square selections, 218–219 sRGB color space, 412 Stack icon, 46, 47 stacking photos, 38, 46–47 standard photo sizes, 102–103 stock photo websites, xv, 384 Straighten tool Camera Raw, 77 Photoshop Elements, 113–114 straightening photos, 77, 113–114 studio photo correction, 154–155 Style Bin, 360–361 Style Match feature, 360–363 styles brushes for working with, 363	Transfer Tones checkbox, 361 transitions for slide shows, 42–43 Transparency slider, 211 tripods, 213, 310 U UnCheck All button, 5 underexposed subjects, 192–194 Undo command, 164, 272, 308, 377 Undo History palette, 134 Unsharp Mask filter Adjust Sharpness control vs., 406 basic sharpening and, 390–396 digital noise and, 331 extraordinary sharpening and, 401 portrait finishing technique and, 379 portrait retouching and, 256–257 resized photos and, 119, 120 sample settings, 391–396 See also sharpening techniques Unstack Photos command, 47 unwanted object removal, 295–313 Clone Stamp tool for, 296–299, 303–304 Content-Aware Fill for, 306–309 distracting objects and, 302–309 Healing Brush tool for, 302–304 scene cleanup and, 310–313 spots/artifacts and, 300–301 tourists and, 310–313 uploading Facebook photos, 50 V Versace, Vincent, 346 Version Sets, 196 Vertical Perspective slider, 199 Very Pearly Whites effect, 261 Vibrance slider, 73 video downloads, xv, 41, 48, 428
sliders for adjusting, 362–363 Surface Blur filter, 334	vignette effects burned-in edge effect, 349–351, 357–358
swatch card, 61, 154–155	edge vignette effect, 335–337, 339–340, 381–382 vignetting problems, 202, 343
T	Visually Similar Photo Search dialog, 37–38 Vivid Landscapes style, 341, 342
tabbed viewing, 110 tags. See keyword tags	Vivid Light blend mode, 333
taming light, 373–374 Tan slider, 237	W
target cursor, 296	Warming Filter, 160, 232, 371
teeth	warming up photos, 159–160
repairing, 262–270 whitening, 259–261	Warp tool, 273–274 Watch Folders dialog, 9
Temperature slider, 59, 60	Web sharpening, 394
text search field, 36	White Balance settings, 58–61, 94
Threshold adjustment layer, 147–148, 153 Threshold slider, Unsharp Mask, 391, 396	White Balance tool, 60, 61 whitening
thumbnails	whites of eyes, 252–254
layer mask, 240	yellow teeth, 259–261
previewing, 11–12	workflow order, 425–429 wrinkle removal, 250–251
Quick Fix mode, 140 sizing/resizing, 10	Service (1997) 1 1 1 1 1 1 1 1 1
TIFF photos	Z
cropping in Camera Raw, 74, 76	Zoom tool
opening in Camera Raw, 55	Carriera Raw, 71, 82, 86 Photoshop Elements, 197, 256, 312
Timeline, 15, 34 Tint slider, 60	zooming in/out, 390
Toggle Film Strip button, 12	·
Tolerance setting, 225	
tonal adjustments, 143	
tools. See	

tourist removal, 310-313

expodisc

Professional White Balance

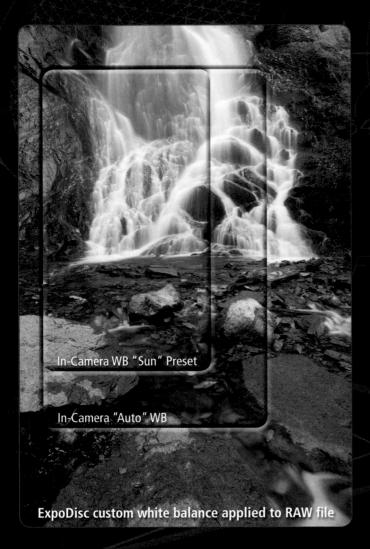

Simplicity & Accuracy

Whether shooting still or video, JPEG or RAW, setting a good custom white balance is the easiest thing you can do to improve your color.

Simplicity

Getting great color with an ExpoDisc is easy. Simply cover the lens and take a reading through the ExpoDisc of the light source (an incident light reading). For most cameras, the custom white balance procedure takes about 10 seconds.

That's it. If you're shooting RAW, simply download your images as shot. No special software, and no post processing required.

Accuracy

The accuracy of a custom white balance depends upon the neutrality of the tool used to set the white balance.

As inventors of the Digital White Balance Filter, we have always gone to great lengths to ensure the neutrality of every ExpoDisc. Every ExpoDisc is assembled, tested and certified in our California facility for 18% light transmission and neutrality across the visible spectrum.

Trust ExpoDisc to capture the color you see

ExpoDisc representative Lab values: L*=49.90,a*=.-0.26, b*=0.17,

"I've tried multiple ways of setting a custom white balance. The ExpoDisc is by far the most simple, consistent and user friendly."

Les Voorhis, Professional Nature Photographer, May 2007.

Do more with your pictures!

Turn your favorite images into fun products at mpix.com.

PHOTO BOOKS

MAGNETS

mpix

Opload your photos to www.mpix.com and start creating.

Getting more serious about digital photography?

Get Adobe Photoshop[®] Lightroom[®] 3, a complete intuitive package designed expressly for photographers.

- · Maximize image quality with state-of-the-art raw processing
- Experiment fearlessly with nondestructive editing tools
- · Achieve amazing results with world-class noise reduction technology

ADOBE PHOTOSHOP LIGHTROOM 3

Focus on what you love about photography with Adobe Photoshop Lightroom 3 software, an intuitive digital darkroom and efficient assistant designed for serious amateur and professional photographers. Easily organize and manage your growing photo collection. Experiment fearlessly with nondestructive editing tools that help you create incredible images. And showcase your work with style and impact in print layouts, slideshows, and web galleries.